To Terry and Ruth,

thank you for your great idea!

Tom McDonald

Oct. 8, 1996

THE BUSINESS OF PORTRAIT PHOTOGRAPHY

THE BUSINESS OF
PORTRAIT
PHOTOGRAPHY

TOM McDONALD

AMPHOTO BOOKS
an imprint of
Watson-Guptill Publications/New York

Tom McDonald, and Jo Alice, his wife, own an active studio in Jonesboro, Arkansas, where they work at the twin goals of increased sales and artistic growth through print competition. They've spoken to professional groups throughout the United States and made three teaching trips to Europe.

A graduate of the University of Texas, McDonald holds the Master of Photography and Photographic Craftsman degrees from Professional Photographers of America (PPA). The American Society of Photographers has awarded him its Fellowship and Associate degrees.

McDonald ranks fourth in PPA merits with more than 650, and fifth in Masters print points with 65. He is a qualified PPA national print juror and one of 40 members of Cameracraftsmen of America. During the 1985-95 period, he had 34 of 40 prints accepted for the national Masters exhibit.

Senior Editor: Robin Simmen
Editor: Liz Harvey
Designer: Bob Fillie, Graphiti Graphics
Graphic Production: Hector Campbell

Copyright © 1996 by Tom McDonald
First published 1996 in New York by Amphoto Books,
an imprint of Watson-Guptill Publications,
a division of BPI Communications,
1515 Broadway, New York, NY 10036

Library of Congress Cataloging-in-Publication Data
McDonald, Tom. 1933-
 The business of portrait photography: a professional guide
 to marketing and managing a successful studio, with profiles of 30 top
 photographers / Tom McDonald.
 p. cm.
 Includes bibliographical references and index.
 ISBN 0-8174-3616-2
 1. Photography—Business methods. 2. Portrait photography.
 3. Photographers—Biography. I. Title.
 TR581.M37 1996 95-49814
 779.9'2'068—dc20 CIP

Manufactured in Hong Kong

1 2 3 4 5 6 7 8 9/04 03 02 01 00 99 98 97 96

In Memory

Michael McDonald

Born, Jonesboro, Arkansas, July 13, 1959

Died, New York City, July 6, 1994

CONTENTS

THE BUSINESS

PROFILES

INTRODUCTION

Almost 30 years ago, while working as a newsman at a television station in Memphis, Tennessee, I had a strong desire to be self-employed. Realizing that I could never own a television station, I started looking for other opportunities. A friendly banker with amazing business acumen led me to portrait photography, and the decision has been rewarding for me.

This profession has enabled my wife and me to educate our children, to own our own studio building, and to travel extensively, almost on a monthly basis. Fulfillment comes to me not only in receiving print awards, but also in creating portraits that please people. Nothing is more gratifying than to hear clients say that I've shown the love they feel in a portrait.

I find people of all ages to be delightful. I enjoy working with toddlers, high-school graduates, and senior citizens. One of the prerequisites for anyone wanting to open a portrait business is to love people. You also have to be able to communicate with them in order to bring out their personalities. The word "portrait" comes from the Latin word "protrahere," which means "to draw forth." To be successful, then, portrait photographers must have the ability to involve a subject so completely that they capture the essence of the person's spirit in a dramatic way.

During a two-year tour in the United States Army (1955-56), I learned to value "mission" almost to the exclusion of everything else in life. In fact, my Army leaders ingrained mission so thoroughly in me that it has become an integral part of my personality. My commander didn't waste his time—or his soldiers'—with spit-and-polish inspections of the barracks, mess halls, or uniforms. But he put the fear of death in us when it came to mission. This training has helped me achieve my goals in both my private life and my business. For example, my professional mission is to create portraits. So the first thing I must do each day is to prepare to shoot. This involves such mundane chores as cleaning up the camera room, loading cameras, testing lights, checking shutter synchronization, setting up backgrounds, preparing props, and—most important of all—preparing myself mentally for a shooting session.

Sounds simple, doesn't it? But constant pressures, as well as distractions, keep me from my mission. Because I am as likely to procrastinate as the next person, I would rather start the day by drinking coffee and talking with my friends, reading the newspaper and the mail, and trying something new on the computer. I also have so many demands on my time—from my family, church, and civic and professional organizations—that I have trouble concentrating on my mission. But the discipline of mission tells me, like it or not, that I must get the camera room ready first.

Long hours and hard work, plus God-given talent, are the first ingredients of a successful photographer. These are followed by the perseverance needed to overcome failure and frustration. Next, you must develop the ability to seek the advice of others who have been successful in such areas as human resources, sales, finance, computer technology, engineering, psychology, and print competition. Through Professional Photographers of America (PPA) affiliate groups, civic-club contacts, and church friends, I've found many experts willing to help. Most important, I've had direction from God throughout my career, leading me to Jo Alice, my wife, and four dedicated business colleagues who make up for my many weaknesses with their talents and dedication to serving others.

When Robin Simmen, Amphoto Book's senior editor, contacted me about writing this book, my first thought was to decline because I was spending about one week out of every month teaching professional seminars and schools, and cramming approximately 60 photographic sessions into the other three weeks. I didn't seem to have any time left in my busy schedule. Then Michael, my older son, died, and I saw this book as an opportunity to do something in his memory.

The objective of this book is to help those who want to fulfill a dream of owning their own business in a profession that will allow creative expression while pleasing clients with a product whose chief benefit is love. Newcomers, as well as those who have been in business for many years, can learn not only how to create portraits but also to make a profit, without which no one stays in business for long.

Asked to contribute to the book or to provide expert advice in areas beyond my expertise, my friends have rallied to support a cause that all of us feel is worthwhile. I believe this book provides a unique guide to a profitable career in portrait photography, thanks to the combined efforts of a lot of dedicated people. In addition to the photographers whose work appears on these pages, I would like to express my deep appreciation to True Redd, Belinda Gambill, Linda Carter, Linda Clements, Clyde Wilhoite, Curtis McKinney, Ron Fleckal, Joe Craig, Bill Miller, Richard Miller, Dick Coleman, Nema Velia, Gary Mattson, John Hurst, Arthur C. Heitzman, Wes Siebe, Barbara Palmer (Kodak-Australia), Kinji Yokoo (Fuji-New York), Jo Alice McDonald, and my loyal clients whose support has made my career possible.

As American lawyer Louis Nizer (1902-94) said, "A man who works with his hands is a laborer; a man who works with his hands and his brain is a craftsman; but a man who works with his hands and his brain and his heart is an artist."

THE BUSINESS

CHAPTER 1
GETTING STARTED

Launching a career in portrait photography requires artistic talent, organizational skills, business acumen, sales skills, and some capital. Obviously, all photographers don't start out on equal footing in every one of those areas, but they build on what they have and acquire the rest over a period of years.

People can develop all the skills needed to run a business—even an art business—but it may take them years to see light or compose as well as the masters do. Some people have natural artistic ability while others have inherent business acumen. The latter can quickly recognize the best value, the best sales strategy, and the best business location without spending too much time studying the situation.

Both the business and art worlds have their share of geniuses, but most successful portrait photographers are average people who have worked hard to get their businesses off the ground and keep them moving steadily upward. Thomas Edison said that genius is 10 percent inspiration and 90 percent perspiration; this formula applies to most portrait photographers. And although a person needs a moderate amount of money to launch a photographic career, it isn't the most important factor.

THE RIGHT ATTITUDE

Through the influence of others, I've learned that we have a choice every day regarding the attitude we'll embrace for that day. We can't change the past, and we can't change the fact that people will act a certain way. All we can do is play on the one string we have, and that is our attitude.

Consider the following quotation from Charles R. Swindoll from *Strengthening Your Grip* (Word Publishing, 1982):

"Words can never adequately convey the incredible impact of our attitude toward life. The longer I live the more convinced I become that life is 10 percent what happens to us and 90 percent how we respond to it. I believe the single most significant decision I can make on a day-to-day basis is my choice of attitude. It is more important than my past, my education, my bankroll, my successes or failures, fame or pain, what other people think of me or say about me, my circumstances, or my position.

Attitude keeps me going or cripples my progress. It alone fuels my fire or assaults my hope. When my attitudes are right, there's no barrier too high, no valley too deep, no dream too extreme, no challenge too great for me."

FORMS OF OWNERSHIP

Before starting a business, the founder must decide on the form of ownership. Three basic kinds of ownership exist: a sole proprietorship, a partnership, and a corporation. The founder should seek the advice of an accountant or attorney about the advantages and disadvantages of each type of entity.

A sole proprietorship is probably the most popular form of ownership in portrait photography. Even some businesses with sales in the millions are sole proprietorships. In the United States, a sole proprietorship's income and expenses are reported to the Internal Revenue Service on Form 1040 Schedule C. The income tax on the net income is paid with the individual's personal income-tax return. A proprietorship usually requires less paperwork than the other forms of business ownership do.

Probably the greatest advantage of a sole proprietorship is that the owner is free to make decisions without having to consult stockholders or a partner. Early in life when I worked for newspapers and a television station, I set a goal of owning my own business just so I could control the thermostat. Looking back 30 years later, that seems like a silly reason for wanting to be a sole proprietor. But it was just the manifestation of the control I wanted to exercise over my own business, and, in the long run, over my own life.

Partnerships are less common than sole proprietorships because they require two or more people to

agree on business and artistic decisions throughout the life of a business. Even if the individuals agree at the start, they frequently grow apart after a few years and dissolve the partnership. Another problem can arise when one partner wants to pursue specialty areas of photography. While the partnership passes on its income and deductions to the individual partners, it is required to file an information tax return allocating the distribution of income and tax benefits.

A third form of ownership, the corporation, is a separate legal entity that may offer some protection from lawsuits. Most lending agencies require personal as well as corporate guarantees from new businesses. Corporations must keep a stockholders' minutes book and, in some states, pay a franchise tax.

Corporations usually report their income and pay income tax on separate federal and state income-tax returns. A photography studio operating in a corporate structure could be subject to "personal service corporation" rules. These rules impose limits on deductions and tax income at the highest individual rate. Income that is distributed as dividends are taxed a second time on an individual return.

The shareholders of a corporation may file a "small business corporation" election with the Internal Revenue Service to have the corporation's income taxed to the shareholders rather than to the corporation itself. Some exceptions to the taxation rules exist, but shareholder limitation rules must be followed. Distribution of earnings usually aren't "dividends," so individuals avoid the double taxation problem.

HOW MUCH MONEY DO YOU NEED?

Owners who don't have sufficient personal funds to open a business will need a personal net-worth statement and a business plan to secure a loans from a bank, a finance company, venture-capital investors, or such government agencies as the Small Business Administration. When other forms of credit aren't available, some people have even started businesses with credit-card loans despite their high interest rates. Writing a business plan may require help from a pro-

fessional adviser, such as an insurance broker, a lawyer, or an accountant. A college business instructor can help you for a smaller fee than you would incur with a combination of experts.

How much money do you need? Some experienced experts recommend that your start-up capital should be sufficient to cover a company's overhead for six months without any income. Overhead includes such necessities as salaries, rent, utilities, taxes, insurance, advertising, and automobile expenses. In addition, up-and-coming photographers also will need enough money for basic equipment.

POTENTIAL PROBLEMS

Three significant problems face a new business:

- Insufficient sales due to lack of public awareness. Some portrait photographers say that four years are needed to establish an adequate customer base in order to turn a profit.
- Lack of experience and/or education. Few portrait photographers are fortunate enough to grow up in their parents' business, so they must gain experience while building their business. They'll make mistakes, which will result in a loss of customer confidence. Education in a top photography school will help minimize errors.
- Equipment expenditures cripple cash flow. Unfortunately, they usually must be paid for quickly. Emerging photographers usually acquire most of their equipment in the early years of the business when they have little or no income. Photographers who are fortunate enough to earn income during the first few years of operations can take advantage of special tax deductions available to businesses.

Despite all the problems, many photographers start successful careers every year because of well-thought-out business plans, hard work, courage, sacrifice, determination, and a willingness to take risks. Most well-established photographers say it was worth the price to gain the freedom and fulfillment they enjoy in this profession.

MARKETING

Like a tripod, the profession of photography stands on three legs. These are art, business, and production. Remove one of these legs, and the photographic profession falls—and fails! Naturally, many photographers don't want to believe a word of this. They want to view their chosen field as one in which success is inevitable if they are good at capturing images on film. Their motto is "My work sells itself."

The stark truth, however, is that some great photographers operate at near-poverty levels because they are poor at marketing, advertising, accounting, managing for profit, and, most important of all, planning. Fortunately, you can achieve success in sales and marketing via a four-step process: finding your market, establishing value, appealing to emotions, and providing incentive.

FINDING YOUR MARKET

Fledgling photographers, as well as established studios, must define their markets. The reason many experienced photographers fail at business is that they never take the time to analyze their markets. They need to think about the following considerations. What do I have to offer that is new, different, or currently unavailable from those individuals already in the field? Who will buy these unique products or services? How can I get my products or services to the market in a manner that I will profit from?

Most successful businesses, even those with billions of dollars of sales, are continually striving for a niche that no one else has filled. This process requires both marketing and research. And while these tasks may seem far beyond most photographers' budgets, they actually aren't. If you spend some time studying your situation and then brainstorming with someone who is knowledgeable in sales, you might come up with many good ideas.

Your research might lead to a realization. You need to develop a new product or put a new twist on an old idea. Suppose, for example, you discover that you want to introduce electronic imaging as an improved method for copy and restoration work in your area. This goal involves learning how electronic imaging is done, and then deciding whether you want to do all or part of the work yourself or to send it to a laboratory that specializes in these services. If you choose the third option, you'll do the sales and marketing and an outside specialist will handle production. (This is common in the photographic industry.)

Marketing, then, would mean finding out if a need for this particular product and service exists. Do potential clients in your area own old photographs that have to be copied and restored? Also, does the lab use traditional methods of copying with film, producing workprints, and making corrections with airbrush techniques and oil artwork? Can you do the restoration work better, faster, and perhaps less expensively with electronic imaging?

One of the basic marketing steps is to determine your place in the market. Do you want to appeal to those people with the highest incomes? If so, do enough families with this kind of wealth live in your geographic area and can support your enterprise? Which photographers currently appeal to these people? How well? Do you have the skill, finesse, image, appearance, and language to work successfully with clients on this level?

Would you rather appeal to the middle-income families in your area, those in the middle 60 percent? Alternately, do your plan to market to families whose incomes fall in the lowest 20 percent? Keep in mind that for both middle- and lower-income families, you'll be competing with mass marketers in the photographic

industry—the people with studios in malls and discount stores. What can you do that the mass marketers can't? What are their problems? Certainly you can spend more time with your clients, create a warm atmosphere for photographic sessions, and offer to go on location to photograph your customers in a strikingly beautiful park or in their own homes. You can also portray them with their pets, their car, or perhaps even their boat.

ESTABLISHING VALUE FOR YOUR PHOTOGRAPHY

As an individual photographer or the owner of a small-studio enterprise, you have to charge more for your work than mass marketers do. So prospective clients must be convinced that your products and services are worth the price you're charging. You can create a demand for your portrait photography and establish its value several ways.

DISPLAY YOUR WORK

One option is to show your photographs in as many high-traffic places as possible. Nothing sells your work like exhibiting it to the public. Some places where you might display your portraits are maternity shops, children's stores, hair salons, movie theaters, video stores, frame shops, doctors' offices, hospitals, restaurants, cafeterias, banks, shopping malls, bridal shops, and tuxedo-rental stores.

During discussions with potential hosts about the display, you should emphasize how it will benefit their location via increased traffic, goodwill toward them, and ready conversation topics for those having to wait. A display also ensures recognition for the subjects, and, of course, it provides advertising for you as a photographer. Any outside display must be a win-win situation for all concerned.

In more than 20 years of displaying portraits and wedding candids at various locations, I've received thousands of positive comments from potential clients. For example, after the owners of a busy cafeteria displayed my work for 15 years, they decided to remodel; this meant removing my portraits for about a month while the walls were resurfaced. As soon as this task was completed, the cafeteria manager called me and wanted to know how quickly I could restore the gallery because customers "wanted the pictures back!"

PRINT COMPETITION

Entering a competition is another way to attract attention and establish value for your work. Most large cities and all states have professional photographic organizations that hold print judgings on a regular basis, either monthly or annually. For information about these associations, contact Professional Photographers of America (PPA), which runs its own international print competition (see the Resources list on page 190).

AUDIOVISUAL SHOWS

These display opportunities leave a longer-lasting impression than any photograph you've ever made because of the synergetic effect of the music and slides. Audiovisual (AV) shows evoke emotional responses from audiences and bring you recognition. These, in turn, increase your chances of being the person the audience members will call for their photographic needs. Themes for shows vary widely. Each of the following ideas can have a strong impact.

Memories. Consider putting together a show by copying old photographs that trace the history of your area. You can provide the pictures with a chronological context by copying old newspapers. I created a popular show in this manner. I started with photographs dating from about 1900, and then progressed through World War I, the Great Depression, World War II, the Korean War, the assassination of President John F. Kennedy, the Vietnam War, and, finally, the Gulf War. I included some memorable local events, such as a flood and a tornado. These dramatic images, combined with stirring music, left hardly a dry eye in the audience when the show was over.

Humor. Images of children always are popular, especially when you show the humor of some sessions. Surprise follows surprise in a merry kaleidoscope of faces as they laugh, cry, yawn, grimace, kiss, blink, and mug. Viewers react with glee as they watch the subjects' natural, uncontrived expressions that show the full range of childhood emotions.

Patriotism. Scenes of America, especially those that show flags and parades, can constitute a stirring slide show when set to patriotic music. Civic groups clamor for this kind of show before national holidays, such as Memorial Day, Independence Day, Labor Day, and Thanksgiving.

Spirituality. Religious groups and organizations always want AV programs with a spiritual flavor. You can fill this need by combining nature scenes with narrations of scriptural passages. Shots of sunsets and rainbows are particularly effective in shows with spiritual themes.

Romance. When the sponsor of a local bridal fair solicited me to buy booth space, I made a counteroffer to put on a slide presentation just before the fashion show. "It's February, and the snow is flying," I explained to the sponsor. "Let me suggest a way to put the audience in the mood for a summer wedding. I'll put on a short slide show, about eight minutes long, with scenes from one of last summer's weddings, set to romantic music." She agreed to my plan. The audience response was so overwhelming that the

sponsor asked me to prepare another show for the following year's bridal fair.

This experience taught me that a slide show is the best way—by far—to sell my wedding services to a prospective bride. In the past, brides and their mothers looked through my sample albums, but they didn't see my photography. They spent their time criticizing the dresses, tuxedos, flowers, cakes, etc. When they finally finished, their typical response was "I'll let you know later." These encounters wasted my time. Now brides and their mothers view my eight-minute slide show and are ready to book immediately because their emotional response is so strong.

APPEALING TO EMOTIONS

When you study the marketing techniques of large advertisers, you immediately notice that they appeal to your emotions. Consider the impact of well-known advertising slogans: "Reach out and touch someone," "It's good to feel so good about a meal," and "We do it all for you!"

AT&T could advertise how convenient it is to dial a loved one in Europe using a touch-tone telephone. However, the company emphasizes the feeling you have—the emotional benefit—after the experience rather than the mechanical features of the telephone. Love is the greatest motivating force in portrait advertising. Almost all of my studio advertisements contain the headline "Because You Love Them." Instead of mentioning details about portraits, the ad copy stresses the benefit derived from buying photographs.

WHICH ADVERTISEMENT SELLS?

Notice that the Studio A advertisement calls attention to the features of a portrait while the Studio B ad focuses on its long-lasting value. People give friends and family portraits out of love and affection. Some of the most successful portraits I've ever displayed tugged at people's heartstrings and brought in new clients. An award-winning portrait of a mother and her son elicited positive responses from a wide range of prospective clients after I showcased it in a number of out-of-studio galleries.

Photographs with emotional value will attract more business for you than anything else you do. Simply shoot some stunning emotional images and then present them to the public through displays; audiovisual shows; and advertising pieces, such as direct mail. Displaying a sunset photograph of a little boy and his horse in a restaurant gallery brought a call from a man 200 miles away who wanted a portrait of his son and their horse like the one he saw. This resulted in an order that was impressive for me at the time, as well as one of the largest of that year. Hundreds of other photographers were probably closer to this client than I was, but their work and approach didn't touch him emotionally the way my display portrait did.

Which of these two advertisements would you respond to?

Family portraits are my best-selling product line, so I always have several group photographs on the wall, including one of my own family. This photograph actually is a composite of family-group portraits, one each year for 25 years. Seeing a family evolve over the course of so many years is an emotional experience for some prospective clients.

You can reap marketing benefits by having your own family portrait done regularly and displaying the results. A few years ago, I used about 10 of my family portraits in a printed direct-mail piece, showing the change over the years, and this led to wonderful results.

In addition to suggesting family-group pictures, you should stress the importance of having a child's portrait taken regularly, at least once a year. Without a portrait, parents will miss an essential stage of their child's development. Many studios have birthday clubs and album plans that offer savings if the clients bring in the child at specific intervals, at least annually.

Because previous clients are so valuable, I contact them a minimum of five times a year. Some people like cars, others like boats, others enjoy horses, and still others desire jewelry, but I seek out people who love photography. And once I find them, I don't intend to lose them. As Peter Orthmann, the owner of Synergetic Selling, says, "It costs six times more to develop a new customer than it does to sell an existing one."

PROVIDING INCENTIVE

Once you establish the perception in the public's mind that your photography has great value and emotional benefits, you can advance to the next step: give people an incentive to buy now. Plan your promotions during school vacations and times of the year when prospective clients already have a need to buy, such as Christmas, Mother's Day, Father's Day, and Valentine's Day. Many photographers try to promote their services only when their sales are slow rather than seizing the day when the public is ready to buy.

Working long hours during peak buying seasons is offset by vacations during slow times. The more you can stretch the buying season at gift-giving times. the more profitable your business will be. This means not only longer studio hours but also moving your deadlines closer to the holiday by using overnight express services and rush processing if you're working with an out-of-town lab.

"Low-Commitment Specials" have proven successful for me because they offer my clients a fixed price for both the session and the product. These promotions eliminate a major roadblock in the path of prospective clients; people realize that they're getting something for their money. For some reason, clients resent paying a session fee with no value received for the expenditure. During my 28 years of being in the portrait-photography business, I've discovered that all people, including the wealthy, want the most value for their money. As John B. Neff, a mutual-fund advisor at Wellington Management, says, "Price is the great equalizer and allocator of spending in a capitalistic society."

"Eight Ways to Say Merry Christmas" and "Happy Father's Day" rank among my studio's most successful low-commitment specials. The eight-way Christmas special is composed of eight 4 x 5-inch color proofs (I call them "originals") delivered in an inexpensive album or folio. The eight-way picture offer is popular with customers because they can have their child photographed in three different outfits with three different backgrounds for a fixed price. This promotion doesn't call for a minimum order or a session fee, and it has almost no restrictions.

Photographers profit from this eight-picture promotion because they can schedule it close to a gift-oriented holiday. The offer also results in lots of sessions and opportunities to reach more potential repeat customers. This increase in volume compares favorably with average package deals and wall portraits sold during a similar time frame (see page 16). Another advantage is that because the promotion consists of only proofs, the deadline can be less than a week from the due date.

Sessions are the fuel that keep a studio running. Someone asked baseball legend Babe Ruth, "How do you hit 60 home runs in a season?" Ruth's answer: "It takes a lot of at-bats!" The portrait-photography business works this way, too. To make sales, you must have shooting sessions, and low-commitment specials attract many customers. Some variations of the low-commitment specials include:

- "Four Ways to Say Happy Mother's Day" (four proofs in a frame with a mat)
- "Six Ways to Celebrate Spring" (six proofs in a frame with a mat)
- "Two for One Special" (two 8 x 10 prints for the price of one)
- "Christmas Cards for Half-Price" (a slimline-greeting-card promotion offered in October to attract early Christmas sessions)

Because small-studio portraiture is such a personal service, it is horribly inefficient when compared to manufacturing or even with chain-store photography. But low-commitment specials increase efficiency since portrait photographers can concentrate on children or groups for an intense period of time. Having to think about only one type of photography for three or four weeks makes photographers not only more productive, but also more creative because they can try seemingly limitless variations. Consider a typical telephone conversation between one of my staff members and a prospective customer:

"McDonald Portraiture, Linda speaking."
"What kind of specials do you offer for Christmas?"
"Would this be for yourself or your child?"
"My child."
"May I ask her name?"
"Ann Margaret."
"And your name is?"
"Barbara Coleman."
"Thank you for your inquiry. May I call you Barbara?"
"Yes, that will be fine."
"Barbara, we have an outstanding value to offer you: eight 4 x 5 portrait originals of an individual for just 59 dollars."
"But I wanted it of both my daughters, Ann and Margaret."
"Oh, I didn't know you wanted a group portrait. The eight-way feature is for individuals only, but we have an unadvertised 11 x 14 group special for just 99 dollars. May I book an appointment for you?"
"Can I get the group 11 x 14 and individual eight-way specials of each girl while we're there?"
"Of course. Would morning or afternoon be better for you?"

Never say "no" to potential clients if at all possible. Get them on the book first, then work out the best use of your time. By offering an unadvertised group pro-

motion at the same time as the eight-way promotion, Linda was able to give a positive response to almost all of Barbara's inquiries. Advertising for the eight-way special results in a high number of group as well as individual sessions.

As the end of a promotion nears, appointment times get scarce, particularly after school and on Saturdays. To accommodate this, I schedule sessions during lunch hours and after the studio's closing time. Usually I allow an hour for each session, but I often shorten the time to 30 minutes when the demand is heavy rather than turn down clients. My staff members call all customers the day before the sessions to confirm their appointment times. If some of them cancel for any reason—a sick child, a minor accident, an unexpected out-of-town trip—I can readjust the appointment book to increase the length of the day's other sessions, thereby giving each client a little more time.

Design low-commitment specials that don't reduce your total order. Since package sales are instrumental to increasing averages, a low-commitment special mustn't eliminate items offered in the packages. This is why the six- or eight-way promotion works so well: it doesn't adversely affect package sales.

After the session, some clients will place large orders while others won't order anything beyond the low-commitment special. As a result, I've learned to play the averages and forget the exceptions. During a recent year, the eight-way special equalled my typical dollar average for portrait orders, and the group special doubled it. (Averages are accumulated by dividing the number of sessions for a category into the sales they produce.) Because these promotions are so profitable, it makes good business sense to expend adequate time, effort, and film on each session. As Timothy M. Walden, co-owner of the highly successful Walden's House of Photography in Lexington, Kentucky, says, "We build our business on the majority, not the minority. We're not going to let the minority run our business!"

DETERMINING A PRICE LIST

When you are ready to establish prices, your first step will be to consult a business manager, who will help you determine how to position yourself in the marketplace. The business manager will ask you if you plan to charge high, midrange, or low prices. Before you answer this question, however, you need to think about the following facts. If you attempt to attract clients via low prices, you'll be competing with the world's largest photographic corporations, which can cut their prices to the bone because of their size and buying power. These companies also have superb marketing techniques, a result of their many years in business.

As you determine your price list, consider the pricing strategy many major manufacturers use. They are aware that people will pay high prices for products that suggest a sense of style and/or bear certain designer labels. Shirts, for example, cost practically the same amount of money to produce regardless of the brand name, but adults and teenagers are willing to pay two to three times as much for garments adorned with a coveted trademark or logo. You'll discover that consumers will do the same for portraits if a businessperson can create a mystique similar to that of Polo by Ralph Lauren, the Gap, Levi, Donna Karan, Tommy Hilfiger, or Guess.

SETTING PRICES

Putting together a pricing system involves an analysis of several factors. I'm not trying to tell you what to charge; I'm merely trying to explain the principle of pricing based on all the elements that go into the cost of a print. The amount a photographer charges for a print depends not only on costs, but also the big variable of overhead and the use of a price list as a selling tool (see page 19). Take a look at the different profit margins in the two examples in the following chart.

HIGH VERSUS LOW PRICES

	High Price (in dollars)	Low Price (in dollars)
Selling Price	90	18
Cost of Print	14	14
Gross Profit	76	4
Sessions Needed to Break Even	2	35

When determining selling prices, portrait photographers need to consider the total cost of each product, including retouching and packaging. Next, they need to think about the markup. In practice, most photographers multiply the final cost using a formula that yields a two- to seven-times markup. The formula depends on each studio's overhead costs plus a return on investment. A businessperson with 10,000 dollars invested in a studio should expect a return on that investment just as if that amount of money had been put in a bank savings account or a government bond.

To calculate the total cost of a print, start with the lab cost for an unfinished print (5 dollars), and add the amounts of the various other costs involved. These include print retouching (4 dollars), spray (1 dollar), mounting (2 dollars), folder (1 dollar), and box (1 dollar). When you add these figures together, the final cost of the print is 14 dollars.

If the overhead expenses, or operating costs, are 140 dollars a day, a high-price, portrait-photography business will need to do only two prints a day to make a profit (2 x 76 = 152). In contrast, a low-price studio will have to sell 35 prints a day just to break even (35 x 4 = 140).

In practice, most beginning photographers start with low prices and gradually increase their rates as their skills and reputation grow. Making a profit during the early years of running a studio is quite difficult when selling prices are low. For that reason, many newcomers to the field hold another job until their photographic career gets off the ground. Many successful photographers discover that they need to earn

a 60-percent gross profit and hold overhead costs to 50 percent of sales in order to make a profit of 10 percent (see chart below). This 10-percent profit, not counting the owners' salaries, constitutes a return on investment.

SAMPLE OPERATING STATEMENT

	Percentages
Total Sales	100
Less Cost of Goods Sold	40
Gross Profit	60
Operating Expense	50
Net Profit	10

PRICING TERMINOLOGY

Since I'm not an accountant, I rely heavily on local experts in this field to guide me. However, they're primarily interested in tax accounting, and I'm concerned with management accounting. I need to be able to see where I'm doing well and where I have to cut expenses. You don't have to be an expert to read an operating statement, especially if you have it written in both percentages and dollars so that you can track trends. For example, is a particular expense going up? If so, why? First, you need to understand pricing terminology.

Cost of Goods Sold. These costs are sometimes called "direct expenses." You wouldn't incur these expenses if you didn't do the job, and you can directly assign them to a specific job or customer. These costs include lab expenses, retouching, frames, albums, glass, mounting materials, folders, and outside contractors hired for a specific job.

Operating Expenses. These general and administrative costs, which are sometimes referred to as "overhead" or "fixed expenses," are critical to opening your studio doors every morning. Operating expenses include such items as salaries, rent, taxes, utilities, repairs, depreciation, and advertising. You should pay yourself a salary based on what it would cost you to hire someone to do your duties. Make sure that you calculate your salary into the overhead numbers.

Net Profit. This bottom-line figure varies from year to year, but during my 30-year career, my net profit has averaged about 10 percent. When I hear of studio photographers claiming a net profit of 30 or 40 percent, I know that they're usually including their own salary as part of the net gain. This practice isn't recommended. You'll need to invest studio profits in edu-

cation and new equipment. So pay yourself a salary, and live within its limits.

Naturally, both sales and expenses affect the net profit. To understand how this works, take a look at the following example (see chart below). Here, you see the effects of a 10-percent increase in sales, with all other costs remaining the same, on the bottom line. When photographers increase sales by just 10 percent, they can increase their net profit by 60 percent if the operating expense remains the same. (The cost of goods sold rises proportionately with the increase in sales, from 40 to 44.)

THE BOTTOM LINE

	Profit in Typical Month (in dollars)	Profit with Increased Sales (in dollars)
Sales	100	110
Cost of Goods Sold	40	44
Gross Profit	60	66
Operating Expense	50	50
Net Profit	10	16

You can increase sales in various ways. One option is to run a promotion that doesn't call for you to reduce prices. You can also offer additional (profitable) services. Yet another approach is to work closer to deadlines for major holidays. For example, if you're taking in 1,500 dollars a day during the Christmas season, you can increase your year's sales by 3,000 dollars simply by extending your deadline two days. How do you do that? Ship film to the lab by overnight freight, and ask for rush processing. The extra cost will be minimal compared with the profit potential.

Be aware that cutting prices to increase sales is dangerous. If you lower your prices by 10 percent, sales must go up 67 percent in order for you to keep the same profit. And if you cut prices by 20 percent, your sales will have to go up 400 percent for the new profit to stay constant. But if you raise prices 10 percent, your sales could fall as much as 29 percent; this figure would undoubtedly be even higher if you were to increase prices by 20 percent. With this knowledge in mind, consider the fact that you can raise prices 10 percent and lose almost one-third of your sales without affecting your profit.

When I learned this formula back in 1968, I decided to increase prices about 10 percent every year until my business reached a profitable level. By doing this, I actually increased my prices 259 percent in 10 years due to compounding! My experience has indicated that the best time to raise prices is when demand is the highest. Ordinarily, I raise portrait prices in October,

wedding prices in November, copy prices in December, and graduation prices in June.

ESTABLISHING PRICES

When you lay out your price schedule, consider listing your most expensive finish and largest print at the top, and your least expensive and smallest print at the bottom. With this arrangement, your clients will see the biggest and most expensive finish first. If you do it the other way, they may never read through your price list to see the 40 x 60 print with the best finish you offer.

Since most customers have a difficult time relating sizes to needs, you should give each portrait size a name. In my price list, the 40 x 60 print is called life size; the 30 x 40 print, wall-decor size; the 24 x 30 print, mantle size; the 20 x 24 print, wall size; the 16 x 20 print, small wall size; the 11 x 14 print, large easel size; the 8 x 10 print, standard size; the 5 x 7 print, easel size; the 4 x 5 print, miniature size; and the 2½ x 3½ print, billfold size.

I think that it is important to have three finishes because clients typically will chose the middle range when given a choice. Sears, for example, sells three types of merchandise: good, better, and best. You must have an expensive finish in order to get your clients to buy the middle finish. For years, I offered only two finishes to high-school seniors, and 90 percent of them selected the less expensive finish. Now that I provide my customers with three finishes to choose from, half of them opt for the middle finish, which increases sales considerably.

Many photography studios charge a session fee, which is also called a sitting fee or a creation fee. This covers the cost of the session, so photographers don't have to build it into the print costs. Among the items that should be included in the session fee are the cost of film, processing, and proofing; overhead; and time charges incurred by the photographer, the hairstylist, the makeup artist, and anyone else involved. To calculate the overhead, divide the number of sessions you did last year into the number of days you worked. For example, if you averaged four sessions a day and you worked 300 days, you would need to include 75 dollars per session in the overhead column.

When figuring out time costs for yourself (the photographer) and others, start with the annual salary and then determine how many workdays the person is available in a year. Suppose you earn 25,000 dollars annually and can work 240 days each year. Simply divide the number of working days by the annual salary. Here, your time cost is 104 dollars per day.

And, once again, if you average four sessions a day, the charge for your time will be 26 dollars per session (see chart).

TIME COSTS

Expense	Charge (in dollars)
Film	2.7
Processing/Proofing	7.2
Photographer	26.0
Overhead	25.0
Session Total	60.9

As you can see, most of your costs are time. This is typical in the industry because portrait photography is a labor-intensive business. I think that it is important to have different session fees for various services because some portraits take longer and/or require more film than others do. A bride's session takes more time than a child's session, and a pet session calls for more film than an adult session, etc.

A price list isn't just a reflection of costs; it should also be a selling tool. When you establish prices, you can help your sales personnel by making it easy for them to move a client from your least expensive finish to the next better finish, or by moving from a small-size portrait to a larger one.

I try to charge the same price for a large print in the least expensive finish as for the next smaller print in the middle finish. For example, a 16 x 20 portrait in the low-end finish costs as much as an 11 x 14 portrait in the middle-range finish. This pricing strategy also applied to moving from the midlevel finish to the most expensive finish. And an 11 x 14 portrait in the middle finish is the same price as an 8 x 10 portrait in the most expensive finish. Items that should appear in a price list include:

- Name of studio
- Address (city, state, zip code)
- Telephone and fax numbers (with area codes)
- Credentials of studio or photographer
- Copyright statement
- Explanation of finishes
- Explanation of session fees
- Terms (list of credit cards accepted, check policies, etc.)
- Revision date.

MANAGING FOR PROFIT

Regardless of how many portraits you make, regardless of how much money you take in, your survival in photography depends on how well you manage your business. With machines that can copy your portraits becoming better and more abundant, you must make policy decisions to protect the time and money you've invested in photographs that are going out the door of your studio. These policy decisions involve such questions as: Will you let proofs leave the studio? Will you charge a substantial session fee rather than cover most of your expenses in print fees?

COPYRIGHT PROTECTION

The aggressive enforcement of copyright laws depends on you through membership in the professional associations that are working as a group to combat copyright infringement. You and your colleagues can make a cooperative effort to survey stores offering copy services to the public in order to determine the extent to which the stores are obeying the law. For example, all the photographers in your city or area could meet to discuss the problem, and then take some of your copyrighted photographs to stores with copy machines to see if they'll copy the prints. You can—and should—report violations to these professional organizations, such as Professional Photographers of America (PPA), so that they can take legal action.

Your first step is to imprint both the front and back of your images with the copyright symbol. I imprint © McDonald on the front of each proof and photograph by using a Wyman or Veach gold-stamping machine. On the backs of the prints, I attach a sticker that states "All photographs by Tom or Jo Alice McDonald are protected by U.S. copyright laws. Unauthorized copying is subject to prosecution. (Copyright Act of 1976; Classes J, K, L, and M. U.S. Code.)" And my color lab uses an overlay negative to print my copyright symbol on every billfold-size (2½ x 3½-inch) portrait I order, thereby saving my staff from hand-stamping thousands of small prints. We do, however, stamp our copyright symbol on proofs ourselves because the lab doesn't offer this service on proofs, just billfold portraits.

Many professionals don't allow proofs to leave the building. They require their clients to come to the studio to view slides, electronic images, or paper proofs. When proofs don't leave the studio, they can't be illegally copied. Keep in mind, however, that some businesses can't force their customers to return to the studio for a viewing session.

In addition to the copyright symbol, you can protect proofs by writing on the front of them with a Pilot Super-Color Gold marking pen or an alcohol-based pen, such as Sanford's Sharpie or Staedtler's Lumocolor 313. Some photographers number their proofs with these pens, writing so close to the subjects' faces that the numbers can't possibly be cropped out.

Protecting finished prints is more involved and demanding than protecting proofs is. Fortunately, textured prints are difficult to copy, and wall portraits don't fit automated copy machines. Professional labs offer many textured surfaces, as well as bonding prints to canvas, making them hard to copy.

PAYMENT POLICIES

Because of the encroaching problem of copying, many professional photographers seek a substantial amount

of money, in the form of either a session fee or an advance payment, before any photographs leave their premises. For example, with a minimum order of 300 dollars, some photographers collect 100 dollars at the time of the session, 100 dollars when they send out the proofs, and 100 dollars when the customer places the order. Other professionals, however, prefer to collect the entire sum (300 dollars) at the time of the session as a professional fee or minimum order.

I also believe in making financial policies a team effort, so that my clients and I create an appealing portrait. I maintain that since I've invested time and money in the session, my clients should, too. I've found that when customers don't have money invested, they are quite critical, and the proofs are unimportant to them.

The amount of the payment depends on the value you place on your time and your proofs. (The word "payment" is more appropriate than "deposit" because the money isn't refundable.) Because most clients want "value received" for their money, they want their payment to be for a product, not just the photographer's time. In addition, they sometimes regard the session fee as a roadblock because it, too, represents time not product, so my staff and I try to tie every fee to the delivery of photographs. For example, a promotion might include the session fee and an 11 x 14 portrait for a fixed price of 99 dollars.

REQUIRING PAYMENT IN FULL

I adhere to a non-negotiable policy: No orders leave the studio without payment in full! I don't allow clients to pick up and pay for part of the order while leaving the rest. This is called a "split delivery." The reason, of course, is that many clients never pick up the balance of the order, leaving it unpaid forever.

Sometimes a client asks me to do an involved session, usually on a rush basis, for a small publicity print (and small fee), promising to "buy a big one later." My response is, "Yes, I'll be happy to help you, with payment for the wall-size portrait at the time of the session."

CHARGE CARDS

In today's business climate, it is essential for retailers to accept credit cards, thereby making it easy for clients to pay for goods and services. This option eliminates another roadblock that might get in the way of additional sales. You can set up charge cards through banks or factoring companies, such as EFS Merchant Authorization and Payment Service (see the Resources list on page 190). Charge cards are simple to deal with. You just deposit the credit-card slips as you do checks, and the bank deducts its fee monthly. This figure is usually between 2 and 5 percent of the amount charged. You can negotiate the monthly fees, which depends on the amount of sales. PPA members can take advantage of a low, charge-card bank fee that PPA arranged for if they wish to set up an account with the organization.

CHOOSING AN ACCOUNTING SYSTEM

One of the early decisions a businessperson needs to make involves accounting methods. Because of the small size and nature of their business, most portrait photographers use the cash method of accounting, rather than the accrual method. The cash method is easier to use because of the way it handles inventory and income-reporting statements. Accrual accounting is a much more complicated system for a small business, especially for those with limited accounting experience.

With the cash method, a sale isn't considered a sale until money changes hands. If, for example, a client signs a wedding-contract invoice for 1,500 dollars and makes a payment of 500 dollars, the sale is recorded as 500 dollars. The balance of the invoice isn't recorded as a sale until the remaining 500 dollars are paid. Expenses are recognized when paid.

It is important to call each installment a "payment," not a "deposit." Then, if a client hires you for a prime Saturday in June and later cancels, you'll be able to retain the money as payment for lost time. If you call the installment a deposit, however, the customer will probably demand the money back.

SETTING UP A SYSTEM

The business side of portrait photography can be as much fun as the actual shooting when you treat it as an art. Keeping track of your clients' payments requires a careful paper trail, which can be done either by computer or by hand. But if systems aren't your forte, hire an associate who has management skills.

The Invoice. This form, which is the basis for all paperwork, lists the client's name, address, telephone number(s), fax number, date of the order, date due, pose number, quantity, size, finish, and price per item. All items are added up, discounts deducted, and taxes added on the invoice. It also contains two signature lines: one for approving the purchase and the other serving as a model release.

I have four copies of each invoice. The original white copy goes into the negative envelope, the yellow copy is given to the client as a receipt, the pink copy is attached to the ledger card, and the gold copy is delivered with the order.

Daily Report. Also called a daily journal, the daily report acts like a cash register in a small business. All customer transactions are recorded on the daily report, including payments, deliveries of prepaid

orders, and refunds. The daily report also has columns for various pieces of information: product-line code, such as portrait, wedding, or frame; client name; subject name; invoice number; amount of tax; amount of order; total paid, which is the order plus tax; form of payment (cash, check, charge card); client account number; and coded category (men, women, children, promotion, etc.).

At the close of each business day, the payments recorded on the daily report are totaled, and a deposit is prepared. The daily-report payments and the deposit total should balance, less any start-up change in the cash drawer. For example, if you begin the day with 100 dollars in the cash drawer, you should deduct 100 dollars from the deposit so that you also end the day with 100 dollars in the drawer.

Statement. This summary of payments and charges enables me to give clients immediate answers about what they owe for all the services I've provided up to that point. I can, for example, tell a client who has a bridal portrait, a wedding, and a family session in progress how much money she owes by looking at the

The smooth running of any portrait-photography studio requires careful accounting. I keep track of my clients' payments via an invoice (bottom left), a daily report (top left), and a double-sided statement (right).

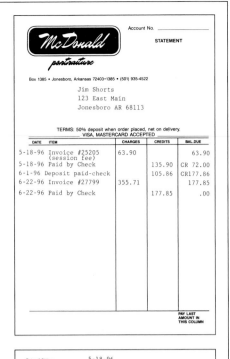

statement. I keep the statements in alphabetical order, so that my staff and I can locate them quickly. Keeping customer statements up to date requires diligence. Every morning one staff member breaks down the daily report, posting payments to the client statements. Another staff member posts invoice charges to the statement when orders are completed. The invoices themselves are posted to the ledger only when they are final. If payments run ahead of invoice charges, the client has a credit balance until the final invoices are posted to the ledger. If I need to mail a notice to a client, the statement can be copied and the copy stuffed into a window envelope. Notices are mailed on the first of

each month to clients who have work in progress, such as proofs out or orders ready for pickup.

Sitting Card. The backside of the statement card does double duty as a sitting card, thereby streamlining paperwork. Customer sitting cards contain the names of family members, addresses, telephone numbers, and birthdays of children up to 10 years old. (My staffers and I arbitrarily use this age as the dividing line between children- and adult-session designations because that is about the time blemishes develop and require retouching, which usually isn't necessary with children.) These dates are recorded later in a special birthday file, so that I can send the child a greeting card.

The sitting card also indicates whether the session is to be a surprise and how the previews are to be delivered. In addition, it contains a reminder to my staff about showing finished samples and ways to decorate with portraiture. And the card has room for me to write down a description of the clients' clothing, which helps to identify them later.

Negative Envelope. I use a 5 x 7 manila Kraft paper envelope open at the end for storing negatives, proofs, and invoices. I put two labels on each envelope, one on the outside and one on the inside. The negative envelopes are moved according to the status of the order: upcoming, film being developed, proofs out, acknowledgments out (a file for held orders awaiting payment), being retouched, being printed, ready for delivery, being displayed, and order done.

After I complete an order, the negative envelope is stored in a current negative file for three years; after that time period, it is transferred to an air-conditioned warehouse. Negative envelopes are stored side by side in 8½ x 11 Stax-on-Steel transfer files, which can be stacked 10 feet high. I store negatives alphabetically by year, using a card file to index clients by the year of their session. If I ever lost the card file, I would still be able to find a particular client by searching through each year's negatives alphabetically.

Status of Order. When clients call to ask about their orders, I can either find the status in the computer or look for the corresponding negative envelope in the various stages of progress. I arrange alphabetically finished orders and boxed previews and keep them in a cabinet. I store wall-sized portraits in frames in larger cabinets with numbered slots. A note on the order box indicates the numbered slot where the wall portrait is.

Monthly Reports. Gleaning information from the daily reports, one of my staff members prepares a monthly report, totaling the sales, number of sessions, and averages for each product line, each category, and each promotion. Year-to-date totals also are reported, thereby providing a comparison to those of the previous month and the previous year.

ACCOUNTS PAYABLE

Bills from suppliers are paid only when accompanied by invoices; no invoice, no payment. If a vendor sends me a statement showing an unpaid invoice, one of my staff members checks the statement against the studio journal (see below). If the vendor lists an invoice I don't have, my assistant requests—and must receive—the invoice before the vendor is paid. I take all cash discounts because a 2 percent discount paid in 10 days on a monthly billing equals a 24 percent discount on an annual basis. So you might find it worthwhile to borrow money from the bank, if necessary, to take advantage of cash discounts.

My staff members keep a journal for each vendor, even for newspapers and magazines, showing a list of the invoice charges by number, and payments by check number. Staff members keep all of this essential data on computer now, but they did it by hand for 25 years. Only studio owners should know and have access to information about employee salaries. If a staff member handles accounts payable, it is advisable to keep salary figures in a separate account, and to have the studio owner or an outside accounting firm pay the employees' salaries.

My accountant provides a monthly operating statement, which some businesses call a profit-and-loss statement. This statement indicates sales by product line, gross profit, operating expenses by category, and net profit. Totals are provided by the month and year to date. I also receive a general ledger that shows the detailed transactions of all assets, liabilities, capital revenues, and expenses.

Two management ideas have helped my studio run smoothly. My staff marks the final box of all supply items "Last Box—Reorder." This is especially important for printed forms. This step prevents shortages of essential supplies at crisis times. Another useful practice is to number all letter files even though they are in alphabetical order. Decimal points or letters can be used when new files are added. For example, if you already have file 56, you can label the new file 56.1 or 56-A.

The business side of owning a portrait studio can be as much fun as the photography itself when you treat it as an art. If systems aren't your forte, hire an associate who has good management skills.

CHAPTER 5

DEVISING A PROMOTION CAMPAIGN

According to Victoria Mal, who has a distinctive career in marketing with Sirlin Studios, Art Leather, and Professional Photographers of America (PPA), "People spend more time planning their vacations than they do planning their businesses." Why is this true? I think the answer to this question is twofold. First, most people don't know how to set up a successful business. Second, people would rather spend their time doing something else. For some artists, business matters aren't fun.

"One of the well-known axioms of business is that nothing sells itself," says Marcus Samuel, one of the founders of the Shell Oil Company, in *The Prize* by Daniel Yergin. Unfortunately, some photographers think that they don't require a plan for marketing, advertising, and promotions. But photographers wishing to devise an effective marketing plan need to consider such basic issues as:

• Who are my potential clients?
• What marketable skills do I have to offer?
• Which type of marketing plan will appeal to my potential clients?

In all likelihood, newcomers to marketing won't know what will work with their prospective customers, so they'll have to experiment with different approaches or adapt other photographers' marketing ideas. Early in my career, I was fortunate enough to study at the Winona School of Professional Photography under Charles H. (Bud) Haynes and Ted Sirlin. Haynes hammered home the need for a carefully structured marketing calendar, and Sirlin described strong promotions that had worked for him. In 1968, I drew up a calendar based on these promotional campaigns, which have worked well for me for more than 27 years. Other photographers have achieved the same success in both large and small cities.

THE IMPORTANCE OF TIMING

"You've got to pick the cotton when it's in the fields," advised my father-in-law, Gene McGuire, a successful farmer for more than 40 years, when he returned from the mall one December day. "There are people moving around out there spending money." His suggestion led me to develop a plan to attract December sittings that vastly improved my January cash flow. Before that, I concentrated on processing orders in December, missing the opportunity to photograph family groups when they gathered for the Christmas/Hanukkah season. Today, the family-group special offered in December is my strongest promotion, providing cash flow in two of the weakest months of the year, January and February.

Buying emotions is critical to the success of a targeted-time marketing plan. Sometimes it is simple to attract clients, and other times it is almost impossible to entice them. The easiest times to motivate portrait clients are during the spring, with its Easter, Passover, Mother's Day, and Father's Day observances, and during the November/December holiday-shopping period. Promotions usually are successful when tied in to these seasons.

Another factor that affects special offers is the school calendar. Promotional campaigns are always most successful during school holidays. Parents have more time to prepare their children's hair and clothing, and teachers have time to bring their own children in for sessions.

Contrary to popular opinion, it is difficult to motivate clients when the weather is overcast, gloomy, rainy, stormy, or oppressively hot. Also, news of unsettling changes in geographic and economic conditions can kill sales. For example, in December 1993, a geologist forecast an earthquake for my area, and the United States was preparing to enter the Gulf War when Iraq invaded Kuwait. My studio's sales went flat when local people actually left the area. The Gulf War had little or no effect on my immediate area, and, fortunately, the earthquake never materialized. Nevertheless, fear is a

terrible obstacle to overcome when you devise a marketing plan.

DEVELOPING A PROMOTION CALENDAR

You should set up a promotion calendar months in advance to allow for the preparation of advertising materials. About four months before the projected starting date, my associates and I decide what we're going to promote. Next, we select a photograph for the advertising piece and secure the client's signature on a special model release for that promotion. About three months before the campaign kickoff, we send the client's negative to the color lab for a glossy print that the printer can reproduce. We order the best retouching and color possible from this negative. The next step is to start copy preparation. Two months prior to the campaign, we send the 5 x 7 print and copy to the postcard printer. One month before the kickoff, we make up mailing labels and buy colorful postage stamps for the direct-mail piece to get attention. Then when the advertising piece arrives from the printer, we devote our spare time in the weeks before the promotion preparing it for mailing. The promotion calendar should incorporate national holidays when it is relatively easy to motivate clients. Some promotions have worked particularly well for my studio (see chart).

SELECTING MEDIA

After you organize your promotional calendar, your next step is to decide which form of advertising you want to use. Many years ago, I made a list of all the towns in which we had clients and then set up a spreadsheet to see which media would reach them. Direct mail was the only media that would reach all of them, with newspaper advertising coming in second.

Radio. Advertising on radio stations is difficult for an inexperienced businessperson to buy because it is so complicated. If you were to survey your clients, you would probably find that they listen to as many as 10 different radio stations, primarily while traveling. So you would have to buy time on several stations, usually during rush-hour traffic times, in order to reach them.

Television. Advertising on television is expensive if you buy prime-time spots on major network stations. *Guerrilla Marketing* by Jay Levinson suggests a strategy for the effective use of cable networks and local nonaffiliated stations (see the Resources list on page 190).

Mini-Media. In his book, Levinson recommends taking advantage of these various advertising outlets. These include bulletin boards, business cards, low-cost

THE PROMOTION CALENDAR	
January	Copy and Restoration Promotion
	Frame Sale
	Valentine Promotion
February	Valentine Promotion continues
	White Sale (sell proofs more than three years old)
	Bridal Fairs
	Wall-Portrait Promotion
March	Spring Special (keyed to Passover and Easter)
	Graduation Reorder Promotion
	First-Communion Promotion
April	Spring Special continues
	Book Proms and Dance Recitals
	High-School-Senior Ambassador Sessions
May	Mother's Day Gift Certificates
	Graduation Promotion
	Father's Day Promotion
	First High-School-Senior Mailout
June	Father's Day Gift Certificates
	Second High-School-Senior Mailout
July	Third High-School-Senior Mailout
August	Fourth High-School-Senior Mailout
	Back-to-School Family-Group Promotion
September	Fifth High-School-Senior Mailout
	Early Fall Promotion
October	Fall Promotion continues
November	Hanukkah/Christmas Promotion
December	Last-Minute Pre-Holiday Promotion
	Family-Group Special
	Gift-Certificate Promotion

brochures, banners, signs, newsletters, circulars, door-hangers, trade shows, home shows, contests, and sweepstakes.

Yellow Pages. Unfortunately, these directories are increasingly more difficult to select because competing media seek photography studios' advertising funds. Still, many photographers spend too much of their budget on the Yellow Pages because the directories' salespeople are quite aggressive. These individuals continually knock at the door of my studio, so it takes a great deal of effort for my staff and I to resist their sales pitch. I prefer to buy direct-mail pieces, which I consider to be far more effective.

Programs and Yearbooks. These mini-media outlets usually amount to goodwill donations. Some, however, can produce results, especially in large cities where regional advertising is necessary.

Magazines. Well-known photographers seeking an upscale clientele advertise in magazines. For example, Yousuf Karsh has advertised for years in *The New Yorker*, and Sam Gray buys space in *Veranda* magazine.

Newspapers. Advertising display space is affordable in small markets, but businesses in large cities may have to use classified advertising or regional publications. When my late son operated a hair salon in New York City, he advertised in *The Village Voice* to attract potential clients in the East Village area where his shop was located.

My father, a newspaper advertising manager for more than 30 years, taught me some of this medium's principles of advertising:

- Repetition is absolutely essential. It is far better to publish a small advertisement 10 times than a large advertisement only once.
- Readership is higher on Sundays and Wednesdays (or the weekday when food advertisements are published).
- Target your market. Since women are the primary purchasers of portraits, request the section of the newspaper that most appeals to them.
- The page placement of your advertisement is important. Try your best to get above the fold on a right-hand page. Since big, wide advertisements are usually placed at the bottom of a page, design tall, thin ads in the hope that they'll be displayed at the top.
- Use reverse type, which consists of white letters on a black background. They attract attention because a reader's eye is drawn to the point of greatest contrast on a page.

STRESS BENEFITS

The headlines in all forms of advertising, whether newspapers, magazines, or direct-mail pieces, should emphasize benefits, not features. The primary outcome of a portrait is the expression of love, so the headline in most of my studio's advertisements is "because you love them." Too many photographers focus on features, such as size and finish, rather than benefits. I use the following checklist for all of my advertising:

- What is the customer benefit?
- What is the date of the approaching holiday?
- Is the deadline for sessions and/or orders mentioned?
- Is the special price or size indicated?
- Is the amount of savings clear?
- Are the studio's name and address included?
- Are both the toll-free telephone number and the regular telephone number listed? (Providing a toll-free telephone number removes a roadblock that might prevent a prospective client from calling the studio.)
- Are the studio hours specified?
- Is the name of the subject in the advertisement readily apparent? (I always ask clients whose portraits appear in my advertisements to sign model releases; I also ask them if they want their name used in the ad. Some customers give me permission to use their images only if I agree not to mention their name.)
- On direct-mail pieces, is an address-correction line printed? (With the transitory nature of my clients, it is essential that I continually update my mailing list. The United States Postal Service provides me with address corrections at no additional charge on first-class mailings. The "Address Correction Requested" line must be printed 1/4 inch below the return address in the upper left corner of a direct-mail piece.)
- On direct-mail pieces, is there sufficient space for a postage stamp? (I prefer using colorful stamps on my direct-mail pieces because they're distributed faster, handled more carefully, attract more attention, and cost less in the long run via free address corrections than ads with plain stamps.)

DIRECT MAIL

You can compare newspaper and broadcast advertising to firing a shotgun and hoping you hit something, while direct-mail advertising is like aiming a rifle right at a target.

In 1965, my studio started with no customers and no business. To build a mailing list, I wrote down the addresses of the most prosperous-looking homes in town and then used the public library's city directory to find out who lived in those houses. I also bought telephone books of neighboring towns and added the names of the doctors and lawyers to my list. In a few

years, as my photography business grew, I listed all the towns in which my clients were located and which media could reach them. Because direct mail was the only one that could communicate with all of them, I decided to spend the bulk of my advertising budget on mailings.

Today, my best prospects are previous customers because they know where my studio is and that they like my style of portraiture. As mentioned earlier, it costs far more to develop a new client than to retain an existing one, so I send out at least five mailing pieces each year.

When my staff members deliver an order, they include a stamped evaluation postcard so that clients can rate my photography, facilities, service, and advertising. A few days later, I mail a thank-you card to them, enclose a business card, and ask them to refer me to their friends.

All previous clients are placed on my mailing list, which is kept on my computer's hard drive and backed up daily on disk and weekly on tape. Copies of the disk and tape are stored off-premises in case a disaster strikes. During the first few years of my business, I kept the mailing list on 3 x 5 index cards and then hired a data-processing service to maintain the list. The service company provided me with labels and a hard copy, just as my in-house computer does now.

Staff members post address corrections to the hard copy every time they send out a mailing piece. Even though I live in an area with little turnover, address corrections amount to about 1 percent each time, which translates to about 5 percent a year. In other parts of the United States, people move more often, thereby necessitating more frequently mailing-list updates.

My most effective direct-mail pieces have been 3½ x 5½ color postcards; they attract attention, and their size makes them convenient for clients to place them on bulletin boards or refrigerators as a reminder for a call to action. My staff buys the cards from companies specializing in this field, such as McGrew Color Graphics and Marathon Press (see the Resources list on page 190). By requesting dealer status, my staff and I are able to purchase the printed materials at a discount. I also plan to buy the materials in cash, which results in an additional 2 percent discount.

The minimum order for 3½ x 5½ postcards is ordinarily 3,000, a figure that is too large for beginning studios. Bob DiCaprio of Woonsocket, Rhode Island, had a short mailing list during the early days of his studio, so he solved the problem by ordering 8½ x 11 catalog sheets and dividing them into four 3½ x 5½ postcards. McGrew Color Graphics then cut the catalog sheets to postcard size for a small additional charge. You can order these sheets in quantities of 500 or 1,000, which was just right for DiCaprio's list. The paper stock is the same weight as that of postcards. You can also purchase preprinted color advertising pieces in small quantities from Marathon Press and Eastman Kodak Company (see the Resources list on page 190).

When I need a small-quantity advertising piece, my lab prints 2½ x 3½ color billfold portraits with dye-cut rounded corners that I attach to a locally printed card using double-sided tape. Sometimes I have the card done in two colors by a local printer; at other times, my staff and I do it ourselves on a copy machine, with hand lettering or desktop computer publishing.

CHAPTER 6

SERVING CLIENTS

My portrait studio will continue to be successful only to the extent that my staff and I find new ways to improve our service. Individual selling is a means of service. It is also a way to determine what clients really want and helping them find it.

My sales philosophy insists on no negotiation, no intimidation, no manipulation, no intrigue, no tricks, and no pressure. I've been in business for more than 30 years, and clients return year after year because I treat them fairly and respectfully.

The telephone is the most important tool in a salesroom, so you shouldn't leave it in the hands of an untrained person. It is vital to spend time training yourself and your colleagues in the proper use of the telephone. The person answering the telephone should speak slowly and clearly in a well-modulated voice. The conversation should reflect the kind of warmth you would hear between two good friends. Finally, the telephone salesperson needs to learn not only to listen, but also to hear what the potential client is saying. This will enable the salesperson to show understanding and empathy regarding the customer's inquiries.

HANDLING TELEPHONE INQUIRIES

My staff members are well trained in the art of dealing with telephone inquiries. They know how to find out exactly what potential customers want, as well as how to explain the corresponding information in a clear, concise manner. Here is a typical exchange between a prospective client and a staff member.

"McDonald Photography. This is Maria. How may I help you?"

"How much is an 8 x 10?"

"Is this to be a portrait of yourself or someone in your family?"

"I want a picture of my daughter, Elizabeth."

"Can you tell me a little bit about Elizabeth?"

"She won't sit still, she's into everything, she's as curious as a cat, and she has a mind of her own, but she's beautiful!"

"How old is Elizabeth, Mrs. …? I don't believe I heard your name."

"She's two, and my name is Laura Dumas."

(On a notepad by her telephone, Maria writes down both names and Elizabeth's age. She looks into a mirror on her desk and remembers to smile.)

"Mrs. Dumas, two is a wonderful age to capture a child's personality. This is the age when children become aware of their individuality and are more challenging to photograph, but Jo Alice is marvelous with children. She entertains them while Tom captures their expressions on film. Tell me, how will you use the portraits?"

"I'll probably hang one on the wall and give some to her grandparents."

"Where do you plan to hang the wall portrait?"

"Either above the fireplace or in the hall."

"May I suggest you visit our gallery here at the studio so you can see how various sizes fit in different areas? A mantle calls for a larger portrait than a hallway does, and we have all sizes on display here. How do you plan to light the portrait?"

"Well, I really haven't thought about that."

"When you come to the studio, we can show you several ways to light a wall portrait: wall-wash ceiling fixtures, track lights, picture lights fixed to the back of the frame, or projection spotlights that can be focused to illuminate just the portrait, not the entire wall. Have you seen our work before?"

"Yes, I saw your gallery at the mall."

"I'm glad to hear that. When you come to the studio, we can show you not only different picture sizes but also many of the portrait finishes available, as well as our display of imported and domestic frames in all sizes. Which day would be best for you to visit us?"

"Well, I take Elizabeth to day care on Thursdays, so that's always a good day to run errands."

"Excellent. Would morning or afternoon be better for you?"

"I think morning while I'm still fresh."

"Fine. I have an opening this Thursday at 10:30. Is that convenient for you?"

"Yes, that's perfect."

"Now may I get the spelling of your name, with your address and phone number so we can put you on our mailing list?"

The telephone conversation started with a question about price, probably because that is all Laura knew to ask. Maria's response showed that she was genuinely interested in getting to know Elizabeth and learning about Laura's needs. Maria created a desire for Laura to come to the studio so she could make intelligent decisions about her future purchase. Then Maria gave Laura a series of choices about the appointment time, none of them phrased to elicit "yes" or "no" answers. Maria wrote down the customers' names immediately so she could converse more personally with Laura. The mirror on Maria's desk reminded her to smile because a caller can perceive her attitude through the tone of her voice.

The day before an appointment, whether it is for a shooting session or a sales pitch, one of my associates places a reminder call to the client. If the customer cancels, my staff member has time to contact other people on a waiting list for session times. And if a client is late or fails to show up for an appointment, a staff member makes a call that maintains goodwill, so the client doesn't feel guilty. The conversation might begin with the following remark.

"Laura, this is Maria at McDonald Photography. I must have made a mistake. I had you scheduled for an appointment today at 10:30. Can you please check to see what time you have us on your schedule?"

THE CONSULTATION

When customers come to the studio for a consultation, my associate's attitude and command of the situation establish the tone of the entire interview. The staff member must remember several important elements. Smile, be friendly, and show enthusiasm for and genuine interest in the clients and their portrait needs. The staffer must also prepare for the interview by gathering all the sales aids needed, such as sample albums, price lists, clothing-suggestion brochures, and pre-portrait videos. Brochures showing examples of both good and bad wardrobe choices are available from Marathon Press, and excellent pre-session videos are available from photographers Bruce and Sue Hudson (see the Resources list on page 190).

You can also help your clients visualize how their final portraits will look on the wall by showing them a display with a range of picture sizes. This grouping might include, for example, a 20 x 24 and three 16 x 20 prints in the projection room, a 24 x 30 and a 30 x 40 in the frame room, a 30 x 40 in the foyer, and a hallway gallery consisting of several 16 x 20, 10 x 20, and 20 x 24 prints. Be sure that all the portraits are framed and have signs that identify the subject, the size, and the finish. For example, a label might read "24 x 30 Mantle-Size Portrait." And keep in mind that since the correct viewing distance is 12 to 15 feet, the salesroom must be large enough for proper perspective. If possible, you should also arrange to show your client your own family-group portrait, preferably framed as a wall decoration.

You should remind your staff members that empathy is absolutely vital to a salesperson's success. Until you can see through the eyes and heart of your clients, you aren't in any position to serve their needs. As noted California photographer David Peters says, "The consultation is a time to find the client's deep needs; the portrait is only a representation of that need." Asking some revealing questions will enable you and your associates to understand your customers better. Use the following suggestions as a jumping-off place. After you delve into your clients' motivations, you should thank them for sharing their feelings with you.

- What do you think the perfect portrait looks like?
- Where would you put your ideal portrait?
- Did you have your portrait taken growing up?
- What do you remember about your mother when she was your age?
- What would you like your children to remember about you? And vice versa?
- What kind of parent is your spouse?

THE SALES INTERVIEW

In Sweden, photographers call proof projectors "money machines" because they are so effective in increasing sales. Many clients who come to the studio thinking in terms of an 8 x 10 or 11 x 14 leave with a 20 x 24 print after seeing their proofs projected to 30 x 40. And photographers who can project 96 x 120 images find they sell more 40 x 60 portraits. It seems that the bigger you project images, the bigger you sell.

Unfortunately, many studios try temporary projector setups in the camera room or other areas not designed for projection, and they miss sales opportunities. If the projectors are permanently installed in a room that you can properly darken, you'll be able to persuade clients to attend a viewing session. Sales personnel also will be more inclined to show proofs on a projector if it is already set up. Intelligent people tend to do what is easiest and fastest, so it is up to the studio manager to make proof projection an enjoyable event.

No matter how proofs are projected, sales seem to increase. Some photographers prefer to use slide proofs with two projectors, dissolving from one to the other, and to play evocative music. Slide proofs pro-

vide the sharpest large images of all the systems available; this feature is especially important in group portraits, in which the heads are small. Other photographers like to use a video camera to take a picture of a negative placed on a lightbox and then transmit the image to a large television screen. This method is advantageous because it enables photographers to change image sizes electronically, which is faster than refocusing a projector.

Photographers who like to deliver paper proofs use opaque projectors, such as the Beseler or EnnaScop. I chose the EnnaScop because it is light enough to be put on a Photogenic Master Rail System above the clients' heads. With this setup, I can readily move the projector back and forth to change sizes.

Instead of storing images on film, some photographers store images digitally on a disc. This new approach gives them the opportunity to show proofs immediately after a shooting session. As digital imaging improves, this system is expected to become the most popular of all.

Once the preparations are complete, your staff member can proceed with the sales interview. When Laura arrives at the studio, Maria greets her enthusiastically in the lobby: "We have some exciting poses to show you." Maria invites Laura to sit next to her at a round table in the projection room. (Far superior to a counter or desk, a round table removes a physical barrier between my associates and the client.)

Next, Maria removes the gold elastic ribbon on my trademark textured black box, which has my logo embossed in gold on the lid. As she carefully unfolds the tissue to reveal the folio of originals, the client senses that these must be something of value. (Since these are the first prints made from the negatives, I prefer to call them originals, previews, or poses; I avoid the word "proofs.") This presentation poses quite a contrast to being handed a manila envelope over a plastic counter.

Overhead, a spotlight illuminates the table so the originals shine like gems in a jeweler's hands. As Maria hands the folio to the client with an air of pride, Laura realizes that a team of fine artists and craftspeople produced these photographs. Maria then asks Laura if she would like to see the originals projected to wall size. Surprised that Maria can do this, Laura responds enthusiastically.

Maria loads the projector, starting with the first image in the album. (When the originals arrive from the lab, Jo Alice crops them from 5 x 5 to 4 x 5, and then I arrange them according to preference. I put my overall choice first in the album and follow it with the other image of the subject in that outfit. Next comes the best picture of the second outfit, followed by the remaining shots in that group, etc.)

Two wall switches next to Maria make it easy for her to turn on the projector and turn off room lights

without having to walk in front of the client. Maria begins by projecting the 4 x 5 original into a framed 30 x 40 white mat board. The wall-sized image is breathtaking in glorious color. The conversation might go something like this:

"Notice how much more clearly you can see expressions at this size, even from across the room," Maria points out. "In this full-length pose, Elizabeth's face is about the same size as it would be in an 8 x 10 closeup."

"What size is this?" asks Laura.

"30 x 40, which we call Life Size," Maria answers.

"How would it look in a smaller size, such as a 16 x 20?" asks Laura.

When Maria holds a 16 x 20 frame inside the 30 x 40 board, it looks like a postage stamp.

"I didn't realize it was so small," Laura exclaims.

Next, Maria removes the 30 x 40 frame and hangs a 24 x 30 on the channel hanger on the wall. The J-shaped channel hanger, made from paneling "end cap" 18 inches long, is mounted 66 inches from the floor, like all the other display-print channels in my studio. When Laura expresses interest in seeing a smaller size, Maria shows the image at 20 x 24, which she buys.

"May I show you our finishes once again to refresh your memory?" Maria asks. She points out the differences among the three finishes and comments, "Of course, there's nothing wrong with the least expensive finish, but notice the painstaking work the artists did on the better finishes."

After Laura selects the middle-range finish, Maria fills out an invoice form, asking her to sign and approve the purchase.

"We require a first payment of 50 percent. Would you like to pay by check or charge card?" (Note that my associate uses the word payment instead of deposit; this is because this money isn't refundable. Once a client has committed to buying the portrait, I'll have to pay the lab for it. Instead of giving Laura an opportunity to say yes or no, Maria closes the sale with a minor decision about method of payment.

This entire sales interview lasted 30 minutes, which is typical of studios doing a medium volume of sessions. Sales appointments are always scheduled for when two staff members will be present so that one can answer the telephone and handle drop-in clients. If clients need an appointment during the lunch hour, my staff members and I shift our schedules to accommodate them.

Serving our clients continues until they drive away with the order, and beyond. If I see a client leaving the studio after picking up an order or after a session, I walk the customer to the car and offer to help with the children and packages. I've instructed my staff to do the same. On occasion, my associates or I even go to a customer's home to help hang the portrait and suggest ways to light it. Service never ends.

BUILDING TEAM SPIRIT

Just as I believe in working together with my clients to create beautiful portraits, I also want my staff members to work as a team. Building team spirit is one of the most challenging tasks facing a manager. It requires skill to communicate with, supervise, and motivate associates, and acquiring that skill, like any other, is the result of a lot of hard work, training, and experience.

During social events, I continually seek out executives who work in the human-resources departments at large corporations to see how they're building team spirit. Three corporations in my area—Federal Express, Kraft-General Foods, and Nucor Steel—form small teams and reward them for superior production. These teams are also self-governing, setting work hours and holidays. Kenneth Blanchard and Spencer Johnson, the authors of *The One-Minute Manager*, emphasize that the reward doesn't have to be big. For example, they mention a restaurant manager who handed out 5-dollar bills on the spot to employees who excelled in a particular job, such as sweeping the floor or cleaning a restroom. People want to feel appreciated by their colleagues and supervisors. A word of praise or, better yet, a tangible reward, goes a long way in building team spirit.

When sales—and the workload—of a photography business grow, the studio manager either must hire new employees or reduce the number of shooting sessions being scheduled. Some photographers restrict new business by raising prices sufficiently to discourage some potential clients. Most professionals, however, add employees as sales increase.

INCREASING THE NUMBER OF EMPLOYEES

When hiring new employees becomes a necessity, you might want to keep in mind the following rule of thumb. This guideline links the number of people a studio can afford to annual sales in increments of about 110,000 dollars. For example, a business with 110,000 dollars in sales can afford only one person, the photographer/manager; a 220,000-dollar business can afford two people; a 330,000-dollar business, three; and so on. The problem is that beginning studios with annual sales of less than 110,000 dollars have the same workload as businesses with 220,000 dollars in annual sales. This translates into longer hours—for less pay—and probably no profit until sales increase.

Another way to estimate when a studio can afford an additional worker is to look at the business's annual profit. Obviously, the profit must be large enough to cover the new worker's salary. It must also be able to accommodate taxes, insurance, and benefits.

Four years passed before my photography business turned a profit because it took time to acquire the necessary client base, skills, equipment, and confidence. For a while, I had three jobs, then two, and finally—after four years—just my studio. I felt like a free man!

HIRING NEW EMPLOYEES

The day arrives when you need to advertise for and hire one or more associates to work in your studio. When that day comes, studio owners and managers need to discuss the qualities they're seeking and what they're willing to offer candidates for employment. If we happen to find desirable workers, we can be flexible, if needed, to add them to our staff. We might, for example, offer special work schedules to accommodate family problems. As you interview candidates, ask the following questions:

- Would you like the opportunity to work with interesting people?
- Do you communicate well with others?
- Would people who know you describe you as a good listener?
- Do you naturally respond to the needs and feelings of your clients?
- Are you a caring, empathetic person?
- Are you an individual who smiles a lot?

- Do you smile when you make someone happy?
- Do you work at getting people to like you?
- Do you feel good when people you work with compliment you?
- Do you understand the talents of the people you work with?
- Do you have a talent for establishing rapport with others?
- Can you sell aesthetically appealing photographs to an upscale, discriminating clientele?
- Do you like beautiful photographs?
- Can you discuss qualities of art and artistic expression with others?
- Are you professional in work, style, and appearance?
- Are you a hardworking, success-oriented individual?
- Are you a high-energy person?
- Is it important to you to have work done right and on time?
- Do tasks left undone bother you?
- Would you like to achieve your personal goals?
- Would you like a chance to join a company you can stay and grow with?

Some photographers advertise for prospective employees, others go through employment offices, and still others rely on networking to find the right person for a position they want to fill. You'll find the following guidelines helpful when you are ready to start interviewing.

The first step is to write down the job description and the necessary qualifications. This will enable you to clarify exactly what kind of person you're looking for, as well as the responsibilities the position entails. Later on during the interviewing process, check to see that candidates turn in completed application forms. Omissions indicate a lack of thoroughness or even an attempt to hide unflattering information. You should have applicants sign and date a statement that all the information provided is correct and complete, with all previous job experiences listed. You should also ask permission to investigate past employment, authorizing former employers to provide all information requested. This statement will help you obtain references in an era when employers are reluctant to disclose information out of concern over potential legal problems.

Be sure to document information obtained during an interview, especially reasons for hiring or not hiring applicants. This will be useful in the event of a discrimination charge. Check the candidates' past records. Have the applicants made steady progress? Have they continued their education and growth? Are they job hoppers? Look for unexplained gaps in employment. Check the applicants' references and acquaintances carefully. What checks are there on mental capacity and honesty? If the applicants agree, clinical psychologists can test them for intelligence, motor skills, and truthfulness. Finally, are prospective employees up to the job?

Interview candidates more than once. Get more than one opinion. Have your significant other interview them, too. List their strong points and weaknesses. Visualize the candidates in the position, and then give some thought to what they would be good at and where they might fall down. What are their outside interests? Are these a key to their personalities?

Selecting the right person the first time will prevent a lot of headaches in the future. I try to find someone with three essential abilities: to think, to train, and to get along with others. When I hire new associates, I make it clear that their employment begins with a six-month "introductory" period, during which time they can be dismissed without notice. After this interval, they become "regular" associates and are evaluated every six months. I think that it is also important to have all team members evaluate themselves and then discuss their analysis with their supervisor.

ESTABLISHING EMPLOYEE GUIDELINES

Each business must make choices about a wide range of policies regarding staff members, and it is much better to set up employee guidelines before a problem occurs. In fact, this is a necessity in today's employment climate. For example, when a personnel question arises, I don't want to make a spur-of-the moment decision that I might regret later. Associates might want time off to attend a friend's funeral or to stay home with a sick child. Staff members might also want to use the company telephone for extended personal calls, entertain frequent visitors at the studio during business hours, or want to take home company equipment for private use. You must decide these matters before the issue arises. So I wrote a policy manual, following the generic suggestions in *How to Design a Personnel Policy Manual* (see the Resources list on page 190). Your manual must contain a statement that policies are subject to change at any time without prior notice. When policies are changed, the employee must sign and date an amended statement. The topics I cover in my policy manual include:

- Work hours and schedules
- Work-performance plans, goal setting, and job evaluations
- Procedures and conduct for dealing with clients
- Paper flow and order procedures
- Staff meetings
- Overtime work
- Secondary employment/moonlighting
- Time and frequency of salary
- Bonuses and incentive pay
- Dress code and grooming for safety, business, and image

- Breaks and mealtimes
- Vacations
- Holidays
- Sick-leave policies
- Excused and unexcused absences
- Time-off/leave policies
- Hospitalization- and life-insurance programs
- Accident/injury procedures
- Housekeeping requirements
- Personal use of studio equipment and facilities
- Employee purchases and discounts
- Advancement opportunities
- Training and educational opportunities
- Retirement/profit programs
- Employee rights and grievance procedures
- Firing policies and documentation
- Employee resignation and notification.

Finally, during the orientation of new associates, show them a checklist that includes the statement that they've read and they understand the policies, agreeing to adhere to them as a condition of employment. Then have the new staffers sign and date the checklist.

EMPLOYEE RESPONSIBILITIES

Most portrait studios start with one person, the founder/owner. This individual has to do all the tasks that might otherwise be done by 40 people in a large studio. As the business grows, the workers still must be able to handle a multitude of tasks, from cleaning the windows to decorating a gallery. To succeed, associates must have not only the ability to learn new tasks, but also the willingness to do such dirty jobs as basic janitorial services. The five members of my staff help one other whenever necessary, but each associate has specific responsibilities.

Linda handles reception-room sales, telephone sales, order deliveries, final order checks, overdue originals, overdue deliveries, posting accounts receivable, posting daily reports, setting up new accounts, monthly promotion reports, monthly sales-tax reports, preparing advertising, promotions, price lists, brochures, model releases, frame inventory, frame pricing, office-supply inventory, and print spotting (making little art corrections on black-and-white prints).

Lynn is in charge of production. This includes organizing proofs and orders for delivery, preparing session cards, confirming sessions the day before they're scheduled, setting up computer records, securing family histories, printing out daily session schedules and labels, posting birthday lists, mailing out birthday cards, maintaining mailing lists, backing up the computer daily, totaling daily reports, making up deposits, preparing advertising mail-outs, and maintaining display point-of-sale card racks. Lynn also opens and closes the studio each day, greets clients when they arrive for sessions, shows finishes, explains prices, and collects session fees.

Belinda is responsible for preparing out-of-studio portrait displays, signs, framing client portraits, school and seminar teaching materials, class notes, negative files, letter files, correspondence, and setting up the studio for clients. She also is active in telephone and reception-room sales. Jo Alice is in charge of accounts payable, payroll, set design, children's photography, making signs, and cropping originals. Tom handles all other photography, inspects originals, writes lab orders, and supervises quality control.

REWARDING EMPLOYEES

Through the years, I've learned that what gets rewarded, gets done. So I try to build team spirit by rewarding the entire staff when the studio is particularly successful. I offer a "carrot" for each month that the studio exceeds sales for the same month in the previous year. For example, if sales for May this year are higher than last May's sales, each member of the team (including the manager) receives a gift certificate. Usually I give out meal certificates for a restaurant where my portraits are displayed, but sometimes the certificate is for a concert or clothing.

The advantage of this plan is that every team member benefits from a job well done, thereby avoiding unhealthy competition between sales personnel that can result from individual sales commissions. For example, if my salespeople worked on individual commissions, they would compete to be the first to wait on a good customer who places a big order every year. But under the team system, my sales staff cooperate with each other to help a client placing a large order. One sales associate might put the portraits in frames while the other writes out the invoice.

Additionally, I give out bonuses in mid-December if sales for the year surpass those of the preceding year. All members of the staff get the same bonus, with taxes withheld. Associates also receives a longevity bonus on the anniversary of their employment with the studio.

CHAPTER 8

LEARNING TO USE COMPUTERS

Computers can be wonderful aids for any size business, but the use of these marvelous machines can create problems. Most photographers love gadgets, and the computer—the supreme gadget of them all—demands a great deal of time. Some photographers become so enthralled with their computers that they actually interfere with the smooth operation of the business. Photographers let computers become toys that take precedence over more important tasks, such as improving their photography or doing a marketing plan.

Once you determine that you need to get a computer, you have to make a management decision about whether to use a point-of-sale terminal. After consulting with Mickey Dunlap and Ted Sirlin, two of California's most perceptive photographers, I opted not to use point-of-sale computers in my studio; my goal was, and still is, to operate a small business that offers a high degree of personal service. In the salesroom, my associates and I like to sit at a round table next to customers, not behind a counter, desk, or computer. This decision meant that point-of-sale invoices couldn't be generated on computer, so my staff members continue to write them out by hand. Some professionals leave the salesroom and go to the office to enter an invoice on the computer, but my associates and I write out the invoice by hand in the salesroom and don't want to write it again later on the computer.

In order to get started, I hired Dr. Steve Corder, an instructor, and James Newberry, a graduate student from Arkansas State University, to set up the hardware and software. These consultants also showed my staff and me how to use the computers. I still call on them to help with problems or changes.

SELECTING SOFTWARE AND HARDWARE

When choosing software, you should ask some basic questions. First, will the program handle all of your accounting and status-of-order needs? Will it process all of your advertising needs, such as mailing lists and labels? Can mailing lists be merged or customized? Is the program fast, easy to use, and simple to learn? Is it flexible? Will the programmer or designer make small changes to make it fit your individual requirements?

After considerable research, I chose the CARM software by Studio Systems of Dubuque, Iowa. Wes Siebe, the designer, has been quite cooperative, helping me adapt the CARM software to my particular needs. For example, some address labels called for four lines so that I could write to high-school seniors in care of their parents. And when I print out an appointment schedule, I want to merge it with the customers' family histories. My associates and I can then go into a session knowing the names of all family members.

After selecting software, I looked for hardware to run it, narrowing my choices to well-known brands that had good reputations for reliability and service. I chose one IBM and two Compaq units with bubble-jet printers. With computers, it is essential to select the software first, so you'll know what kind of processor (chip) is required to run it. Even when a computer has sufficient memory, speed is important when a client is waiting; therefore, it is a good idea to buy the fastest processor you can afford.

COMPUTER CAPABILITIES

After working with computers for a few years, I wonder how my associates and I operated without them. They are superior at storing information, making computations, handling correspondence, sorting names, tracking orders, communicating with other computers, and doing desktop publishing for such needs as price lists and advertising. Since we operated for 25 years without a computer, we set a goal to assign a new task to the computer each year. For example, one year we installed our mailing list; the next year, our frame inventory; and the next year, our negative file. The computers in my studio facilitate the processing of the following administrative needs.

Mailing Lists. My associates put all of my clients' names on a master mailing list for future promotions. Staff members update the list every time they send out

an advertising piece so that it is always current. I also have two separate mailing lists: one for high-school seniors, which changes every year, and one for children, which indicates their birthdays.

Account File. This file is activated on the day before the session, picking up information from the appointment book. From this, my staff produces six mailing labels (see below).

Address Labels. Associates run six labels for every customer: two for the negative envelope, one for the statement/sitting card, and three for mailouts (previews-ready postcard, order-ready postcard, and thank-you mailer). When clients arrive for their session, they check to see if any corrections are required.

Appointment Schedule. Members of my staff print out my next day's shooting schedule after they've confirmed the appointments with my clients over the telephone. Once my staffers give me the printout, I familiarize myself with the subjects' names, ages, addresses, and session times.

Birthday File. For all children under the age of nine, my associates ask the parents for their birthdays; the staff then adds these dates to the birthday mailing list. Once a month, staff members call up all the parents whose children's birthdays fall during that month, and the computer prints out a label addressed to each child in care of the parents. I send an attractive child-oriented card plus a special package price list that expires 30 days after the child's birthday. This emphasizes the call-for-action feature of all of my advertising.

Order Tracking. Once staff members set up an account file, they post status-of-order information. This tracking system lists the following:

- The date of the session
- The date the previews were ready
- When and how the client was notified
- The date the previews went out to the client
- The date the client placed the order
- The date the invoices were sent to the client for signature and first payment
- The date the negatives were sent to the lab
- The date special frames or albums were ordered
- The date the order was ready
- When and how the client was notified
- The date the order was delivered.

My associates also indicate whether or not one print in the order is being retained for display purposes.

Sitting Totals. The CARM software I purchased provides the number of shooting sessions held in each category and during each promotion. The software also indicates dollar totals and averages for photographers who enter invoices into the system.

Frame Inventory. When my associates receive a shipment of frames that aren't already in the inventory file, they enter the frame manufacturer, quantity, size, cost, selling price, and finish number. If that particular type of frame is in the inventory listing already, they merely add the quantity and size received. The software will then show the frame's cost and selling price, as well as the number in stock. If, for example, I receive five frames, the program will ask if I want five price labels printed. The labels indicate the manufacturer, frame number, size, selling price, and finish. If I want to, I can also enter the cost on the label via a code known only to my staff and me.

Inventory Totals. The CARM software supplies a running total of frames by manufacturer, size, and finish. It also displays the total value of the inventory by cost and selling price. The inventory includes everything I have for resale: frames, albums, folios, and glass.

Accounts Payable. The CARM software writes all checks, including payroll checks, and makes up federal and state payroll reports. It keeps a vendor file, showing debits and credits for each manufacturer. The CARM software also maintains a running balance after each check, providing a monthly printout of expenditures.

Graphics. My associates and I call upon WordPerfect software for most of the studio's correspondence and graphics needs. Some of the uses include the creation of book plates for preview albums, signs for display portraits, package price lists, and sales letters.

Lab Link. By using a modem and Procomm Plus software, my staff members and I can call up my business's file at Miller's Professional Imaging. This tells us not only the status of any order in the lab, but also the studio's account balance and purchases by category with monthly, one-year, and four-year totals. This software system also has a bulletin board and "swap-shop" and electronic-mail features. The swap shop enables lab customers to list used equipment for sale or trade on the computer.

Because of the vast storage capacity required for digital retouching and the cost of the technology, I haven't tackled this aspect of computer use. From the start, my philosophy has been to let an outside lab do as much of the processing as possible, thereby freeing me to create and market portraiture. I prefer to let my lab hire talented experts for each phase of the processing operation and purchase the expensive equipment that continually needs updating. Technology changes quickly, so I suggest that you buy a demonstration disc before launching into a management system.

CHOOSING THE RIGHT LAB

I f a photographic business had three legs like a tripod, the lab it uses would be one of those legs. Business methods and photography skills would be the other two. Choosing the right lab can make or break a business, especially in the early stages.

Color labs share with photographers the common problem of seasonal production pressures. Neither photographers nor labs can breeze through November and December without an occasional late order. Just as photographers team with clients and colleagues to produce beautiful portraits, they also must make the lab a part of their team. Winners succeed because of skill, practice, hard work, and team work. When team members fight each other, the team loses. So a winner not only cooperates with the lab, but also builds team spirit by sending notes of encouragement to members of the team: the retoucher, the color analyst, the printer, the finisher, and the shipper. In addition to notes, I also send birthday cards to key lab personnel who help me throughout the year.

EVALUATING A LAB'S SERVICES

Communication is the key to a marriage between a photographer and a lab. Most photographers have never worked in anything approaching a production darkroom, so they don't know what a color lab can and can't do. Early in my career, I took courses in color printing even though I never intended to print my own work. This gave me a clear understanding of what goes on inside a color lab, and I've updated that perception with frequent visits to the lab. With this background, you should make a list of exactly what you expect the lab to provide. Your next step is to discuss these requirements with the lab's customer-service staff. You can tailor the following basic questions to your individual needs.

- What color services do you offer?
- What black-and-white services do you offer?
- Do you provide slides or chromes?
- Do you offer digital services?
- Do you do enlarger as well as machine printing?
- Do you offer mounting services including canvas?
- Do you handle negative and print retouching?
- What is your proof-delivery time?
- What is your print-delivery time?
- What is the cost of air-delivery service?

Once you've written answers to these and any other questions you might have, spend some time with the lab's customer-service representatives so that you get a feel for their interest in you and your goals. If two or three labs seem comparably suitable, send nearly identical negatives to all of them and request a fully finished print. Note the delivery time, and see which print you like best. If you have any doubts, simply send another negative to each lab.

When you are ready to make a decision and the lab has accepted your account, try to establish personal contacts with the lab's key people. Some labs will allow you to have the one customer service representative assigned to your account, along with one order-entry and masking clerk, one negative retoucher, one color analyzer, one quality-control inspector, one print retoucher, and one finish inspector.

If possible, you should visit the lab and meet all these specialists in person to show them what you want and expect from the lab. If this isn't possible, send a sample print with the color, density, and finishing you like.

From the start of my studio in 1965, I've wanted to devote my time to photography and business, allowing my lab to do all the processing. When digital imaging came along in 1992, I chose not to invest in expensive computer equipment; once again, I decided to let my lab handle this phase of retouching as well. I've never regretted my decisions.

WORKING WITH NEGATIVES AND ORIGINALS

Most labs return negatives individually cut in glassine envelopes that have a bunch of numbers on them. Ask the lab to tell you what these numbers mean, specifically which one will tell you about exposure. They'll probably say something like "between 52 and 72 is our standard exposure range." So you can look at these numbers each time the lab returns the negatives and figure out the exposure setting for each camera-room and outdoor-location shot. This information also permits you to make continual adjustments, fine-tuning the exposure.

CROPPING NEGATIVES AND ORIGINALS

Since my camera produces 6 x 6cm (2¼ x 2¼-inch) negatives, I order 5 x 5-inch originals my lab and then trim them to 4 x 5; I place a 4 x 5 piece of glass over the 5 x 5s to decide where to make the cuts. Then a staff member trims the proofs to 4 x 5. Next, I send the 4 x 5 cropped originals with the negatives back to the lab, asking them to match the originals' color and density or to make specific changes, such as "print lighter than original."

VIEWING PRINTS

It is important to view the originals and the final prints as soon as you receive them from the lab. Be sure to work under color-corrected lights because fluorescent, tungsten (incandescent), and natural light can all alter the look of the prints. Your lab can advise you about a local source for a color-corrected light, such as a Dayton 2V-351, which has a tungsten bulb inside a circular fluorescent bulb.

Before you begin evaluating color and density, you should have your eyes checked. Some photographers are surprised to learn that they can't see the finer points of color as well as lab specialists who have been tested and trained for the job can. I don't return prints to the lab for reworking because of color or density; I prefer to let my clients make these decisions since they're paying for the portraits. If the prints satisfy the lab specialists and my customers, I am happy with them, too.

When clients view a print at home, it is probably illuminated with a combination of tungsten and fluorescent light. So I make sure that they see their prints in the studio's viewing area under similar lighting conditions. My associates and I don't confuse them with a lecture on the color temperature of the viewing lights. They either like the prints or they don't.

Early in my career, I returned a lot of prints because of color or density, but then I found that my clients would accept 80 to 95 percent of them. My prejudice toward light, warm prints wasn't necessarily what my clients wanted, so my work has gone much more smoothly since I started accepting lab standards rather than impose my own. Remakes are time-consuming; they not only delay the order, but also require a lot of time on my staff's part to rewrite the order and ship it back to the lab.

MASKING NEGATIVES

If you don't mask your own negatives, you should send the lab a guide original that is masked the way you want. If a 4 x 5 original needs to be masked to a smaller size, send cropping guidelines to the lab, such as "crop at top." Mark the cropping on an acetate sleeve over the original, or run the original through a plain paper copier and mark the black-and-white copy print.

Labs that have machine printers employ masks, usually ranging in size from A to H. Some labs use A for the smallest mask, while others use A for the largest. Most labs sell a proof-masking guide that you can place over an original to see how the image will look in various mask sizes. You can then mark the mask you prefer on the negative glassine, perhaps with some instructions, such as "crop at top, but show all of hands." If you use certain instructions frequently, you can save time by making multiple small copies and slipping them into the glassines. You should use bright-colored paper, so that the instructions will really stand out.

When I mask negatives, I lay the mask over a lightbox and draw a line on the lightbox vertically down the center using a red Sanford Sharpie marking pen. If the subject is looking straight ahead, I position the negative in such a way that the red line runs between the person's eyebrows or down the nose.

Some labs sell masking lightboxes; if yours doesn't, you can purchase them at camera stores. One of my favorite lightboxes is the 10 x 10-inch Richards Idealite. It has a cool fluorescent bulb that doesn't damage negatives when the lightbox is in use for many hours. If you mask your own negatives, remember to ask your lab what kind of tape you should use. We work with Scotch drafting tape #230.

The labs will provide you with mask cards with different-size openings (A, B, C, etc.). The opening in the cards is actually bigger than the print you'll receive. You should also look at the acetate masking guide, which shows cropping for 5 x 7s and 2½ x 3½ billfolds. The 5 x 7 crop is thinner on the sides than the 8 x 10, and dye-cut billfold prints will be even smaller on all sides.

With 6 x 6cm negatives, I ask the order-entry clerk to crop images so that there is about a 1/4-inch (5mm) space between the top of the subject's head and the top of the mask. Then when the negative is enlarged 4.44 times to produce an 8 x 10-inch print, the head space takes up about an inch, which I consider about right. And when the negative is enlarged 8.88 times to produce a 16 x 20-inch print, the head space becomes

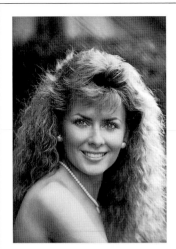

These side-by-side comparison portraits show just how effective masking negatives can be. Although the print from full negative is acceptable, I thought that masking this woman's portrait would increase its impact (left). I masked it to create a diagonal for better composition (below).

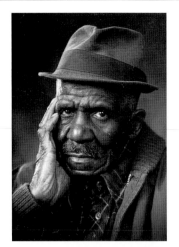

After taking a close look at this man's portrait, I found the full-negative image to be too busy (left). So I masked the print to crop out the distracting elements (below).

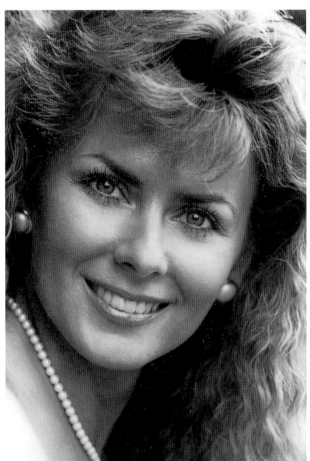

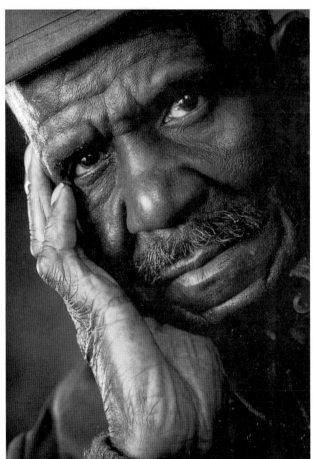

When I saw the print from the full negative of this subject's portrait, I decided to crop both the lower part of the image at the top of the breast pocket and some of the head space (left). To achieve this, I simply masked the negative 1/4 inch from the top of the head to the top of the mask (below).

rubber stamp containing frequent instructions and to stamp the order form in red ink.

Negative Retouching. After consulting with my customers about their wishes, I ask the retoucher to make the desired changes. These might include removing red in eyes, scars, age spots, moles, and facial lines, especially on the neck, forehead, and temples. The retoucher should soften all noticeable blood vessels. With traditional retouching, wrinkles and blemishes show up as white lines on the negative. These can be filled in with lead or dyes, so that they're softened or removed.

Printers. On enlarger prints, I ask the printer to dodge, or lighten, shadow areas, such as dark clothing, in order to retain detail. I also have the printer burn in, or darken, light areas, such as bright or white clothing or shoes, for the same reason. Enlarger prints also enable you to fine-tune cropping if a mask isn't exactly the right size.

Mounting. I have all 5 x 7 and larger prints mounted. I request that all 16 x 20 and larger prints be mounted on heavy art board. This keeps the prints from getting cinched or bent during framing or presentation. Large prints require thick art board because with thin art board they tend to curl in some weather conditions.

Print Retouching. I ask the lab artist to do a thorough, careful job when retouching prints. Naturally, this work will vary from subject to subject. These tasks include toning down facial shine; blending negative-retouching strokes; removing glare from eyeglasses, blood vessels in eyes, secondary catchlights, age spots, and jowls; eliminating stray hairs; tightening up neckties, minimizing blood vessels in the skin; softening Adam's apples; firming up chin lines; and making eyes appear equal in size. Most people seem to have one eye that is a little larger than the other. The artist can open one by subtly enlarging the pupil, and can close the other by slightly closing the eyelid, thereby making them look more comparable in size.

Finishes. With the exception of 2½ x 3½-inch wallet pictures, I have all prints sprayed with a lacquer glaze. This finish keeps them from sticking to glass and protects them from fingerprints. (Billfold-sized portraits aren't sprayed because the spray melts when placed in a wallet, creating all kinds of problems.) Low-priced prints receive a matte spray, while high-priced portraits receive a luster spray with texture. The top-of-the-line portraits are bonded to canvas with a luster spray. Here, the print and canvas are bonded in a massive press that exerts several tons of pressure, pushing the canvas texture through the print.

about 2¼ inches, a proportion I also like. I've shown this formula to the masking department at our lab, and the lab staffers who work with me follow it on our orders.

STANDARD OPERATING PROCEDURES

My lab asks each of its customers to submit a "Personal Order Profile," or "POP." The lab specialists are to follow these standing orders if I forget to mark instructions on the order form. Even if your lab has a similar policy, it is a good idea to make up a

RETOUCHING AND PRESENTATION

P rofessionals call inexpensive portraits "un" portraits: unretouched, unsprayed, and unmounted. These are the characteristics of cheap photographs taken by operators who cut every conceivable corner to reduce prices and still make a profit. Portrait photographers seeking to separate themselves from the pack strive for excellence in retouching and print presentation. Ordinarily, both negatives and prints are retouched, but new digital techniques do all the retouching in one step.

During consultations with clients, my staff members and I ascertain their feelings about retouching. Do they want lines completely removed or simply softened? Do they want moles and birthmarks removed? Do they want their waistlines trimmed? Showing customers "before" and "after" samples helps them make up their minds.

RETOUCHING PROCESSES

For more than 100 years, negatives have been retouched with either leads or dyes. These compounds fill in facial blemishes and wrinkles, which appear as white lines on negatives. Later on, the negative-retouching strokes are blended on the print so that they aren't obvious. Print retouchers also perform a multitude of tasks that might not be possible on the negative. These include:

• Equalizing eye size
• Removing secondary catchlights
• Darkening the white areas at the corner of the eyes
• Removing blood vessels in the eyes
• Adding color to the eyes
• Eliminating glare from glasses
• Strengthening eyebrows
• Getting rid of stray hairs
• Toning down unwanted highlights
• Closing the gap between a subject's tie and collar
• Adjusting ill-fitting clothing, especially the gap between a subject's jacket and shirt collar
• Plugging spaces between teeth
• Firming up jaw lines
• Darkening Adam's apples
• Softening veins
• Removing age spots.

Nema Velia, a nationally recognized retouching expert and the head of the digital department at Miller's Professional Imaging in Pittsburg, Kansas, tells me that you can do all of this and more via digital retouching. You can also remove braces on teeth, lighten or darken backgrounds, eliminate clothing wrinkles, fill in missing teeth, increase or decrease contrast, and rescue otherwise "lost" causes, such as torn negatives or paper leader in the film gate that blocks off part of the image.

Digital operators first scan a conventional negative, and then retouch it with a powerful computer using a stylus and sophisticated software. Next, the computer writes out a new negative that can be printed conventionally. (Chromes and prints also can be scanned by various machines.)

With digital retouching, little or no additional work is needed on the print, which saves a considerable amount of money. All of the prints will match perfectly since digital retouching is done on the negative. With conventional print retouching, it is difficult to make prints match when a great deal of work is done on them.

If digitally retouched prints fade, the dyes fade evenly so the change isn't very objectionable. When conventionally retouched prints fade, however, the corrective artwork becomes quite obvious because pencil and dye retouching doesn't fade at the same rate as the print.

These formal portraits of a distinguished-looking man show how effective retouching can be. In the original print, the man has a number of wrinkles (far left). In the print retouched by traditional methods, his skin appears smoother (left).

This client wasn't completely satisfied with the way her mouth looked in her portrait (far left). To please her, I had the print retouched to remove her braces digitally using the Lucht Repri system (left).

If a client needs to reorder at a later date, the artwork on the new digital prints will match that of the old digital prints because it is all done on the negative. When a negative is too contrasty, a digital operator can improve shadowed areas; however, the results won't be as good as those achieved with a negative with proper lighting ratios.

Cloning makes digital print retouching vastly superior to conventional print retouching. Suppose, for example, that when eliminating braces, a digital artist picks up the color and texture of a tooth with her stylus and transfers it to the metal braces, thereby removing them from the negative. Once the negative is retouched digitally, it can be used to make as many

prints as needed. Since there isn't any artwork on the print, the final lacquer spray won't cause any dye shifts.

To eliminate braces via conventional print retouching, the artist must find a dye or pencil that matches the tooth color and use it to remove the braces on each print. This is an expensive, time-consuming process. Then when the print is sprayed, the retouching pencil might change color, so that it doesn't match the tooth enamel. The artist would then have to do the entire job all over again.

At this stage of development, the weaknesses in digital retouching are costs and quality. Digital retouching is usually more expensive than traditional negative

retouching, but savings in print retouching or multiple prints from one negative may make up the difference. And since digital prints are second-generation productions, the color, contrast, and grain may not be as good as those of the original. But I've delivered 30 x 40 digital prints that looked almost indistinguishable from the original, except, of course, they'd been superbly retouched.

Imagine the difficulty in retouching each face in a group of 30 people using conventional methods. Digital artists have a huge advantage in that they can enlarge a section of the negative 50 to 100 times to perform the work, then reduce it to standard size for printing.

PREPARING PRINTS FOR PRESENTATION

After the negative and print have been retouched, you must apply a coat of lacquer spray to the print. This serves to protect and seal its surface. The spray will keep the print from sticking to frame glass, as well as shield it from fingerprints and moisture.

Lacquer spray comes in different finishes: matte, luster, and glossy. The matte finish tends to dampen color, while the luster and glossy finishes brighten the hues of a print. Texture can be used to enhance a print, too. You can achieve texturing by pressing the print into a ridged metal plate or canvas. Another method is surface modification via spray texture, which puts a pebble finish on the print via a special lacquer spray gun.

You can mount prints on art board, canvas, Masonite, plastic, wood, and foam plastic. Art-board prints can be single weight, double weight, triple weight, flush, or gold-beveled. As mentioned earlier, because prints can curl in some types of weather, big prints are usually put on heavy art board. Most prints are flush-mounted without a border, but some photographers leave a 1/8-inch border, so the frame doesn't cover any part of the portrait. You can also bond prints to canvas on a stretcher frame, Masonite, or art board.

After you mount and spray the prints, you can gold-stamp or sign them with your studio's or your own name and a copyright symbol. Gold-stamping machines use custom-made metal dyes that are heated and stamped onto the print through a roll of gold foil.

You can sign sprayed prints three different ways: with alcohol-based pens, such as Sanford's Sharpie extra-fine point and Staedtler's Lumocolor 313 pens;

with heated pens signed through gold foil, such as Veach pens; and with Pilot's Super Color Gold pen, which has an extra-fine point.

When you are about to deliver the finished print, you should show it in a quality frame that complements the portrait. If the client chooses to frame the print later, you should first put it in a folder or dry-mount cover and then carefully place it in a box with tissue and bound with an elastic ribbon. Your name or your studio's name should be on both the folder and the box. Manufacturers can emboss your name on folders and boxes, usually with a one-time charge for creating the dye. I use various levels of lab artistry to define three categories of print finishes:

Standard. With the standard finish, print retouching involves a moderate amount of negative retouching. The prints are then matte-sprayed and gold-stamped with a machine.

Classic. To achieve the classic finish, labs retouch the negative first and then do extensive print retouching. Next, the prints are luster-sprayed, machine-textured, and gold-stamped with a machine.

Signature. For this finish, negatives are retouched either traditionally with extensive print retouching and enhancement, or digitally with print enhancement. The prints are then bonded to canvas and luster-sprayed. Finally, I sign the prints with a Pilot Super Color Gold extra-fine-point pen.

In 1971, I made a time-management decision to have a professional laboratory handle my entire manufacturing process. I wanted to be able to devote my time to my photography as well as the sales, marketing, accounting, planning, and other aspects of my business. When a print arrives from the lab, all that remains for an associate or me to do is gold-stamp the portrait, put it in a frame, and deliver it to the customer.

I think that a professional portrait should represent the photographer's finest effort. When I put my name on a print, I want it to look as perfect as the artists under my direction can make it. Even though they work at a lab 400 miles away, I've developed effective communication with these artists through written order forms, examples, and—from time to time—in-person visits. These experts and I work together as a team to create high-quality portraits for my clients.

COPIES AND RESTORATIONS

Billions of snapshots and old photographs provide an infinite market for professional photographers with the ability to create demand for copy and restoration work. The key to marketing these services is reliability because discerning clients won't leave their cherished originals with someone they don't trust.

How do you establish trust? In addition to longevity in business, you can attract clients through your demeanor, as well as a tasteful display of your credentials. Every time you receive a certificate or diploma, exhibit it in a frame and mat that demand respect. Hang the certificates in a well-illuminated area that your clients can discreetly see.

Your studio and personal appearance also send important messages to potential customers. You should appear well groomed, with neat clothing, hair, hands, face, and shoes. Your clothing doesn't have to be expensive, but it should be newly laundered and as wrinkle-free as possible.

From the public area of your studio, your clients should perceive your business as clean, neat, and well-organized. This means that every detail of the public area must be inspected continually to be certain it is clean and orderly. You don't want chipped paint, worn carpeting, stained upholstery, or faded drapes, for example, to give a bad impression. Finally, the contacts you make in civic clubs, in your church or synagogue, and at the social events you attend can also help build public confidence in you and your studio. If prospective clients see you as warm and friendly, they'll be more likely to come to you for their photographic needs, especially if you present a professional appearance. I make it a point to sit with someone different each week at my civic club, so that I can broaden my contacts and expand my networking possibilities.

HANDLING THE INITIAL INQUIRY

Ted Sirlin of Sacramento, California, my first photographic-business instructor, trained me in the art of restoration sales as well as a thousand other marketing and management skills. I am indebted to him for many of the business principles that have proven successful for more than 25 years. One of the many strategies Sirlin shared with me revealed how to successfully deal with an initial inquiry about copying and restoration from a potential customer.

You'll probably receive the first inquiry over the telephone, so you and your staff members should be able to ask the right questions and provide the key information the caller needs to know. Otherwise, the inquiry will turn into a breakdown in communication, not a jumping-off place. Consider the dead-end conversation that follows:

Caller: Do you copy old pictures?

Studio staffer: Yes, we do…(pause).

Caller: How much do you charge for an 8 x 10 copy?

Studio staffer: Ten dollars for making the copy and 15 dollars for the print.

Caller: I'll let you know later (click).

As you might guess, this caller will never be heard from again. What did the staff member do wrong? The staffer showed no enthusiasm or interest in the caller's needs, and volunteered no information.

When people call you with a price inquiry, they're actually calling for help. Because they don't know anything else to ask, they request information about prices. If you answer the price question before telling the callers what they really want to know, you've lost the battle before it begins. Take a look at a different scenario with a well-trained salesperson answering the telephone:

Studio staffer: McDonald Photography. Elizabeth speaking.

Caller: Do you copy pictures?

Studio staffer: Yes, we specialize in copy and restoration work, Mrs. …(slight pause). Excuse me, I didn't hear your name.

Caller: I'm Mrs. Jones.

Studio staffer: Tell me about your photograph.

Caller: My aunt died last month, and I found this old photograph of my parents, one I'd never seen before. It's really the only one I have of them as newlyweds.

Studio staffer: Wow! I bet it means a lot to you. What kind of shape is it in?

Caller: Well, it's bent in the middle, and one corner is torn. But it's the only one I have and I don't want to risk losing it.

Studio staffer: I don't blame you for wanting to be careful with a priceless keepsake. We place your photograph on a copyboard and take a picture of it, so it isn't harmed in the least. It never leaves our studio; in fact, we can copy it while you are here so you don't even have to leave it. No work is done on your original, which is returned to you unharmed. Let me suggest we make an appointment for you to come by the studio so I can see your photograph. Then I can show you types of restorations and finishes. After seeing your original, I can give you a price estimate, as well as some suggestions about displaying your prints. There won't be any charge for this estimate, of course. Would mornings or afternoons be best for you, Mrs. Jones?

Caller: Afternoons, and Thursday would be best.

In this conversation, the staff member dealt with the caller on a personal level by asking her name, conveyed interest in her photograph, understood her concerns, explained the next step, and expressed a willingness to help her. Because of the attention she received, this caller undoubtedly showed up for her first appointment.

HANDLING THE NEGOTIATION

When a client brings a photograph to your studio to be copied, your skill, knowledge, and ethics are challenged. If the photograph bears a copyright symbol or the name of an existing studio, you must advise the client to return to the original studio for additional copies. Some high-volume photographers don't keep old negatives, but they'll give you written permission to copy the picture. Occasionally, clients send an original photograph through the mail, but we don't recommend this because of the danger of loss or damage. If we must handle a job by mail, we send the original in a separate package from the copy print. We send both via a courier that requires the recipient to sign for the package.

You can gain your client's confidence if you can identify which kind of old photograph they have, such

as a tintype or a daguerreotype. If you and your associates need to learn about the various types, you can find examples of early photographs in many museums and libraries. In addition, many books describe early photographic processes in great detail.

When it comes to copy and restoration work, you can offer your clients a range of choices.

- A simple copy with no retouching or correction
- Cracks and spots retouched
- Missing parts restored
- Faded prints restored
- Subjects or objects removed
- Regrouping: photographs of two or more individuals put together to make a group
- Various print finishes: glossy, matte, sepia, handcolored, digitally colored, and traditionally colored.

Samples that you can show customers are essential. Find a badly cracked and torn original that you can use as a "before" sample. Then make up restoration samples in different finishes, such as a simple copy without any corrections, a copy with cracks retouched, a digital restoration with everything corrected, and a brush oil print with both corrections and color.

Restorations require careful sales techniques. Many clients ask us to create beautiful wall portraits from small, fuzzy snapshots; sometimes we're asked to lift just one person out of the snapshot. "Because there is no detail in your snapshot, it will be difficult for our artist to create a portrait like the image you have in your memory," I typically say to my clients. My policy is to undersell and over-deliver restorations. I promise little and work tirelessly to produce a better result than my customer expects.

If you aren't sure how to price a difficult job, send a copy of it to your digital or oil artist for an estimate. Once you have the cost, the selling price will depend on many factors, such as your overhead costs, return on investment, and risk of rejection. You continually face the possibility that your customers will refuse the occasional job. This results in a total loss that the selling price of all jobs must cover. Although some photographers double the cost and others make it as much as seven times higher because of the chance of rejection, the majority price their work somewhere in between. A high markup on a difficult restoration might cause the client to turn down the job, but a high-risk assignment requires compensation. If a client rejects a print, the photographer has to swallow the cost.

WORKING WITH AN ORIGINAL PRINT

To gain customer confidence, studios should copy originals on the premises, thereby eliminating the chance that the clients' property will get lost in transit. I never attempt any alteration on client's original

because of the danger of damaging it. All restoration work is done on the copy print.

Client originals are copied with two photoflood bulbs rated at 3200K (General Electric ECA bulbs), covered by polarizing filters, or polarizers. Another polarizer is placed over the camera lens to control reflections. The originals are held on a metal copyboard with magnetic strips. The metal copyboard has a nonreflective, matte surface.

Almost any camera can be used for copy work, including the Hasselblad that I also use for portraits and weddings. To avoid camera vibration, I focus on and frame the original, and then put the camera mirror in the lockup position. The copy camera has a Lindahl lens shade that blocks out stray light while permitting use of filters next to the lens. Without special control, contrast increases in copy work. Harrison and Harrison makes a series of low-contrast filters (LC) that provide the easiest way to solve this problem. I prefer the LC-1 filter for most jobs; the 3-inch-square version fits in the Lindahl filter slot next to the lens.

Another way to control contrast is via a technique called flashing. Here, you expose the original normally and then double-expose the film by placing a white card over the original for 5 percent of the first exposure time. For example, if the first exposure time is 100 seconds, the exposure time for the white card will be 5 seconds. This step actually fogs the film slightly, thereby reducing contrast. "Flashing" is consistent, but lab tests are recommended to determine the exact flash time with various films.

When I do copy and restoration work, I choose Kodak Tri-X film for black-and-white jobs and Vericolor Type L (VPL) for color jobs. The Vericolor film is balanced for the 3200K bulbs I use. Copied alongside the original is a 7-inch Kodak gray scale that helps the printer determine density and color. A gray scale shows all densities from pure black to pure white in gradual steps. When the lab analyzes the negative to show detail in all parts of the gray scale, the original will be reproduced correctly both in density and color.

Over the years, I made an important discovery: maintaining a notebook proves valuable as a guide to exposure. For each job, write down the exposure time, the f-stop, and the filtration. Keep separate pages for jobs done with filters and flash. Note the size of the original because closeups (which are made with a long bellows draw) require more exposure. Also note the density of the original. Is it light, medium, or dark? After a few years, your notebook will be a more accurate exposure guide than a light meter will. Each time you get a processed negative back from the lab, indicate in your notebook whether it was correctly exposed, overexposed, or underexposed.

New technology is sweeping the copy business, along with the rest of the photography industry. Some photographers are purchasing the Fuji Pictrostat or Kodak Copy Station to make copies of photographs instead of relying on traditional copy negatives. Digital imaging will get better and better, and the price of technology will get smaller and smaller every year.

SELECTING ESSENTIAL EQUIPMENT

As a professional portrait photographer, you should choose your camera equipment with a careful plan based on needs, not wants. Most photographers are gadget-oriented by nature, buying equipment because it fascinates them, not because they need it. The litmus test for any equipment purchase should be: how long will it take the piece of equipment to pay for itself?

For years, I wanted a wide-angle lens for my Hasselblad, but it cost a couple of thousand dollars, and I couldn't book enough jobs to pay for it. The only commercial use for it would be an occasional wedding photograph that might bring in 30 dollars and a special-effects portrait that might yield 70 dollars. I would need to shoot a lot of these infrequent photographs in order to come up with 2,000 dollars. Finally, a commercial account offered me a job that provided an opportunity for a 10,000-dollar sale. To get this assignment, I had to have a wide-angle lens. So after 25 years in the photography business, I bought one, assured that it would pay for itself.

Because the following gear endures such heavy use, I recommend that you buy at least two camera bodies, two 150mm lenses, two 80mm lenses, and four film magazines. You should also decide on either 120 or 220 magazines in order to simplify film inventory and reduce confusion.

You can amortize the expenses of some equipment, such as camera stands, over long periods of time. Quality lighting equipment, such as that made by Photogenic, also has a long life. This means that your investment probably will last 20 years or more.

If you concentrate on shooting outdoors and holding sessions in your clients' homes during the early part of your career, you can avoid the expense of setting up a camera room. This way, you don't have to buy backgrounds, chairs, carpets, muslins, and countless other accessories that are available in your customers' homes.

As your sales volume increases, I recommend advancing to a studio location in stages, so you don't have to contend with overhead at one time. Initially, I would do everything in the clients' homes, including showing proofs and delivering the final order. Next, I would rent about 500 square feet with space for a gallery, a projection room, and a small office. This would provide a base location for booking sessions, projecting proofs, and delivering final orders. The third phase would be the addition of a camera room, an outdoor-photography studio, a dressing room, a larger work space, and a storage area for negatives.

How do you tell when you can afford each additional phase? First, you should have saved enough money to pay for the furnishings and equipment needed for each new phase. Then you need to look at your operating statement to see if there is enough profit to absorb the additional overhead. Remember, occupancy costs include not only rent, but also utilities, insurance, taxes, and maintenance.

CAMERAS

Some essential equipment, such as cameras and lenses, require backups. If a camera, lens, or light fails just before an important wedding or portrait assignment, you must be able to continue to work. You might not have time to go elsewhere to rent or borrow backup equipment. If I had only 5,000 dollars to spend for equipment, I would prefer to buy two complete sets of used equipment rather than one set of new equipment. Of course, I carefully test all equipment purchases, whether new or used, processing a roll of film from each camera before use on a revenue-producing assignment.

I like the 6 x 6cm (2¼ x 2¼-inch) format because it readily accommodates negative retouching and 40 x 60-inch enlargements. In addition, the light weight of 6 x 6cm cameras enables me to use them for

both weddings and portraits. Most portrait photographers prefer cameras with frontleaf shutters because they can synchronize faster exposures with electronic flash. This capability is helpful when you shoot sports, dance, or candids.

For example, photographing a bride and groom running with the sun behind them requires a fast shutter speed and flash fill, both of which are possible with a shutter in the lens. Lens shutters synchronize with flash up to 1/500 sec., while focal-plane shutters, found in most 35mm cameras, can't sync with flash faster than 1/60 sec. A focal-plane shutter would result in blurred movement in the above scenario.

Since a focal-plane shutter scans the film from side to side, different areas of the film are exposed to light at different times. This means the flash must fire when the shutter is open over the entire film area; otherwise only part of the film area will be exposed. With focal-plane shutters, this never happens at high shutter speeds, so flash photographs can be made only at slower speeds. Portrait pros prefer 120mm format cameras because the negative is much easier to retouch than 35mm and provides sharp wall portraits without apparent grain.

Most professional photographers prefer single-lens-reflex (SLR) cameras because they can see exactly what will appear in the final image. This is critical in terms of vignettes and diffusion. It is almost impossible to use vignetters and diffusers with twin-lens-reflex or rangefinder cameras.

FILM

The fierce competition among major manufacturers benefits portrait photographers because films are getting better and better. High-quality prints up to 40 x 60 inches are possible with 120mm film if the negative is sharply focused and properly exposed. Most portrait photographers use ISO 160 films for indoor work with flash because they'll usually produce bigger prints with less grain than ISO 400 films. Two popular ISO 160 films are Fuji's NPS 160 and Kodak's VPS III.

Most photographers use ISO 400 films for outdoor portraiture because the increased speed allows for fast shutter speeds. But some use this faster film for indoor work, too. My favorite ISO 400 films are Fuji's NPH and NHG, along with Kodak's Pro 400 and Pro 400 MC.

Which film should you use? Discuss films with your color lab to see which gives them the best results. To get optimal quality from a film, the lab must have their system tuned to the manufacturers' guidelines, so you want to use a film that your lab feels comfortable with. Then test the films the lab specialists recommend by using flash, window light, and outdoor light on both high-key and low-key subjects. Make three exposures on each setup: one prescribed by your meter, one overexposed, and one underexposed.

If film is left in the camera after a wedding, I finish it off during the next portrait session. Pennies add up in the management of a studio. So it makes sense economically not to wind off portrait film before a wedding, or wedding film before a portrait session.

As mentioned earlier, when I shoot square format film, I order 5 x 5-inch originals from my color lab and then trim them to 4 x 5 inches before presenting them to the client. Laying a piece of 4 x 5 glass over the 5 x 5 original will help you visualize the best way to crop the image. With this method, I can decide whether to go horizontal or vertical after I receive the originals. This technique is especially helpful for shots of active children.

Another trimming aid is the marking of crop lines on the focusing screen, so that I compose rectangles rather than square images. I place my color lab's biggest 4.5 x 6cm mask over the screen as a guide and then make the crop lines with an alcohol-based ultra-fine-point pen, such as a Sharpie. I draw two vertical lines and two horizontal lines on the focusing screen.

LENSES

Portrait photographers prefer long lenses because they produce few problems with perspective distortion or foreshortening. With these lenses, people in the front row of a group appear to be the same size as those in the back, and a subject's hands won't appear grossly larger than the person's face if placed closer to the lens.

For head-and-shoulder portraits, I recommend working with a lens that is twice the diagonal of the negative. For example, the diagonal of a 6 x 7cm negative is 90mm, so 180mm, or twice that length, is the recommended lens focal length for closeup portraits with that format.

I do probably 85 percent of my portrait work with my 150mm lens. This figure includes closeups, full-length shots and pictures of groups of up to eight people. Full-length and small-group portraits require about 23 feet of working space with my 150mm lens, but it prevents foreshortening problems. For large-group shots and bridal portraits, I use my 80mm lens.

For 25 years, I didn't even own a 50mm wide-angle lens for my 6 x 6cm camera. I didn't invest in this lens because I knew that it wouldn't pay for itself with my work schedule of portraits and weddings. Furthermore, I didn't like the idea of using a wide-angle lens with people because it can distort faces if you place it too close to your subjects.

LENS SHADES
To control lens flare, a bellows lens shade made out of fabric is a must. Flare is a haze over the image that reduces contrast. Fabric is less reflective than metal, so it makes a superior lens shade. The Lindahl double-bellows shade blocks stray light from the lens, while

SUGGESTED LENS FOCAL LENGTHS FOR CLOSEUPS

Film Size	Diagonal of Negative	Lens	Working Space (Closeup to Full Length)
35mm	45mm	90mm	5-23 feet (1.52-7m)
1¾ x 2¼ (4.5 x 6cm)	75mm	150mm	6-23 feet (1.83-7m)
2¼ x 2¼ * (6 x 6cm)	75mm	150mm	6-23 feet (1.83-7m)
2¼ x 2¾ (6 x 7cm)	90mm	180mm	6-23 feet (1.83-7m)
4 x 5 (10.2 x 12.7cm)	165mm	300mm	5-23 feet (1.52-7m)

* When you make an 8 x 10 print, the usable portion of the 6 x 6cm negative is 4.5 x 6cm.

also serving as a holding device for diffusers, filters, and vignetters. The shade has a slot next to the lens that is wide enough to hold glass filters, such as those made by Tallyn and Harrison. The center slot accommodates high-key vignetters, and the front has a ferrous metal plate for low-key vignetters with magnetic strips. Diffusers are filters made of glass, plastic, or fabric that soften the entire image, while vignetters soften, lighten, or darken only part of the image.

VIEWFINDERS

Prism viewfinders provide a magnified, upright, and laterally correct image. Portrait photographers select prism viewfinders according to their height. Since I am about 5'9", I use an eye-level prism viewfinder in order to raise the camera as high as possible. I like to keep the lens at the subject's eye level. Without the prism, I would have to use a step-stool to get the camera high enough. Tall photographers can use the waist-level focusing hood that is standard equipment with Hasselblad's 6 x 6cm camera.

Because sharp focus is vital for portraiture, I use the Hasselblad Acute-Matte viewfinder. The Acute-Matte and similar groundglass screens are made with special materials that collect more light from the lens and make the camera easier to focus. This effectively doubles the brightness of the focusing screen. Hasselblad and other manufacturers make replacement eyepieces for prism viewfinders in a range of diopter strengths for those who need eye corrections.

TRIPODS

When you work with backgrounds that include doors, windows, and molding, it is important to keep the camera level. Select a tripod head that has a spirit level or choose a spirit level that fits into the accessory shoe of the Hasselblad. This bubble level permits accurate

and convenient leveling of the 500C and 500 EL cameras.

Start with a sturdy portable tripod, such as the Bogen 3011, which you can use in the camera room, outdoors, on location, and at weddings. The late Lester Bogen used to sit on his tripods to prove their stability. That might not be possible for me, but I can put my camera on my tripod to see if it feels sturdy.

When putting a camera on any camera stand, I always have the camera strap around my neck in case the locking device isn't secure. When I think the camera is firmly attached, I pick it up to see if the tripod comes with it. Only then do I remove the camera strap.

Later, you might want to add a monostand, such as the Regalite Six Footer. A monostand will pay for itself quickly because it enables you to move the camera from the 6-foot height to the floor within a matter of seconds. Time is money in the camera room, and anything you can do to increase efficiency will pay dividends.

Many years ago, I used a stopwatch to determine the time required to raise or lower three tripod legs. Then I calculated how many additional sessions I could do with the time I'd saved. With the volume of portraits I was shooting, I realized that I would be able to pay for the monostand in two months. The way I see it, this piece of equipment has been making money for me for more than 20 years.

LIGHTS

Monoblock lights are popular with portrait photographers because the lamp head and power supply are together in one compact housing. Photogenic's PowerLights have built-in, photocell triggering devices and variable-power settings, making it possible to fine-tune the output. Some lights have only half- or full-power settings, so you have to move the light closer or

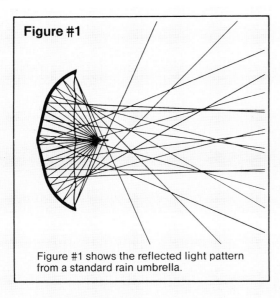

Figure #1

Figure #1 shows the reflected light pattern from a standard rain umbrella.

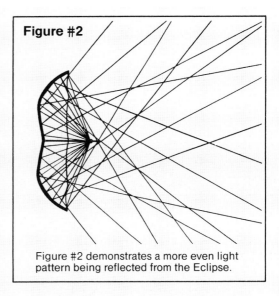

Figure #2

Figure #2 demonstrates a more even light pattern being reflected from the Eclipse.

Eclipse Light Coverage Advantages

Indirect light reflected from an umbrella is often more desirable than direct lighting. The result is a broad, soft light especially pleasing for facial skin tones, for group lighting and exposing of soft shadow areas. Since umbrella lighting produces a soft, broad angle of coverage, retouching and light placement become less critical.

Curved umbrellas give a smaller spread of light than do flat umbrellas. Conversely, the angle of coverage becomes wider as the umbrella becomes flatter. With a curved umbrella, the angle of reflection is less near the curved outer edge, which results in a wraparound effect, quite pleasing for portrait work. The Eclipse with its curved outer edge and flat center gives the user the advantages of both. For simplicity, illustrations #1 and #2 demonstrate a point light source being reflected from a mirror-like surface. The Eclipse has a

textured fabric surface, which gives a somewhat irregular or diffused reflected light pattern. However, the basic effect remains the same as the illustration. The Eclipse is available with a white satin fabric or silver. All models are somewhat translucent and will pass varying amounts of the light through. This additional light can bounce around the camera room and produce an even softer effect, very desirable for high key photography. See Figure #3.

More often this effect is not desirable and the light passing through must be blocked. All Eclipse models, therefore, come with outer black blocking covers to eliminate the unwanted light. See Figure #4. Eclipse models are an excellent choice when ceiling, walls, or floor colors are not suitable for additional bouncing light. They also eliminate lens flare when being used in front of the camera.

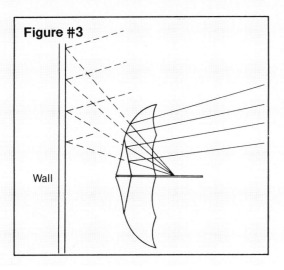

Figure #3

Wall

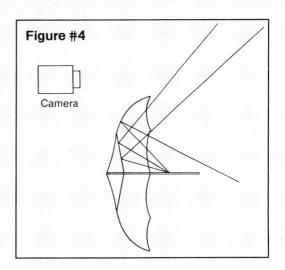

Figure #4

Camera

These illustrations compare a traditional parabolic umbrella to the Eclipse umbrella. Because the Eclipse has a curved outer edge and a flat center, it provides a broad, soft illumination that is well suited to portraiture.

farther from the subject to change the output. The variable-power-setting switch lets you change the output without moving the light. Built-in photocells mean that you don't have to buy any additional triggering devices.

For starters, I recommend two monoblock lights, such as the Photogenic PowerLight 1500, with two caster-base stands. One can serve as a main light and the other as a fill light. Next, you might want to buy a 60-inch Eclipse umbrella for the fill light and a 27-inch-square silver reflector for the main light. The PowerLights have built-in, photocell triggering devices, or slaves, as well as variable power settings, which enable you to fine-tune the output. You can add other lights, such as hair lights and background lights, later on when funds are available.

Keep in mind, however, that relatively inexpensive lights are available from Photographers Warehouse. You can use these as accent lights and as a second light at weddings. The Medalite 4001 weighs only 2 pounds, produces a flash-meter reading of $f/11$ at 10 feet with ISO 100 film, and has a built-in photocell triggering device. When you turn off the PowerLight, it won't continue to fire when triggered. But the Medalite may hold two or three charges before it stops completely; this is a major disadvantage. The PowerLight costs more but it is worth more. You have to decide which is more important, price or efficiency.

If you shoot weddings, you'll need a couple of battery-powered flash units, or strobes. These can do double duty, serving as supplementary lights for outdoor and location sessions. I recommend the Lumedyne nickel-cadmium flash equipment because of its rugged reliability.

RAIL SYSTEMS
In time, you might consider the use of an overhead rail system for the lights in your camera room. Rail systems keep wires off the floor and facilitate moving lights in all directions. They even enable you to place lights on the floor for photographing children. While teaching at the Winona School of Professional Photography about 20 years ago, I compared session times for a camera room with a rail system and one with caster-based stands. I estimated that with the amount of time the rail system saved, it could pay for itself easily within a year. So the rail system I purchased in 1975 has paid for itself 20 times over.

WIRELESS TRIGGERING UNITS
Remote triggering frees the camera from the need for a wire to connect with the lights. The Quantum Radio Slave 4i, which I use, works flawlessly both in the camera room, on location, and at weddings.

REFLECTORS
For outdoor- and window-light portraits, I recommend a Larson 42-inch, black-and-white, reversible Reflectasol. You can use this reflector to soften shadows or to block light. It also can prove helpful in the camera room when you need to block stray light from the lens for profile shots.

LIGHT METERS
Meters can serve two functions because they measure both flash and daylight, so one good one will do the job. A high-quality light meter, then, can do the job. Look for a meter with easy-to-find batteries, such as double As, and an automatic-shutoff feature. I use the Sekonic L-328. Like automobiles and computers, many meters have many more features than you really need, driving up their price and complexity. Simply make sure that the meter can read both incident and reflected light; you don't need a lot of whistles and bells.

CHAPTER 13
CONSTRUCTING A CAMERA ROOM

Some photographers never build a camera room because they feel that they can capture their client's personality better in their home. Sooner or later, however, most portrait photographers dream of a camera room, so they don't have to lug lights in and out of client homes all day. How do they know when it is time to build a camera room? When they have enough money to buy the equipment and furniture they need, plus sufficient net profit to cover the overhead.

Given a choice, most photographers would build a huge camera room, about 50 x 50 feet. This space is large enough for big family groups and brides with long trains. However, with the cost of space, either renting or owning, most of them compromise with a size they can afford.

Some photographers build camera rooms that are only 10 feet wide and 15 feet long, but they're limited in the size of groups they can photograph. A few photographers build a camera room that adjoins an atrium or greenhouse, making it possible to move from indoors to an outdoor studio with heat and sometimes even air conditioning. These enclosed garden studios have the advantage of being available year round, regardless of wind, cold, heat, snow, or rain.

Some photographers convert two-car garages into efficient camera rooms. They glue thin, neutral-gray carpeting to the floor and extend it up three walls at one end of the garage. Some photographers use a rounded cove at the horizon line. Dark gray and dark brown carpeting also works well in most portraits, especially those of executives. The resulting camera room is space large enough for photographing family groups and brides.

When you plan your camera room, keep in mind that adjoining it should be a restroom and two dressing rooms. This way, clients won't have to rush so that you can begin another shooting session. You should also make sure that the camera room is well positioned. Choose its location carefully; you don't want staff members or clients to need to use it as a hallway to get from one room to another.

CAMERA-ROOM ESSENTIALS

When you design a camera room, it is a good idea to outline your goals and requirements. You can modify the following checklist according to your individual needs. First, you'll want a minimum width of 18 feet to accommodate large family groups, as well as brides with long trains. If the bride has a train 9 feet long, you need enough camera room width so she can be centered in the format and still show all of the train.

A minimum length of 23 feet (26 feet would be better) will facilitate the use of a lens that reduces the foreshortening problem associated with short-focal-length lenses. To determine length, focus on a subject about 6 feet tall, using a 150mm or 180mm lens. With the subject about six feet from the background, see how far back your camera needs to be, plus room for you behind it. In my case, this means about 23 feet.

You'll also require adequate ceiling height, minimally 10 feet, so the main light casts a shadow from the subject's nose to the corner of the mouth during standing poses. To determine the ceiling height, see how high your main light must be while you shoot a portrait of a man 6 feet tall. It probably will be 10 to 12 feet.

Keep in mind, too, that a white, smooth ceiling allows for the efficient use of bounce light. Textured ceilings soak up a great deal of light, so the bounce light isn't strong enough. Colored ceilings probably will reflect unusual colors into your portraits, causing problems, especially with white clothing.

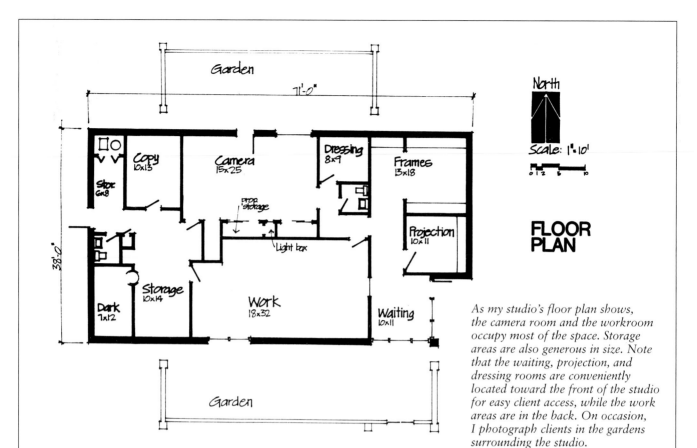

North

SCALE: 1" = 10'

FLOOR PLAN

As my studio's floor plan shows, the camera room and the workroom occupy most of the space. Storage areas are also generous in size. Note that the waiting, projection, and dressing rooms are conveniently located toward the front of the studio for easy client access, while the work areas are in the back. On occasion, I photograph clients in the gardens surrounding the studio.

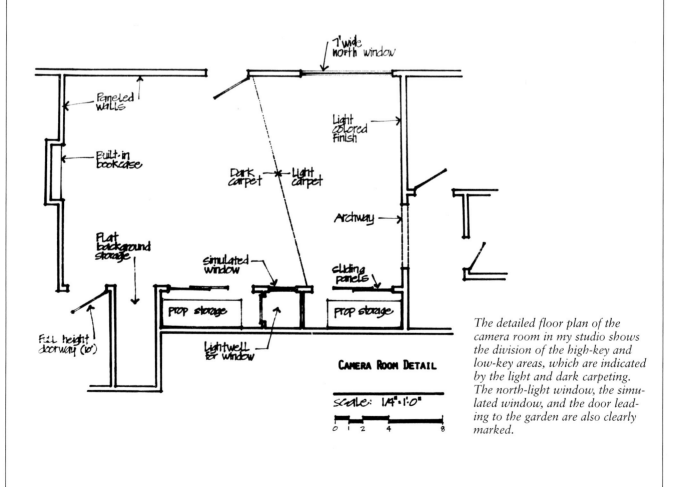

CAMERA ROOM DETAIL

SCALE: 1/4" = 1'-0"

The detailed floor plan of the camera room in my studio shows the division of the high-key and low-key areas, which are indicated by the light and dark carpeting. The north-light window, the simulated window, and the door leading to the garden are also clearly marked.

Next, consider nondistracting floor and wall surfaces. These eliminate such problems as reflections and horizon lines. A horizon line can be distracting in a portrait, especially if it is a convergence of light and dark. It will draw the viewer's eye to the floor rather than to the subjects. Some photographers have a thin carpet extend from the floor up the wall, using a rounded cove at the horizon line. Dark gray and dark brown carpeting works well in most portraits. Dark carpet merges with a dark wall, so the horizon line isn't noticeable. You'll also want a floor surface hard enough so a subject wearing high heels can stand on seamless background paper without punching holes in it. I recommend a hard carpet, about 1/4 inch (6mm) thick. Once again, avoid mixing light carpet with dark walls or vice versa.

The camera room should also have a lighting system that ensures consistent exposures and repeatable posing situations. It should be an efficient, well-organized room with all equipment, props, and furniture readily accessible, thereby maximizing time usage for both the photographer and subjects. Closets and cabinets can keep props, furniture, and equipment out of sight. Heavy furniture should be placed on casters or skids so it can be moved easily around the room. I use an accessory tray on my Regal camera stand to hold frequently used diffusers and vignetters. Finally, you'll want a versatile design that permits all four walls of the camera room to be used as backgrounds, along with space for flats, muslins, and roll-down backgrounds.

CUSTOMIZING THE ROOM

When architects Dwain Beisner and Howard Shannon drew up plans for my studio building, they oriented all the rooms around the camera room. The architects wanted to provide a north-light window and a door leading to the outside photography area. One side of the camera room resembles a fine library with a built-in, floor-to-ceiling bookcase at the end, plus a simulated fireplace on one of the side walls. I purchased unfinished, A-grade plywood and later stained it a medium-tone birch color and then finished it with matte varnish in order to reduce glare. (The gloss on pre-finished paneling creates a glare problem.) I used molding to bridge seams in the paneling, which added

to the decor. The carpeting is dark brown, so the horizon line isn't noticeable.

Above the bookcase are six roll-down backgrounds nestled in a ceiling cove; they are out of sight when not in use. Opposite the bookcase is an arched door that serves both as an entry to the camera room and a background area for full-length, high-key portraits. This end of the camera room is painted ivory and has matching ivory carpet. The result is the look of a fine home. Because the side walls are also painted ivory, this end of the room is large enough for full-length bridal portraits.

One of the side walls leads to the north-light window, which I can use for closeups as well as full-length portraits. The arched entryway leads to the restroom, the lobby foyer, and one of the dressing rooms. When I work with a long lens, I can back into the entryway door frame and the hallway to gain an additional 3 feet of shooting room for portraits in the library area.

Closets cover the wall opposite the north-light window. They are roomy enough to store furniture, props, and equipment—and to hide them from view. I store flats, measuring 4 x 8 feet, in one deep closet.

Most of the lights are mounted on a Photogenic Master Rail System, which makes them easy to move while keeping wires off the ground. This setup, which is a real timesaver, also makes the camera room safer and less cluttered. I can lower the lights all the way to the floor with scissor-like light lifts. The only light not on the Master Rail is the fill light, a Photogenic Flashmaster on a caster base stand. This needs to move from one end of the camera room to the other, depending on whether the subjects are being photographed in the high-key or the low-key end.

Most photographers begin their careers by working out of their homes, then build camera rooms so they can accommodate sessions more efficiently. The decision about whether to build a camera room or continue to work on location is a difficult one. It depends a lot on individual style, as well as the marketing plan. A photographer who wants to do six or more sessions a day needs a camera room. A photographer whose marketing plan calls for a limited number of sessions with a higher average sale may prefer location sessions. Certainly, location sessions provide greater variety than working inside the same four walls every day does.

DETERMINING EXPOSURE

You can calculate exposure with a light meter two ways. You can take either an incident reading directly from the sun or flash or a reflected reading of the light bouncing off your subject. Most light meters work both ways, sometimes requiring an attachment for one or the other. Photographers debate a great deal as to which approach is better. I usually prefer the incident method because I find it to be faster and less prone to error than the reflected method.

Keep in mind that most light meters are made to give you the reading for an 18 percent gray card. This standard assumes that your subject is comparable to a gray card, which is seldom the case for portrait photographers. So what should you do to properly expose your subjects? Set the film-speed, or ISO, indicator on your light meter for the film you're shooting, put the meter in incident mode, and then point it at the light source. If you're working with a continuous light source, set the meter for daylight or ambient light. If you're working with flash, set the meter for electronic light. Either way, you'll have a starting point for determining exposure. I use the term "starting point" because the true test for a portrait photographer is a series of exposures that you send to your lab for evaluation.

MAKING TEST EXPOSURES

Select a subject wearing both light and dark articles of clothing against a dark background. The light clothing should have a texture, so you can see if the film shows detail in the whites. A subject with dark hair should separate from a dark background without a hair or background light. When you properly expose dark hair, you can see it against a black background.

Suppose the ISO rating of your film is 160. Set your light meter accordingly, and then aim it at the light source. If the meter indicates a flash reading of $f/11$, make a series of exposures at half-stop increments on either side of $f/11$. This means shooting at $f/5.6$, $f/6.3$, $f/8$, $f/9.5$, $f/11$, $f/13.5$, $f/16$, $f/19$, and $f/22$.

Next, send the film to the lab, and ask your lab specialists to tell you which exposure they like best. Imagine that they prefer the negative exposed at $f/8$ even though your light meter called for $f/11$ at ISO 160. The effective ISO for this particular lighting setup, then, would be 80. You would then set your light meter on ISO 80, so it will give you a correct reading for the next setup.

DETERMINING FILM SPEED

Film-Speed Rating	Meter Reading	Your Laboratory's Preferred Exposure	Set Your Meter on:
ISO 160	$f/11$	$f/5.6$ (+ 2 stops)	ISO 40
ISO 160	$f/11$	$f/8$ (+ 1 stop)	ISO 80
ISO 160	$f/11$	$f/11$	ISO 160
ISO 160	$f/11$	$f/16$ (– 1 stop)	ISO 320

Most negative films have a tolerance range in terms of exposure, which is called exposure latitude. As such, you can slightly over- or underexpose them and still get printable negatives. So most professional portrait photographers determine the ISO setting for the film they're shooting and don't bracket exposures in a sitting. Because good expressions are difficult to capture, portrait photographers can't bracket exposures and hope to catch that certain smile three times in a row. If I'm not 100 percent sure of the correct exposure, I prefer to slightly overexpose subjects because I want rich detail in the shadows. However, I can't push this too far because I'll fail to get detail in any white clothing that my subject is wearing.

With quality equipment and careful use of lights, exposure in the camera room should be consistent. By "careful," I mean maintaining the same distance

between the lights and the subject for every exposure—even if you have to run a string from each light to the subject. After many years, you won't need to do this because you'll be able to judge the distances by sight, and probably even the intensity of the modeling light on the subject's face.

Fortunately, many labs provide exposure information on the negative glassines, indicating over- or underexposure. Study these for each indoor and outdoor situation, so you can adjust your exposure as necessary. After working many months in the same shooting situations, you'll discover that you won't need light-meter readings to guide you; you'll be able to fine-tune your exposures based on information from your lab's glassines. For example, when the sun is shining brightly, the correct exposure for the northern-light window in my camera room is 1/15 sec. at *f/5.6* with Fuji NHG 400 film. And with my many years of experience, I now have to use a light meter only when the light is low.

BALANCING APERTURES AND SHUTTER SPEEDS

In order for you to maintain sharpness in window-light and outdoor portraits, the shutter speed must be as fast as possible. Some experts say that it must be at least 1/250 sec. for handheld exposures. I try to use shutter speeds of 1/15 sec. or faster with my Regal Six monostand indoors or my Bogen 3011 tripod outdoors. And by choosing a fast film, such as Fuji NHG film with its ISO rating of 400, I can utilize faster shutter speeds when I shoot than slower films would otherwise allow.

Outdoor portraits are always a compromise between aperture and shutter speed. Small *f*-stops, which are needed for extensive depth of field, call for slow shutter speeds. This can create fuzzy portraits if the subject moves even slightly. Ordinarily, I prefer a shutter speed of 1/60 sec. when I shoot at *f/5.6* because it freezes most subject movement. The only exceptions are active children and pets. When working without a tripod, I prefer 1/250 sec. with my 150mm lens to produce sharp handheld exposures.

EXPOSING ARTIFICIAL-LIGHT PORTRAITS

Electronic lights in the camera room stop action via the short duration of the flash, so the shutter speed isn't critical. It simply must be fast enough to prevent room light from adversely affecting the image. I usually opt for a shutter speed of 1/60 sec. The duration of an electronic-flash pulse varies from 1/400 sec. to 1/10,000 sec. or faster, depending on the equipment you're using. Lens shutters synch with electronic flash at any speed up to 1/500 sec. So I usually use 1/60 sec.,

EFFECTIVE DEPTH-OF-FIELD LIMITS				
CAMERA-TO-SUBJECT DISTANCE (IN FEET)				
	5	10	15	30
f-stop*	Depth of Field (in feet)			
f/4	5	10	14¾-15¼	28¾-31⅓
f/5.6	5	10	14⅓-15⅓	28¼-32
f/8	5	9½-10½	14-16	25½-34
f/11	5	9½-10¾	13½-16¾	24-39½
f/16	4¼-5¼	9-11	12¾-18	22-47
f/22	4¾-5⅓	8¾-11¾	12-19¾	20-60

* On a Hasselblad 150mm lens

which is fast enough to keep the flash modeling lights from registering on the film.

Which aperture setting do I prefer? When working in my camera room with strobe lighting, I adjust my lights so that I can use an aperture of *f/11*. This guarantees adequate depth of field for groups and, at the same time, some falloff for individuals so that the background will be out of focus and noncompetitive. Obviously, an aperture of *f/11* is a compromise. An *f/22* setting would provide more depth of field, while an *f/4* setting would throw the background more pleasantly out of focus, thereby preventing it from competing with the subject's face.

EFFECTIVE FOCUS

For groups outdoors, I prefer *f/8* for added depth of field when I focus on the subject in the foreground. I almost always focus on the person in the front row of groups or the near eye of a single closeup subject. Frequently, I focus on clothing near the subject's face, especially when I photograph children. They move so fast that it is impossible to focus on their eyes.

There are two ways to tell if all the members of a group are in focus. First, you can press the depth-of-field-preview button and look at the image in the groundglass at the shooting aperture. Unfortunately, when the lens is stopped down to *f/11* or *f/16*, the image on the groundglass is so dark that you can't determine depth of field.

Another method is to focus on the nearest subjects. Simply look at the lens' focus indicator. Suppose that it shows 10 feet. Next, focus on the subjects farthest from the lens, and then see what the lens' focus indicator shows, perhaps 15 feet. When you look at the engraved depth-of-field scales on the Hasselblad lens, you'll see that *f/8* would bridge these two distances. I would then focus on 12 feet, knowing that there is more depth of field behind the focal point than in front.

LIGHTING RATIOS

The proper placement and ratio of lights can make a subject's face jump off the paper. In effect, they transform a one-dimensional piece of paper into a three-dimensional roundness. The light that creates roundness by means of shadow patterns is called the main light.

Although you can create beautiful portraits with only the main light and a reflector, it is much easier to use another light to soften the shadows. This is called the fill light because it fills in the shadows. Reflectors can't duplicate the effectiveness of a fill light, especially for full-length and group portraits.

You'll also want a couple of accent lights. The background light illuminates the background (of course), and the hair light illuminates the top of the head and sometimes shoulders. If the camera exposure is properly related to the main and fill lights, there will be separation between dark hair and a dark background without the hair light.

You must match the ratio between the main and fill lights with the latitude of color paper, which can reproduce about 1½ stops between highlights and shadows. To capture detail in both highlights and shadows, I try to make the main light one stop brighter than the fill light.

MAIN LIGHTS

One popular type of main light is the polished parabolic reflector, an aluminum dish that looks like a kitchen mixing pan. It yields masterful portraits when properly feathered but requires such precise placement that it is difficult to use with active children. Feathering a light means turning it slightly away from the subject toward the background, so that the illumination comes off the edge of the reflector rather than from the flash tube in the center.

Large umbrellas are much easier to work with because they cover a broad area, thereby permitting subject movement. Keep in mind, however, that the umbrellas don't produce specular highlights in close-ups. Large (4 x 8 feet) fabric or vinyl panels also provide a broad main light. But these light sources are quite difficult to control when the subject wears glasses because they put broad reflections in the eyeglasses.

A medium-sized softbox or silver umbrella, 25 to 36 inches wide, provides a good compromise between the metal parabolic reflector and the broad main lights. Silver produces better specular highlights than white does because of the metallic fibers in the fabric; they simulate metal reflectors but do so without their harshness. At the same time silver prevents the color crossover problems associated with some gold umbrellas. These occur because they reflect yellow onto the subject, which doesn't mix well with the correctly colored, balanced illumination coming from the fill light.

For most shooting situations, I use a 27-square-inch Larson Reflectasol silver umbrella with barndoors 39 inches (1 meter) from my subject as my main light. For groups of more than four people, I switch to a 45-inch white umbrella and position it 48 inches from my subject. In both scenarios, the main light results in a meter reading of *f*/11.

When you properly position the main light, you create five highlight points on the subject's face. These are on the forehead, nose, left cheek, right cheek, and chin. Don't let the main light produce unwanted highlights on the ear, neck, and chest.

Ideally, the main light should create a shadow from the nose to the corner of the mouth. But this must be sacrificed at times to get catchlights. The main light must penetrate both eyes in order for you to achieve proper luminosity.

FILL LIGHTS

The bigger the light source, the softer the shadows, so large reflectors make superior fill lights. Although fabric panels are large. I find that they cause problems with glare on eyeglasses and are difficult to move. And since bounce light also effectively illuminates the tops of heads and shoulders, as well as backgrounds, it is excellent for group portraits.

I use twin fill lights: a 60-inch white Eclipse umbrella placed at nose level and a light bounced off a 10-foot-high white ceiling. The meter reading of the two lights combined is $f/8$. In closeups, the bounce light creates a shadow under the nose and chin. And when you combine a bounce light with the main light, objectionable double shadows are created. To solve this problem, I combine the bounce light with a second fill light. I place an umbrella at nose level about 12 feet from the subject to wash out the shadow under the nose. Ideally, you should position the umbrella light next to the camera on the same side as the main light. This prevents shadow crossover because all the light comes from the same direction.

If the subject is wearing glasses, I'll bounce both fill lights off the ceiling, yielding a combined flash-meter reading of $f/8$. The bounce light is 10 feet from the subject. Two lights bounced off the ceiling produce the nose shadow, but I tolerate this in order to get rid of eyeglass glare, which I feel is a bigger problem. Bouncing the light off the ceiling significantly reduces eyeglass glare because the ceiling itself serves as a reflector. Umbrella and softbox fill lights can be raised only until the top of the reflector hits the ceiling, so they can't go as high as light bounced off the ceiling.

HAIR LIGHTS

Photographers use this type of light for accent only. It should skim the top of the subject's hair. Place the hair light about 7 feet behind the head, aim it toward the camera, but angle it in such a way that the light doesn't strike the lens.

If the hair light is directional, it should come from the same side as the main light, thereby giving the illusion of one light source, just as there is one sun in the sky. I like the hair light to yield a meter reading of about $f/5.6$. Note that this setting is two stops less than that produced by the main light, as well as two stops less than the exposure of $f/11$.

The hair light doesn't have to work as hard as the other lights. Because it is aimed at a 10-degree angle toward the lens, it doesn't require as much power as the other light sources. The angle of the main light usually is about 45 degrees to the lens and that of the fill light is 180 degrees to the lens. So the fill light requires a great deal of power to do its job.

BACKGROUND LIGHTS

Sometimes I use one background light directly behind the subject; sometimes I use two lights on either side of the background out of camera range for full-length portraits when I can see a single light through the lens. Sometimes I don't use any background lights. If the exposure is correct, I don't need a background light for separation. You must, however, illuminate white with the same level of exposure as the subject's face in order to render pure white.

For a dramatic effect in head-and-shoulders portraits, I position one background light so that it creates a soft halo at shoulder height when used with a medium or dark background. I avoid the single background light with three-quarter poses to minimize the light trap between the subject's elbow and waist. The single background light positioned 16 inches from the backdrop yields an incident-light reading of $f/11$.

For the most part, I use twin background lights on a white seamless background to "wash" the paper with shadowless light. The combined lights yield $f/11$ when metered from the center of the paper. The Photogenic lights with 16-inch parabolic reflectors are 36 inches high, and 54 inches from the edge of the paper.

An incident reading of $f/11$ of both the subject and the background gives a pure white background and optimum print quality when you set the camera at $f/11$. Too much exposure on the background results in lens flare. In addition, too much light spills onto the subject. When you take an incident reading of two background lights, stand in the center of the white seamless and point the incident meter at the camera.

Reflected-light readings of white backgrounds are quite different. Meters are made to read 18 percent gray. Since white is $2\frac{1}{2}$ stops brighter than 18 percent gray, the reflective meter reading of the background light must be $2\frac{1}{2}$ stops brighter than the incident meter reading. So, if an incident reading is $f/11$, the reflective reading off white will be $f/22\frac{1}{2}$ or $f/27$.

USING MAIN LIGHTS AND FILL LIGHTS TOGETHER

When setting up my camera room, I like to place the subject about 7 feet from the background. This way, the lights won't create shadows on the backdrop. The main light should be directional, produce specular highlights, and provide facial contours via the proper placement of shadows. The fill light should be shadowless, nondirectional, and nonspecular. For consistency, I always base my exposure on the main light. When the only light comes from a flash on the camera, it acts as the main light, and I must base my exposure on it. When I shoot outdoors, I use the sun to determine exposure. The fill light, which is a stop less than the main light, softens the shadows.

To meter the main light or fill light, you should turn off all other lights. If the main light meters at $f/11$, you'll want the fill light to register $f/8$. Keeping this one-stop difference between the main light and the fill light ensures consistent negatives and prints. Some photographers try for more dramatic portraits by increasing the ratio. But this means that they'll get either shadows without detail or washed-out highlights because the photographic paper won't reproduce the increased contrast.

CHAPTER 16
ELEMENTS OF A SUCCESSFUL PORTRAIT

Every portrait must have three essential elements in order to be successful in the eyes of its audience, whether the viewers are print jurors or, most important of all, members of the buying public. These three components are light, line, and mood. My friend Alessandro Baccari, a gifted photographer who lives in San Francisco, says, "I look at each assignment as if it were my last. With commitment, I gather my energy, thoughts, and creativity to produce what I think to be the last image. Pride drives me to say it must be worthy of my signature. If work completed does not reflect one's best effort, then it was not worth doing" (*The Professional Photographer*, March 1994).

And in the book entitled *Photography*, Paul Strand, one of the pioneers of American photography, believed that "the decision as to when to photograph, the actual click of the shutter, is purely controlled from the outside by the flow of life, but it also comes from the mind and the heart of the artist."

CREATING A MOOD

You can shoot brilliantly illuminated, well-composed portraits, but if they don't capture a mood or feeling, you won't be successful. For that reason, it is very important for you to consider the five steps of portraiture that follow.

- If your subject is sitting or standing in a manner that will result in an appealing portrait, ask your client to remain that way. If your subject isn't in a flattering stance, direct your customer to assume a better pose without regard to hand or eye positions.
- Next, fine-tune the lighting setup, and then focus and frame the subject in the camera's viewfinder.
- Refine the pose by placing the subject's hands and head in the exact position you wish. Next, ask your subject to sit or stand erectly. If needed, press on the individual's spine at the small of the back to aid the posture.
- Then, and only then, show your subject where to look while you photograph. Clients should glance at one spot for only 5 or 10 seconds to prevent the stare fixation that destroys so many portraits. For a profile shot or a three-quarters view of the face, ask your client to look at an object that will keep the eyes centered; this will let you avoid showing excessive whites in the eyes.
- Finally, that brief shining moment, the 1/100 sec. when the exposure is made, comes. This is the most important moment for a photographer. It is the essence, the very life, of a portrait. If you successfully elicit wonderful expressions from your subjects, your portraits will sell even if other qualities, such as posing and lighting, aren't as strong.

ESTABLISHING RAPPORT

In order to build rapport with clients, I become friendly with them before the session. Sometimes I do this during the pre-portrait consultation and sometimes right before the shoot. To explore their personality, I might say something like "Tell me about yourself, your family, your job (or school), or your last vacation." I might also ask "Do you like music (or movies or books)? Tell me about your favorite composer (or author or actor)."

Armed with this information, I usually can say something that will trigger a response during that fraction of a second when I make the exposure. Ordinarily, I ask my customers to think about something rather than to say something because the thought will prompt a smile or pleasant expression. And this is exactly what I'm seeking, an insight into their personality. When you ask subjects to say a word, their lips may be pursed in an unfortunate position during the moment of exposure.

I have a number of prompts that I use to get my subjects to respond, including the following:

• Think about the day you graduated!
• Think about the day you got married!
• Think about your favorite food.
• Think about lying on the beach in Hawaii.
• Think about skiing in Colorado!

Sometimes I find that simply saying "Cheer up!" works well, especially to a group. And if you smile, your clients are more likely to smile, too. Sometimes, just for fun, sit in the subjects' chair and see what the scene looks like from their viewpoint.

CAPTURING A SUBJECT'S SPIRIT

A few years ago, a young college graduate with a degree in photography asked me for career guidance. He had sound technical knowledge but no experience in working with people. At my suggestion, he went to work for a high-volume, chain-store studio, where he had to learn to get saleable expressions with every exposure. After doing 30 to 70 sessions a day for two years, he launched a successful business, first with one location and then developed a small chain of glamour studios in several malls.

California's Robb Carr, a world-renowned retoucher, described the problem with capturing people's spirits: "Still photography, unlike motion pictures, is a static, two-dimensional representation of a person's character. If you were to see these people live or in a film, you would look into their eyes and deal with their personality, not with their pores! A still photograph should be a proclamation of the person's spirit, but more often than not, it absolutely crucifies them. Imperfections become bigger than life, primarily because the essence of that person, the personality, isn't there to refocus our attention—to shroud the unimportant flaws that might otherwise catch our interest. Retouching, if you will, refocuses our attention."

Clients tend to see their loved ones through rose-colored glasses, tinted by emotion. They see a "motion picture." They see spirit. They see character. They see someone who is continually moving, speaking, and expressing themselves in body language. Contrast that with the image customers sometimes get in a photograph: a face frozen by two harsh parabolic reflector lights illuminating every defect and every wrinkle, but no expression in the eyes. Sometimes the subjects are poorly posed and uncomfortable looking. On occasion, they are also the victims of ill-fitting clothes and a poorly chosen camera angle.

My goal is to capture the spirit of each person in front of my camera. I try to portray all clients at their absolute best so that viewers of the portraits will think that the subjects look as if they could speak. If I've accomplished this, then many years from now I will be able to look back on my career with pride. Accomplishing this requires several steps.

PREPARATION

Ask your clients to bring photographs, either snapshots or professional portraits, of themselves for you to study. Which side of their face looks best? Is a smiling or serious expression more appropriate? Which clothing enhances your customers? Prepare your clients by sending them an appointment letter or video that offers suggestions about clothing, hair, makeup, time of day, etc. For example, instruct your adult male clients to come with a fresh shave and a week-old haircut, and your adult female clients to wear their usual hairstyle rather than one created specifically for the shooting session.

Next, prepare yourself for the shoot by studying successful portraits of similar subjects. You won't copy a pose or lighting, but this method can reawaken your creativity. I keep several looseleaf notebooks broken down by subject (men, women, children, brides, pets, groups, etc.). I fill them with photographs and clippings from newspapers and magazines. When I attend a convention, I carry a point-and-shoot camera to take pictures of items that interest me, such as a pose, a prop, a location, or even furniture.

Finally, prepare your studio by creating a warm atmosphere, with sights, sounds, and smells that send pleasant messages deep into your client's subconscious. Test various air fresheners to see which evoke the most positive response from your clients. You certainly don't want the smell of photochemicals or even stale air to permeate your sales area, and cigarette smoke is almost universally banned in retail businesses in the United States.

Music sets the mood for almost any business, and portraiture is especially sensitive to aural influences. Your choice of music will depend on the audience you want to attract. If you're marketing to a younger audience, your choice probably will be rock, pop, or country music. If you're seeking more mature clientele, you might want classical music or show tunes.

For 25 years, I've played Muzak in my studio's lobby and sales areas, and used a separate stereo system in the camera room so that my clients can choose from about nine radio stations. (Be aware that just as photographers protect their work under copyright laws, the musicians' unions, ASCAP and BMI, should be paid royalties. Muzak includes these charges in my service fee.)

Displaying well-illuminated portraits plants a desire in the minds of your clients to have similar wall art in their homes. Large areas in your studio call for mural-sized portraits, perhaps illuminated by projection spotlights that can be set to hit only the prints, not the entire wall, via built-in barndoors. In a hallway with a

viewing distance of only 4 feet, you should use smaller images, perhaps with picture lights mounted on the frame. If you shine various types of lights on your display portraits, you can suggest to potential customers that they come to the studio in person. By encouraging a studio visit, you can show them portrait sizes and finishes and diverse ways to illuminate the portraits.

Prepare the dressing rooms or spaces by making them clean and attractive, yet warm and homey. Remove any hazards that might injure children or snag the clients' clothing, such as hot light bulbs and dressing stools with sharp tips. Offer dressing aids that your clients might need. For example, you might want to stock the dressing rooms with unscented hairspray, sterilized combs and brushes, hair pins, a hairdryer, a curling iron, scissors, static-removal spray, makeup, a clothes steamer, an iron and ironing board, and an electric razor.

The consultation and appointment letter I send out covers clothes, hair, makeup, glasses, and beards, but I usually face a few surprises when clients arrive anyway. If they wear glasses, I ask them to get a pair of empty frames that look like theirs from their eye specialist. When clients don't comply, I offer them a jeweler's screwdriver to see if they would like to remove the lenses from the frames. If they decline, I have to handle the problem using corrective lighting.

When male customers need a shave, I ask them if they would like to use the electric razor and aftershave lotion provided. Because some men want the look of a dark beard or even stubble, I show them photographs of other male clients or male models in clothing advertisements to be certain that I know what they want.

Makeup is a delicate legal problem, which you should investigate thoroughly. For the most part, only licensed cosmetologists can apply makeup. Some laws allow clients to use your makeup. If permitted, they can do wonders with a spotting brush and a little liquid makeup to lighten scratches or conceal blemishes.

I ask clients to bring several changes of clothing and jewelry even if the session calls for only one outfit. I go through their clothing with them, carefully selecting one outfit in favor of another. I prefer solid colors, simple lines, and nonreflective jewelry. Keep in mind that dark clothing diminishes while light-colored clothing expands in portraits. Also, cool colors, such as black, gray, and green, recede, but warm colors, such as red, orange, and yellow, come forward. Stripes, plaids, and bold prints dominate portraits, overpowering the subject's face. Finally, pearls are good choices, and reflective coin necklaces terrible!

When I want to make subjects appear smaller than they actually are, I opt for dark solid-colored clothing and a dark background. If they wear light clothing, I work with a light backdrop so that their clothing and props blend into the background. Here, the subjects' faces come forward. When people look at a photograph, the eye travels first to the point of greatest contrast. So if the subject's face is the lightest element in a portrait and all the other elements are dark, the face will dominate the image. Conversely, if the face is the darkest element in a portrait and all the other elements are light, it will still command the most attention. As a portrait photographer, naturally I want my subject's face to be paramount in a photograph—not the person, the furniture, scenery, or background.

OUTDOOR AND AVAILABLE LIGHT PORTRAITS

Outdoor and window-light portraiture can be stunning when all the elements come together to produce photographic art. Clients love soft light because it is so flattering. And closeups of people with blue or green eyes are beautiful when light penetrates the eyes to bring out their brilliant color. Photographers like outdoor and window light because they involve less work and less expense than a set of studio lights does. Print jurors like these types of illumination because film shot in them produces a greater tonal range at slow shutter speeds than film shot in electronic light does.

Any kind of clothing, formal or informal, is suitable for outdoor portraits. This versatility comes in handy when you or your clients have a hard time deciding on a setting for a portrait. I've done outdoor portraits with clothing ranging from evening gowns to swimsuits. Portraits of subjects wearing glasses are possible outdoors, too, if you are careful. Ordinarily I use a high camera angle, place black or green fabric on the ground underneath the subject, and position the face to avoid bright reflections from sidewalks and streets. Outdoor illumination and window illumination also are helpful at weddings. They provide more lighting variety and greater capabilities to flatter clients.

Another convenient advantage of outdoor portraits is that you can do them at any time of the day if you work in the shade, especially on the north side of a building. And you can shoot basically anywhere for the first hour after sunrise and the last hour before sunset. Many professionals even work several minutes after the sun sets during what they refer to as the period of sweet light.

For outdoor- and window-light portraits, I prefer an ISO 400 color film, such as Fuji NHG 400. This film-speed rating enables me to use a fast shutter speed, as well as to achieve extensive depth of field for group shots. Of course, I perform tests to determine the film-speed rating needed with my camera and the lighting.

WHAT TO LOOK FOR

Because the human eye adapts so well to changing light conditions, it sees detail in shadows that film can't see. So it is helpful to view window light or outdoor scenes through a Harrison and Harrison Color Viewing Glass. This is the same instrument movie directors use to determine when they need fill-in lights or reflectors. The viewing glass can serve the same purpose for portrait photographers.

As the eye scans a scene from its brightest to its darkest areas, the pupil opens up to compensate for those differences. Unfortunately, film can't do this. The human eye can see a wider range of tones than film can record, so Harrison and Harrison developed the viewing glass. It converts what your eye can see into what the film can record, thereby revealing shadow areas that need more light. You can then supply this illumination via the use of either reflectors or flash fill.

When I shoot in either outdoor or window light, I look for a quality of light that is suitable for portraiture. To me, this means soft illumination with sufficient contrast to act as a main light. I also look for backgrounds that enhance and support, not detract from or compete with, the subject. An ideal outdoor background would be foliage in soft shade without sunlit hotspots, but with green glass blending into the green foliage; this way, the horizon line won't be distracting.

In addition, I keep an eye out for interesting features of the location that will add to the composition, such as rocks, trees, gates, fences, and decorative windows. At the same time, I check carefully for elements that might spoil the portrait; these include reflections; hotspots; light streaks; strong horizontal lines, such as streets and sidewalks; and bright vertical lines, such as telephone poles and street signs. Finally, I evaluate the contrast in the scene. Does it need to be raised or lowered for a pleasing portrait ratio? The highlight side of the subject's face should be a half to a full stop brighter than the shadow side.

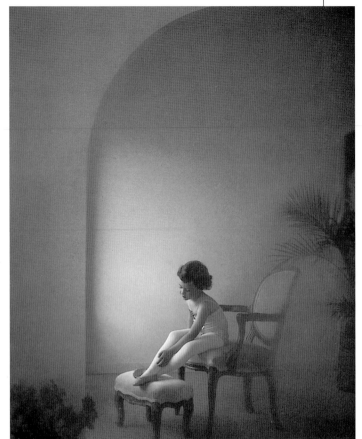

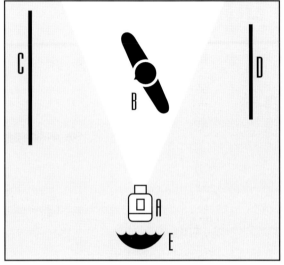

HANDLING CONTRAST

After learning to truly see light, photographers can create beautiful outdoor- and window-light portraits by softening shadows or increasing contrast as needed. In the camera room, you can control contrast by balancing the main and fill lights. But when you shoot outdoors, you are at the mercy of existing light conditions, which may be too contrasty or too flat. When selecting an area for outdoor portraiture, I choose the background first.

Next, I try to find a foreground area where light falling on the subject's face will provide contrast between the highlight and the shadow. Usually, I position the subject's face so soft light illuminates the cheek that is farther away from the camera, and at the same time forms a triangle of highlight on the other cheek. This is comparable to the short light a flash in the camera room produces.

INCREASING CONTRAST

Flat light is just as much of a problem as too much contrast when it comes to fine portraiture. When the highlight and shadow sides of the face look almost the same, I create more contrast. To achieve this effect, either I intensify the highlights or deepen the shadows.

When shooting outdoor portraits, I can strengthen highlights by adding an electronic main light. For the most part, I combine a battery-powered light, such as a Lumedyne, with a medium-sized softbox or a Larson 42-inch white Reflectasol. The softbox is better on windy days, but the white umbrella produces softer illumination. If the existing light in open shade measures f/5.6, I'll set the electronic main light to yield f/5.6 also, thereby giving me a 2:1 ratio. The lower ratio works well outdoors because outdoor light is softer and more subtle than indoor flash.

Leon Kennamer, who has shared his passion for outdoor portraiture with thousands of professionals, perfected the subtractive-light technique to increase contrast in flat-light situations. Kennamer uses a black fabric on one side of the subject's face to create shadow.

DECREASING CONTRAST

Window light and some outdoor situations require photographers to use reflectors or flash to reduce contrast. When the contrast range is more than one stop—for example, when the highlight side of the client's face measures f/8 and the shadow side measures f/4—it is necessary to soften the shadows. You can do this by positioning a reflector on the shadow side. I prefer white reflectors to silver or gold reflectors because I don't like spectral highlights in the shadows.

Overcast days or open shade can be deceptive because you might assume that reflectors or fill-in flash aren't required. Here, the light falls directly

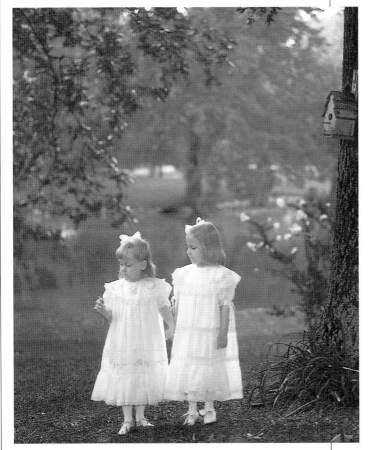

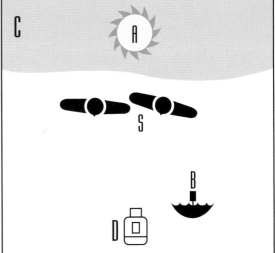

In this moody portrait of two sisters (E), the main light came from the lake (C), which together with the surrounding trees provided the background. A Lumedyne 200 watt-second battery strobe set at full power and aimed into a 42-inch Larson Reflectasol on a folding stand (B) provided the fill light. Working in the late-afternoon sunlight (A), I used my Hasselblad 500 ELM, a 150mm lens, a Lindahl double bellows shade, and a Sailwind Leon Pro II vignetter with darkening edges (D). I exposed for 1/30 sec. at f/5.6 on Fuji NHG 400 film.

down on the subject, thereby producing subtle shadows in the eye sockets, especially on subjects who have deep-set eyes. The Harrison and Harrison Color Viewing Glass can be helpful in these situations because it shows where fill-in flash or reflectors are needed.

Sometimes I use a 42-inch white reflector under the subject to put light in the eyes and place a black Reflectasol over the subject's head to block any overhead illumination. I put the reflectors and light blocks as close to my subject as possible without letting them be visible in the viewfinder. This is usually a distance of 12 to 24 inches. I position the black light block over the front part of the client's head to achieve a hairlight effect on the back of the head—unless, of course, the individual has a receding hairline.

The overhead light block looks like a flat, black rain umbrella. It prevents light from striking the subject's nose and enhances detail in the eyes by softening shadows that the eye sockets create. When you move this light block back and forth, from the back to the front of the head, you can see the light change on the your subject's hair.

I usually work with fill-in flash for full-length and group portraits because reflectors get in the picture when they are close enough to do a proper job. For full-length shots, I almost always bounce a flash off the wall behind the camera to reduce the contrast to a 3:1 ratio. The fill flash softens eye-socket shadows and

lessens contrast on the shadow side of the face when needed. I keep the fill flash one stop below the existing light so it doesn't overpower the beauty of nature's lighting. For example, if the available light measures 1/30 sec. at f/8, my fill flash will meter f/5.6. Similarly, if the window light measures f/5.6, the fill flash will read f/4.

Electronic flash provides an additional benefit in that it warms up the shadows. The color of light is measured by the color-temperature indicators on a Kelvin scale; the lower numbers meaning red, and the higher numbers indicate blue. Typically, north light from a window registers between 7000K and 27,000K. Electronic flash is balanced for 5600K, which is a little warmer than north light. So when you use electronic flash as a fill flash in combination with north light, it puts red in the shadows. Electronic fill flash also produces a warm light on the background and foreground.

When I work alone, I use lightstands for reflectors and flash units. One of the reasons I like the Larson Reflectasols is that they are so well engineered that I can position them on lightstands wherever I need them. On windy days, I put weights on the base of the lightstands to keep them from blowing over. These can be water bags, sandbags, or metal weights made by Larson that fit on the lightstand bases. Window-light portraits usually require reflectors or fill flash to reduce contrast.

CHAPTER 18
DIFFUSION

anufacturers make most camera lenses as sharp as possible, but unfortunately, they are much too sharp for portraiture. If a lens is sharp enough to show every brick in a building, it also will capture every wrinkle, every blemish, and every scar in a portrait. Therefore, most photographers use some kind of diffusion so their portraits are kinder to their clients.

Just as surgeons must choose which instrument to use and when, photographers have to learn which diffusers to use and when. Before you can make this decision, you must do some research and conduct tests. These steps will help you attain the skills and knowledge needed to master this area of portraiture.

The amount of diffusion necessary is relative to head size. A closeup calls for more diffusion than a full-length portrait. And a closeup of two people requires more diffusion than a portrait of a group of four.

Communication with the client is absolutely essential when you make decisions about diffusion. It is a good idea to let your clients see portrait samples of the same subject with varying degrees of diffusion. If they want a group portrait, show them group samples.

CHOOSING A DIFFUSION SYSTEM

Obviously, a portrait photographer must select a diffusion system that is sufficiently flexible for many types of assignments. I need a system that will enable me to vary diffusion in small increments with no changes in exposure. I also want to be able to change diffusers quickly without having to remove the lens hood each time. And I want a system that will provide a minimum of flare without significant loss of contrast or color. I look for eight qualities in a diffusion system.

Variable Diffusion. Harrison and Harrison, Tallyn, and other manufacturers offer as many as five diffusers in their systems. The extent to which they alter the subject matter ranges from very slight to heavy. Among the strong diffusion filters, some decrease contrast more than others do. For example, Nikon diffusers lose about 25 percent of their contrast, while the Harrison and Harrison "D" series filters lose even more. The Harrison and Harrison "Black Dot" filters and the Tallyn filters retain contrast better than most of their competitors. Some strong diffusion filters, however, get "mushy."

Many photographers create diffusion by using net fabric or hosiery stretched across the lens. But each layer of material requires additional exposure, which means that you have to open up a stop for one layer, two stops for two layers, etc. This limits the amount of diffusion possible with hosiery or netting because you won't want to give up two or three stops of exposure for increased diffusion.

Minimum Flare. Diffusers and soft-focus lenses modify the subject's appearance by forming a second image, putting it slightly out of register. This produces a white veil, which is called flare or ghosting, in certain situations at the point of contrast where blacks and whites converge. Metal jewelry, such as a gold necklace, also results in flare. Harrison and Harrison won an Academy Award for technical excellence with its black-dot diffusers because of their ability to minimize flare. These filters look like glass splattered with black spray paint. The black offsets the characteristic flare that the diffusers produce.

No Exposure Increase. Black-dot diffusers and most forms of net diffusers require a wide lens opening, which can restrict depth of field. Some filters demand one additional stop of exposure, so, for example, f/11 becomes f/8. This can make it difficult to bring a group into focus from front to back. And remembering to change f-stops every time you change diffusers can be a bit problematic, too.

Most soft-focus lenses alter the degree of diffusion via disks that necessitate exposure changes. For example, Mamiya's 150mm soft-focus lens is sharp at f/8

For this high-key portrait of an aspiring ballet dancer, I chose a Tallyn 3 diffuser; I also used net to soften the edges of the image.

and quite soft at *f*/4. The holes in the disks have an effective aperture of *f*/5.6. So if you set your lights for a working aperture of *f*/11, you would have to change all of them in order to achieve an aperture of *f*/5.6.

Durability. Some diffusers made of glass, such as those manufactured by Harrison and Harrison, break easily under the duress of a wedding or portrait session. Others, such as the Cokin AE83, are made of hard plastic that is almost indestructible. These diffusers do, however, sometimes get scratched. When this happens, the plastic diffusers bend light differently than the way they were intended to. The Tallyn Softfusers are made of glass but are mounted in plastic filter holder that protects them when they're dropped. Obviously, though, all glass breaks when it is abused.

Predictability and Consistency. High-quality diffusers with similar manufacturing tolerances produce predictable results. Some leaders in the field are Harrison and Harrison, Tallyn, Nikon, B+W, and Tiffen.

Ease of Use. Portrait photographers need to be able to vary the amount of diffusion quickly as they move from a closeup to a full-length pose. So it is much easier to adopt a system that lets you change diffusers without removing the professional lens shade, or compendium. Some filters have threads that screw onto the lens while others, such as the Hasselblad Softar, have a female bayonet mount that fits onto the lens' male bayonet threads. These require you to remove the shade each time you switch diffusers, which is time-consuming and wears out the fabric lens shade. I use a Lindahl double-bellows lens shade made out of fabric on my Hasselblad 150mm lens because it has a filter slot next to the lens. This feature enables me to change diffusers in a matter of seconds. The Tallyn

and Sailwind diffusers are fixed in mounts that drop easily into the Lindahl and Sailwind lens shades.

No Herringbone Effect. Some filters produce diffusion by a series of lines etched into glass or plastic in a pattern similar to an open fish net. In some portraits these diffusers cause a swirling, or cross-hatch, effect, especially with certain types of clothing patterns, such as herringbone, or net vignetters.

Moderate Price. Soft-focus lenses made for or adapted to 120mm cameras are much more expensive than a set of diffusers. Having tested and experimented with many soft-focus systems for more than 25 years, I use Tallyn diffusers because they have five degrees of diffusion, are relatively inexpensive, and offer manufacturing quality and consistency. And when you mount them in a filter holder, you can change them quickly and easily with the Lindahl lens shade. Almost unbreakable, these diffusers produce minimal flare, don't require an exposure increase, and don't cause a herringbone effect.

SUGGESTED DIFFUSION SELECTION

Type of Portrait	Recommended Filtration*
Man, full-length pose	No diffusion
Man, 3/4 pose	No. 1
Man, closeup	No. 2
Young woman, full-length pose	No diffusion
Young woman, 3/4 pose	No. 3
Young woman, closeup	No. 4
Older woman, full-length pose	No. 1
Older woman, 3/4 pose	No. 4
Older woman, closeup	No. 5
Child	Only for special effects
Small group, closeup	No. 2
Large group	No diffusion
Bride, full-length pose	No diffusion
Wedding groups	No diffusion
Wedding, closeup of bride	No. 3
Wedding, closeup of mother	No. 4
Newspaper reproduction	No diffusion

* A No. 1 diffuser is the weakest; a No. 5 diffuser is the strongest.

VIGNETTING

Subtle touches separate portraits that qualify as wall decor from plain pictures made by photographers who either didn't have the skill or didn't take the time to make them better. One of these subtle differences involves the use of vignettes. Webster defines vignette as "a picture (as an engraving or photograph) that shades off gradually into the surrounding ground or the unprinted paper." That definition covers two aspects of vignetting, but this marvelous technique helps portrait photographers in a couple of other ways, too.

For hundreds of years, portrait painters used vignetting to soften the edges of art, thereby drawing the viewer's eye to the center of interest. Photographers can achieve the same effect today, creating subtle changes that make the difference between a mere picture and a portrait.

DARKENING VIGNETTES

Vignettes that darken the edges of a photograph direct the viewer's attention to the subject because it is brighter than the edges are. To achieve this darkening, I prefer a vignette made of dark net material because it allows some detail to show through without obliterating the edges.

Famed outdoor-portrait photographer Leon Kennamer developed a set of darkening vignettes (sold by Sailwind of North Carolina—see the Resources list on page 190) called "Leon Pro II." I use them in a modified form by cutting the three layers of material to achieve gradual darkening with one layer of net closest to the opening, two layers 1/2 inch from the opening, and three layers 1 inch from the opening. The effect darkens the image about 1/2 stop next to the opening, a full stop in the two-layer stage, and 1½ stops in the three-layer stage.

The Leon Pro II vignettes have magnetic tape on the side facing the camera that enables them to bond to the ferrous metal plate on the front of the Lindahl compendium. As such, you can easily attach them to

I manipulate Sailwind's Leon Pro II darkening vignetters to achieve different effects (top). I cut out an oval in one vignetter to use for outdoor portraits of individuals and couples; this shape darkens all four corners of the image (center). When I shoot indoors, I use a vignetter that I cut in half (bottom). This darkens the bottom part of portraits, which is especially helpful in concealing hands. Note that one section of the vignetter has a single layer of net, another section has two layers, and the last has three layers. These darken the image 1/2 stop, 1 stop, and 1½ stops, respectively.

or remove them from the lens. To keep them at my fingertips, I tie an elastic string between the vignettes and the posts under the lens shade.

Be aware that you always face the danger of the vignettes coming into focus, thereby becoming a problem rather than an aid to fine portraiture. When I press my camera's depth-of-field-preview button, I can see the problem in the groundglass. You can get around this by keeping the following suggestions in mind. First, long-focal-length lenses, about twice the diagonal of the negative, are preferable. For example, you would want to use a 150mm lens with a 6 x 6cm cameras. Vignettes aren't recommended for wide-angle lenses because their extended depth of field allows them to come into focus too easily. If you choose to use a vignette with an 80mm lens on a 6 x 6cm camera anyway, the vignetting device must be close to the lens. The distance from the lens to the vignette is relative to the focal length and *f*-stop. The shorter the lens, the closer it must be.

I tested the vignetting device at various distances to see how the scene looked on film with each change. I concluded that the darkening vignette needed to be about 5 inches from my 150mm lens and about 2 inches from my Hasselblad 80mm lens, working at *f*/11. Because wide-open *f*-stops are less likely to come into focus, I recommend *f*/2.8 to *f*/11 for your tests. As you stop down, the vignette moves closer to the center, so *f*/2.8 would touch only the outside edges of the image, while *f*/16 would cover most of the negative.

The focusing distance also affects vignetting. The vignette is less likely to come into focus in closeups than in full-length shots when the angle of view is increased. Test your vignettes at different *f*-stops, different focusing distances, and different distances from the lens. Also, make sure that you don't use a dark vignette with a subject wearing light-colored clothing, or a white opaque vignette with a subject in dark-colored clothing. And if you see direct light—available or artificial—striking your vignette, either remove the vignette or shade the light from it. You can use a dark-fabric light blocker, such as Larson's black Reflectasol, for the shading.

Customize your darkening vignettes to fit your needs. For outdoor portraits, cut an opening about 2 inches wide and 3½ inches high with one layer of net next to the opening and three layers at the outside edge. For use in the camera room, cut the Leon Pro II vignette in half, scooping out a half-oval, so the center is about 1 inch lower than the edges, with the same layered effect (one layer of net at the top, two layers in the middle, and three layers at the bottom).

Keep in mind, though, that darkening vignettes made of net can cause a confusing cross-hatch effect when used with net or hosiery diffusers and some types of clothing, such as those with herringbone or seersucker patterns. Dark vinyl or plastic vignettes can cause a color shift toward blue or gray tones, which don't occur with dark net. Vignettes made out of charcoal-colored plastic color anything they cover. For example, green grass could be blue-green, and tan clothing could be dark gray.

CLEAR VIGNETTES

When you look at a photograph, your eye almost always accepts areas of sharp focus and rejects images that are out of focus. It is fairly easy to use selective focus with closeups, particularly with a wide-open aperture because the resulting depth of field is so shallow. But full-length and pictorial portraits have such an extensive depth of field that it is virtually impossible to throw the background out of focus.

I've solved this problem with homemade vignettes constructed out of clear, untinted vinyl that is ordinarily used for motorcycle face shields. I can usually cut three 4 x 5-inch vignettes out of one face shield. I make the outside cut with a paper cutter and the inside trims with a sharp knife, an electric drill, or a small saw used for miniature hobby work. The 4 x 5-inch vignette fits nicely in the center slot of a Lindahl double-bellows lens shade, giving me about 2 inches of bellows in front of it for protection from stray light.

I made these clear vignetters from motorcycle face-shield vinyl for selective softening. I use the long oval for full-length portraits to soften the edges of the doorway while rendering the subject tack sharp (top). I use the clear vignetter with the 1-inch center hole to keep only the subject's face in sharp focus (bottom left). The somewhat oblong cutout enables me to soften the bottom half of a portrait, which comes in handy with such obtrusive elements as chair legs and baby-carriage wheels (bottom right).

This light can cause unwanted flare if it strikes a clear vignette, so I make sure to block it with the front part of the bellows lens shade, as well as other devices if needed. These include the Photogenic head screen or black light blockers, such as the Larson Reflectasol attached to a lightstand.

The clear vignette that I use most often covers the bottom half of an image, softening chair legs and other distractions. After cutting a scoop-type oval, I create lines on the vinyl about 1/4 inch apart, giving a slight diffused effect. I make the tiny lines with model cement. Another popular design, with a cutout shaped like a long oval that is about 1 inch wide and 3 inches long is used for full-length portraits. It leaves the subject in sharp focus while the edges, such as doorways or curtains, are rendered soft. Clear vignettes are difficult to see in the viewfinder. So I stop down the diaphragm to the shooting aperture, usually f/11. Next, I move my finger around the edges of the vignette opening to see where it appears in the image.

You can use flat black spray paint to make different vignettes from the motorcycle face-shield material, including a blocking device for double exposures. I cut the design I want from the clear face shield and then spray both sides with the black paint. The double-exposure blocking device has a vertical opening exactly in the center, so half of a vertical image is blocked while the other half remains clear. I make one exposure with the left side blocked, flip the device over, and make a second exposure with the right side blocked.

I used Sailwind's Leon LVK white opaque vignetter to soften the corner of this portrait. Shooting with electronic flash, I set the aperture at f/11.

OPAQUE WHITE VIGNETTES

For those situations when you need to "white out" an object—for example, a child wearing dark shoes against a white background—consider the use of an opaque white vignette. One of the best on the market is the Leon LVK, sold by Sailwind (see the Resources list on page 190). This vignette is opaque gray, which allows some slight detail to show through but turns everything white or gray.

The Leon LVK vignette comes in both all-around and half-vignette versions. The half-vignette is used more often than the all-around because of the occasional need to lighten a child's dark shoes. When a young subject is wearing white clothing, I prefer to use a white black background so that everything blends. But because the child's dark shoes would create a distracting point of contrast, I use an opaque white half-vignette. The all-around opaque white vignette comes in handy on those rare occasions when you must eliminate an electrical outlet or a ceiling light fixture.

Most opaque vignettes work best on the front of the Lindahl lens shade with light striking them, thereby creating a luminous effect. Unless a small amount of light strikes the opaque vignette, it will become gray instead of white. Usually, the light reflected off the white background is sufficient to keep the vignette radiant, but some photographers aim a low-power flash at the vignette from below so that it doesn't hit the lens. I don't like this method because it involves another lengthy step that takes time away from having a conversation with my subject.

To soften the edges of this portrait of a little girl, I used a clear vignetter with a long oval cutout.

PRINT COMPETITION

One of the best ways to build a reputation in photography is through print competition. Photographers can improve their skills and gain valuable publicity by entering and eventually succeeding in print shows. During your struggle to earn degrees or accolades from photographic organizations, your skills and reputation will grow. In turn, you'll enjoy increased sales as your clients recognize your progress.

From a personal standpoint, you'll feel more confident in your own skills, as well as in your ability to take command of a session. A runner's high didn't compare with the exhilaration I felt when I received my first 80 score at a Professional Photographers of America (PPA) print judging. I thought that my heart was going to explode when judges at the 1968 convention gave me my first print merit. But some tough years followed. I didn't earn any print merits in 1970 and 1971. I kept studying, however; I went to photography classes and continued to enter print competitions until I learned more about how to win.

LEARN THE RULES

Working on the print committee for the five-state regional Southwestern Association probably helped more than anything else. I not only learned the rules, but also had the opportunity to hear judges comment on prints. I was able to observe new trends and styles that scored well. During breaks, I had the opportunity to ask print winners questions, including how they came up with new techniques and who did their artwork.

The print judgings of PPA affiliates have strict standards that prevail from coast to coast. Competitors can enter only four prints with an outside dimension of 16 x 20 inches. The prints must be more than 1/8 inch but less than 1/4 inch thick. The photographer's name can't appear on the front of the print; it must be listed on the back, along with the print's title and category. Prints are entered in four categories: commercial/industrial, illustrative, portrait, and wedding.

The Southwestern photographers also taught me that at every session I should work toward producing a trophy-winning print. I benefited from this approach, my clients loved it, and my sales increased. As a result, I've shot about half of my more than 60 award-winning prints during regular portrait sessions.

I do, however, use invitational sessions to experiment with new techniques, styles, and locations. I enjoy this part of the growing experience. Usually, I devote an afternoon or evening to concentrating on the creation process. Most of my experimental shoots don't yield award winners, but they lay the groundwork for success in the future.

JUDGING LIGHTS

You should view prints that you intend to enter in a competition under the same lighting conditions that the judges will use. PPA and other accrediting groups provide the rules governing the competition, including lighting requirements, to their members.

When I look at my prints under judging lights, I find that a Harrison and Harrison Color Viewing Screen helps me evaluate my prints for competition because it isolates highlights and shadows. The filter clearly shows the areas that need to be darkened with printing or artwork and those that need to be lightened.

DEVELOP A THICK SKIN

Most photographers need to have their prints critiqued in order to grow and improve as artists. When your prints are displayed at conventions, ask the judges to give you their professional opinions. As you listen, you should keep an open mind, take notes, and refrain from arguing with the judges. Although it is difficult to bite your lip and listen to someone criticize the "work of art" you've tried so hard to create, your photography will improve if you learn to isolate your work from your feelings.

Seek out the toughest critics you can find, not just judges or other photographers who tell you how good you are. Sometimes you might have to drive to another city to get help from a judge or a photographer you respect.

GET THE BEST PRINT POSSIBLE

Regardless of whether you do your own printing or use an outside laboratory, get the best print possible from your negative. If you use an outside lab, either give its staff members a print guide or trace the composition on a piece of paper, ideally the same size as the print. You should also provide these professionals with detailed instructions about dodging, burning, color, and density. If possible, you should supervise the printing either at the lab or by requesting test prints.

If you don't do your own artwork, get the best artist available. Then give the person time to do the job right. Producing a winning print often requires months and sometimes even years, so start early!

QUALITIES OF A WINNING PRINT

Prints entered in professional judgings get better every year. Most experienced judges say that some of their own prints that received awards 10 years ago wouldn't win today because the competition has increased significantly. Good portraits don't stand out. They must be great! Prints must have something else, such as an artistic touch or an unusual subject, to make them special. Award-winning photographers must work not only to develop techniques, but also to discover the inner self that provides the spark that separates their work from that of others.

Impact. Is the print an attention grabber or a show stopper? Impact is an important element in winning pictures, providing the quality that stops viewers in their tracks and demands attention. A portrait of a ballet dancer doing her stretching exercises on a railway boxcar was just such a show stopper for me a few years ago. Ask yourself, "Is this a new and fresh approach to an assignment?" If your answer is no, the image probably looks like you set up a scene that appears unreal or contrived. Try again.

Composition. The effective use of space, diagonals, pyramids, leading lines, and other compositional elements is essential for artistic photographs. In *The Power of Composition*, noted Canadian photographer Frank Kristian says, "When we stand in front of a truly well-composed photograph, the only feeling we can have is humility, for we know that we are freed from the many details of our daily lives."

Some people have a natural gift for composition. They instinctively place their subject in a position that is pleasing to the eye. Most people, however, have to learn composition by studying art principles. Five types of composition exist: from left to right, from right to left, the triangle, the "S" composition, and the "L" composition. For more help, you can ask for cropping or composition suggestions from talented artists whose work you respect. You can also study books or take classes on composition.

Subject Matter. Extraordinary faces and places attract more attention than ordinary ones do. Beautiful women, handsome men, adorable children, and expressive faces make superior subjects for portraits.

Center of Interest. Does your eye zoom to the photograph's center of interest? If it doesn't, you may have two or more centers of interest that vie for the viewer's attention. Anything that detracts from the center of interest lowers print scores. For example, I made a portrait of a North Carolina state official in the capitol rotunda in Raleigh. In addition to the man, the portrait also showed the rotunda skylight, a round rail leading up to him, a statue in the foreground, and two doors illuminated by big light fixtures in the background. The portrait contained so many elements that the subject almost got lost. This was a good, not a great, portrait.

Style. Does the photograph tell a story? In some images, the story is confused by conflicting elements. Fortunately, you can soften or darken these with a vignette or artwork. And in other photographs, contrived props or locations, such as a hay bale combined with a painted background, adversely affect the story.

Lighting. Does the use of light improve or detract from the photograph? The ability to truly see light is one of the most precious gifts a photographer can cultivate. Learning how to observe and utilize various types of illumination often requires years of practice or study under skilled instructors.

Light must illuminate the areas of interest in an image while placing subordinate areas in shadow. The power of a stunning outdoor portrait can be damaged by raw sunlight striking a secondary area, such as a fence or a tree. Judges don't spend time discussing whether or not the illumination comes from a short light, a broad light, or a split light. They analyze how well the photographer used the light.

Color Balance. Do the strongest colors add to the center of interest or do they lead the viewer's eye elsewhere? Warm colors, such as red and orange, dominate photographs, while cool colors, such as green or blue, recede into the background.

Print Quality. Does the print contain detail in the

highlights as well as the shadows? An award-winning print must have both. Also, is the print sharp? Did enlargement, focus, or subject movement create a fuzzy image?

Presentation. Does the mounting and/or mat help the print or do they detract from the overall effect? Any mounting or matting that calls attention to itself will hurt the print score. For example, a sensitive portrait of a baby's christening was ruined because the mat surrounding it looked like a heart. The skillful use of underlay and other mounting techniques can enhance a print.

Sometimes, there isn't enough room in front of the subject. To solve this problem, simply mount the print on one side of the 16 x 20 mountboard. Be sure to leave an area blank in front of the subject. This creates the illusion of space in the foreground, which wasn't on the original negative.

Finish. A luster or glossy lacquer spray intensifies color brilliance and saturation. Matte spray dulls colors and lowers print scores. When you consider the finish, you should also keep in mind that textured prints are difficult to see under bright judging lights.

The final judge of a photograph is the buying public. Nevertheless, in my experience clients are attracted to the same high-scoring prints that pleased the judges.

CREATIVITY

For me, creativity always requires concentration and sometimes exercises that help light an inner spark. From my doctor, I learned to wash my mind clear of all thoughts except my client. I ask my associates to aid my concentration by deferring telephone calls and other interruptions for a short length of time.

From talented California portrait photographers Alessandro Baccari, David Peters, and Michael Taylor, I learned to prepare for a session with warm-up exercises to free the creative spirit that comes to me from a higher power. Often I'll skim books by great photographers or artists before a session. I also keep notebooks filled with magazine clippings and photographs organized by subject, such as men, women, children, groups, and brides.

Composer Johannes Brahms said he tried to put his mind in neutral so the music would flow through him. Some of my best creative ideas have formed on extended, predawn walks when I have time to listen without interference from telephones, radio, television, or other people. Discipline and creativity seem to be in conflict, but for me they go hand-in-hand: I must force myself to take time for long walks in order to have quiet time alone for prayer and contemplation.

Dr. Eugene Lowry of St. Paul's Seminary in Kansas City, Missouri, says: "Like a river, creativity has two elements, flow and banks. Without flow, it is a dry gulch. Without banks, it has no direction and flattens out, just as there would be no river if there were no banks." For me, the flow is the spark that comes from the inner spirit, or the unconscious. The banks represent the discipline: learning the rules, mastering the mechanics of the camera, and seeing the light. It took me quite a while to develop my photographic skills so that I didn't have to spend a lot of time thinking about camera operations. My camera became an extension of me.

Years of working 8 to 10 hours a day behind the camera finally paid off when I learned to see light, composition, and emotion in a session. Some days I don't feel like doing the scheduled sessions in my appointment book, but my sense of professionalism requires me to work anyhow. And by the end of the day, I usually feel exhilarated. An added bonus: sometimes on these jam-packed days I create award-winning prints.

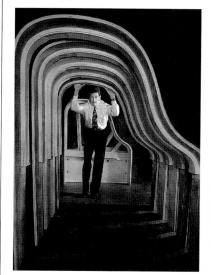

The reflection in the table serves as a leading line for this executive portrait, which I shot in a college conference room (above). For a more unusual portrait, I composed so that the upright grand-piano molds frame my subject (left). I made both photographs with my Hasselblad 50mm FLE lens set at f/11 and Kodak VPS III film.

CHAPTER 21
ADULT PORTRAITS

Portraiture is a delicate balance between art and technology, and between left-brain and right-brain tendencies. Unfortunately, one aspect can't survive without its counterpart. Although you need to be disciplined in order to achieve technically consistent portraits, emotion is vital to making them saleable. It is necessary to learn the mechanics of camera operation, lighting, and posing so thoroughly that they require little conscious thought on your part. You'll then be free to concentrate on the emotion you want to depict in the portrait, to communicate with your client, and to draw forth your subject's personality.

Fortunately, I began my portrait-photography career by photographing dozens of college and high-school students every day. Operating my cameras, setting up my lighting equipment, and posing my subjects became as routine as breathing. This volume portraiture gave me the opportunity to study thousands of faces over a four-year span. Unfortunately, however, it left no time to capture emotions and feelings, so I changed my business in order to do fewer, more artistic portraits.

PREPARING TO SHOOT

As part of the discipline of my craft, I check the equipment each day before starting my sessions. I also run the same tests before every wedding because equipment failure on such an occasion can be catastrophic! First I make sure that the electronic lights synchronize with the camera shutter. Using my customary exposure settings of $f/11$ and 1/60 sec., I remove the back from my Hasselblad and aim the lens at the main light. While looking through the lens with only one eye, I release the shutter. If everything is working correctly, I should see a flash through the lens. The opening should have a hexagonal shape, which is consistent with an $f/11$ aperture. If everything is black, then I know that the shutter and flash aren't in sync. One possible reason is because the shutter is on "M," which stands for "Manual," instead of "X" for "Electronic."

Next, I test all the lights by turning them on and pushing the press-to-fire button on my Quantum Radio Slave 4i. Photogenic's electronic power supplies have recycle lights that are illuminated when the units fire. As such, I have to look at the recycle lamps rather than the flash tube. The recycle lamps remain on as long as the capacitors are recharging. When they go off, the power supply is ready to fire again.

MAKING CLIENTS LOOK THEIR BEST

During consultations with clients, I discreetly study their faces to determine what lighting and posing will be best for them. I also use this time to figure out which corrections are needed to provide customers with the best possible portraits. When people have an operation, they expect doctors to use their training, skill, judgment, and surgical instruments to effect the best possible outcome. When clients enters your camera room, they should have the same confidence in your ability.

FACES
As part of your portrait-photography training, you must be able to capture faces. The photographs should be introspective glimpses of who the subjects truly are, not formal, stony-faced portraits. This requires skills, strategy, imagination, and vision. As you analyze your customers' faces, you should first determine the structure: oval, round, narrow, V-shaped, or square.

Oval Faces. The oval face is so nearly perfect that few corrections are needed. Of the five types of faces, this classic shape is considered to have the most harmonious proportions. As such, you can utilize many different lighting setups when photographing subjects with oval-shaped faces. Keep in mind, however, that a subject with an oval face might pose other problems, such as a receding hairline, a long nose, protruding ears, or eyeglass glare.

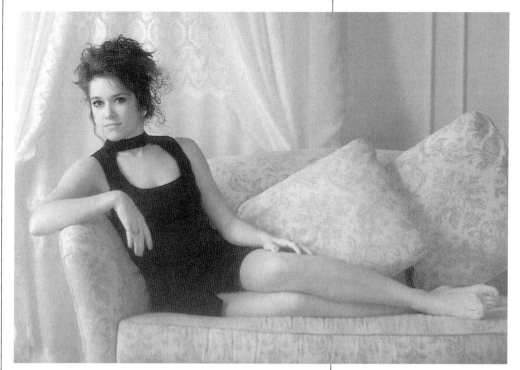

During this high-school senior's shooting session, I decided to try several variations. For this full-length shot, I had my subject pose on a couch in my studio. The result was a flattering graduation portrait.

Round Faces. The short light is best for these face shapes because it makes them appear a bit angular. To create this lighting effect, position the main light so that the cheek closer to the camera is in shadow. If the main light is positioned properly, it will produce a triangular-shaped highlight on the shadow-side cheek.

Narrow Faces. Subjects with narrow faces call for a broad light. Here, the cheek closer to the camera is in highlight. In other words, the main light is between the subject and the camera and makes narrow faces appear wider.

V-Shaped Faces. V-shaped faces usually are associated with long, pointed chins, so camera position is critical when you photograph them. Ordinarily I keep the lens at eye level, a strategy that works well with long chins, too. Be sure to avoid high camera angles; they'll increase the length of the chin. I sometimes try a few poses with a low camera angle when photographing a client with a V-shaped face. A low camera angle would have the lens positioned about waist high.

Square Faces. The correction for square jaws is easy, but identifying the problem isn't. One of the best ways for a beginner to detect square faces is to look at earlier photographs of the subject. You can also make a Polaroid test shot at the start of the session. To successfully photograph a client with a square jaw, simply turn your subject's head so that it is opposite to the angle of the shoulders. This pose hides one side of the jaw from the camera's view, so the problem is solved.

Here, I opted for traditional poses. To effectively capture one subject's round face, I asked the woman to look at the camera at an angle, and I used a short light (above). For the informal graduation portrait, I photographed the subject's oval face with the camera at eye level (left).

EYES AND EYEGLASSES

In addition to a rainbow of colors, eyes also vary in many other ways. People have small eyes, large eyes, far-apart eyes, close-set eyes, and deep-set eyes. One way to correct for small eyes is to place them close to the lens and illuminate them with large light sources, such as outdoor light, window light, umbrellas, large softboxes, and panels. Deep-set eyes require the main light to be positioned lower than usual, so that it penetrates both eyes. Placing the main light too high creates a shadow from the forehead over the eyes.

Avoiding Red Eye. The so-called red-eye effect occurs when the light is too close to the axis of the lens, producing red catchlights instead of white ones. This is a common problem with amateur cameras that have a built-in flash. Here, the light travels directly through the subject's eye and bounces off the retina at the back of the eye. The retina then shows up in pictures as red catchlights; this is especially noticeable in photographs of people with green or blue eyes. Professional portraits seldom contain red-eyed individuals because the lights strike the retina at different angles and don't reflect back into the lens.

Eyeglasses. Probably the most common corrective problem facing portrait photographers is handling eyeglasses. My staff and I try to minimize this by sending an appointment letter at least a week in advance of the session. In it, we ask our clients to borrow a pair of empty eyeglass frames that match their own from their eye specialist. Sometimes our clients will remove the lens from a pair of old frames; we supply the jewelers' screwdrivers. We never remove the lens ourselves because of the danger of damaging our clients' eyeglasses. There is no perfect solution to the problem, though, because some eyes will cross if the lenses are removed.

If your subject failed to bring empty eyeglass frames, you can control reflections in the lenses. Keep in mind that it is easier to evaluate glare when you eliminate nonphotographic reflections from the camera room. Otherwise, it is almost impossible to tell if the reflection in glasses is caused by your photographic lights or from some other light source in the room, such as fluorescent lights, picture lights, or window lights. You must either turn off or block all of these so you can see if reflections are caused by your photographic lights. Also, you must eliminate the effect of a reflective floor, such as white linoleum.

You can reduce or eliminate glare from eyeglasses three ways. First, the fill light causes most glare from glasses, so you must raise it to relieve the problem. When placed in a high position near the ceiling, a small, metal-reflector fill light produces heavy shadows on the face, especially in the eye sockets, under the nose, and under the chin. So I prefer to bounce the light.

All of the shadows are present with the bounce light, too, but the illumination is so soft that the problem isn't serious. Bouncing the light off the ceiling gives you the maximum height possible for the fill light while keeping the light soft at the same time. The bounce light creates a small shadow under the nose, which becomes darker when the main light crosses over. But the resulting double shadow is only a minor concern to clients who think you are a hero for removing the glare from their eyes.

When the camera's angle of view is higher than the eyeglasses, the angle of reflection falls below the camera lens. It is difficult to raise the camera high enough when clients are standing, so I usually ask them to sit down. Also, the subjects can tilt their heads down slightly—but not too much or they'll appear to have a double chin. I avoid tilting the eyeglasses because the earpieces can show and the frames can appear crooked over the customers' ears. Some eyes cross and some people look weak when they don't wear their glasses, so I need to know how to handle this problem. When clients bring in empty eyeglass frames but look unattractive in them, I ask my subjects to wear their real glasses while I shoot.

Another problem is the shadow the eyeglass frames create; this is quite noticeable with thick or heavy frames. In order to solve this problem, use a soft main light, such as an umbrella or softbox, and position the main light in a lighting pattern known as a loop. The loop light puts a small shadow beside the nose unlike the common shadow that runs from the nose to the corner of the mouth. When the illumination from the loop light comes from the short side, the light is called a short loop; when the illumination comes from the broad side, the light is called a broad loop. You'll find that it is easier to evaluate eyeglass glare if you eliminate nonphotographic lights from the room. So turn them off if possible, and use a curtain to block out window light.

Blinking. Another common problem you might encounter involves people who blink during an exposure. Usually, they blink because they hear the single-lens-reflex (SLR) mirror, which has to move out of the way before the exposure can be made. This happens in a split second, of course, but some people have keen hearing and quick eyelids.

If you notice a subject blinking during the exposure—and you can after years of experience—simply use the mirror-up feature on your camera. After your subject hears the mirror and then blinks, you can shoot. Another option is to put a small coin on your forehead. The oil from your skin will make the coin stick. Most of your subjects won't know this, so they'll probably keep their eyes open waiting for the coin to drop. I've used this technique successfully many times, so I know that it works!

Stares. You can avoid a stare fixation or a glassy-eyed look by carefully directing your subjects at the moment of exposure. Most of the time, I have my subjects look at me or slightly above the lens in order to get good light in their eyes—but not until the split second that I am ready to make the exposure. If they have protruding eyes, however, I ask them to look slightly below the lens.

Crossed Eyes. Sometimes you can get a subject with crossed eyes to look at your hand for the split second needed for the exposure. When this happens, the eyes won't look crossed in the final image. If this method doesn't work, try using a profile or three-quarter view of the face. Put one eye in shadow.

One way to accomplish that is to use a split light. This light is similar to a short light; here, however, the subject's face is perfectly split between highlight and shadow. The main difference between these two types of light is that the split light doesn't produce a triangular highlight on the shadow side of the face. When you work with a split light, bring the main light around to where it almost—but not quite—creates a highlight on that side of the face. You should then see a glow from the main light on the shadow side.

HAIR TYPES

There are almost as many hair types as there are subjects: thick, thin, frizzy, sophisticated, youthful, formal (unnatural), and informal (natural). Hair comes in almost every color under the rainbow. I've made portraits of people with green and orange hair, as well as everything in between. Black and other dark-hair colors can accept a great deal of light, while this level of light would overexpose blonde hair. For dark hair, I set the hair light at *f*/8, or one stop less than the *f*/11 setting of the main light. For blond hair, I set the hair light at *f*/5.6, which is two stops less than the main light's *f*/11 aperture. For white hair, I use an *f*/4 opening on the hair light, which is three stops less than the *f*/11 setting of the main light.

When working with children and teenagers, I try to keep their hair out of their eyes because otherwise I know that will be their parents' primary complaint. I never squirt hair spray directly on my clients because of the danger of it hitting their eyes. I prefer to put spray on my hand and touch the hair that needs attention. One stray hair sticking up on the top of a subject's head can cause hours of retouching problems.

Be aware that on low-humidity days, your subject's hair might stand out, looking as if it has been electrified. One solution to this problem is to blend the hair with the background. Diffusion also helps when you work with frizzy-haired clients because it softens the hair and makes individual strands seem to disappear.

PROBLEMATIC FEATURES

Everyone who comes before your camera doesn't have a perfect face or body. Portrait photographers have the job of making their subjects look their best by emphasizing their best features and downplaying their worst. If subjects have a well-shaped body, I do a number of full-length poses, separating the arms from the waist to show off a good waistline. I camouflage problematic physical features. I use furniture, backgrounds that blend, subtle lighting, and carefully chosen camera angles to hide flaws.

Overweight. Almost all overweight people have round faces, but not all round-faced people are overweight. Nevertheless, you'll find that the short light is best for both types of people. To create a short-light effect, place the main light in such a way that the cheek closer to the camera is in shadow. This shadow-side cheek should then have a triangular-shaped highlight produced by the main light. Pose heavy subjects with their shoulders at an angle to the camera, so they don't appear too broad. Highlight the shoulder and the side of face farther from the camera with the main light; let the shoulder and the side closer to the camera be in shadow.

You can flatter heavy subjects in other ways as well. You can, for example, ask these clients to wear dark clothing, which you can blend into a dark background. Here, the point of greatest contrast will be the subject's face rather than body.

Another complementary approach is to ask your subjects to lean forward, thereby stretching the neck. You can use props, such as furniture, to hide the body. If you want a three-quarter or full view of your subject's body, consider a profile pose. Have your clients sit with their back to the camera in a chair with a solid back; this will hide much of the body. Good choices are wingback, emperor, barrel, and captain's chairs. Finally, ask your subjects to turn their face toward the camera for a profile or three-quarter view of the face.

Deep Smile Lines. Smile lines are deep dimples found on either side of the mouth. These lines create additional, unwanted highlights on the subject's face. One way to solve this problem is to utilize a butterfly light. Here, the shadow under the nose sometimes looks like a butterfly. In this setup, you position the main light so that a shadow forms halfway between the nose and the upper lip. The ideal subject for a butterfly-lighting arrangement has prominent cheekbones and a thin, narrow nose. You should avoid this technique if your subject has a wide nose because the lighting will make it look even wider than it is as the shadow continues to widen like a pyramid.

Double Chins. Subjects with double chins and soft

chins require careful positioning. To photograph these clients, have them lean forward, using a desk, chair, or ladder; this pose effectively lengthens the chin. Be sure to shoot from a high camera angle. When a subject is standing, I sometimes get on a ladder in order to obtain the proper camera angle. On other occasions, I have the subject sit on the floor while I stand on the ladder. This results in an extreme camera angle that flatters customers with problematic chins.

Long Noses. Long lenses compress such features as long noses. For example, in a portrait situation that ordinarily calls for a 150mm telephoto lens, the use of

These three portraits show masculine poses that successfully camouflage minor physical flaws, such as a bald head (left), a slightly overweight subject (center), and a long nose (bottom).

a 250mm telephoto lens will shrink a subject's long nose. Another way to minimize this facial feature is to position your client so that the nose points directly toward the camera. Bring the fill light closer to soften the nose shadow, and keep the camera at nose level. Avoid shooting profiles of individuals with large noses.

Long Necks. When you photograph clients with long necks, remember that whatever is close to the lens appears large, and whatever is far away looks small. Keep in mind, too, that short-focal-length lenses exaggerate this. The solution for working with long necks, is shooting from a high camera angle. You can use a stool or a ladder to get the lens well above the neck.

Large Ears. The best solution for large ears is to show a profile or a three-quarter view of the subject's face. Here, only one ear shows. If you decide to include both large ears, let them blend with the background and keep the main light off them, so that you don't call attention to them. Use a short light.

Bald Heads. Like large ears, bald heads and receding hairlines should merge with the background. With light-skinned people, this calls for a light background; with dark-skinned people, this means a dark background. A low camera angle draws attention away from the top of the head. As such, you'll often ask your subjects to pose standing up.

When you photograph a bald subject, first turn off the hair lights and aim a rim light along the edge of the customer's face to draw attention away from the receding hairline. A rim light comes from behind the subject toward the lens, so that it illuminates only the outline of the face. Avoid having the rim light strike the subject's nose. The rim light should be about two stops less than the main light. You can make this reading by pointing an incident flash meter at the light from the face. For example, if the main light reads *f*/11, the rim light should read *f*/5.6.

Since you point the rim light almost directly at the camera, you must take care to keep the illumination out of the lens by using barndoors, a light-blocking device that is found between the light and the lens, on the light itself, as well as a fabric lens shade, such as the Lindahl double bellows. You can also try another light-blocking device called a gobo, such as a black fabric Larson Reflectasol or a Photogenic head screen, which is a plastic board on a goose-neck stand.

Using a dark background with a bald head requires meticulous lighting control, which is almost impossible with broad light sources, such as umbrellas. You can, however, use a spotlight to illuminate the face while keeping the forehead in shadow. If you ordinarily use 16-inch, silver, parabolic reflector lights when you shoot, you simply have to add barndoors or head screens to prevent a bald head from being illuminated.

CHAPTER 22
BRIDAL PORTRAITS

I'm sorry. I'm booked for another event on that date, but I can do an exquisite, unforgettable wedding portrait before the wedding. Many brides display a large, framed portrait on an easel at their reception, so the wedding guests can see you and your dress elegantly presented in soft, alluring light."

The ability to shoot stunning wedding portraits gives photographers another strong product line, one that results in high sales averages. In some parts of the world, as well as in the United States, bridal portraits are considered more important than wedding candids and, therefore, worthy of a bigger investment. Styles and traditions vary widely throughout the world. Some areas emphasize bride-and-groom portraits, while others usually show the bride alone. Probably the best-selling wedding photographs all over the globe are full-length poses of the bride and groom together and of the bride alone.

STUDIO PORTRAITS

Wedding portraits shot several weeks before the ceremony actual require a great deal of studio space and considerable skill. A studio sitting typically lasts 1½ hours. For a full-length, standing-pose shot, portrait photographers usually place the bride in the center of the negative frame, with her bridal train extending to one side. Some trains are 9 feet long, so with the bride centered and standing, they require a background 18 feet wide. So when you build a camera room, it is a good idea to provide for this kind of width.

What do you do with all the space on the side opposite the bride's train? In the Deep South, photographers traditionally offset the train by placing an elegant chair in front of the bride. Sometimes they direct her to put her hand on the back of the chair. As one bride told a photographer in North Carolina, "I don't care what your backgrounds look like, just show me what chair you're going to use."

LOCATION PORTRAITS

Although I designed my camera room so that it had sufficient width to accommodate bridal portraits, I prefer to do wedding portraits on location. On-location shooting poses many challenges, but the absolute realism of the environment make all of your efforts worthwhile. Location portraits usually are done in the bride's home, but occasionally brides prefer the larger space offered at a friend's home or a public building, such as a museum. The problem of negative space in front of the bride is more easily solved on location. I can take advantage of windows, columns, tapestries, arches, paintings, and sculpture. Location bridal sessions typically require three hours from setup to breakdown.

Staircases are excellent for posing bridal portraits because they allow the train to flow at a 45-degree angle below the bride. This eliminates one problem for the photographer: figuring out what to do with all the space in front of the bride. Because any scene that includes doors, windows, and walls must be kept vertical, I use a spirit level on both my tripod and camera. For most portraits, the walls should be level, not leaning one way or another.

For full-length portraits, I usually adjust the camera height so that it is level with the bride's waist. This relatively low camera angle keeps the architectural elements straight and makes the bride appear taller than she really is. Full-length seated poses of the bride are popular, too; here, the train is elegantly draped in front of her. I prefer to have the bride sit on a beautiful bench with no chair back. This makes it easy to pull the train around in front of her.

For the most part, I use my Hasselblad 80mm lens for full-length bridal portraits. Sometimes, however, I

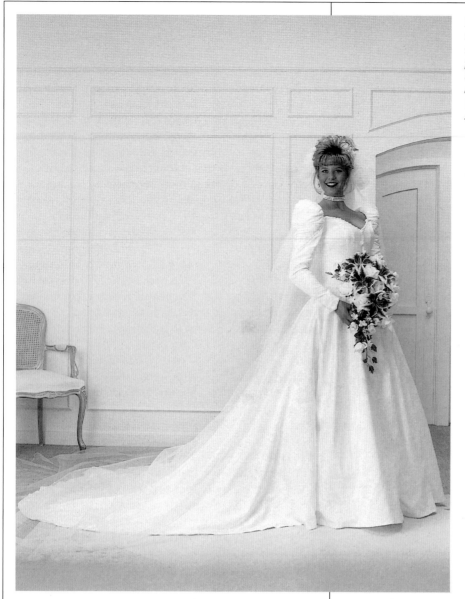

For this portrait of a bride, I utilized the high-key portion of the camera room in my studio (left). A staircase provides an excellent setting for a bridal portrait because the steps allow the train to flow downward (opposite page). This creates a superior vertical composition.

use my 50mm lens on location to show all of the train. But during my 30 years of shooting bridal portraits, I've learned to spread out and show the entire veil and train in full-length pictures. If you have a certain part of the bride's attire on the negative and she doesn't want it to show in the portrait, you can always crop the image if the client prefers. But you can't print what you didn't shoot in the first place.

You can pin the bride's train and veil to the floor in order to stretch them out and to show the beauty of their fullness. If you're working on a hard floor, you can pin small lead weights to the underside of the train and veil. This will keep them in position. These weights also work well for outdoor portraits when the wind proves troublesome.

Bouffant-type veils tend to sag due to the weight of the net pulling them flat on top. Sometimes I run a long hatpin through the bride's veil and hair to take the weight off the veil, thereby enhancing the bouffant effect on top of the bride's head.

On any location portrait, my first goal is to capture the environment. Next, I look for problems that require special care, such as windows, mirrors, and distracting colors or patterns. Finally, I decide how to illuminate the portrait.

POSING THE BRIDE

Getting the bride to stand erect is important, not only to successfully compose the image, but also to keep wrinkles out of the waistline. I strive for the "S" curve by asking the bride to put her weight on her back foot, and to extend her other foot toward the camera. Her hip should pivot toward her back foot.

The bride should be posed with her body at an angle to the camera, with both arms away from the waist so they don't make her waistline appear larger than it is. If she is posing with a bouquet, she should hold it with her back hand low at the waist, showing only the edge of her front hand, which doesn't actually

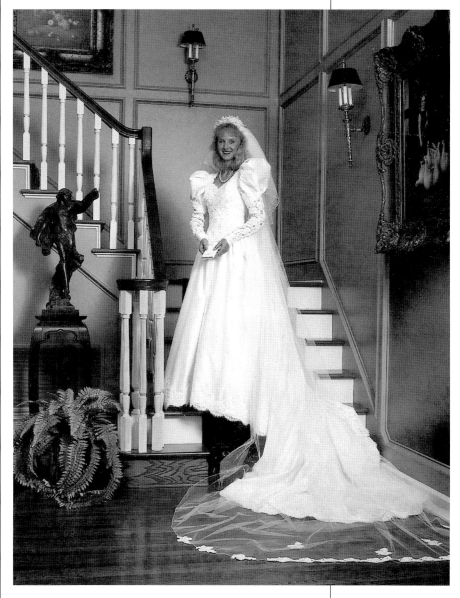

tion this light carefully so that the illumination from it doesn't destroy the detail in the veil via overexposure. For example, if the camera is set at $f/11$, the veil light should register an incident reading of $f/5.6$ on the flash meter when read from the bride's back.

I often use a miniature, battery-powered electronic flash unit for the background light, so wires don't show. My choice is a Photographers Warehouse PG160S with a built-in photocell, powered by two AA batteries. I mount the flash unit on a 3/8-inch threaded rod that is 4 feet high. I insert the rod into a plumber's lead weight with a hole drilled in it.

Finally, I conclude the session with some candlelight portraits, placing a candelabra on the same side as the main light. I am very careful to light the candle several feet away from the subject, so that the spark from the match won't ignite the hair spray on the bride's hair. Of course, I keep the candle flame away from her hair and veil, as well. The exposure is made with the 250-watt quartz modeling light of the electronic flash, which usually requires a reading of about 1/2 sec. at $f/4$ on ISO 160 film, such as Fujicolor NPS.

hold the bouquet. The bride's head should be at an angle to her shoulders and tilted slightly toward the front shoulder. For standing poses, I ask the bride to keep her knees and feet moving continuously; I don't want her to faint because of improper blood flow.

Correct posture is vital for seated poses, too. Ask the bride to sit erect, and then lean her upper body toward the back hip and slightly forward. This produces a diagonal composition. Finally, toward the end of the session, I shoot some poses from the waist up for newspaper announcements. I do these shots exactly as I do the other seated poses, using the same posture and lighting.

LIGHTING BRIDAL PORTRAITS

When I shoot bridal portraits, I use my standard main and fill lights whether I'm working in the studio or on location. I do, however, add a background light that shines through the veil at shoulder level. I must posi-

Since the fill light's modeling bulb usually doesn't produce enough illumination to soften the main light, I place a white reflector next to the shadow side of the bride's face. Accented by an eight-point star filter over the lens, the warmth of the quartz light on daylight-balanced film produces a beautiful effect.

Sometimes brides select this pose for their large portraits, and they almost always buy an extra print of it for the groom because the golden glow of the candlelight is so romantic. (This technique works equally well for First Communion portraits of girls with bibles and rosary beads—see page 86).

A bridal portrait may be the most important photograph in a woman's life, and it is worthy of the finest effort a portrait photographer can master. When you're entrusted with this important responsibility, you should expend every ounce of energy in the portrait's preparation and execution.

GRADUATION PORTRAITS

Graduation portraits of high-school seniors provide the biggest product line for many photography studios in the United States, sometimes accounting for more than half of their annual sales. Graduating seniors not only have a need for portraits, but they are a renewable resource. Another class comes along every year.

Some high-school officials sign a contract with one studio for exclusive rights to photograph the senior class, while others permit the graduates to go wherever they wish for their portraits. Even though some seniors are required to go to a contract photographer, they can also go elsewhere for additional, more creative portraits. Graduating seniors top all other product lines for the highest average sales at many studios.

HOW TO COMPETE SUCCESSFULLY

Contract photographers typically operate under time and financial constraints because they're required to provide a school with money, goods, or services in order to get a contract. Many schools ask photographers to submit bids in order to win a contract to schedule all of the graduating seniors. The bids usually include not only what prices the seniors will pay, but also what the photographer will give the school in return for the contract. Sometimes these "favors" include film for the yearbook staff; an advertisement in the yearbook; free processing for yearbook photographs; free photographs of school clubs, ball games, and homecoming activities; and/or a cash payment. To overcome this drain on profits, photographers must reduce the amount of camera time allotted to each senior and/or product quality. In effect, graduating seniors are underwriting the school's yearbook or other extracurricular activities.

To compete in this market, noncontract photographers must offer more time for senior sessions to accommodate a higher number of clothing changes, locations, and props. These professionals also must pay more attention to each graduate's individuality. Because seniors are a close-knit group in daily contact with each other, they spread the word quickly about the good or bad treatment they receive at the hands of a photographer, as well as stylistic portraits that appeal to them.

Photographers wanting to enter the graduate market must do extensive research in order to understand the teenage mind. This means spending a great deal of time with them and listening to them, so that you can speak their language. Noted California photographer Ted Sirlin has a sign in his window: "Teen spoken here." Also, it is a good idea to find out what music they like; what magazines they read; what cars they like; and what they eat, drink, and wear. Graduating seniors select the photographer they think will make them look best and who will bring out their best qualities. They want a photographer who can make them relax and capture their personality on film.

REACHING POTENTIAL CLIENTS

Direct-mail advertising is my favorite medium for reaching graduating seniors and their parents. I schedule five mailing pieces. The first is a large—either 4 x 9 or 6 x 9—color postcard that I mail to eleventh graders in May, before the end of the school year. This postcard contains pictures of about 9 or 10 members of the current graduating class, selected from different schools, featuring some of my best portrait styles. I shot these portraits the preceding summer or fall.

In June, I send out the second mailing, which consists of a 4 x 9½ window envelope (a No. 10 enve-

lope), with a billfold-sized photograph showing through the window. This is a portrait of a popular classmate from each student's school. I send a direct-mail piece to upcoming seniors in about 15 high schools, so I select a representative from each school to appear in the advertisement.

The third piece of direct mail is a small 3½ x 5½ color postcard with a "call-to-action" line urging upcoming graduates to have their sessions completed during the summer before they get busy with school activities. I mail this card in late July.

Next, I send out a 3½ x 5½ monochrome postcard in September after school starts. This advises graduating seniors about the need to book their sessions as

soon as possible in order to have portraits ready for the yearbook deadlines.

Finally, I mail another 4 x 9½ window envelope in March, offering additional portraits at a special savings. This mail-out encourages the students' parents to order photographs to be sent with graduation announcements.

KEEPING THE PEACE

Graduates usually decide which portrait studio they want to go to, but their parents decide how large the print order will be, sometimes after heated negotiations with their teenagers. Seniors want lots of billfold-sized portraits to exchange with their friends, while their parents want larger prints for the home and relatives. It isn't unusual for an order to exceed 500 dollars for wallet pictures alone, with the total sale exceeding 1,000 dollars.

Sometimes my staff members and I act as referees between graduating seniors and their parents when they arrive at the studio fighting over how the teenagers want to look in the portrait. The real debate, of course, centers around the coming-of-age issue. Most parents want to maintain control as long as possible, and most seniors want independence as early as possible. The problem manifests itself in conflicts over personal choices regarding clothing, jewelry, hairstyles, makeup, music, cars, and romance.

Addressing the parents, I usually say something like, "You remember how goofy we looked in high school, and if it weren't for pictures, we may have forgotten some of the best times of our lives. Let me suggest we do some outfits the way your son wants, and we'll do some formal poses for you and the graduation announcements." Then I negotiate with the senior to select some outfits that will satisfy him and others that will please his parents. I always hope that this attempt at a compromise will produce a session that is photographically pleasing for all concerned, including me.

If the family members are getting along, I'll invite the parents to stay in the camera room to help me look for stray hair and clothing wrinkles. If the family is arguing, I'll tactfully suggest that the parents go shopping for an hour or so. I don't want parents in the room when they're waging a war with their child.

"Wheels" are an important part of a high-school senior's life, so I try to include them in the graduates' informal portraits.

THE SHOOTING SESSION

When seniors arrive for a session, I have them look at a gallery of graduation portraits so they can tell what they like and don't like. Typically, they'll say something along the lines of, "I like the couch, the shutters, the library, and the doorway, but I don't like projected lights and colored backgrounds."

Music is an important part of the session, so I ask my teenage clients, "Which radio station do you

To make this double exposure of a high-school senior with his track medals, I photographed them against a black-velvet background (above). As I composed, I made sure that I left room for the graduate's face. For this casual, full-length pose of a graduating senior, I used the door to the camera room as a frame (right).

like?" My stereo system has about nine radio stations in memory that play hard rock, classic rock, oldies, rap, blues, jazz, gospel music, country music, and classical music.

My associates and I treat seniors with the respect that a 17-year-old who has completed 11 years of school deserves. Even when we discuss them during staff meetings, we refer to them as "this young woman," "this young man," or "this student." Our attitude toward clients in private carries over to our face-to-face relationships with them. Everyone, even toddlers, sense love and respect from an adult. At the beginning of the sessions, I use the following questions as icebreakers:

• What kind of music do you like? (I then tune in the radio station the senior prefers.)
• What television shows do you like?
• What movies have you seen lately?
• Why don't you tell me a little bit about yourself?
• Are you into any special activities?
• What kind of car would you like to have?

During the session, the dialogue continues nonstop, aided by the beat of the music. Often, a graduate will bring along a classmate, who is welcome in the camera room to break the ice. Sometimes I ask the friend to help move props, look through the viewfinder, or

hold reflectors, thereby giving the student a sense of participation in a session that should be fun for everyone involved.

I devote at least half of every session to classic portraiture. These photographs call for live plants, real bricks, genuine books, and authentic doors and windows. I find that my teenage clients want absolute realism and natural settings. They reject imitation props, cheap plastic and styrofoam, and projected high-tech backgrounds.

When I decide to use paper backgrounds, usually they are solid white or solid black and accompanied by simple cubes, ladders, or chairs. Both teenagers and their parents agree on outdoor settings as natural backgrounds for portraits. I enjoy outdoor portraiture because the available light enhances the subjects' faces, especially when broad catchlights in the eyes seem to penetrate their souls.

I enjoy working with graduating seniors for two reasons: they are full of energy and optimism, and their tastes are continually changing. But regardless of the latest teenage trends, parents want well-illuminated, well-posed graduation portraits with traditional backgrounds that they can give to their relatives with pride. Because of the challenges, as well as the opportunities, I find that seniors are my favorite subjects. They certainly keep me thinking young!

CHAPTER 24
CHILDREN'S PORTRAITS

JO ALICE MCDONALD

The psychology of marketing children's portraits runs much deeper than most photographers can comprehend because it is so multifaceted. Children can tug at your heartstrings like no one else, especially if they are your children or grandchildren.

Never underestimate the love of a parent, grandparent, or caregiver for a child. If you cultivate these adult clients, they'll return year after year for more portraits. In time, this can even lead to graduation and wedding photographs. Clearly, the cycle can be never ending as long as you please your customers. From a marketing standpoint, children provide a renewable resource for portrait photographers because new ones keep coming every year.

At this stage of our careers, Tom and I are photographing second-generation children whose parents we worked with 20 or 25 years ago. And in Tokyo, the Photo. Kunst-Atelier Ariga studio has been doing portraits successfully for 80 years (see page 96). Yumiko Ariga photographs children whose grandparents or great-grandparents were photographed by her grandfather, starting in 1915.

WHAT A SMALL STUDIO CAN OFFER

As the owners and operators of a small business, Tom and I need to analyze the competition we get from large corporations operating in department stores, discount stores, and chain-owned studios. What can we do better? Obviously, Tom and I can offer better service, better packaging, and, we hope, better portraiture.

Variety is essential to our success with children's portraiture, as well as to our ability to capture the many aspects of this cherished, soon-to-be-gone stage of life. Tom and I seek variety in children's clothing, asking parents or caretakers to bring light-colored, dark-colored, dressy, and casual clothing to the session. We then coordinate the garments with different backgrounds that range from light to dark, and formal to informal. Our knowledge and skill enable us to utilize many forms of illumination: high-key, low-key, profile, window, and outdoor light. We like to capture many expressions, including somber, pleasant, happy, and inquisitive looks. And, of course, we try to preserve lots of smiles.

Because Tom and I work by appointment, we don't keep children waiting, so parents and caregivers avoid the long lines they must endure elsewhere. In fact, our schedule is so flexible that we can wait if a baby is still sleeping at the designated time for the session. On one occasion, we let a baby sleep in the dressing room while the parents went to lunch. The baby awakened while they were gone, and we finished the session by the time they returned.

Because Tom and I have a convenient dressing room in the studio and schedule a minimum of an hour for the session time, we can often photograph children in three to five changes of clothing, if their patience will allow for it. Parents like to bring favorite clothing for their children to wear during the portrait session. As we continually remind parents, "Take your time. We're in no hurry." We switch backgrounds and furniture with every clothing change.

For example, if a child is dressed in classical, dressy clothing, we'll select a formal, classical prop, such as a Queen Anne chair. If, on the other hand, the child is wearing jeans and a T-shirt, we may photograph the child in our outdoor garden area where we have live plants and large stones that a child may sit or lean on. The color and style of the child's clothing determine the background and prop selections. Our goal is to achieve a monochromatic or harmonious effect.

We want the child to be the star of the portrait rather than the clothing, props, or background. We usually include poses made with actual window light or in real outdoor garden areas as part of the session. Volume operators can't offer these options, relying only on painted backgrounds and stage-type sets.

In terms of marketing, you can learn a great deal from McDonald's, the fast-food giant. This incredibly

successful company attracts customers through repetitive advertising; a consistent, good-quality product; the development of new products; seasonal promotions; a friendly atmosphere; a children's playground; and special packaging for children.

In terms of artistry, you can learn from painters Anthony Van Dyke, Thomas Gainsborough, and John Singer Sargent. Art-gallery staffs throughout the world revere their work. These artists followed a carefully detailed formula for commercial success, portraying patrons in their fine clothing in their expensive homes, complete with columns, elegant furniture, and manicured gardens. Tom and I have a similar artistic approach, photographing children in their best clothing with an environment to match.

PREPARATION

Preparing parents and children for the portrait session is important. Tom and I do this through both a consultation and an appointment letter, advising the parents to schedule a time when the children will be at their best. The parents must be assured of our sincere concern for the children's security and well being during the session.

Before the session, Tom and I work with our staff members to remove all objects that could harm children from the reception room, dressing room, and camera room. We also ask the parents or caregivers to talk about the good time the children are going to have playing with bubbles and toys.

Tom and I also tell parents to avoid the word "doctor" during this discussion because the children may associate it with painful memories. We do everything possible to keep our studio environment from looking like a hospital or doctor's office, and we never wear clothing that suggests a medical environment on days when we're scheduled to work with children. Tom and I have hung portraits of babies in the dressing room to create a friendly atmosphere. If children seem apprehensive, we start the session outdoors so that they quickly see that this is a fun place.

We use our standard lighting equipment and setups for children's portraiture. And, once again, white seamless paper plays a prominent role on the set. All of our seamless backgrounds are 9 feet wide, so we can quickly move them up and down with electric background rollers. The edge of the paper is held flat with two pieces of aluminum bar stock or flat bar 1/8 inch thick, 3/4 inch wide, and 8 feet long. The two pieces are attached to either side of the paper with four No. 3 Bulldog clips (Hunt-Boston No. 2003). Because children move so rapidly, Tom usually focuses on the seams or texture of their clothing rather than their eyes.

Select chairs and other props that your most discriminating clients would welcome in a portrait hang-

Sometimes the informal poses of children attract the most attention. For this casual portrait, I had rollers put in the baby's hair and then positioned her in a wicker chair. She did the rest. The baby's bright eyes and wide-open mouth, which was about to let out a loud squeal, reveals her lively nature.

ing on their wall. Until your budget enables you to purchase expensive furniture as props, use simple pieces, such as cubes and benches, that don't draw attention to themselves. Avoid cheap-looking furniture.

Two of the greatest joys of children's portraiture are the delight that comes from earning your subjects' friendship and the fulfillment that comes from capturing an expression that warms the hearts of viewers everywhere.

WORKING WITH CHILDREN

Photographing children always requires teamwork. First, a good working relationship must develop between the photographer and the assistant. Because this camaraderie is so important to a smooth session, I recommend practice sessions before beginning revenue-producing assignments.

Tom and I involve the parents or caregivers as partners. We ask them to handle clothes changes, keep the children's face wiped clean and their hair in place. Coaxing cooperation and wonderful expressions from children is my responsibility during the session. I genuinely like and enjoy children. They usually sense and respond to the way I care for them.

Because of this natural ease on my part and the children's positive responses to me, Tom and I ask the caregivers and anyone else in the camera room to provide silent assistance. Too many voices and too much noise confuse children and prove to be counterproductive (see page 85).

Children are very sensitive to adult comments and criticism. They often misinterpret what people say to them. Adult talk may cause children to react inappropriately. These responses can manifest themselves as fretfulness, tics, uncooperative behavior, and/or temper tantrums.

Children view the world from their perspective, which is based on limited experiences. An interesting example of this occurred when a father bought his

Sleeping children capture everyone's heart. This little boy slept soundly during his session; he was completely oblivious to the large teddy bear propping him up.

young daughter a videotape of Disney's "Beauty and the Beast." One of the scenes in the movie made a special impression on the child when the beast told Belle to go anywhere in the castle except the west wing. The beast roared, "It is forbidden!" After viewing the movie a number of times, the little girl went to her father and said there was something she couldn't understand. "Who is this Bidden guy?" she asked. "Why can he go into the west wing and Belle can't?"

Often, children don't have the language skills needed to communicate what is on their minds or troubling them. They are aware of adult facial expressions and body language, sensing different moods and feelings. Children respond positively when adults are pleasant, relaxed, and confident. Adults who are tense, unsure of themselves, and irritable elicit negative responses from children. They react to the adults' tone of voice, as well as to the words that are spoken to them.

Since I have an easy time directing our young subjects, Tom is free to stay behind the camera once the lights have been set up and the scene established. I know the operating range of the main light, so I keep the child in place. This method enables Tom to focus, frame the subject, and make the exposures.

Some photographers, such as Sarah Rizzo, involve the parents more actively than we do, getting the caregivers to draw out expressions while she operates the camera (see page 146). Rizzo spends a great deal of time preparing caregivers for the session. They have an advantage in that they know their child better than anyone else.

Although Tom and I don't hurry the parents during their child's session, we work fast once the child is ready. Most toddlers, for example, have short attention spans. We work together to prepare the set, and then I position the feet while Tom operates the camera because children don't stay in one place for long. Most

children perform better for women, but occasionally Tom and I switch roles when a toddler seems to interact better with men. On rare occasions, one of us has to leave the camera room because a child has had a bad experience with a man or a woman.

DIRECTING CHILDREN

The following suggestions are based on 25 years of working with little ones. Children, like adults, enjoy people who are interesting and who genuinely like and appreciate them. A successful session depends on:

- Gaining children's confidence
- Getting them to cooperate
- Creating a sense of security
- Eliminating their fears
- Ridding children of suspicions.

When you work with children, you also have to establish authority in the camera room. Explain to the parents or caregivers that everyone's attention must be directed and focused. Someone speaking at the wrong time can break a child's concentration.

Ask everyone in the camera room to remain quiet during the session. Tom and I need children to look toward the main light in order to get light in their eyes, as well as to achieve the proper highlights on their faces. For these reasons, I work between the main light and the camera, so that the lighting pattern will be correct as the children look at me. When young subjects hear other voices, they'll look in the wrong direction.

Never ask stubborn or cantankerous children if they "want" to perform a certain activity. This kind of question plants the idea in the children's mind that they have the power to refuse. This, in turn, gives them the advantage over you. It is better to tell the children in a positive tone of voice that they'll be busy with a specific activity. This approach eliminates the opportunity for the children to say no and to refuse to cooperate.

You should never make promises to children that you don't intend to keep. Bribing children to make them cooperate can be risky. They'll test the limits of the bribe by seeing how much misbehavior you'll tolerate and still give them the promised reward.

When you make a promise, be sure to carry out the commitment according to the guidelines you explained. I find it best to reward the child after the session has been completed. I might say something like, "Congratulations on being such a good model," and then offer a token gift, such as a coloring book or small toy. These expressions of appreciation give the children a sense of accomplishment. Positive affirmation results in a loyal friend, which will help during any future sessions.

Throughout the session, it is important to involve the children in some appealing pastime. This strategy

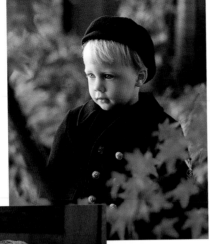

North light provided the main light for this outdoor portrait. I photographed this little boy in the garden outside my studio; the roof overhang prevented eye shadows. The exposure was 1/60 sec. at f/5.6 on Fuji NHG 400 film.

Coin banks are useful tools. They come in handy when you need to keep an active child in place long enough to capture the pose.

I wanted to create a warm glow in this First Communion portrait, so I used the 250-watt modeling bulb of the Photogenic Flashmaster to illuminate my young subject. I exposed for 1/2 sec. at f/4 on Fuji NPS 160 film.

lets you gain their confidence and alleviate their fear at the same time that you divert their attention from the photographer and the camera. For the most part, emotionally secure children quickly enter into interesting pursuits, such as watching and/or catching bubbles or listening to stories. Younger children are often intrigued by books with pictures that are animated or have part of the story concealed under a flap that lifts up. An assistant or a caregiver can hold these books while reading or showing them to a child.

Allowing active children to put coins in a bank is an effective way to keep your subjects in position

while you photograph them. Concealing squeakers in your hand that cause mysterious sounds to come from unexpected places can pique a child's interest. Curious toddlers usually try so hard to reproduce the sounds by mimicking your motions that they stay in the desired spot for the portrait.

Keeping children located within the boundaries of the light and camera angle can sometimes be difficult with youngsters who are hyperactive or have a short attention span. I've discovered that a challenge or dare often helps me accomplish this goal. Such statements as "I can stay still longer than you!" or "I can be quiet longer than you!" are amazingly successful in achieving the desired results. This is especially true when you allow the children to win. You can then say, "You won that time, but I'm going to win next time!" You can continue to play the game until your subjects become bored.

Finally, you should always treat children with the same courtesy and consideration you would extend to adults. Give genuine compliments. Children aren't deceived by insincerity. When you are dishonest with children, they become suspicious, cautious, and uncooperative.

THE AGE FACTOR

The photographic techniques and tools you use vary according to the age of the child. You can coax expressions from very young babies by communicating through the senses of sight, sound, and touch. Newborns and infants have little peripheral vision, so rather than try to establish eye contact, I use a small bell or squeakers to capture their attention. In response, the babies turn their heads toward the sound.

If the child's sight is developed enough so that the child can observe and react to moving objects and or bright colors, I'll wave a colorful toy to direct the eyes. Young babies see black and white better than color, so a black-and-white object may serve to focus your subject's attention. Sometimes I elicit expressions by using a long feather to produce a tickling sensation or a bamboo fan to create a sudden movement of air.

When a baby isn't old enough to sit up by itself, I often prop up the subject in the corner of a wingback chair covered with velvet. (Any chair with a closed back works well.) Sometimes I arrange a "nest" of pillows on the floor or use a christening bench from Wicker by Design (see the Resources list on page 190). The look is soft: the baby is lying on a white lace blanket, and white tulle is woven under and around the bench or pillows to create a "cloud" effect. Tom softens the edges with a vignetter and raises the camera higher than usual to get the proper angle on the subject's face. Ordinarily, he keeps the camera at the nose level of the person being photographed. In these situations, he brings the camera up to about 5 feet in

height and angles the lens downward in order to photograph the complete face.

A fearful or fretful baby may need the touch of a trusted caregiver, usually the mother, for comfort and reassurance. You can accomplish this during an actual exposure by covering the caregiver with a piece of black velvet. The adult is completely concealed but supports the child by holding the baby on her lap or shoulder, which is covered with the velvet. You should use a dark background behind the baby. This technique can save the day when a crying child can't be separated from the caregiver.

To make the velvet drape, which is 8 feet wide by 9 feet long, simply buy 6 yards of velvet 48 inches wide. Next, cut the fabric into two 3-yard pieces and sew them together. Velvet has a grain, so be sure it is all going the same direction when you sew the pieces of fabric together. One of the advantages of using velvet is that it absorbs light, so wrinkles don't show. Velvet also comes in handy during sessions in the clients' homes when their furniture fabric isn't suited for portraiture. Tom and I also use black velvet as a backdrop for on-location assignments and weddings, as well as a way to block unwanted light coming in a window. For commercial jobs, we use the velvet drape to hide unwanted objects and to control reflections.

With young children who can sit alone, I play such games as patty-cake and peek-a-boo with them. But even if a 6- or 7-month-old child can sit up without any assistance, I place a large pillow on the floor in front of the baby. This way, if the baby tumbles out of a child-sized chair, the landing will be soft.

When I work with a 1-year-old child, I sometimes use a feline puppet and make a noise like a cat, often stroking the child's leg with it. Tom photographs all children on the floor, never on a table, because it poses the danger of falling.

Tom usually works with older children by himself. Some of his techniques include asking questions within the realm of the child's experience or entertaining them with riddles. Reading magazines, such as *Highlights for Children*, can be a valuable resource for material to improve communication with older children. This magazine has a section on riddles that children enjoy. In fact, you can find entire books of riddles in the children's section of bookstores. Depending on the age of the child, Tom may ask such questions as:

• "If you had three apples in one hand and three in the other, what would you have?" (The answer: big hands.)
• "How many seconds are in a year?" (The answer: 12—January 2nd, February 2nd, etc.)

The laughs usually will come when you give your subjects the answers. Sometimes, the response is just a pleasant expression, which may be preferred in a portrait.

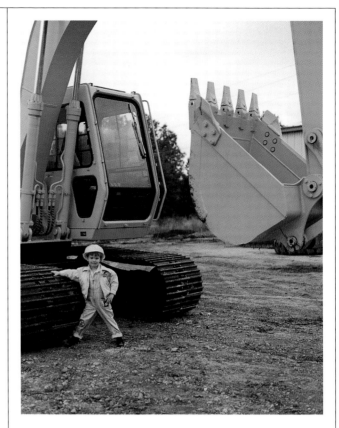

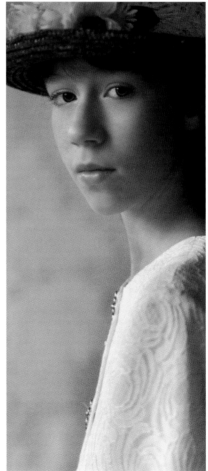

"I Like Big Toys" is the title of this portrait, in which the huge construction equipment dwarfs the child (above). This window-light portrait of an 11-year-old girl captures the look of an Old Masters painting (left).

CHAPTER 25
FAMILY PORTRAITS

Of all the opportunities in the portrait business, photographing family groups represents the most of everything. These group shots are the most difficult, the most challenging, the most fun, and the most lucrative. They are the hardest because a group can include posing men, women, and children individually and a unit, so that the group presents a pleasing design. Getting children to stay in one place and look happy, preventing the adults from watching the children, and keeping everyone's eyes open all present a challenge.

But if you like people and enjoy working with them, the challenges can be rewarding. You'll find that photographing family groups enables you to understand them better, and that they are fun. In addition, family groups provide the biggest average sale of all the types of portraits I make, and these sessions don't require any more time than a bridal or graduating-senior session does.

SELECTING EQUIPMENT

When I photograph families, I prefer the longest lens possible because of the foreshortening problem. This means that I use the 150mm lens on my Hasselblad whenever possible and change to the 80mm lens when necessary. For groups of 15 or more, I have to use an 80mm lens because the 150mm lens' angle of view isn't wide enough for my camera room. I avoid using a wide-angle lens because of the distortion that results when one person in the group gets too close to the camera. Be aware that even an 80mm lens can make subjects in the front row look bigger than those in the back if you get too close.

To achieve proper depth of field, I usually expose at $f/11$ for studio portraits and at $f/8$ for outdoor scenes. Sometimes, however, I choose an aperture of $f/5.6$ when my camera is more than 20 feet from my subjects. An aperture of $f/11$ would be better for both indoor and outdoor shots, so the resulting depth of field would render both the front and back rows of a group would be in focus. Occasionally, however, the outdoor lighting isn't bright enough for that aperture to produce a reasonably fast shutter speed, at least 1/30 sec. I must then use $f/8$. Shooting at a shutter speed slower than 1/30 sec. would probably record even the slightest subject movement as blurs. If I'm shooting at a distance of 30 feet with my 150mm lens set at $f/5.6$, depth of field will range between 28 and 32 feet. Clearly, two rows of people can stay in focus when the camera is far enough away. But remember, the closer the camera is to your subjects, the less extensive the depth of field is.

A camera stand, such as a tripod or monostand, is a must for groups. It not only minimizes the problem of subject movement, but also keeps architectural lines straight. A spirit level on the camera or camera stand helps, but you can line up a doorway or wall molding with the center line on your viewing screen in order to level your camera.

LIGHTING FAMILY GROUPS

For groups of four or less, a small light source, such as a 27-inch softbox or umbrella, works well as the main light. Larger groups require larger light sources. When the group comprises more than four people, I use a 48-inch umbrella as the main light. For groups of all sizes, the fill light is a combination of bounce lighting and a 60-inch umbrella.

When I set up the lighting equipment, I aim the main light at the farthest subject, so that the illumination is feathered away from the person closest to the main light. This arrangement helps spread the light more evenly, thereby preventing hotspots. As the size of the group increases, I move the main light closer to the camera, so that the illumination becomes flatter

and less directional. For very large groups, of 10 or more people, I simply try to spread the light evenly with two, three, or four umbrellas on either side of the camera.

Large light sources, such as umbrellas, bounced lights, and panels, provide even illumination; this eliminates the problem of one person throwing a shadow on another. However, you must elevate these light sources when you photograph people with eyeglasses to avoid reflections. As mentioned earlier, one of the corrective procedures for eyeglass glare is to raise the lights as high as possible. I also ask subjects wearing glasses to tilt their heads down to help control glare.

You should also be careful to avoid double shadows on people and backgrounds. This isn't a problem when you position large umbrellas behind the camera. The resulting illumination is so soft that they don't create shadows on the background or from one row to another.

Sometimes portrait photographers use background lights and snooted hair lights on small groups, but they become sources of error in large-group shots because they produce hotspots and uneven illumination. Rather than a small snoot hair light, I prefer to shine a broad light, such as a wide-strip (10 x 36-inch) softbox, over groups so that the top of each person's head is lighted evenly. Sometimes bouncing a single light off the ceiling above the group produces the same effect. With a group extending 15 feet across the camera room, it is difficult to get a background light to spread even illumination over the entire space, so I leave it off.

Keep in mind that the hair light should be two or three stops less than the main light. You want it to provide only accent lighting, not shadows or hotspots. If one of your subjects is bald or has a receding hairline, turn off the hair light so that it doesn't call attention to this physical feature.

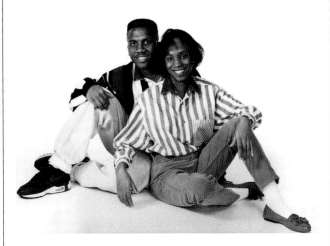

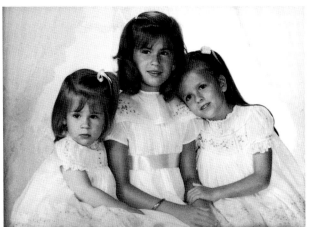

PLANNING THE PORTRAIT

Group portraits probably require more planning and preparation than any other type of portraiture. Proper clothing selection can make or break a group portrait. It is essential, then, for you to communicate clearly with your clients about this. Show them samples of suitable and inappropriate clothing, so they can see the difference.

Solid colors harmonize better than plaids, stripes, and bold prints. Cool colors, such as blue, green, gray, and black, recede, thereby letting the subjects' faces dominate. Warm colors, such as red and orange, come forward and compete with the faces.

Family groups can range from couples to a family of 18. When I photograph groups, I have my subjects pose with their heads at different levels in order to create effective compositions filled with triangles and diagonals.

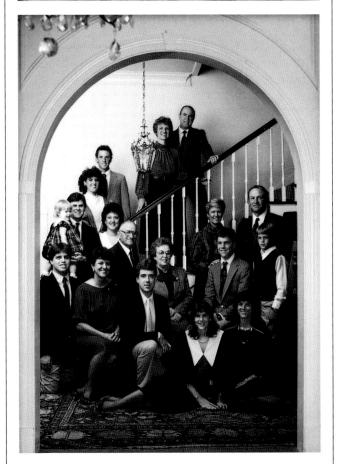

89

Your subjects' garments should blend. For example, all of the family-group members should wear informal or formal outfits. It is difficult to pose a group when some people are wearing suits and ties and others are wearing jeans and T-shirts. Shoe styles and colors should blend with the rest of a person's attire: dark outfits call for dark shoes and socks.

Printed materials showing family groups wearing both good and bad clothing selections are available from such sources as Marathon Press (see the Resources list on page 190). These guides make it easy for clients to see why they should plan their clothing carefully. Schedule a pre-portrait consultation with the family group, and ask the relatives to bring along the clothing they're planning to wear during the actual session.

Talk with your clients to learn what they want in the portrait. If their goal is a wall portrait for the living room, they'll probably want to wear formal clothing and pose against formal backdrops. If, on the other hand, they want to hang the portrait in the den or family room, the clothing and the backgrounds can be casual. You should also inquire as to whether they want the portrait to be done in their home, in your studio, or outdoors. If they want the portrait session to be held in their home, you should try to capture the environment. Include such props as a fireplace, a staircase, or a favorite chair.

Years from now, when the family members look at the portrait, they'll remember their time together, as well as a special moment of love and togetherness like no other. The magic of photography can capture and preserve this memory.

POSING FAMILY GROUPS

Posing groups is the most difficult of all portrait assignments. As a photographer, you must be able to direct men, women, and children, so that they look natural, comfortable, and graceful. Next, you must position your subjects so that the family group presents a pleasing design. Remember, the ultimate goal here is a portrait suitable for wall decor.

While artists paint or draw elements of design into their creations, portrait photographers must use the arms, legs, and torsos of their subjects to achieve design. Their compositions can, perhaps, be aided by architectural components, furniture, or natural elements, such as hills, trees, shrubs, and flowers. Although photographing family groups is complicated and difficult, you can learn how. The following anecdote will give you a clue. A passenger asked a New York City cab driver, "How do I get to Carnegie Hall?" The driver replied, "Practice, practice, practice."

Study drawings, paintings, photographs, and design books to see how great artists posed groups. Almost every public library has books that contain the paintings of such masters as Peter Paul Rubens, Anthony

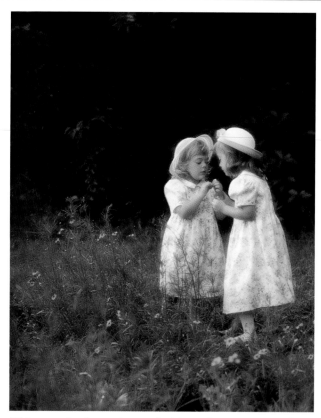

This portrait of two sisters admiring a flower captures the innocence of childhood, as well as the natural beauty of the great outdoors. Photograph by Jo Alice McDonald.

Van Dyke, Thomas Gainsborough, Joshua Reynolds, Jacques Louis David, and John Singer Sargent. If you have an opportunity to visit a gallery, go. You'll be able to study original works of art rather than print reproductions. Concentrate on aesthetics, composition, design, perspective, rhythm, style, and lighting to see what constitutes a work of art. Some outstanding photographers sketch the composition they're trying to achieve before the session. Others bring a painting or photograph into the camera room as a guide for posing family groups.

Learn to pose individuals first. Practice posing men, women, and children separately. You can then move onto posing groups. Start with small groups of two, three, and four. You might want to hire models or use your family for practice sessions. Mold your subjects into various designs, such as pyramids, "V" arrangements, and diagonals. Try to avoid having heads on the same plane. And be sure to position subjects so that they form a harmonious family unit, reflecting love and warmth.

I usually begin posing traditional family groups with the mother in the center of the design; next, I have the father stand behind her, thereby accentuating his slightly taller build. An ideal design relationship is to have the mother's eyes approximately even with the father's mouth. I then add the other relatives so that

they complete a pyramid, "V," or diagonal design. If an infant is part of the group, I'll have the adults form a "protective nest" around the baby. The resulting portrait tells a story of a family bonded by generations of love.

ESTABLISHING A MOOD

To be successful, family-group portraits should depict emotion. In addition to showing a family's love, you want to capture this feeling forever in a photograph that will be handed down from generation to generation. Place the figures close together and link them. Direct your subjects to touch hands, rest an elbow in the mother's lap, or place a child's head on the father's shoulder.

Family portraits can be activity-centered. Instruct the relatives to read a book; you can also have the adults gaze at a child in the group. You might want to try camera-centered portraits. Here, family members look at the lens, so all faces are readily visible. Ordinarily I shoot both ways because some clients prefer one style over the other.

When you study the work of portrait painters, you'll notice that Gainsborough usually depicted his subjects looking at the viewer, while Sargent typically had his subjects involved in an activity. Both were popular painters in their day, so your approach is just a matter of taste, then as now. Some highly regarded photographers don't always even show the subjects' faces in portraits. They work from the back or in deep shadows. It is absolutely essential for you to communicate with your clients beforehand, so that you know their preferences. Some customers like dark backgrounds, while some like white backdrops; some like smiles, while some don't; and some like sharp photographs, while some like soft-focus images.

When I work with subjects to achieve compelling expressions, I try to get my clients to look cheerful. To do this, I ask them to think of something pleasant, such as a favorite family meal or vacation. If I'm shooting an activity-centered portrait, I'll direct the family members to play with an infant or a pet. The result: a portrait of family that appears to be genuinely happy.

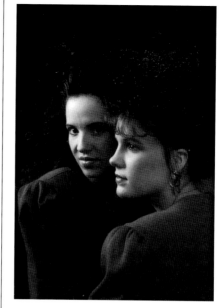

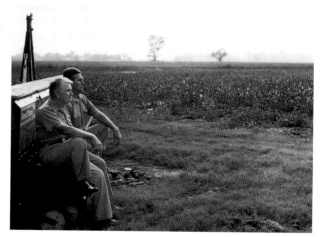

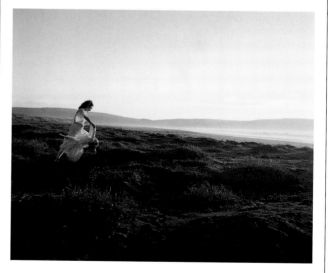

In these family-group portraits of two people, I used my subjects' arms and legs, as well as the tilt of their heads, to establish lines of composition. Placing subjects in the left third of the print also helps composition.

CHAPTER 26
ANIMAL PORTRAITS

Some portrait photographers specialize in pet pictures, while others work with pets only occasionally. But enterprising—hungry—photographers don't like to turn down any job, so it is helpful to know something about the subject. Quite often, family groups insist on including pets in their portraits, so photographers must be willing either to learn this specialty or to face the possibility of losing the assignment.

A veterinarian once told me that human medicine is simple compared to animal care because with people you have only one species to deal with, but with animals, you have hundreds. Animal portraiture is similarly difficult because photographers must deal with sundry kinds of creatures and many breeds within each species. Like each human being, each animal has its own personality, which requires special attention.

PHOTOGRAPHING DOGS AND CATS

Probably the most common animals appearing before a camera, either alone or with family groups, are dogs. You might find yourself photographing big dogs, little dogs, friendly dogs, vicious dogs, dark-furred dogs, and light-furred dogs. Cats, which comprise the second-largest group, are more difficult to photograph. They're easily frightened by their new environment (the studio), strangers, and flashing lights.

If a dog or cat needs to be moved or brushed, I let the owner handle this task. I've been nipped four or five times during my 30-year career, always as a result of being careless and moving too quickly. I've never been seriously injured.

POSING DOGS AND CATS

For studio sessions, all animals need time to adjust to the strange surroundings. So I let them sniff around for a while before attempting to pose them. If you don't know how to pose animals, study pictures in magazines aimed at pet owners. These images will also give you ideas about backgrounds and lighting setups.

Backgrounds for animal portraits are similar to the ones I use for people pictures. These are canvas, muslin, seamless paper, room settings, and outdoor locations. When I use a muslin background, I'll pull a piece of canvas over a table or bench, so that it blends into the background. With other backgrounds, I cover the table with some unobtrusive velvet material. My goal is to show the animals without calling attention to the props and background.

For both dog and cat portraits, I ask the animals' owners to remove their collars, which are distracting. Animals are more likely to stay in one place if they're posed on an elevated perch. I try to pose the animals on a table, bench, chair, or couch for another reason: to get a background light behind them. I like to take advantage of the drama and subject/backdrop separation this type of illumination produces.

I shoot outdoor portraits of animals in a fenced garden, so I can let dogs run free without any fear of them escaping. When I photograph dogs and cats in the camera room, I close all the doors. I don't want them to wander into an area where they can get hurt.

Once I've completed the lighting setup and posed the animal, I use a noisemaker at the moment of exposure to get its ears erect. Like children, animals have a short attention span and become bored quickly. When a noisemaker stops being effective, I switch to a small bell, then a whistle, and then coins in a metal can. I use these noisemakers with cats, dogs, and horses.

You can go only so far when you pose animals. For example, I try to do most of the session with a dog's mouth closed, but it is acceptable to shoot one or two exposures with its tongue out. Because dogs are more likely to keep their mouths closed in a cool camera

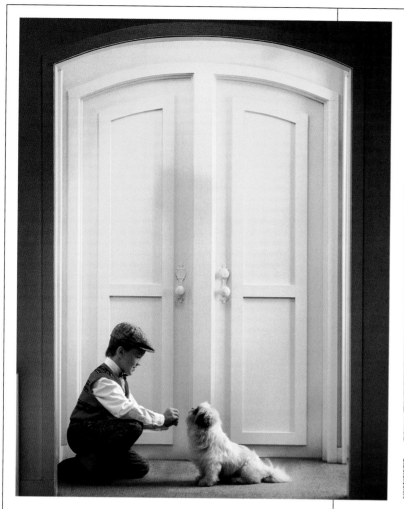

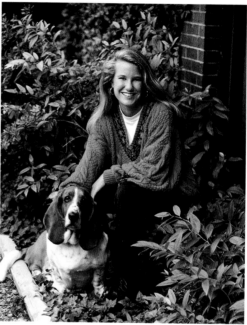

During this session, the boy got the dog's attention with a small piece of food (left). For the main light coming from hallway, I aimed a Photogenic Powerlight into a 45-inch Eclipse umbrella and used bounce fill light. I took advantage of north light for this informal portrait of a young woman and her dog in the garden outside my studio (below). The garden has a roof overhang that blocks toplighting, thereby preventing shadow pockets near my subjects' eyes.

room, I keep the air conditioner going full force, even in winter. Sometimes I put lemon juice in an atomizer bottle and ask the dog's owner to spurt some into its mouth. Then when the animal closes his mouth to taste the juice, I ring the bell to get his ears to stand up and quickly make the exposure.

LIGHTING DOGS AND CATS

The various lighting setups used for furry animals are similar to those used for just about any other kind of portraiture. Be aware, however, that animals might require more exposure because their dark fur soaks up an incredible amount of light. A dog or cat with black fur can require either two additional stops of light or the use of a fast film. For example, when I photograph a black dog or cat alone, I usually switch from my standard indoor ISO 160 film to ISO 400 film, keeping the same *f*-stop.

If you don't have any experience in this specialty, you might want to run exposure and lighting tests with a friend's dog or cat. Practice with animals that have dark-, light-, and medium-colored fur. Conduct these trials just like other "ring-around" tests: make one exposure exactly as the flash meter indicates, another exposure one stop over that reading, and a third exposure one stop under the suggested reading.

I recommend making extra test shots two and three stops over the meter reading, too.

When a dark-furred animal is included in a family group, I place the dog or cat closest to the main light. Obviously, the animal receives more illumination than the human subjects do. With some jet-black dogs, I aim an extra spotlight, such as the Bowens Monospot, at the animals. They then get two more stops of exposure than the people in the picture do.

Accent lights, such as hair lights and rim lights, add texture and depth to animal portraits. They can create luminous highlights around the edges of the animals' fur. I never use diffusion with animals; I prefer their fur and eyes to be tack sharp.

PHOTOGRAPHING HORSES

Because of the subject size, equestrian portraits are easier to do when the horse is in a valley and I am on a hill. This eliminates the problem of the horizon line cutting the photograph into two parts. Available light is best in the first hour after sunrise and the last hour before sunset when shadows are soft, reducing contrast.

A background blends best with a horse if it is solid green, doesn't produce hotspots, and doesn't contain such distractions as fences, barns, and telephone poles.

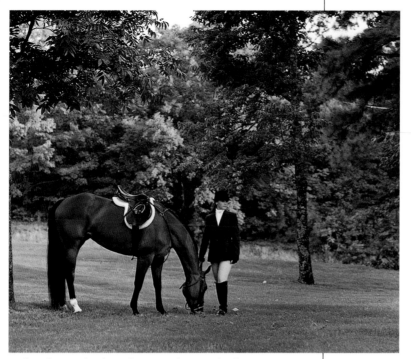

I placed some food on the ground to get this horse to graze near its owner's feet. I made this portrait approximately an hour before sunset when the light was soft.

If people are included in picture of the horse, I do most of the session with the rider dismounted. This way, their faces appear big. When the rider is astride the horse, their faces are small because the camera is so far from the subjects.

In addition to poses showing all of the horse, I move in for a full-length shot of the rider, showing the front half of the horse. If I want the horse's head bent back toward the rider, I put honey or peanut butter behind the horse's leg. When the animal bends its head down to lick its leg, I press the shutter-release button. In the resulting image, the rider will be standing between the horse's front and back legs.

I prefer to use a 150mm lens with horses to minimize the problem of foreshortening. I use an 80mm or a 50mm lens only in extreme circumstances. Closeups showing faces of the horse and rider are popular poses, and it is possible to use a reflector in these situations to soften shadows. Profiles also work well, with both the horse and rider looking either in the same direction or at each other. Just as in profiles of people, the light should be behind the subjects in profiles of riders and horses.

For these profiles, I ask an assistant to stand in front of the horse with a noisemaker to get the animal's ears erect at the exact moment of exposure. When I have a difficult time getting a horse's ears up with noisemakers, I get a lightweight acrylic mirror, about 24 x 30 inches in size. I let the horse see its reflection. This strategy works almost every time, but be aware that a spirited horse might run toward the mirror, thinking that it sees another horse.

PHOTOGRAPHING SNAKES

Although many people are afraid of snakes, the nonpoisonous varieties are among the easiest pets to photograph. For the most part, these snakes stay in one place and move slowly. In addition, they don't require any special lighting techniques because their skin reflects light just as human skin does. The most common snakes I'm asked to work with are pythons and boa constrictors, and I almost always include their owners. Best of all, snakes don't require you to resort to noisemakers to get their ears up!

To get a snake to "pose" where I want it, I have the owner hold it behind its jaws and position the head correctly. This sometimes means unwinding the snake from the owner's arm, leg, or neck. If I photograph a snake alone, without its master present, I get it to move by gently tapping its tail.

I wouldn't accept an assignment to photograph a poisonous snake, although I once caught and photographed a live rattlesnake early in my career. I say "once" because I never did it again, especially after seeing the rattler strike at the wire door after I put it in a cage. Venom flowed from its fangs. At the age of 20, I was young and foolish; now I confine my photography to nonpoisonous snakes.

PHOTOGRAPHING BIRDS

Frequently owners want to be photographed with their birds. These usually are parakeets or parrots, although I've photographed hawks, eagles, and a myna bird, too. The eagle had been hurt, and the caretaker was preparing to return it to the wild. The myna bird was able to imitate any noise, including the telephone and the doorbell. The bird's master said that he was continually getting up in the middle of the night to answer the telephone, only to find out that it was the myna bird.

The easiest way to shoot bird portraits is to have the bird perch on its master's finger. This pose brings the bird close to the human face. A black velvet background works well with birds by bringing out their brilliant plumage. I usually use a hair light above them and perhaps a rim light coming in from the side to make the lighting more dramatic.

Pets keep life from getting dull in the camera room, as well as add revenue to portrait sales. Once pet owners find that you have the ability to work with animals, they'll become regular customers and tell their friends about you. The only animals I refuse to photograph are skunks!

PROFILES

YUMIKO ARIGA

TOKYO, JAPAN

A third-generation photographer, Yumiko Ariga heads Photo. Kunst-Atelier Ariga, a studio that has photographed members of the Imperial family, Japanese prime ministers, and other famous people. Along with her mother, she directs five studios in the Tokyo area and more than 50 workers.

After graduating from New York's Rochester Institute of Technology in 1986, Ariga came back to Japan to take over the family business following her father's death. She directed the opening of new studios at the Royal Park Hotel in 1989 and Keio Plaza Hotel in 1994.

Ariga is a member of the Professional Photographers of Japan, INKEN (Professional Photographers' Organization), BUNKYO (Professional Portrait Photographers' Association) and The Society of Photographic Science and Technology of Japan.

Photo. Kunst-Atelier Ariga was founded by my grandfather in 1915, so this is our eightieth year of business. We have studios in four hotels in the Tokyo area in addition to the main studio in downtown Tokyo.

Most Japanese couples get married in hotels, so weddings account for more than 90 percent of the work in our four hotel studios, contrasted with the Ginza studio where portraiture makes up 80 percent of sales. The other 20 percent comes from weddings and commercial accounts.

Members of the Imperial family, prime ministers, ambassadors, financiers, doctors, artists, and musicians have been photographed by our cameras. In recent years, Japanese young people have been influenced by television and magazines from all over the world, so they are more educated in art and photography. I think it is important to research the market and change our styles as people change. High quality is the key to success in the future.

About 10 times a year, we advertise in the newspaper prior to such occasions as Adult's Day, 7-5-3 Year-Old Day, Decoration Day, and wedding season. For example, January 15 is Adult's Day, a national holiday when 20-year-old people get dressed in kimonos and have their pictures taken at portrait studios. Then they go pray for their health and future.

Adult's Day is one of the busiest times of the whole year for portrait studios in Japan. We promote Adult's Day with advertisements in a national newspaper in December and on New Year's Day. If people have their portraits taken on Adult's Day, we send them direct-mail advertising for graduation photos two years later. We continually market ourselves to the public.

Since I was a child, I've always been interested in art and photography, but I never had my own camera until I went to the United States as a high-school exchange student and decided to make a journal with pictures. Then I made a decision to become a photographer and studied at the Rochester Institute of Technology (RIT) for four years, receiving a Bachelor of Fine Arts degree in 1986.

One method RIT used to help me was photo critique. The teacher gave certain exercises so we could see how everyone else solved the problem, letting us learn techniques and ideas from each other.

My father died in 1985 while I was in college at Rochester, so my grandfather encouraged and advised me until he died in 1993 at the age of 104. Since my father and grandfather have passed away, my mother and I currently participate in the business. My mother, Masumi Ariga, does office work and accounting while I handle marketing and photography.

Some of our photographers have worked with us for more than 20 years, so we leave them in charge of our hotel studios. We have about 50 workers altogether: 20 at the main studio in Ginza; 8 at the Keio Plaza Hotel in Shinjuku, Tokyo; 10 at the Keio Plaza Hotel in Sapporo, Hokkaido; 7 at the Royal Park Hotel in Nihonbashi, Tokyo; and 5 at the Keio Plaza Hotel in Hachioji, Tokyo.

Most of our staff members study with us for about five years, then return home and work for their fathers' studios. We try to give them as much experience as possible while they are here, so they rotate from position to position. These include photo assistant, negative developing (black and white or color), negative retouching, printing (black and white or color), print retouching, and mounting.

Photo. Kunst-Atelier Ariga aims to be an all-around studio history-wise, art-wise, and technique-wise. My father and grandfather had lives full of ups and downs. My grandfather spent seven years in Berlin, studying photography and working as an assistant in a portrait studio that was under Imperial House patronage, making portraits of Kaiser Wilhelm II. Pictorialism was at the zenith of its prosperity, and my grandfather was influenced by it very much. He learned not only diverse lighting skills but also varied printing techniques, such as the gum-bichromate process, the pigment process, and the albumen process.

Because the people were nice and the technique highly advanced, he told me he would have stayed and worked in Germany if World War I hadn't broken out in 1914. However, it was very dangerous to remain in Berlin, so he decided to leave the country. It took him about three months to return to Japan, first escaping to London, then boarding a Japanese repatriation ship in Marseilles. On the way, passengers feared pursuit of the warship Emden, so they had to turn off the lights for an entire week. Sailing through the Suez Canal, and on the Indian Ocean and the Pacific Ocean, they finally arrived safely in Tokyo late in 1914.

My grandfather opened the first atelier half a year later, photographing people exactly as he was taught in Germany. The Japanese people were used to a lot of negative retouching on their faces to achieve a doll-like look, but my grandfather showed shadows,

wrinkles, and unevenness of the skin clearly by not retouching too much.

It took a long time for his natural look to be accepted by the public, but his first photo exhibition at the Shiseido (the cosmetic company) Gallery in 1925 won unstinted praise. After an article in the newspaper, business improved and he started to see the light of day.

Portraits were very expensive at that time, and only upper class people could come to portrait studios and have their pictures taken. As our customers spread the news, more and more people came to the studio, and our business began to grow.

From then until now, our building has collapsed twice. The first time was due to the Great Kanto earthquake in 1923, which had a magnitude of 7. The studio was completely destroyed by fire; we lost most of the exposed dry plates and original prints.

Ten years later, my grandfather constructed a five-story concrete building a couple of blocks away from the first one in Ginza. In World War II, it was bombed by B-29s, but fortunately we lost just the upper part of the building. My grandfather became ill after the war, and my father supported the family by developing negatives and prints for American soldiers.

Since my father had a bachelor's degree in dye chemistry from the Tokyo Institute of Technology, he was very interested in color photography. He researched it extensively, matching color negatives and paper with strobe lighting. My father taught photo science at Chiba University for almost 30 years, in addition to lecturing to photographic associations and institutions. He showed an interest in almost all kinds of visual media, such as VTR, holography, and ceramic photography.

In 1966, my father and grandfather built the studio in Ginza where we're located now. It is an eight-story building housing the studio and a beauty salon (which is managed separately). My father's extensive collection of old cameras, tintypes, and daguerreotypes are in a showcase in our reception room where they can be admired by the public.

When I was studying at RIT, a number of nationally recognized photographers presented lectures to us: Ernst Haas, Horst P. Horst, Arnold Newman, and Annie Leibovitz. It was a great experience for me to listen to these photographers and see their enthusiasm. I recommend that aspiring photographers go to lectures, museums, and art galleries as much as possible. They should become sensitive to contemporary design and visual aspects of society.

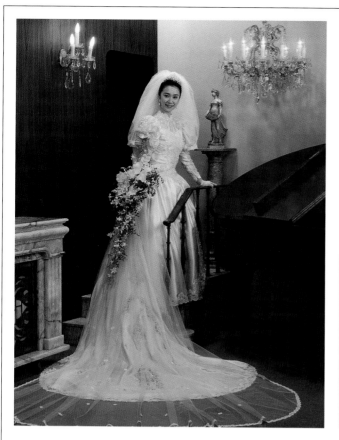
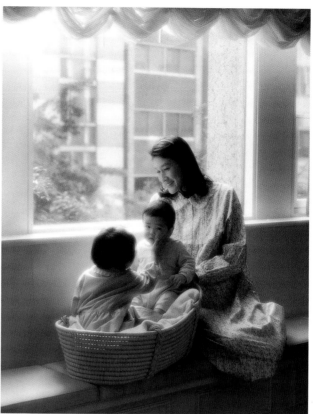
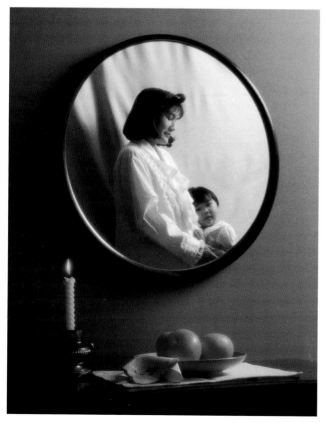
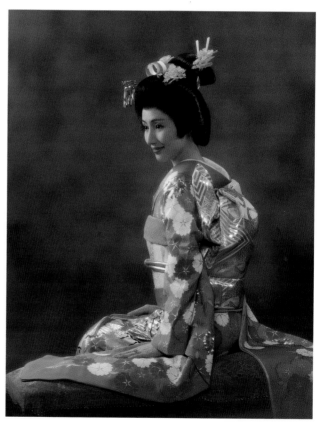

GREGORY AND VICKY BARCKHOLTZ

SAGINAW, MICHIGAN

Six times in 11 years either Gregg or Vicky Barckholtz won Michigan Photographer of the Year honors. Vicky took the high-point trophy in 1993 and 1995, and Gregg won in 1984, 1989, 1990, and 1994. Both professionals hold Master of Photography and Photographic Craftsman degrees from Professional Photographers of America (PPA).

Vicky and Gregg were speakers and judges at the New Zealand national convention in 1992, after appearing at many state and regional conventions in the United States. In 1994, each had four entries accepted for the PPA Exhibit, and three of their prints went into the Loan Collection.

Vicky has been among the top 10 photographers in Michigan every year she has entered the competition, and she won a Kodak Gallery Award in 1992. Her work was exhibited at the Midland Art Gallery.

A qualified PPA national print juror and member of the Cameracraftsmen of America, Gregg won four Kodak Gallery Awards and one Fuji Masterpiece Award. Kodak has used several of Gregg's images, including one for the cover of the inaugural issue of Kodak Times and others for numerous magazine advertisements. He was a speaker at the 1990 and 1995 PPA national conventions.

It doesn't matter which of us is behind the camera. The quality is the same, and we feel this is a great asset for our studio. In fact, all four members of our staff at any given time can do the other's job, but some naturally are better in certain areas than others.

Once people start talking to Vicky on the phone, they are hers if she wants them as clients. She is also number one in the salesroom, but all employees sell about the same number of prints. We don't want to squeeze the last dollar out of our clients and run the risk of never seeing them again. We want to meet their needs, so they'll come back over and over.

I am absolutely the worst person when it comes to sales because I want to give everything away. I do portrait photography, black-and-white darkroom work, mounting, and matting, and I write poetry for our advertisements and brochures. Our employee, Holly, handles the weddings, team pictures, and negative masking. Pat, who has been with us for 10 years, is responsible for accounting and banking, in addition to sales.

In 1994, Vicky came across the old, dilapidated garden area of the Saginaw Art Museum. Because of its historic value, she and the curator discussed a plan to restore it. With her typical enthusiasm, Vicky approached the curator with an offer to donate our 100-dollar sitting fee to the museum for every session in the garden or at our studio during a two-month time span.

This had a two-fold purpose. The first was to elevate the perception of photography as an art form in the eyes of the public, with the museum validating that thought. Second, we wanted to raise money for an area of the museum that had been obviously neglected.

The museum sent an invitation to its members, and we dispatched a flyer to our entire direct-mail list. In planning the promotion, the curator came to our studio and really liked the black-and-white portraiture she saw on our walls. The result was an exhibit entitled "The Art of Contemporary Portraiture: The Work of Master Photographer Gregory Barckholtz." Running from August 17 to September 4, 1994, the exhibit was a wonderful public-relations venture for our profession. It affirmed photography as a valued art form.

Booklets showcasing children, families, and graduating seniors provide another effective form of advertising for us. Even though only about 10 percent of the booklet deals with high-school seniors, we send it to them because those 3,000 homes not only have students who are about to graduate, but have other needs as well.

Four different mailings directed to parents go out every year. One of the most effective advertises "Children's Week in the Park." Another successful direct-mail piece emphasizes family groups. All of these pieces are done on our computer with a color printer.

Sometimes I feel I am ahead of my time. Five years ago, I spent 2,400 dollars on the creation of a senior video, but I can't say it was successful direct-mail advertising. In the studio, however, it became a more effective way to book prospective seniors. And instead of going through the mechanics of setting up slide projectors, our staff prefers the ease of video equipment. We also mail the videos to prospective clients who call from a distance.

Our photography careers started out of the need to support our family when my carpentry job dried up due to a building recession in the late 1970s. I'd taken photography courses in college, and I was taking pictures of football games and whatever else the local newspaper could use. About that time, I won a Kodak amateur photo contest, and friends started asking me to shoot special occasions for them.

The first wedding I photographed brought in 45 dollars. I stuck a K-Mart flash on my Canon camera but had no idea of what I was doing. Fortunately, the pictures turned out.

After that, I thought I could make more money doing portraits. So I ran an advertisement in the local newspaper shopper, offering to make pictures in clients' homes for 10 dollars. The first and only job I got from that ad required me to drive 45 miles, only to find out that my subject was a 2-year-old child with spaghetti all over his face. I hung up a bedsheet as a background and, needless to say, the pictures were terrible.

On the sidelines of a football game, I met a man who had just bought a studio. When he asked me if I could print color, I replied, "No, but I can print black and white." The man then said he could teach me color if I would go to work for him, and that turned out to be my first break.

In addition to darkroom work, I did weddings. The studio owner made me wear a powder-blue tuxedo. In six months, I could see I was doing better work than the owner because he was putting my work in the window. I knew I needed to move forward, and others who were aware of my potential encouraged me to do so.

Vicky's uncle had a beauty salon with a spare room and offered it to me as a studio. It gave us exposure because people were going in and out of the salon. Since I didn't have any lights, I

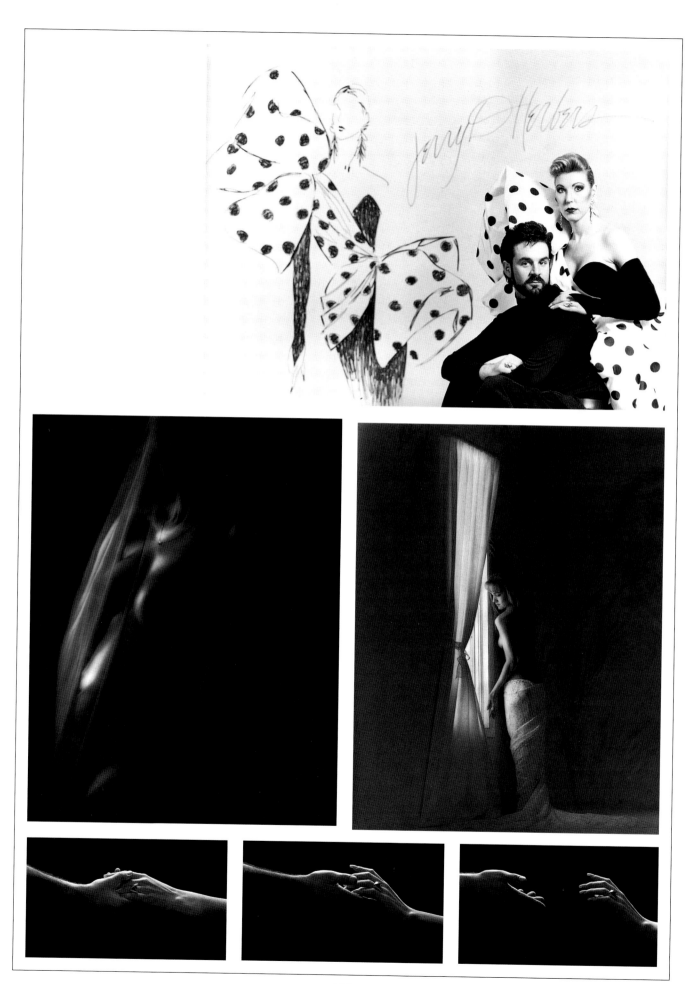

did the portraits outdoors, and people liked them. About this time (1980), I became a seminar "junkie," going to every program within driving distance. Leon Kennamer was one of my first instructors, teaching me to see light. I joined the Mid-Michigan Association in 1982, and the other members convinced me to enter print competition. At the Michigan Professional Photographers convention in 1983, I finished in the top 10, and the next year won Photographer of the Year.

Around this time, I was booking every wedding I could do and my outdoor photography was doing very well, so I decided to make a studio out of my garage at home. It had beautiful outdoor locations because we lived in the woods. After a couple of years there, the local high school gave me its senior contract. That was a great break because it gave me 120 clients instantly.

Not only was our business growing, but our family was expanding, too. We put up our house for sale with plans to build a house with a studio in it. The house sold in May, and we had to move the studio into a "temporary" shopping center location. Instantly our sales doubled, and I knew we were going to remain there instead of building a studio in our house. We stayed in that location for four years, expanding every time another unit adjacent to our space became available to rent. In 1990, it was evident that it was no longer advantageous for us to rent, and it was now time for us to own our own building. Vicky and I built a new studio with 3,200 square feet, which we expanded in 1995 to take care of our growing business.

People get into our profession because they have a love of photography. Unfortunately, many photographers don't have a strong business background to help them do what they love and still support themselves. My advice for someone starting today is to have a good command of the craft and a strong desire to learn, balanced with at least a two-year study of business. And when you open the doors of your business, devote as much time to business as you do to photography.

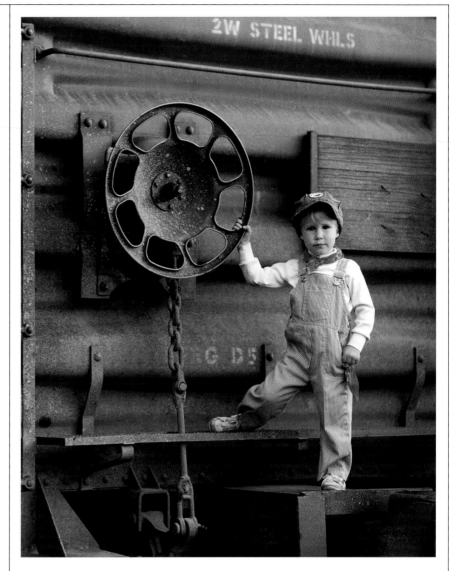

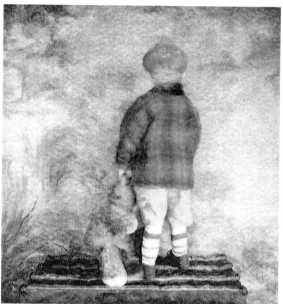

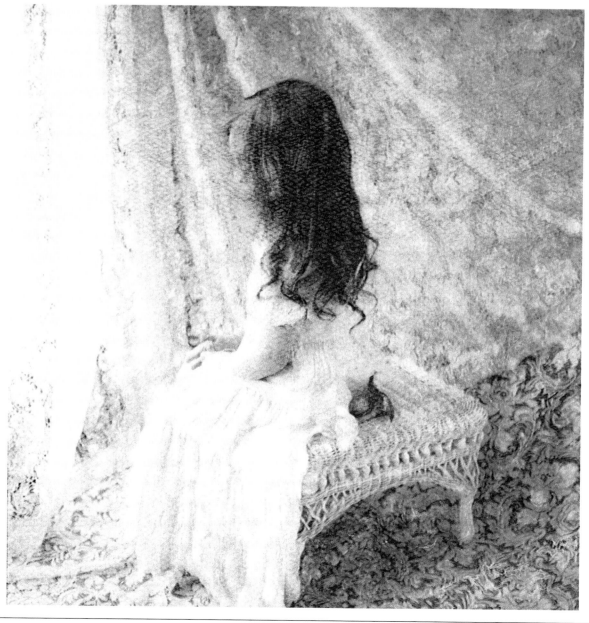

FRANK E. CRICCHIO
PORT ARTHUR, TEXAS

To date, Frank E. Cricchio, noted worldwide as a teacher and educator, has accumulated almost 900 merits, more than anyone else in the 100-year history of Professional Photographers of America (PPA). A former president of PPA, he earned the Honorary Master of Photography, Photographic Craftsman, and Certified Professional Photographer designations, as well as the American Society of Photographers (ASP) Fellowship.

Mexico and Japan awarded Cricchio their Honorary Master of Photography degrees, and the United Kingdom named him an Honorary Gold Circle Photographer. The director of education at the Winona International School of Professional Photography for three years, he is an honorary professor of Sam Houston University and a graduate of Lamar University.

Cricchio's prints have been exhibited at the New York Coliseum, the Photographic Hall of Fame, and Kodak's Epcot Center at Walt Disney World. He has spoken more than 12 times at the PPA convention, 8 times at the Society of Mexico convention, and 3 times at the Canadian National Convention. He has also made appearances in Spain, Japan, Germany, France, Switzerland, the Republic of China, Indonesia, Manila, Singapore, Thailand, Hong Kong, Brazil, and the United Kingdom.

We always thought if you turned out the very best product possible, the clients would beat a path to your door. As I look back on my career, I see that isn't always true. If you have a good marketing plan, they'll come to your door.

I don't think people place enough value on skilled photographers. They have to dream up the concept, produce it, package it, and sell it. We have one of the few occupations where you get to take a project from conception to completion all by yourself.

We are lucky in that we work with people when they are happy, and they can provide us with an emotional high as we see our creativity fulfilled. If I had to choose, I would prefer a photographer with the ability to communicate over one with technical ability. With what we have today, equipment becomes second nature, and it should be. It allows us to be more creative.

The best education for a photographer would be a business degree with art as a minor. If you love it, you can learn photography from seminars a week at a time; learn by doing. Once aspiring photographers have their education, I suggest they go to work for someone in a town different from where they plan to set up business. Today's photographer has to be a designer with the ability to select the proper location in a home, pick out the colors, select the clothes, and advise about makeup. You also have to be involved in your community so that your customers know you, and your work must be so awe-inspiring that the viewers will say, "Wow!"

Our biggest problem is that the client isn't able to place a value on our work due to vertically integrated advertising. In other words, the chains advertise with so many prints priced so low, the clients buy by size and number instead of placing a value on the image itself and who's producing the image.

We've failed to market ourselves as artists, falling into the trap of pricing in sizes. I think that is a mistake. The other mistake is that we charge too little or nothing for our creation fee and too much for the prints. We should charge very little for the prints and a premium for the creation fee.

It is a consumer conceptual problem to determine the actual value of a photograph, but in case of a storm or fire, portraits are the first thing clients want to save from their home. So, somehow we've failed.

I opened my first studio with 200 dollars, and that took care of all of my deposits on utilities. Then I went to the bank and borrowed another 200 dollars for a window air conditioner. That wasn't very much, but 200 dollars went a long way back then (1958).

My plan was to be a commercial photographer because of all the petroleum-chemical industry around here, but the demand for portrait photography grew much more than the industrial so it became my main business. The thing that made me successful in the beginning was credit lines in the local newspaper, which didn't have a photographer at the time.

Then a television station opened in Port Arthur, and they paid me 100 dollars a week to photograph car wrecks. So every time there was an automobile accident, I photographed it for the television station, got a credit line in the newspaper, and sold pictures to insurance companies. Every time I photographed a wreck, I put my business card on the vehicle, and the insurance companies would call me.

Children, weddings, and senior portraits kept coming through the door because the consumer knew my name. The competition was so strong in the industrial market that we never really broke into it and still haven't. Our business today is 20 percent copy and restoration, 20 percent weddings, 20 percent seniors, 20 percent portraits, and 20 percent commercial.

I started out as a chemical-engineering major at the University of Texas, and then transferred to Lamar University where I got a degree in business management. I got a well-rounded education with science, journalism, and business—all of it useful in my career.

Kodak's introduction of Type C color coincided with the opening of my studio, so I instantly set up a color lab and became known as the photographer who did color. My goal for the first year was to make 5,000 dollars in profit when 2,500 to 3,800 dollars was a good annual salary. Instead, I made 25,000 dollars! My business was growing rapidly. By 1966, I had seven or eight employees with 2,000 seniors under contract.

I also entered my first print competition and wrote an article entitled "Why Brown Colors Go Blue." That little thing shotgunned me onto the speaking circuit because nobody had an answer for that previously. My fourth program was at the PPA National Convention, and it just steamrolled from there. Someone once asked me how to get on the circuit, and I said I have no real clues. It takes care of itself if you have a good message and are good at what you do. You can't let a geographical location keep you from thinking you can't be successful because it is what is within you that counts, not where you're located.

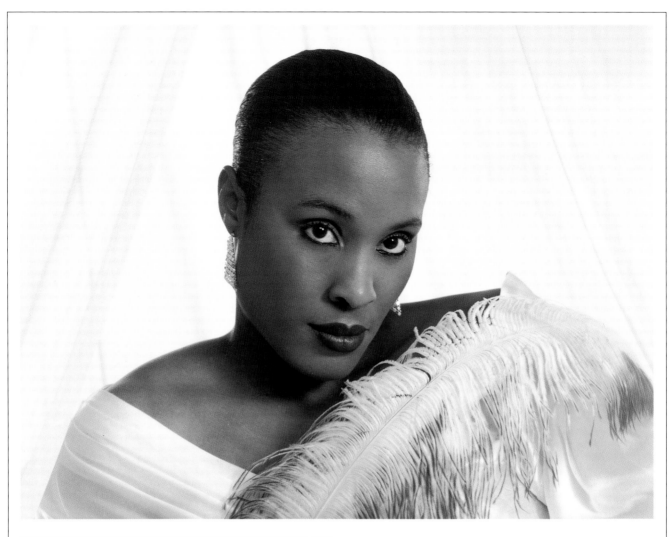

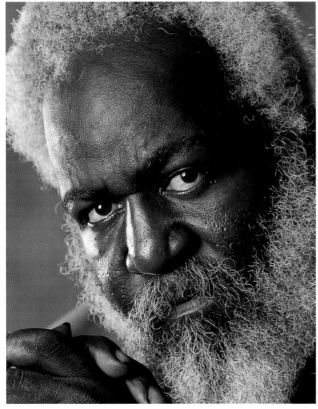

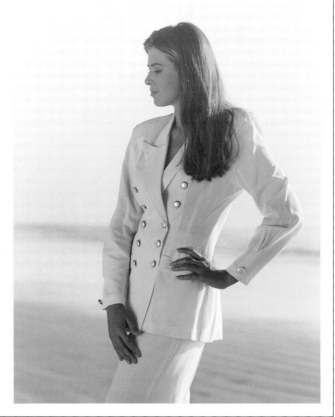

GREGORY T. AND LESA DANIEL

TITUSVILLE, FLORIDA

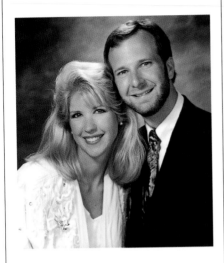

In 1991, Gregory T. Daniel became the youngest member of Cameracraftsmen of America, a prestigious group of photographers from the United States, Canada, and Mexico. He won the coveted Kodak trophy for highest print case score three times in the Florida Professional Photographers Association competition, where he placed first in most portrait and wedding categories.

Daniel has earned many Loan Collection prints and Loan Collection wedding albums in Professional Photographers of America (PPA) competitions. He earned the Master Photographic Craftsman and Certified Professional Photographer designations. Greg and Lesa spoke at three PPA national conventions, as well as at the Winona International School of Professional Photography and many state conventions. Kodak selected 11 of his images for print and display advertising, showcasing one of his portraits in its New York boardroom.

In the beginning, most of our income was derived from weddings, and we needed to focus on increasing other product lines. To accomplish this, we began photographing dance-studio recitals, where we found zillions of children, giving us a gold mine of a mailing list.

Every three months, these families received a direct-mail piece from us, offering promotion specials and—most of all—keeping our name fresh in their minds. It was in no time at all when weddings began to take a secondary roll in our income. This diversification helped our cash flow, too, because when one product line seemed to be slipping, another took up the slack.

When we moved out of our home into a storefront studio in 1987, we were fortunate to win several print-competition awards. These not only attracted the attention of our portrait clients, but also the network of bridal consultants in the Orlando area, leading us to several high-end weddings.

Then came the responsibility to always produce the highest quality and service for each client. The sales environment and presentations had to suggest superior workmanship. It became apparent that we needed to solidify the objectives and goals we wanted to achieve. With my wife, Lesa, and our staff, I brainstormed our philosophy. This led to a plan to help us remember and implement our thoughts.

First, build a business where the employees would feel they were part of the whole operation. We outlined each person's task (including ours) and empowered everyone with the ability to make decisions and change the process. This gave everyone ownership of their processes, thereby encouraging change and improvements.

Also, make our clients feel like a part of our family, where a mutual commitment would be established for a lifetime. We vowed to nurture a relationship with everyone who called or walked through the door. If we became their friends, we would understand better how to satisfy their needs, practicing "seek first to understand, then to be understood," which I read Dr. Stephen R. Covey's book, *The 7 Habits of Highly Effective People.*

We wanted to be known for the finest-quality product obtainable. Ensure that every decision isn't based on cost, but on the highest quality available. We also wanted to develop a common direction for all of us, which led to our Mission Statement: Nurture a relationship with each client. Seek first to understand, then be understood. Provide the highest level of photographic excellence possible.

When it was just the two of us, Lesa handled the sales, public relations, and telephone responsibilities while I did the photography and took out the garbage. This left a lot of production work that neither of us enjoyed, so we invested in our first employee to pick up the production end. This proved to be money wisely spent because it enabled us to concentrate on the areas where we excelled: increasing our production and quality.

Until 1987, we operated out of our home with our business dominated by weddings. For the first few years, this wasn't a problem, but we knew that some day we would need to eat off our kitchen table rather than produce wedding albums and sit in our living room instead of perform sittings.

Our long-term business plan called for locating property for the construction of a studio, and in 1984 we purchased an old home on one of the main streets in our town. Realizing that major renovation would be needed, we decided on a phased operation.

The first phase consisted of renting out the home as a residence, so that income would offset the payments until we had the money to renovate, thereby giving us sizable equity before we started construction. Our plan was blessed by the Lord because commercial property in the Orlando area escalated dramatically in the next few years. Of course, we had to struggle to get the site rezoned for commercial use.

In 1987, our plan materialized as builders transformed the old house into an elegant studio with efficient use of space. Patience paid off as the major overhead expense of rent became an asset rather than a liability in our business portfolio.

Both before and after opening our new studio, Lesa and I have emphasized education as paramount to growth. At age 21, my life switched into high speed after meeting Lesa. She sparked energy into my life and career. Early on, Lesa encouraged me to attend the Winona International School of Professional Photography and its affiliates in different states.

Fortunately, my first course was on business, leading to development of short- and long-term marketing plans. This class marked a turning point in our career because we were able to put past experiences into perspective and begin to build a profitable business. The principles taught by Bud Haynes built on the burning desire we had to make our business a success.

My interest in photography started in junior high where an instructor took me under his wing after realizing my unusual interest in creating images.

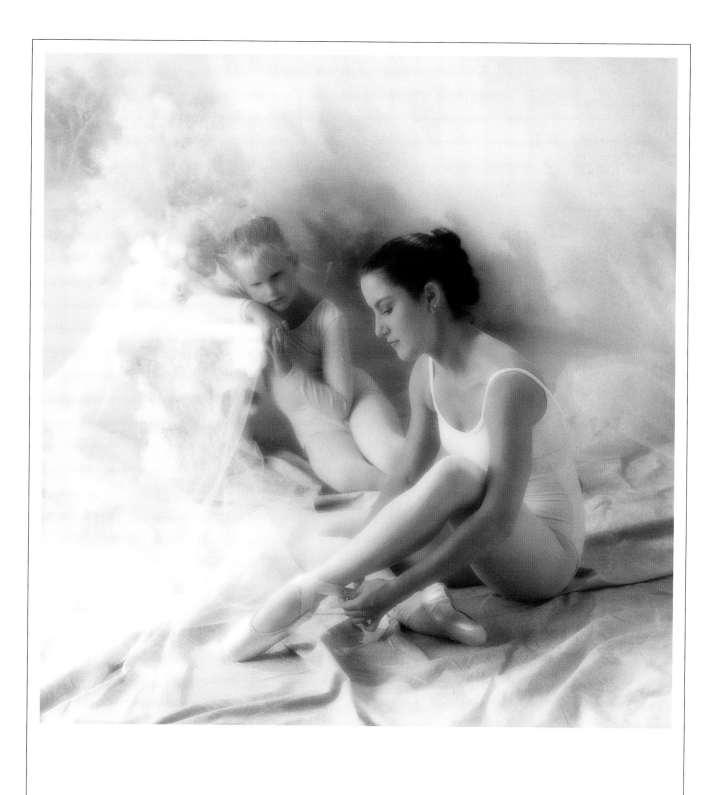

This led to involvement with the yearbook staff throughout my high-school years, while working weekends for a local photographer, selling cameras, and helping with weddings.

After high school came a wonderful job with Rockwell International Aerospace at the Kennedy Space Center. Ever busy, I started my own wedding business on the weekends while going to school at night to earn an industrial-photography degree.

The first few years in business provided me with many lessons on what not to do. There was plenty of work but no profit. After paying lab fees and associated material expenses, there wasn't much left for me.

Even though I was going to school for photography, my skills at marketing hadn't yet developed. I was unable to step back and objectively analyze my quality or marketability. However, I was gaining invaluable experience that would later prove useful in my business decisions.

Early in our start-up period, Lesa and I made a decision not to bring in additional photographers, so our style would have a recognizable signature value. This has led to its drawbacks because of the limited number of sessions that one photographer can do, and it drives up the cost for each unit sold—but it leaves your creative destiny under your own control.

The use of a reputable outside lab frees me from those responsibilities. It also lets me specialize in creating images. And computers reduce management chores and give me more time for photography.

When our sales hit 120,000 dollars and our mailing list reached 500 clients, Lesa and I decided it was time to buy our first computer. At that point, the effort to maintain manual records was overwhelming. We selected Studio Access software, which is designed to manage most typical studio operations: income, expense, checkbook, mailing list, and reports. This revealed that our cost of sales (direct expense) was 26 percent and overhead was 64 percent, leaving a profit of 10 percent. Included in the overhead are building expenses (rent), which is 6 percent of sales; salaries, 20 percent; office expenses, 5 percent; advertising, 2 percent; and miscellaneous , 31 percent.

A note of caution: Don't let a computer run your life. It can consume every moment. A computer is a tool intended to enhance and improve time management. It can evaluate your workflow processes and improve them.

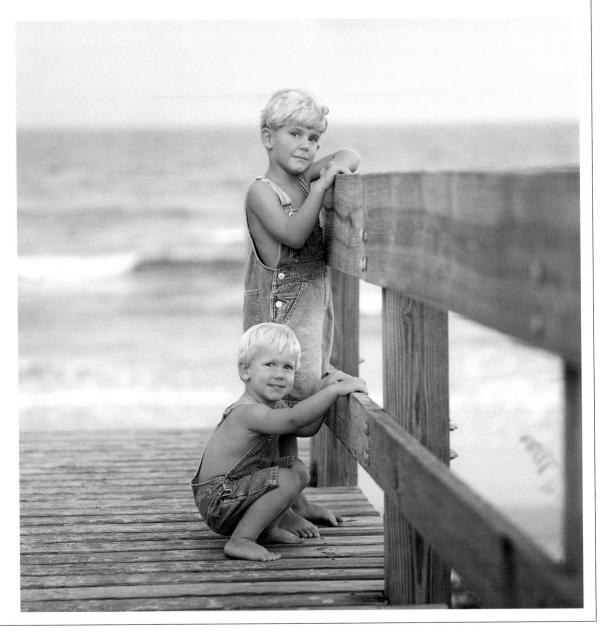

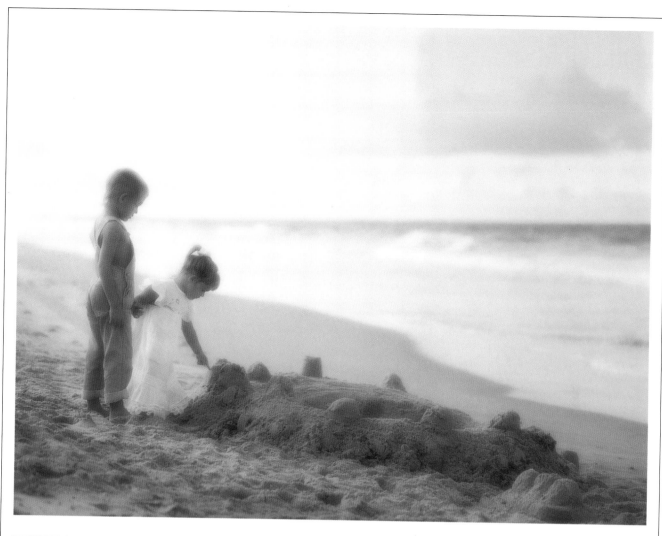

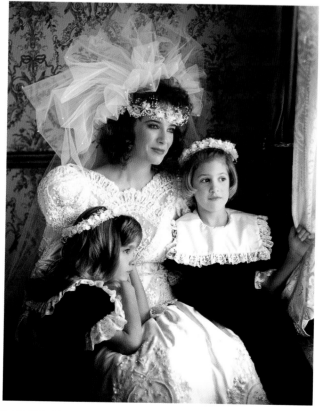

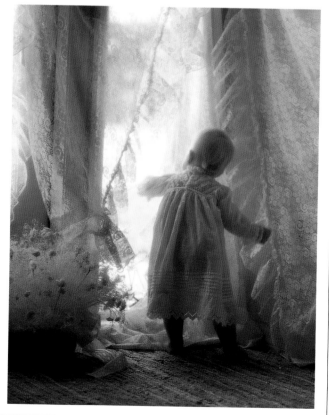

LISA EVANS

LAFAYETTE, CALIFORNIA

Lisa Evans is internationally recognized for her wall-portrait art. She lectures in England, Scotland, Ireland, Spain, New Zealand, Australia, Mexico, Canada, the Bahamas, and the United States. She has a unique flair for capturing the emotions of her subjects, winning her many accolades. These include the Medal of Honor from the Professional Photographers of Japan, the Kodak Gallery Award, and the Master Photographic Craftsman degree from Professional Photographers of America (PPA).

Evans has been named Photographer of the Year by the Professional Photographers of the Greater Bay Area many times, and her work has been exhibited in Kodak's Epcot Center at Walt Disney World. Her Mount Diablo studio in Lafayette, California, has shown an ever-changing collection of her impressionistic work for many years, attracting both clients and designers.

From the time I first opened my business, I wanted to be an artist. I wanted to create fine art for the wall but personalize it by adding people. I needed to find ways to show the public that I wasn't running the typical photography studio where they could go to buy an 8 x 10. I wanted to attract people who wanted large art for their walls.

I didn't want to follow the standards the industry had set. I created an environment to cause my clients to expect something different from the record of faces they expected of the usual photography studio. No cords, no lights, no cameras—just a tastefully decorated conference room and slide show that filled their minds with ideas beyond their original expectations.

I decided to combine my office with an interior-design firm. This was a great first step for me because I moved into a beautifully decorated office long before I could afford to have such a place of my own. Here, the clients came into an environment that helped make it clear that I had something different to offer. I held the initial design consultations, and all photography was done on location. I was in business, and it was happening. Eventually, I outgrew that office situation and moved to my own space in the same building, but with storefront, main-street visibility. I continued to grow. I saw no obstacles, only opportunities.

I feel lucky because, from the beginning, I knew exactly what I wanted to do. That allowed me to focus all my energy on studying great portraiture and on appropriate marketing and business techniques. Too many photographers make the mistake of compromising their dream in the beginning. A scary thing happens when you print your name on a business card and hang your name over the door. It is called overhead. It causes most photographers to start responding to anyone who walks in their door. They produce what they're asked for, and put out work that will sell instead of following their heart. Often, this takes photographers in a direction they never plan to go.

Think about the kind of requests that come into a portrait studio: business photographs, passports, senior pictures, weddings, etc. Notice that wall portraits aren't on the list. I carved a niche for myself, doing only the sort of work I want to do. I see young photographers entering the commercial field making promo pieces of what they think is selling in the market, and they end up with jobs photographing "bottles" instead of what they love to do.

I was told that I could never make a living solely from wall portraits.

Fortunately, I never listened, because 13 years later I've made my entire living from designing and creating portraits as art for clients. They have art on their walls that continues to mean more to me every year, and I'm following my heart, creating images I love, and never feeling that I'm "working."

If you follow your heart and trust your intuition, you'll always create your finest artwork. Put the style of work out there that you want to do, and you'll attract the type of client that appreciates your art. Take the time to think about what is really important in your artwork, listen to your heart, and follow your dreams.

For a long time now, I've been convinced that each one of us has a gift to give the world, a unique message or contribution. Throughout the course of our lives, we find different forms and ways to offer this gift. I feel my gift is my "portrait art." A carefully designed and artistically created portrait—one that captures a feeling and tells a story—is a piece of art that will evoke emotions and enhance the life of the owner. My goal is to capture this sensitive portrait, while creating art that my clients will be proud to display.

To achieve this, I must first sincerely care about my subjects. I must take the time to get to know them; otherwise, I can merely record their faces and surface selves, not how they feel. As a result, I spend a lot of time with my clients, listening to what is important to them: loved ones, special interests, places they love, and the little things that matter to them. This is the information I need to make their portraits true reflections of them.

My clients provide me with the inspiration to create something unique and different each time. The time we spend together also gets them involved and excited as they start to envision a very personal creation on their wall. The process is what keeps me fresh and excited about creating portrait art.

Too often, photographers rely on formulas that they've learned and mold the clients to fit their preconceived ideas. This is why we see so many portraits in which the subjects are stiff and unnatural looking. I try to keep my palette open and let the client take my thoughts in a whole new direction.

And many mass-production photographers rely on a formula because they have to. Their time is limited, so they can't afford to personalize their experience as we are able to do. They use known poses and backgrounds and mold their subjects into their environments. The result is a posed, usually uncomfortable-looking portrait. If lucky, it may record the faces well and

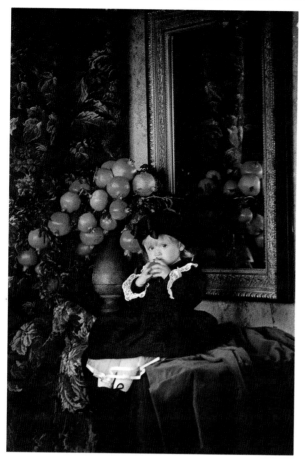

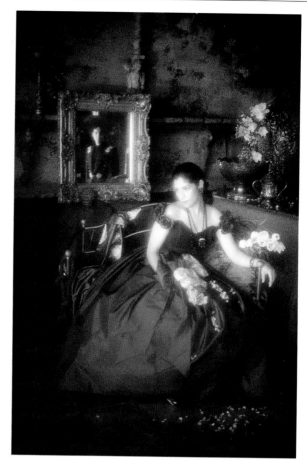

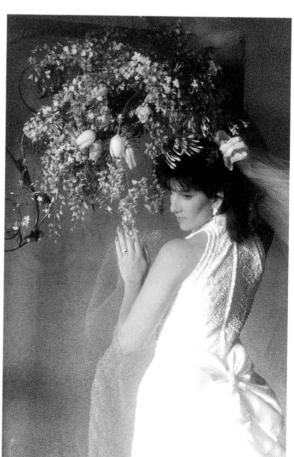

may be technically sound, but it tells nothing about the people, their feelings, or what is important to them.

Seek to understand, rather than to be understood. It is so important to build the skill of listening to inspire openness and trust and to truly care about your subject. You listen with your ears, but more importantly with your eyes and with your heart. Remember, the client has the answers; you just have to have the right questions. So much of your final success, in creating an image that truly touches your client and then in turn results in a "nice" sale, comes from the consultations. This comes from creating a relationship that allows the client to open up and give you the ingredients.

Responding to their needs and their tastes and trying to understand the story they want to tell are of paramount importance because, after all, this portrait is to be viewed and enjoyed by them, not me. This is why I need to find out about the area where the portrait will be displayed. I must know the color scheme and mood of the room, the type of wall surface the portrait will be hung on, and whether a vertical or horizontal format is required. Only then can I create a piece that will harmonize with and add to its environment.

Too often, photographers let their vision end at the edges of their viewfinders, without considering the final setting of their work. If the portrait doesn't show beautifully in its intended venue, then we'll have failed to do our jobs as commissioned portrait artists.

Compelled to go beyond my color-portrait artwork, to explore and distill the very essence of the emotions that give meaning to our lives, I began my "Photo Sketch" work. This work represents my vision and helps to answer the question I am asked most often: "How

do you capture such feeling?" For me, the answer often lies in not telling the whole story. Sometimes the emotion is contained in a simple touch or a glance. By creating a new look that resembles a pencil sketch, I can use a simple line to isolate a moment in life. These sketches can help me show the source of the emotional response. They are simple in design and almost devoid of negative or black space. The challenge is to take your vision, learn to perfect a technical method, and translate it adequately to paper. I've been quite pleased with the results, which look remarkably like pencil sketches.

Nothing is more inspiring than life itself. In 1993, I created my finest creation yet, my daughter, Quinn deLacy. What a joy! She added a whole new dimension to my work. I'm learning to see life all over again through her eyes. How refreshing! As I teach her the basics of life, I reconsider the foundations of my art. Amazing, I once thought I had experienced a lot about life; I'd traveled the world and done a lot. A child makes you realize how little you know about life. I appreciate this new sensitivity she adds to my artwork. It has caused me to look deeper into myself and to challenge myself to grow in new ways.

I value the image I create and the feeling I capture in an image far more than the pricing-by-the-square-inches reflects. Therefore, I began a pricing structure many years ago that incorporated the "sitting fee" and the first image up to 30 inches in a rate that was the minimum day rate. This reflects a commissioned-portrait look, like that made by oil-portrait artists rather than picture-takers. Their images are expected to be cheaper the more they make and cheaper by the dozen because the photographs are packaged for economy.

It has become hard to compete with the mass-production studios as an independent artist and will become even more difficult in the future. The future for sending out proofs and making a living selling 8 x 10s seems dismal. But we capture something our clients can't get from a mass-production studio—mainly feeling—and create a product for the wall. And our clients can't make their own color copies.

It has been said over and over, because it is essential, "You'll sell what you show." So for goodness sake, show what you love. Get your work out there. Get it where the people you want to attract do business. Get it into homes, shows, museums—whatever your vehicle is—and let your work be seen. Be persistent.

But remember, promotion will get you only so far. Then your art must please the discerning eye and stand the test of time. If your publicity gets ahead of your work, it will catch up to you. Authenticity is the key to marketing. Don't use the words you read on someone else's brochure that looked nice. Don't name your business with someone else's name. Speak from your heart. Tell how you feel about your work, about the gift you have to give clients, and they'll feel it is the truth.

I have a sincere desire to attempt to see the world through my subjects' eyes: to tell the story they want to tell and to capture wonderful memories every time they glance at their portrait art. Vision is the foundation on which individual artists can create what really matters for themselves, for others, and for humanity. I always want to grow, evolve, and explore my art in new ways. If you ever feel as if you have it all down, you are in trouble. Play! Don't be afraid to make mistakes. Stretch. Discover.

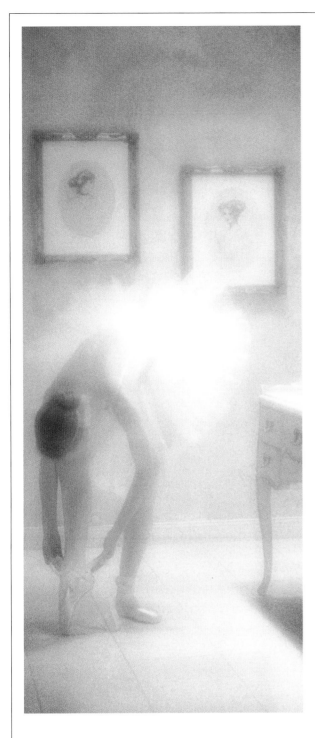

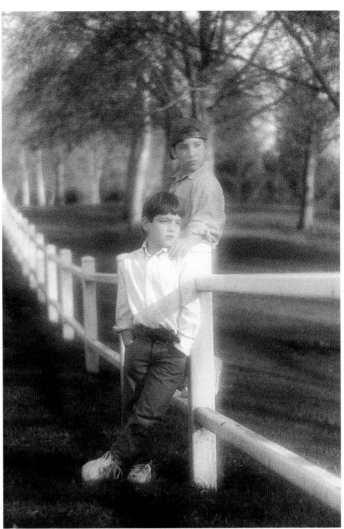

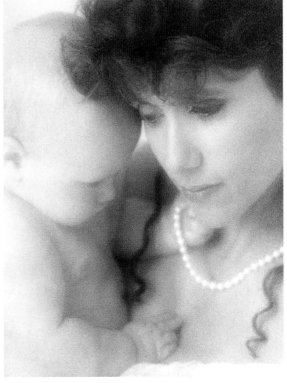

HANSON FONG

SAN FRANCISCO, CALIFORNIA

California's top wedding award winner among Professional Photographers of America (PPA) members, Hanson Fong has won international acclaim as well. He speaks to groups in Canada, Mexico, England, Germany, China, Australia, and the United States.

Fong's beautiful studio in the Chinatown section of San Francisco is a showplace for his portrait talents, and his work has been selected for Kodak advertisements. He earned his Master of Photography degree in only four years, later adding the Photographic Craftsman degree. A member of the prestigious XXV, Fong has been a professional photographer since 1979.

Starting out to be a pharmacist, I dropped out of City College in San Francisco and went into photography even though my folks regarded it as a very poor profession. When I realized that Asians love photographs, I opened a studio right in the heart of Chinatown. My staff is small, with an office manager, a contract photographer, and three part-time people. My ability to speak fluent Cantonese helped a lot. In fact, that is my first language, so if clients don't speak Cantonese, we converse in English.

I own the only studio in this area doing classical family portraiture. Most of the other studios do stylized portraits of tiny people in a vast space. Making big people look small is our strong selling point, and this includes a clothing consultation.

Projection is important in selling wall portraits, and I prefer projecting from paper proofs onto an 8 x 8-foot wall. All of our sizes have names. For example, 16 x 20 (inches) is "miniature," 20 x 24 is "small," and 24 x 30 is "standard."

Electronic projection works fine for headshots, but it isn't sharp enough for family groups. We also have a 50-inch television that we use for weddings. It is perfect for 30 x 40s, and it has a window in a window so you can see two images at one time.

The problem with that is they have to be perfectly exposed. It works so-so, but I have to admit it has helped, particularly when passersby can view the television images through our window. We advertise in the San Francisco Yellow Pages; we tried the Asian Yellow Pages, but that was a waste of money. We don't do any direct mail.

Asians don't get into high-school senior portraits, but we do a lot of cap-and-gown portraits when they finish school: high school, college, and/or graduate school.

When we book a wedding, we do a complimentary family-group sitting and that has helped because we get to know the people before we see them at the wedding. This has improved sales a lot. During the wedding season, I average one a week, which is all I am physically able to do because when I am at the ceremony I'm going at full pace. Our wedding sales average about 4,200 dollars, which is a contrast to the way I started. I would do a wedding for 225 dollars with unlimited time, which usually meant 10 to 12 hours. For 225 dollars, clients received 20 8 x 10s, and our policy allowed them to buy what they wanted, with no pressure to buy more. At that time, we were averaging about 600 dollars a wedding. The first year (1979) we did about 30 weddings;

the second year, about 60; and the third year, about 120.

I survived in those early years because of low rent. I had a 2,000-square-foot building, which rented for only 400 dollars a month, and I lived there, too. When sales reached 100,000 dollars a year, I hired my first full-time employee, but we had four photographers who got paid only when they worked. We had a shoebox operation.

My wife and I did the sales, but I found out that photographers are very poor salespeople. Then I set goals for my wife. If we did 10,000 dollars a month, we would go to Lake Tahoe, and for 20,000 dollars a month, we would go to Hawaii. She had the courage to ask for the sales and for the money. We went on a lot of nice trips! By 1989, I had maxed-out on weddings in my original studio and moved into a prime location. Now my business is about 50-50 weddings and portraits.

From 1979 through 1994, I've attended a week-long photography course every year. My first instructor was Tibor Horvath, and shortly afterward I saw the rapid posing for weddings demonstrated by Bill Stockwell. Then I studied under Monte Zucker, followed by Rocky Gunn. Nobody did the environmental program like Rocky, and that changed my career.

My advice for a photographer starting out today would be to take a business course, then a photography course, then a public-relations course. I would recommend working for a photographer over going to a photography school or an art school.

The new generation of young people want to have fun but you have to work hard. That may mean 12-hour days. Being educated is wonderful, but continuing education is better with week-long courses at places like the Mid-America Institute, West Coast School, Golden Gate School, and Winona International School of Professional Photography.

Most professionals have photographic skills, but they don't have people skills and business skills. People skills are a lost art. I have public-relations people to do my bragging for me.

Our prospective clients aren't aware of quality, so the key is to educate them about what quality is all about. They see these one-hour places in the malls, as well as the low-price ads in the newspaper, and they're confused.

When people come into my studio, I ask them what is their best side and they'll typically respond, "I don't look good either way." I study their faces and point out which is their better side. We guarantee they'll be pleased with our results.

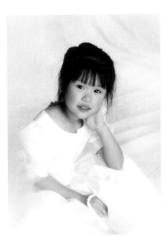

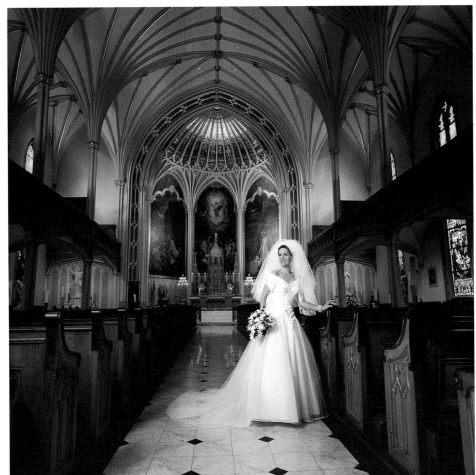

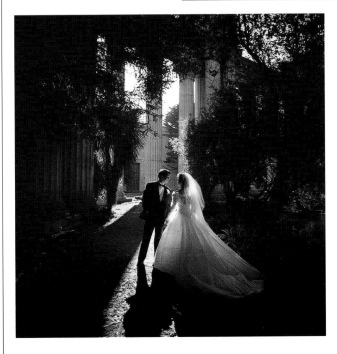

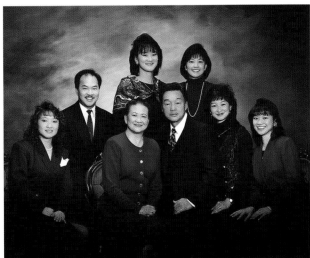

AL GILBERT
TORONTO, CANADA

Recognized as one of the world's finest portrait photographers, Al Gilbert has a list of credits that is almost endless. He is a Fellow of Britain's Royal Photographic Society and The British Institute of Professional Photography (BIPP), as well as the American Society of Photographers (ASP).

Gilbert earned the Master of Photography and Photographic Craftsmen degrees from Professional Photographers of America (PPA), and the Canadian Master of Photographic Arts degree. He was voted the Canadian Photographer of the Year in 1968, 1969, and 1973. In 1979, Gilbert was commissioned by the National Photography Collection, Public Archives of Canada, to photograph 25 leading Canadian personalities.

Gilbert is an able teacher as well as a professional photographer, whose expertise and energy have enabled him to give hundreds of lectures and workshops in Canada, the United States, Mexico, Australia, New Zealand, Iceland, and Ireland.

My dad was a photographer, and in those years you had no choice: you did what your father did. He came from the Ukraine in 1922 and opened a studio in the ethnic area of Toronto, selling a dozen postcards for $2.50 with an 8 x 10 thrown in at no charge. In my dad's north-light studio, all his pictures looked alike, although they were top quality. The poses were identical, and the lighting was identical. When he realized he was constrained in his artistic approach because he never left the studio, he sent me to art school (Central Technical School in Toronto). So I did four years of commercial art, and that is when I learned to see light and reflection. Those were the great years, the early 1950s.

When I got out of art school, I fell in love with the pictures of George Hurrell, so I built myself some little spotlights out of tin cans so I could create his type of shadow. Today, I own 20 original Hurrell prints.

The Hurrell Hollywood glamour look helped us move up in the marketplace because we were in an area where thousands of people passed our window every day. I made it a point every Friday to change the window and put in glamour pictures of young women. Obviously, every woman wanted to be in the window, and everybody would come to see who made it into the window. Every week I would put a new bride in the window, too.

Trying to get ahead, I took refresher courses under Kodak's top photographers at Rochester, where we took the pictures, developed the negatives, and made the prints. Again, my pictures started looking alike because that was the direction they wanted you to take.

In the middle 1960s, I got back to window light. I remember giving the first lecture on window light in 1969 at the Professional Photographers of America (PPA) convention in Chicago. After showing window light and outdoor portraiture there, some of the writers were negative about my program, saying that I would doom the classical portrait forever, that everybody would take their camera to the park, and no one would go to the studio again. Although I was brought up in a north-light studio, I went from bounce lights to speedlights, you name it.

During our candid era of the 1960s and 1970s, we had 10 candid people on our staff, and we did weddings every day of the week because in Toronto we had every nationality in the world. At one time, we did as many as 250 weddings a year. We worked hard seven days a week, and at the end of the year there was no money left. It all went out in wages and retouching.

After years of doing bridal portraiture on location, the next thing was wide angle. There were no books written on the type of portraiture I was going to do, so everything was a gamble. You start with the knowledge you have, make mistakes, redo the mistakes, and keep going. Window light, outdoor and classical portraiture: I involved all of them in the wide-angle portraiture. It was exciting! Winning Photographer of the Year in Canada in 1968 and again in 1969 helped me move up in the marketplace, and we kept moving. We took large windows in the financial district of Canada and kept changing them. Next thing we knew, we had large corporations calling us.

I had a photograph published in *The Professional Photographer* magazine, and I got a call from John Deere (the tractor manufacturer) who was interested in wide-angle portraiture. From there, we picked up United Airlines and Quaker Oats. I think at the time all the large corporations were looking for a new direction, and they liked the direction we'd taken. With my knowledge of wide-angle portraiture and the exposure PPA gave me, everything just fell into place.

Once we were established in corporate portraiture, we kept raising our candid-photography prices because we wanted to get out of it. You don't get out of one product line without being established in something else. I think that the most lucrative part of our business is portraiture. The fashion business has died, and the wedding business is competitive.

Today our staff is slim. We have a receptionist, a color printer, and a black-and-white printer. Starting a studio today, you have to have a storefront, you have to look and dress like a professional, and you have to be involved in the community. You can say you want a certain price, but if you don't have the goods to back it up, you can forget it. You have to have something that is the alternative to anything else that is being sold on the market.

In teaching photography at Winona and elsewhere, I can give you all the techniques in the world, but I can't see for you and I can't feel for you. If you can't see light and if you can't compose in the camera, your training will be wasted.

Every person has an attractive character that I feel I must embellish with lights and psychology to produce a portrait of lasting memory. I'll always strive in my chosen field of photography to upgrade and improve my knowledge and share it with others, loving every moment of it.

SAM GRAY
RALEIGH, NORTH CAROLINA

The recipient of more than 450 state and national awards and honors, Sam Gray is an amiable Vietnam veteran whose portraits reflect the quiet, peaceful retreat he has built in North Carolina. His remarkable background, combined with God-given talent, contribute to his portrait studies, revealing relationships, character, and values.

Gray's mastery of technique and skill have earned him the Master of Photography and Photographic Craftsman degrees from Professional Photographers of America (PPA). His work was exhibited at the International Hall of Fame and Walt Disney World's Epcot Center. A popular teacher, he has lectured in more than 25 states and Canada, as well as the Winona International School of Professional Photography.

With the Vietnam War going full force, I joined the Army because of the draft and thought it would be fun to jump out of airplanes. Wounded and sent back to Japan to recuperate, I bought a 35mm camera, which led to my photography career.

For the last year and a half of my Army tour, I worked as a photographer, then upon discharge found a job in a studio for a short time doing school pictures. Afterward, I worked in television news and started doing weddings on weekends. About 1968, I started working out of my home and a year and a half later realized that I needed more space. A few months after moving to a shopping center, I calculated I could buy a building for what I was paying in rent, and I did. Providing 1,300 square feet of space, it worked out fine for about eight years.

In 1979, we sold both our home and studio to combine them into a 6,000-square-foot home/studio operation. Since my wife and I own the entire building, we are able to lease the lower level to the photography business, using the rent to help make payments on the house. Now we are able to redecorate the studio and not have the pressure of a lease.

The lower level is the studio where we have a camera room, a consultation area, a display area, and a small presentation room for audiovisuals. That is where the clients see a 10-minute slide show, describing clothing and backgrounds, so they can advise us on what they like. We also have another room with a couch and six projectors where sales are completed.

Originally we showed paper previews, but now we're showing only slides. I think it was hard for clients to visualize size from a paper preview because they had to see something projected on the wall. That was always a sales battle. Now with slides we can project a 40 x 50-inch image on the wall. In the past we served popcorn and soft drinks during the sales session, but it got too untidy.

Maintenance, inside and out, is done by part-timers, and we use outside contractors as much as possible to keep our staff small. I do all the photography and bookkeeping, and our one full-time employee handles consultations, sales, and computer work.

With about 280 sittings a year, our average is in the neighborhood of 2,500 dollars on a mixture of families, children, and brides. For the past 25 years, I've specialized in the things I enjoy the most. I don't do weddings or any commercial work. Our goal is to schedule sittings three days a week, so we can work on orders, displays, advertising, and book work the other two days. The most I do in a day is four sessions.

The studio is landscaped, so we can do outdoor sessions year round, but I prefer to work outside when it isn't too hot or too cold. Usually, we can do outdoor portraiture about 10 months of the year. I would say about 40 percent of our sittings are in the studio, 40 percent are outdoors, and 20 percent are in the clients' homes. I like variety.

Mall exhibits have been our most effective advertising, but we've tried everything over the years: magazines, radio, newspapers, and television. We have a 4- or 5-inch advertisement in the newspaper every Sunday with a portrait in it. That way you see the photograph first, next the logo, and then a one-line motivational message. In addition to displays in a couple of malls, we also have an exhibit in the baggage-claims area at the Raleigh-Durham International Airport. We have to rent these spaces.

At all the exhibits, we have a card for prospective clients to fill out, and it has really worked well. They have an opportunity to win a portrait gift certificate worth 100, 200, or 300 dollars, and we get valuable marketing information. The card asks what they expect to pay for a portrait, how they rate our work, etc. We also have a referral card, so that every customer has a chance to get a gift certificate by giving a referral.

Our area population exceeds 900,000 and continues to grow, thanks to mild weather and the Research Triangle supported by Duke University, the University of North Carolina, and North Carolina State, all of which are within 30 miles of each other.

The weakest area of my career has been the lack of business knowledge. I feel the Lord gave me talent, but I needed to go to school to learn more about our business. I've been able to watch what others have done and capitalize on their strengths. I've tried to learn from my errors and not repeat them. It is hard to tell someone where to begin, but I would say study business first because the photography will be easy if you enjoy it. Learn sales, marketing, and advertising—things that you can use in everyday business.

Because of the advance in electronic cameras, I think photography as we know it today is on the decline. We've been seeing it coming for a long time. Now it is possible to take a photograph in one part of the world and send it by satellite to a newspaper or television station on another continent. I think portrait photography is coming to that, too.

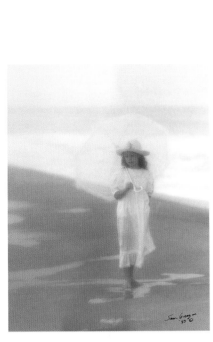

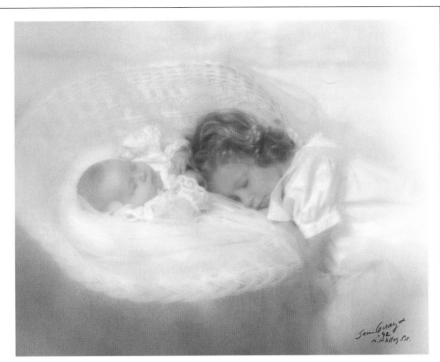

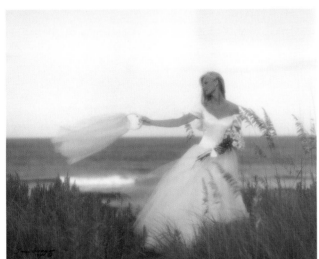

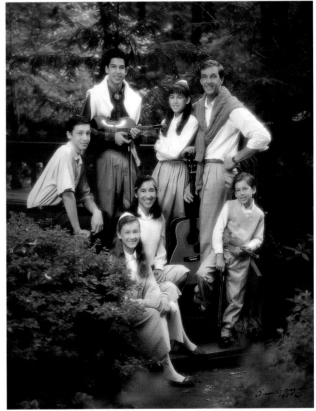

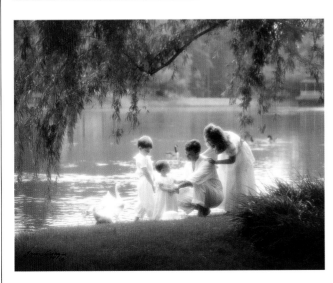

CHARLES GREEN

LONDON, ENGLAND

Creating portraits for Queen Elizabeth and Prince Philip at Buckingham Palace, as well as Prime Minister John Major, puts Charles Green at the pinnacle of portrait photographers around the world, as well as in London, where he makes his home. He caters to discerning clients who want only the best.

Some well-known personalities who have sat before his lens include Richard Branson, Sir Andrew Lloyd Webber, Sir David Frost, the Archbishop of York, Lord Forte, Anita Rodick, O.B.E., and many more. Green has won 12 Kodak Gold Awards for creativity and technical excellence, the highest number any single photographer has ever won. He is also a Fellow of the Master Photographers Association, a Fellow of the Royal Photographic Society, a Fellow of the Royal Society of Art, and a Fellow of the British Institute of Professional Photography (BIPP).

In 1991, Green was awarded the Master of Photography degree from Professional Photographers of America (PPA), whose members have selected many of his portraits for their national exhibition-and-loan collection. His photographs also have been chosen for display at Walt Disney World's Epcot Center in Florida and the World Council of Professional Photography, which tours the globe.

Author of the book, Shooting for the Gold, *and co-producer of three best-selling instructional videotapes under the same name, Green also has produced an inspirational audiotape entitled "Creating Success." He is on the cutting edge of electronic imaging and its application to social photography, for which he received the BIPP Presidential Award.*

One of the most wonderful days in my life was when I photographed Her Majesty the Queen and Prince Philip at Buckingham Palace. I'd finished taking the portraits and stood back waiting for them both to leave the room. The Queen's private secretary beckoned to me to come forward, and Queen Elizabeth came over to me. She shook my hand and spoke to me for over five minutes. Then as she turned to leave, Prince Philip came over to converse with me for another 10 minutes. It still is the highlight of my life. I shall treasure the memory of that day forever!

People decide to come to us because they want to buy our number-one product. No, it isn't our photography. Our number-one product is us. They come because they like what they've heard about us and the way we do business.

It is, therefore, very important to make a good impression, to dress smart, and to be polite, even when you are outside the studio. If there is a problem or complaint, deal with it to the customer's total satisfaction, even if the customer isn't right. The goodwill this creates is the best publicity money couldn't buy. The most important wall in the studio is my "brag wall," which is located in the reception area and can be seen clearly from the street. The wall is covered with certificates, diplomas, and awards. We rarely receive a complaint. When people see the wall, they think I must be fantastic. Therefore, they realize that if they have a complaint, they must be wrong.

Not many people start at the top. Most start at the bottom, and that is where I started. We were so poor that the first argument I had with my wife was because she was washing the milk bottles with hot water, and we couldn't afford to pay the electric bill. I first decided I would like a career in photography, or rather the movies, at the age of six. Sitting every Sunday at the cinema, watching cartoons, Laurel and Hardy, and Charlie Chaplin, I decided I wanted to become a film director when I grew up.

By the time I was 20, having spent two years at the London School of Film Technique and having directed numerous short films and documentaries, the last thing I wanted was to become a film director. I hated it. However, I'd fallen in love with still photography and decided on a freelance career as a photographer specializing in special effects for pop groups and singers.

Although I managed to get some work by going to agents and showing them my samples, I was hardly making any money from it. Pop groups would split up before I delivered the proofs. Members would change, and some would order prints while drunk or on drugs and then refuse to pay because they couldn't remember ordering them.

Then I met Toni, the woman I knew was the one I wanted to marry. She was from Belgium, and after 10 days I proposed to her. Her parents were concerned that I wasn't earning enough money to live on, but they had an idea. They told me of a photographer in their town who was doing very well photographing weddings and suggested that maybe I try doing the same thing. Although I didn't particularly like the sound of "wedding photography," (pop groups sounded much more exciting), I did want to get married. So I decided to give weddings a try. I hung a picture of a female singer in a local restaurant with the words: "Creative Weddings by Charles Green." I soon had a call from a bride, who invited me to her house to show her parents my work.

Having shown them many 10 x 8s of pop groups and singers, the father asked to see some of my bridal portraits. When I told him the truth—that I'd never photographed a wedding—he nearly threw me out of the house. However, his daughter argued with him, explaining that because I was so artistic and enthusiastic, I would probably take better wedding photographs than someone who had been doing it for too long a time.

They argued for some time, and eventually the bride won. I had my first wedding! That was on August 20, 1972. From that wedding, I received three more and from each of them, yet more. I also was getting bookings at each weddings for portrait sessions in peoples' homes. That was the beginning of my success.

The only gear I had then was an old Nikon camera, and I rented other equipment as needed. All monies I received were invested in purchasing equipment, and within a year I had my first Hasselblad camera. I'd never advertised, as at the time there wasn't enough money to do so. All the bookings were by recommendations and referrals, and so it remains to this day. Every picture that is purchased has my signature on it, and this is my advertising. Every award I receive creates as much publicity as possible.

My belief has been that to earn money, one has to work for people who have money. So I've aimed to provide the best quality of product and service to discerning clients at the top end of the marketplace. I could then charge a high price and produce low volume without the need for staff.

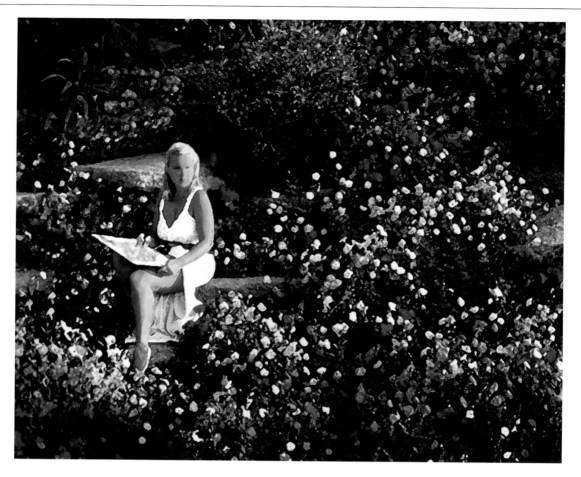

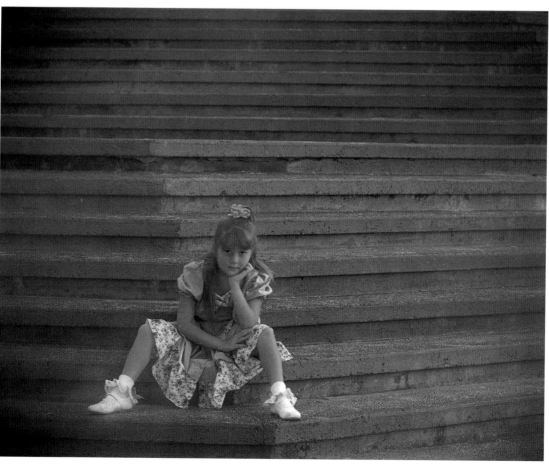

After two years, we moved from a small, rented flat to a beautiful house in one of the best areas of northwest London, all thanks to wedding and portrait photography. Two years later, unable to have peace and quiet at home due to clients calling and visiting at all hours of the day and night, we opened our first studio and employed our first part-time receptionist.

We continued to grow and needed larger premises. Four years later, we moved to our present studio in London's main shopping area and employed two more full-time staff members. I decided the best place to set up business would be in an affluent area with exquisite shops and homes, where people expect to spend money on beautiful products. The volume of work was such that we needed to install our own color lab on the premises in order to maintain the quality of photography and speed of service that our clients expected. So we added a lab and took on a lab manager.

In 1994, we became the first portrait studio in the United Kingdom to install our own electronic-imaging room, thereby giving us the ability to scan, manipulate, enhance, and print images electronically.

I believe my success is due to a number of factors. First, I've identified my ideal market for weddings and portraits and provide the exact product that appeals to these clients. Second, I'm continually improving my photographic and marketing skills. I also provide the best possible service and product quality. And by my winning awards, my name is regularly featured in newspaper and magazine articles.

Before making any major decisions, I always seek the advice of my "A" Team (my advisory team). They are my accountant and my financial advisor for business plans, and my architect and designer for studio and stationery designs. I believe that to do a professional job, one needs to employ a specialized professional, just as people do when they employ me.

The future of photography is assured for photographers who continuously expand their knowledge, and their photographic techniques and marketing skills. They must be prepared to go that extra mile to satisfy their clients, always doing the very best they can. New products and technologies, like electronic imaging, should be welcomed and tried with a desire to make them succeed. We can't grow if we always do things the way we've always done them.

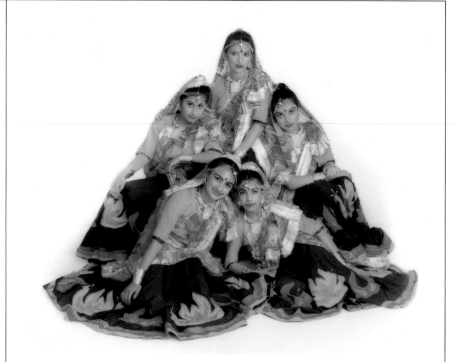

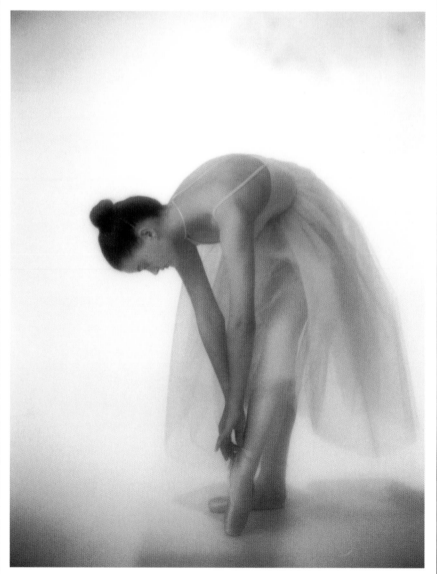

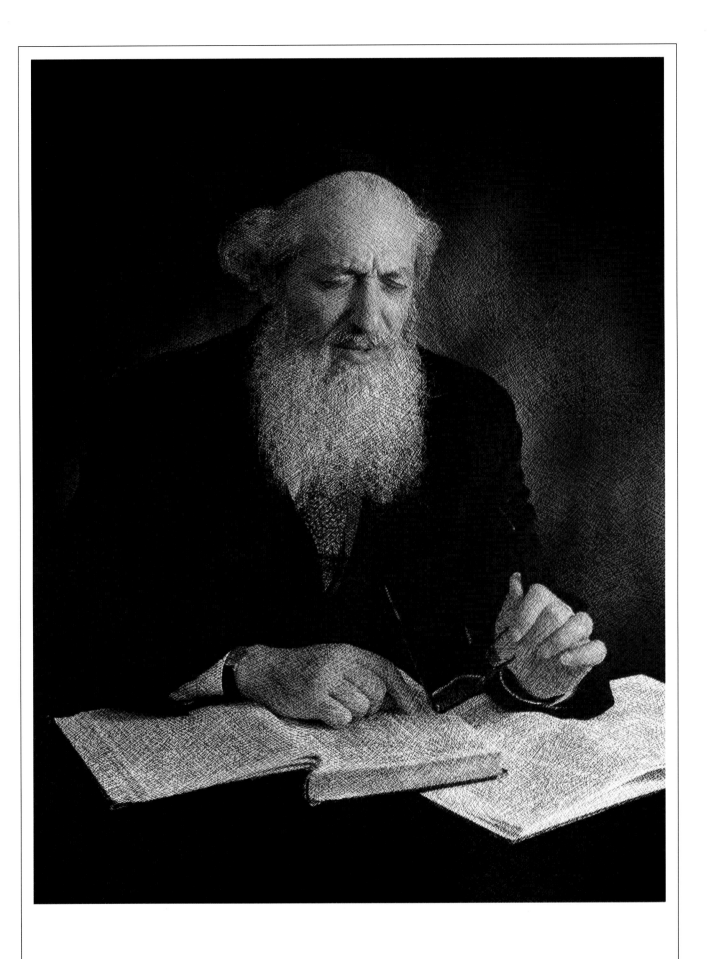

LIZBETH GUERRINA AND PAULINE TARICCO

POUGHKEEPSIE, NEW YORK

Curiosity, surprise, slight bewilderment, joy—a whole repertoire of expression is set forth in Lizbeth Guerrina's wonderfully sensitive portraits, which have earned her honor and respect from her peers. Professional Photographers of America (PPA) awarded her the Master of Photography degree in 1981 and the Master Photographic Craftsman degree in 1985. And when the American Society of Photographers (ASP) named her a Fellow in 1988, she became one of the first women in the United States to earn this coveted award.

Guerrina has given many lectures and workshops throughout America and abroad, in addition to teaching at the Winona International School of Professional Photography and the West Coast School in California. Many of her photographs were selected for the PPA Loan Collection and the International Hall of Fame. She is a member and former president of the Hudson Valley chapter of the Professional Photographers Society of New York.

Guerrina and Pauline Taricco, her partner, combine their imaginative talents to create artistry in portraiture at their studio in Poughkeepsie, New York.

To be successful in photography today, you must develop a style because if you don't, you'll just be run of the mill. If you want to make a living at photography, you have to produce something people really want. If you believe in what you do, there are people out there who will want it. From the very beginning, we had tremendous feedback from our clients, and that is inspiring.

In 1972, I wanted to have my children photographed. I took them to somebody and I wasn't pleased, so I decided to do it myself with a borrowed Rolleiflex. Eight months later, I had an exhibit, and that was it.

After working alone for a short time, I was joined by Pauline Taricco, and together we developed our style of photography and our philosophy for business. Those early years were so exhilarating! Every time we took a photograph, it was a joy to see the image we'd captured. It was so exciting seeing those images we had in our minds develop on paper.

When we went into business, we never intended to do weddings, but people just expected it. Soon we had 30 bookings a year. We really enjoyed the actual portraiture and being with the bride, but we didn't like our lives committed so far in advance. Seven years ago, we gave up weddings. It was definitely a risk because we realized that is the bread and butter for a lot of photographers. When we gave up weddings, we had enough portrait clientele built up so we couldn't fail. We don't need to do weddings any more.

When we first started, there was a photographer in the area who was wonderful, and his prices were at the top of the market. There was another photographer with high-volume sittings, so we priced ourselves in the middle. Eventually we went to the top because we felt we had earned it. Being at the top, you have to realize that you're going to cut off a lot of people who can't afford you, but you want to establish yourself as being something special. There are those who will come to you no matter what because they love what you do.

At that level, you have to offer wonderful service and tremendous variety, and we do! One major problem is that our clients are disappointed by the fact that we don't offer small prints. Our smallest print is 8 x 8, but we wouldn't suggest that for everybody.

Before we do a sitting, we ask clients to visit the studio, showing them a great deal of our work. We emphasize our philosophy of photography, that we want to create a feeling rather than just a record of faces. We listen to the parents to find out how they've fantasized the portrait of their children. We would be extremely reluctant to do a session without a consultation.

When discussing clothing, we first listen to what they have in mind, then show some things that we think might suit them. We don't like to overwhelm them with all the rules and regulations because they could say, "Oh, this is just too much work, and I don't want to do it." We give clients a broad statement as far what colors would be good. If something goes wrong, we always have backup clothing at the studio.

Our advice for newcomers is to have extreme patience in the beginning. Don't compromise your style of photography. Fill your studio walls with pictures that you really love even if you aren't getting that type of clientele in. Find people to pose for you, and do what you really believe in.

There is a lot more competition than there has ever been before. Every small town in America has a mall now, and almost every mall has two or three photography places. Now they're all doing what a general studio was doing five or six years ago. They're doing high key, low key, and all that. There will always be people who want fast service and a quick turnaround.

There also is a clientele for the professional small studio, offering extra service and something special or something unique. You have to be smarter, but the future is there. You have to be able to market to the right people. There are people with good taste, and you have to show them your work.

We have portraits in beauty salons, restaurants, and real-estate offices. We don't make any concessions for our displays; most people just like them to decorate their walls. Of course, you have to change the displays regularly or the onlookers will get to where they don't even see it.

In the beginning, we did more editorial-type advertising just to let people know we were there, but mostly we just tried to keep in touch with the people we had. We sent out thank-you cards or notes to let them know we were here.

Once we took a Lisle Ramsey course, and he stressed that our customer file is our biggest asset. We cherish our customer file—those are the people we keep in touch with. Finally, we've chosen never to have a promotion because people would wait until then to book their sessions. We like sessions coming in regularly throughout the year rather than all at once during a promotion.

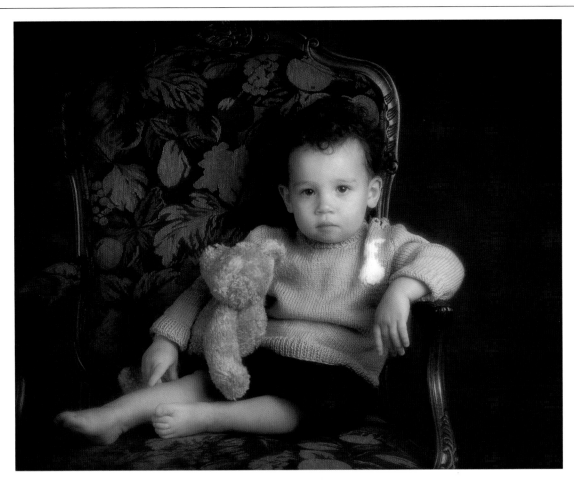

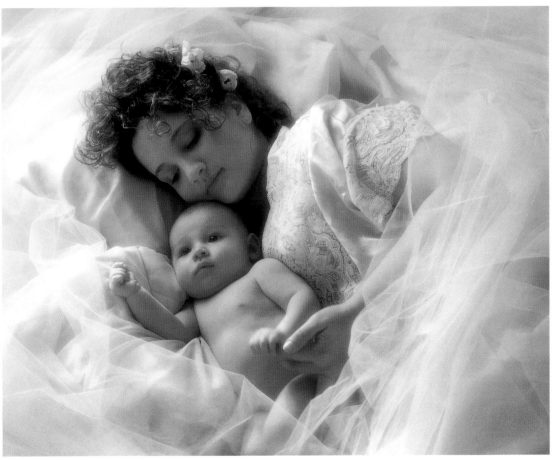

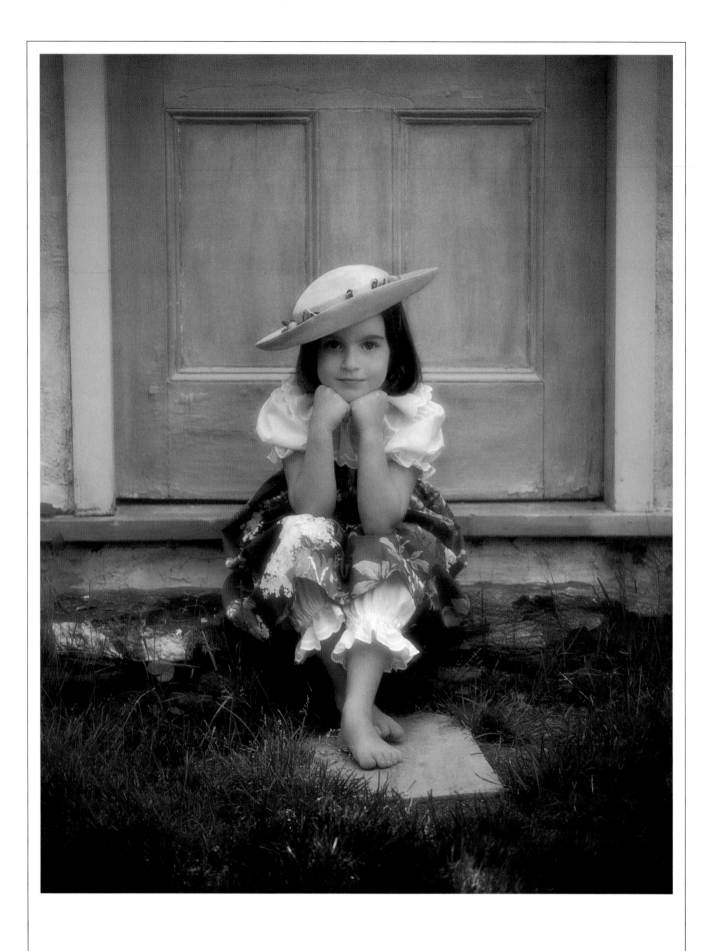

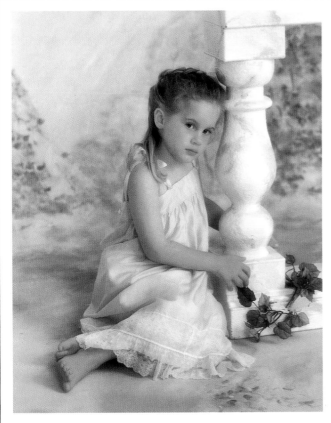

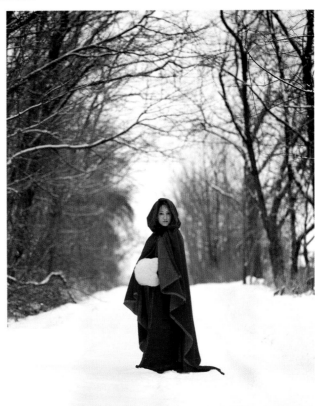

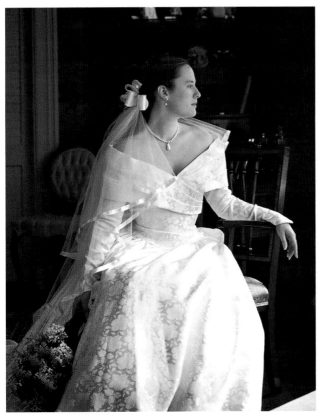

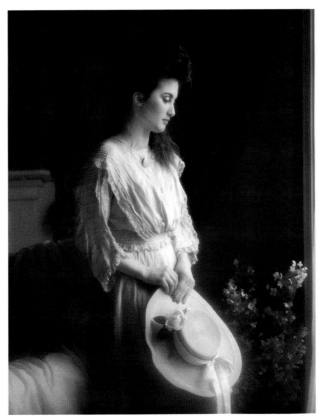

HECTOR HERRERA

MEXICO CITY, MEXICO

Four generations of the Herrera family have sought to make "photography the magic place where our feelings can perceive, capture, and interpret the show of life." Born in 1934 in Mexico City, Hector Herrera is the father, son, and grandson of professional photographers. He has done official portraits of three presidents of Mexico.

Herrera has lectured and exhibited in 19 countries on four continents and was a featured speaker at Photokina in 1986. Considered Latin America's portrait leader, Herrera has been honored by the most important photographic organizations in the world, including the British Institute of Professional Photography (BIPP), Professional Photographers of America (PPA), the Royal Photographic Society of Great Britain, Brazil's Sociedade Fluminese da Fotografia, and the Photographic Hall of Fame in the United States. He is one of 40 members of the elite Camera-craftsmen of America.

Herrera was awarded Master of Photography honors from the Mexican Society of Professional Photographers and Madrid's Association of Spanish Photographers. His photographs have been displayed at the Musée Nationale de la Photographie in Paris, the Professional Photographers of Kyoto in Japan, and the Lucky Film exposition in China.

As an "Author of Photographic Artwork," I don't sell portraits or sittings. What I sell is my personality, and people pay for it through royalties to use the portraits I capture. The system has very good results for me. As a matter of fact, I don't have employees now; I have only associates or outside contractors, retouchers, labs, occasional assistants, a driver, an expert on makeup, and a hairstylist. I don't have a computer. My manager owns it, and she does everything: letters, contracts, bills, programs, etc. Of course, I seek professional help from an accountant, a lawyer, a financial advisor, and an architect.

As a third-generation photographer, I learned family photographic techniques from my father with large formats, 8 x 10 and 5 x 7. Besides my earning money, my desire to secure my place in society made me fight to make changes in the old photographic systems. I felt the necessity to hire employees to help me with my expansion plans. I felt more employees could get more work done, and I didn't wait until I had the work to hire them.

I've established my position in the marketplace through prestige and maximum personal attention. With low volume, I have time to think about what I'm going to do. In a sitting, I am able to relate the environment and the people, so that the precise moment of the exposure is a real delight.

The principles for my "success" are the same as when I became a professional: discipline, double effort, formality, and an excellent relationship with my clients. I don't believe in success because I trust innovation.

In the creation of a portrait, the ability to give confidence to my customers is the most important step, leading to goodwill and friendship. From the first telephone call until I deliver the portraits, I'm dedicated to the joy of dealing with them. With the warmth and hospitality of my studio, they're going to open their hearts and let me identify their needs.

Because they see me as honest and an expert in my field, customers don't think about money. Their problem isn't money, but finding someone to hear, listen, and understand their necessities. All they know is they want to be photographed.

In our studio, they enter a special atmosphere that combines warmth with the excitement of a theater. "Showtime" starts with an explanation of the unique way I do sittings, talking about my experiences, followed by video and slide presentations through CD-Rom on television. If they enjoy the sitting, they'll pay more. Whether it is in the studio or on location, the most important thing to me in the entire portrait process is the relationship I've established with my clients from the very beginning. By the moment of the actual sitting, we already love each other, respect each other, and have achieved a depth of understanding that is unparalleled in other forms of communication.

Photography is a science, and it becomes art when it awakens an emotion. The professional uses technique to do a well-remunerated job, but it is the artist who uses photography to interpret the ideas he imagines and feels in his heart. This artist-photographer is a person who has the gift of feeling light, sees things others don't, and relates to people like no one else. The artist is perceptive and sensitive to everything that happens around him. He interprets all this through portraits.

The photographer learns how to be a photographer; the artist-photographer is born that way. Throughout a photographic session, I make people forget about the lights and camera. Only mutual communication is important. I am practically never behind the camera. I don't hide behind it or use it as a shield. I always use a conductor's baton to help me direct the movements of my subject. People consider it a curious extravagance because I'm not a musician. As a director, I find the baton an easier tool than my hands to show subjects certain adjustments and changes to their pose. When I'm portraying, I first create the ideas in my mind, then I feel them deeply in my heart, and produce them with delight.

Money shouldn't be the only goal for newcomers to photography. Money is a consequence of doing your best, and it will arrive in due time. For beginners, I recommend you try to understand the photographic system, the relation between light, lens, and film. Learn to portray without a camera. Learn to observe, feel the light, and imagine everything on the minds of your subjects.

Capture their personality with your heart by developing a sincere relationship with the people you're going to photograph. It is vital to know the background of each person, their environment, their friends, the image they want to be portrayed. Read books and magazines related to their community. Photography is a magic observatory from which we can watch the show of life and capture it with our feelings.

I understand emotion as a sensitive area where science and art meet and confront themselves. I consider human emotion the most important ingredient in the art of photography.

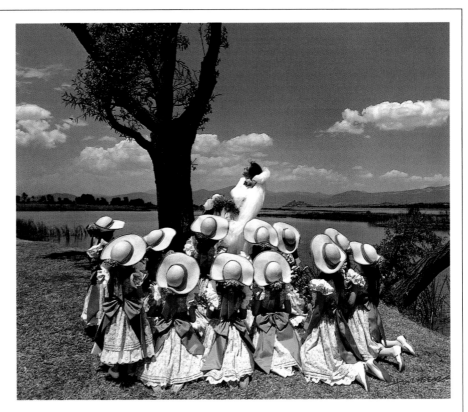

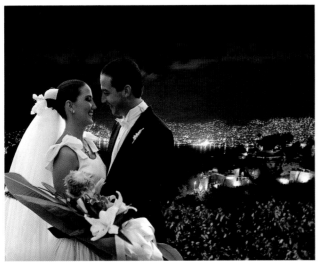

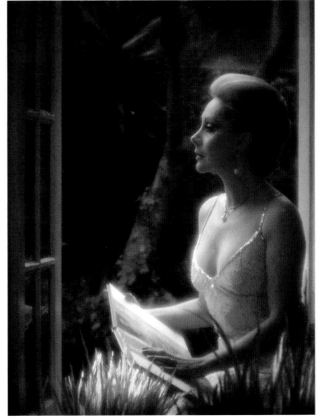

FRED HINEGARDNER

ST. CHARLES, MISSOURI

Fred Hinegardner and his wife, Rita Gamm, own Gallery Photography, a 6,000-square-foot studio just outside St. Charles, Missouri, where they do 1,500 sessions annually, mostly in an illustrative style. The American Society of Photographers (ASP) honored Hinegardner with its fellowship in 1993, and its Gold Medallion Award for the most outstanding print in the Masters Exhibit in 1992.

Hinegardner has had Loan prints every year since entering Professional Photographers of America (PPA) competition, in addition to winning the Heart of America Photographer of the Year twice, the Illinois Best Out-of-State award four times in a row, and the Missouri Photographer of the Year four times. Eight of his images in the last eight years have been selected for the International Photography Hall of Fame. During one period, Hinegardner won first place in 27 consecutive competitions. A qualified PPA national print juror and member of The XXV, he was the first photographer to be named to the St. Charles County Arts Council.

When I was 16, I figured out that questions get answered by going to a quiet place and relaxing, so I decided I would live and work for 50 years, then leave civilization on my fifty-first birthday and go alone to the quietest place of all in order to get answers to the biggest questions of all. In 1997, I'll sell my studio and wrap up personal affairs. But before I leave, I want to pass on some of the things I've learned and leave the place better off than the way I found it.

Select only people who know themselves well enough to tell you the truth. Don't let anyone else become a customer. They'll only confuse you. Second, when serving those clients' needs, don't try to please yourself and the client with the same image. The Bible, and many other books, point out that a slave can't serve two masters, for while serving one, the other is neglected.

When you contract with clients, you owe them 100 percent. Then when you get ready to please yourself with the creation of an image, you can give yourself 100 percent. This is how you get the most out of your business and the most out of your art. This is how you get the most pleasure, the most money, and the highest print scores.

It is also how your customers get the most for their dollar. Win-win. And the way you get the least out of life, with the greatest cost per print, mediocre scores, and zero financial reward, is to set out with the goal of pleasing the judges. This act is hollow.

What do clients think of me and my business? Everyone who is a client thinks that I'm the greatest, my prices are superb, and my product is the best in the land. The people who hate me or hate my product or think my prices are too high have a much different story, I am sure. But I can't call them clients now, can I? Fortunately, those people are few.

Treat every client as an individual, and don't lump clients into categories. Treat each problem for what it is: an individual problem. Don't set policies because of a few problems. Policies will standardize you, and your business, and your product. They'll also standardize your client base. Then you'll end up in a rut, and you'll stop being a happy camper. Your spirit will get damp, losing that creative spark. This is a signal that the end is near.

In photography, only truth is beauty. Flattery is fake and, therefore, a lie. Great truths can be told through fiction but never fake. Shoot the truth. Live the truth. Be moral in every action. Treat others exactly the way you want to be treated because you'll be treated that way.

There was no stress in my early years. When you're marching toward a goal and making good progress, there is only fun, excitement, anticipation, learning, growth, and cheap meals. Stress only comes later when we forget why we got into photography in the first place.

When I bought my first studio, I sold life insurance for two years in order to keep my photography going. That kept me out of PPA for a while because a local "master" said that made me a part-timer. That made me mad because he didn't think I was very serious. You have to be very serious to be selling life insurance just to keep a fledgling studio alive.

Before that, I traveled through seven states, photographing kids for 97 cents. That was my best education. I would get experience photographing 300 kids a week while I heard of studios who would photograph maybe two in the same amount of time. I figured I was forgetting stuff faster than others were learning it.

Before that, I was into photojournalism for daily newspapers. This was where I learned to tell stories with pictures, and that has carried over into my present illustrative style of portraiture. My boss gave me his old Argus C-4 35mm camera, and he let me squeeze in little advertisements wherever they had an empty spot. I had no money at all. I think everyone should start out this way. It would help thin the herd.

Someone with a huge desire and a dream could start a business today for 1,000 dollars. And if people had at least a quarter million dollars, they could ride the leading curve of the digital revolution. But without the right stuff inside, they probably would fail. The person with the 1,000 dollars would, I'm guessing, pass them in less than two years.

The foolish western idea that bigger is better is a ridiculous concept. It is wrong in every way. I ended up with 18 employees and 7,500 weddings, families, seniors, kids, and other sessions per year. To get there, I ignored all the indicators that told me I was killing myself—just to do as I was told. Grow, expand, more, more, more. I began to drink heavily. Growth—phooey. Follow your own path, the path with heart. And don't let others define success for you.

I allowed others to tell me first to get some business cards and some nice stationery, then a nice desk, a telephone, a Yellow Pages ad, and a secretary. They were wrong on every count. With age and experience come wisdom, mercifully. I no longer have employees. By the way, the last day that my last

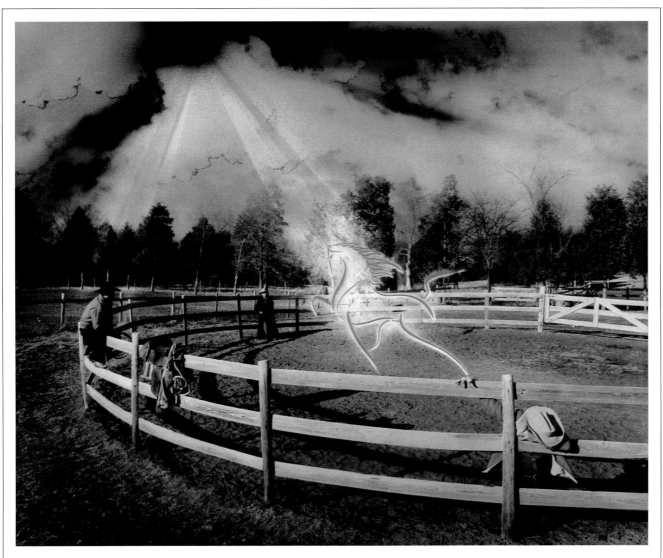

employee worked was also the very first day I sang on my way home. I got rid of my lab and put in an art gallery in an effort to raise photography to an art form in my customers' minds instead of the traditional price-per-square-inch mentality.

At the gallery, I exhibit paintings, my own and others, plus photographs, my own and others. Additionally, I combine the two art forms at times, since film and paint both have their own unique assets, as well as their own limitations.

Early on, a very smart man advised that to make it big I had to become either the best or the cheapest. All the others get lost in the shuffle. I chose to become the best because I'd already noticed that the cheapest made the most money, and that people I knew who had scads of money weren't as happy as I already was. So I knew money wasn't the answer. The best was the only logical choice. I determined to win every competition. The way to become the best at something is very simple: make sure your effort is unequalled.

After much thought, I worked out my ultimate goal: to die with a great big smile on my face. I worked backward from there. In the middle, which I chose to be my fifty-first birthday, I set out to achieve my biggest goal of all: to leave civilization for a year, at the top of whatever profession I would choose for myself, with all the money I would need for the rest of my life. Then when I got back from "the wilderness," I wouldn't have to go back to work from necessity. I'll drop all that I have and go alone, straight to the horse's mouth, there to receive answers to the biggest questions of all, avoiding the "middlemen."

What you claim to be your greatest winner now will someday be your albatross. Plan for change. What will someday be your greatest triumph is something you haven't yet even contemplated. Plan to accept change. By making change part of your being, you'll be able to learn and grow. For anything to grow, change is required. If change becomes your lapdog, then growth will come easily for you. If you want to measure your success, add up all you've given and subtract all you've kept.

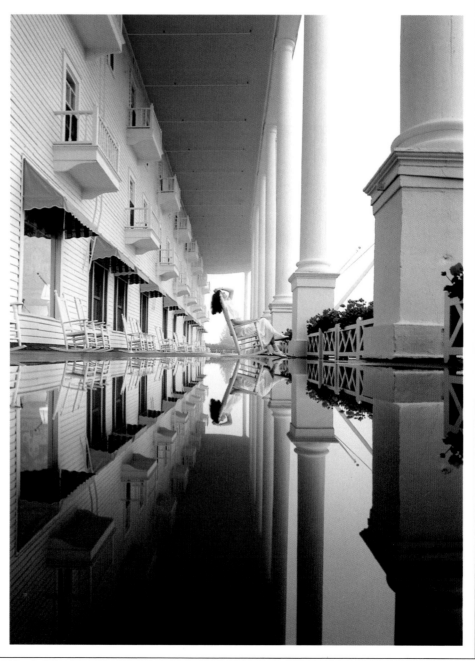

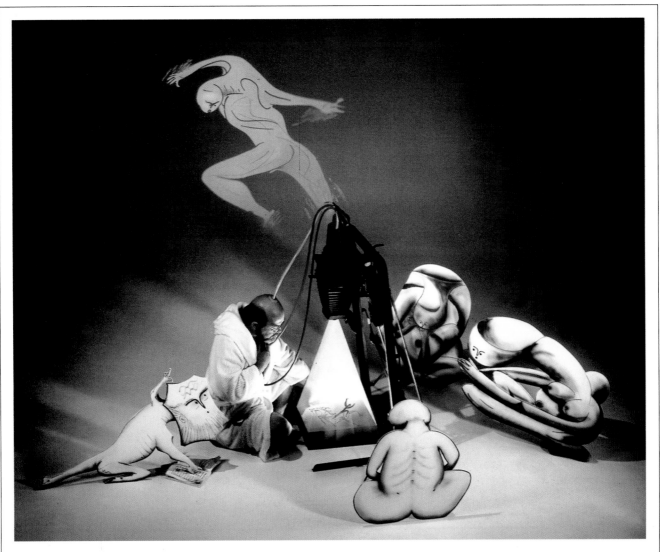

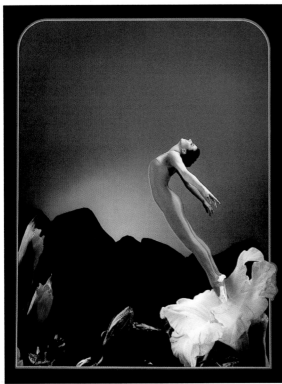

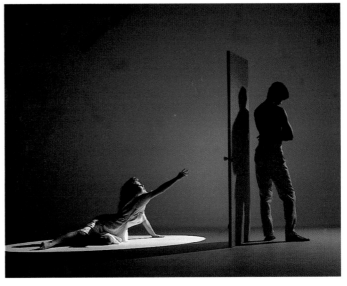

OLAV KENNETH LINGE

SANDEFJORD, NORWAY

In 1995, Olav Kenneth Linge became the sixth person ever to receive the highest print honor (gained by accumulated print-competition awards) conferred by the Norwegian National Association. Since first entering print competition in 1990, he has garnered more print awards than any other Scandinavian portrait photographer during this time period. In 1994, Linge won the prestigious Kodak Nordic Photographer of the Year, commonly known in Europe as a Gold Award.

That same year he received his Master of Photography degree from Professional Photographers of America (PPA). His prints were included in that organization's Loan Collection in 1993, 1994, and 1995. Linge also won the Scandinavian Fame Portrait Exhibition three years in a row, from 1992 to 1994.

Linge is in demand as a speaker and judge throughout the world. He is known not only for his photography, but for his ability to convey precise, usable information to his audience.

The average person loves sunsets, reflections, and romance. Our first award-winning print was of a wedding couple taken in the December frost just after sundown, using a 100-watt video lamp. This was 1990, and we still have people say, "I decided who would photograph my wedding the day I saw that picture." The impact of one photograph captured the wedding market for us.

It was important to follow up with exciting pictures, of course, but we honestly attribute much of our ability to capture the wedding market quickly to that print. Our biggest help was—and is—displaying photography with impact. We've been lucky enough to do well in print competition, which keeps press releases in the paper regularly.

At 17, I began as an assistant to photographer Harald Ohnstad in Norway, then did a tour in the Norwegian Air Force, followed by a job with Kodak-Norway, mixing chemicals. After some bit jobs with various photography studios and shops, I received an offer I couldn't refuse: working—without pay—as a still photographer on a movie filmed in France.

It was here I discovered the fantastic possibilities of combining daylight with tungsten light, a technique that through varying color temperature allows me to create more depth and dimension in my photographs. This added warmth has become my trademark. We've found that customers love warm-toned photographs. This knowledge, as odd as it seems, has really helped our sales of wall-sized prints. People, after all, spend a lot of time and money on tanning. We often use gold reflectors and tungsten light outdoors, plus warm-toned filters or maybe just the modeling lamps of the electronic lights indoors. People go crazy: they've never looked so good!

After my experience with the French film company, I returned to Norway to open a modeling agency together with a makeup artist. It was the perfect opportunity for me to begin experimenting with techniques for creating golden light under all kinds of conditions. Car lights, reflectors, mirrors, regular light bulbs—nearly everything was put to use—but 100-watt video lamps began to emerge as my favorite tungsten source.

During this period, I didn't have a studio, so I had to learn to "see" a great background almost anywhere. Spending time developing this ability really pays off, especially when your client wants outdoor photography before there is anything green in sight.

Another good skill to develop is the ability to make a picture tell a story.

When I photographed for "Det Norske Teater," one of Norway's most renowned theater companies, I had to learn to emphasize an important person or element in order to convey a message. Obviously, this skill is valid in any kind of photography.

A new opportunity arose, and I took a job as a still photographer for a large film studio in the United States. Working at the studio was interesting but at the same time quite boring. Everything was too planned, but I gained a lot of respect for true professionals and learned the value of working as a team. I almost always work with at least one assistant now because I find it allows me to concentrate on the important aspects of the shoot.

After four years—rich in experience—I returned to Norway. Without a doubt, the best thing about America was that I met my wife there. We decided that portrait photography was a more suitable profession for a family man, so Mary Lyn and I returned to Norway shortly before the birth of our first child.

In 1990, we sold our car for 20,000 dollars to buy a newly established studio in a villa in the center of Sandefjord, a city of 36,000. We lived cramped on the second floor and ran the studio out of the first. We needed to double our sales very quickly just to survive. Living frugally without a car really helped. This was possible because in Norway, wedding couples have their sittings done mostly in the studio, plus we had a garden for outdoor work. My wife assisted where she could, but our children were small so she couldn't provide a second income.

Expanding our customer base quickly was essential for us. We had two main competitors, one well-established (70 years) and the other fairly new. We knew the photography traditions of our area: weddings and one-year-old baby portraits. So we decided to get the weddings, and the one-year-olds would follow. Our marketing plan worked, although undercapitalization caused our biggest struggle.

Today, we have four children, and we've expanded from our home studio to a main-street location. We didn't increase the size of our camera room or workroom, but we now have a large showroom. We felt this was important if we were to increase our sales.

In a large showroom, a 16 x 20-inch (40 x 50cm) portrait looks like a postage stamp on the wall. The reaction from the public has been extremely positive with lots of people coming in just to look. That is exactly what we want! We don't try to sell "big pictures." We sell the "right" sizes.

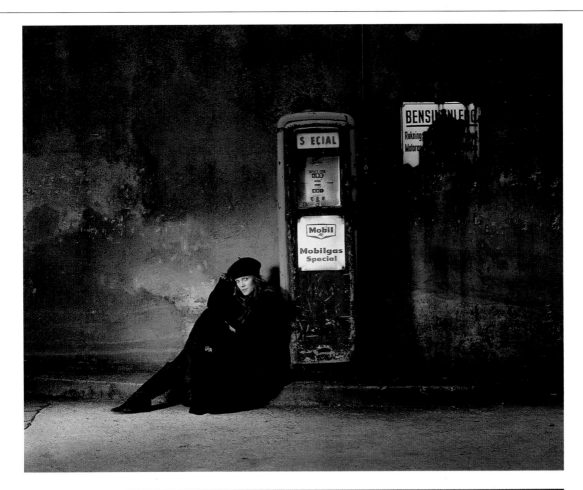

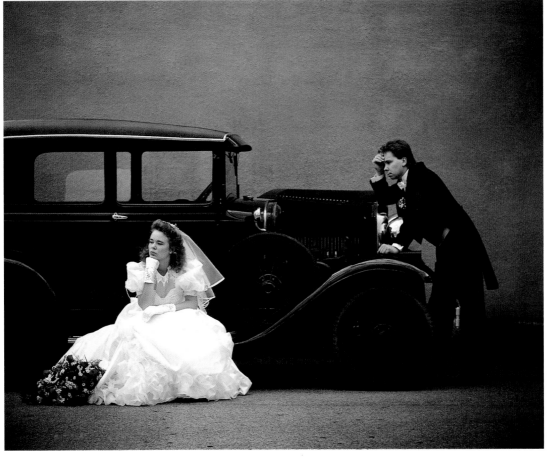

We help our customers figure out the appropriate size by considering the viewing distance and the head size of the subject in the print.

For example, a full-figure photograph of a small child, with a small head size, that will hang across the room from the sofa, from a viewing distance of approximately 10 feet, will need to be larger than a closeup portrait hanging in a hallway. It is logical, and your customer will be satisfied. You'll start taking fantastic full-figure photographs!

The other thing we concentrate on is so simple it shouldn't have to be mentioned: Make the client look good! We don't do glamour photography, but we display some trendy portraits just for our image. We sell this type of photography only a couple of times a year, but displaying the images seems to make our clients trust us to make them look good.

I spend the time to find flattering angles, and I've studied a bit of facial geometry. I am also careful not to allow the shadow areas to "disfigure" my clients, an amazingly common error in portrait photography.

"Retouch in the camera" is our motto, but we do some print retouching with wet dyes, especially on outdoor work. The Scandinavian market doesn't require retouching and would find, for example, the removal of wrinkles offensive.

Taking good pictures from the customer's viewpoint is so important. This is where variety comes in. I feel a photographer should practice with a wide range of poses, compositions, and lighting patterns. You should have your own "style," but be careful not to lock yourself into a couple of predictable variations. Each customer wants something special.

In 1990, I began entering print shows. This has proven invaluable. Through competition I became exposed to the best work in portrait photography today. I am in awe when I view the work of my peers. This respect also motivates me to stretch myself and add that extra polish to my work.

Because of our success in print competition, we've been able to create a very good image. This image is backed up by the decor of our showroom and the use of extremely high-quality frames. Halogen spots throughout the showroom are a must.

The other side of the coin is that people expect a lot. We are very careful to plan with our clients, so they won't be disappointed. Top quality must be followed up with top service.

The success I've enjoyed has come from three sources. First, I keep Sundays free for family whenever possible—no matter how much work needs to be done. This gives your mind a break from photography and keeps your family happy.

Next, I enter print competitions, which gives you an impartial "ruler" to measure yourself with. And finally, I keep in touch and share ideas with other photographers. I have a "no-secrets" rule: We must all contribute to the progress of our profession.

I also feel that determination is very important, as well as the ability to dream while staying focused on present goals. I visualize five years at a time and work on specific ways to achieve the dream by having quarterly goals. Listen to advice but trust yourself. Be stubborn when trying for that great shot. Dream and then set your goals. Try to find someone who believes in you to share your goals with. You'll find success if you don't give up!

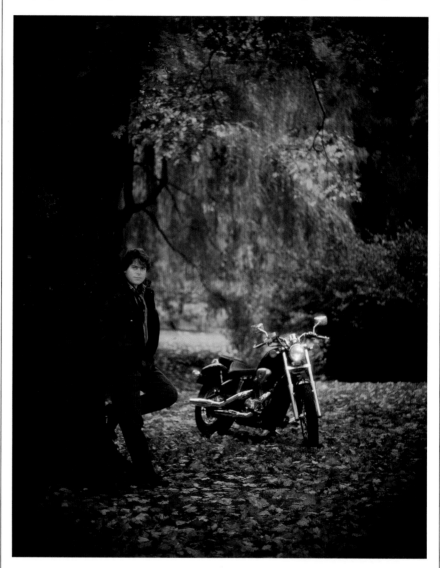

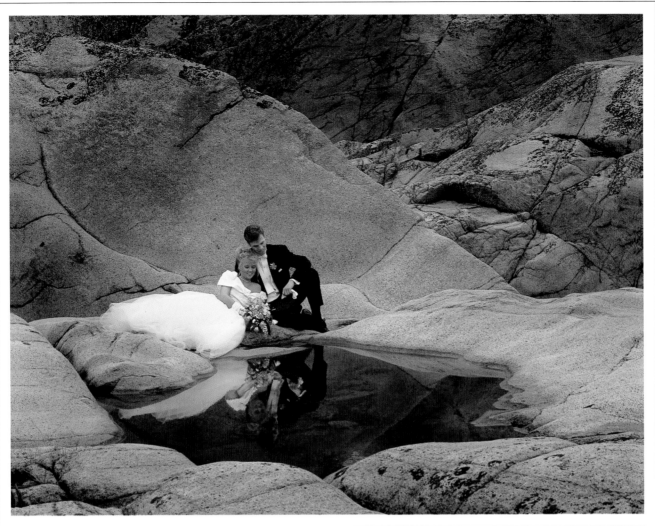

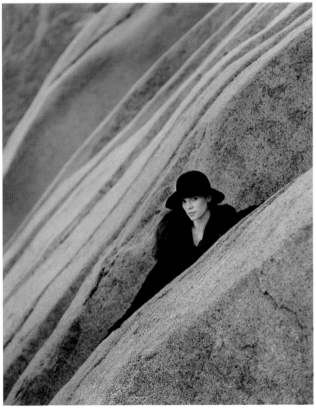

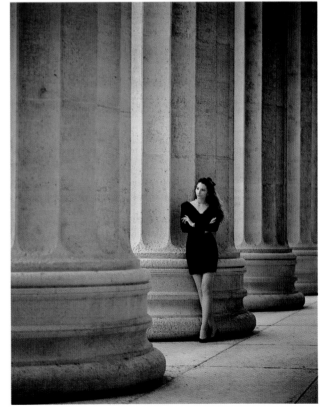

JEFF LUBIN

MCLEAN, VIRGINIA

The author of a book on the business of photography, Jeff Lubin also has produced educational videos on children and bridal portraiture. His name and photograph appeared all over the world on every professional pack of Kodak VPS film.

Lubin was awarded the Grand Photographic Award by the Virginia Professional Photographers Association in 1989 and 1992. He was also named Portrait Photographer of the Year twice by the Maryland Professional Photographers Association. Lubin's portraits won a Kodak Gallery Award in 1993 and twice have been displayed at Epcot Center in Walt Disney World. His prints have been published three times on the cover of Rangefinder *magazine, and he wrote a three-part series on children's portraiture for* The Professional Photographer *magazine.*

Holder of the Master of Photography and Photographic Craftsmen degrees from Professional Photographers of America (PPA), Lubin has lectured in New Zealand, Australia, and China, as well as at the PPA National Convention and the Wedding Photographers International Convention.

I began my work career mopping floors and washing dishes for a dollar an hour after dropping out of a New Jersey high school and joining the Navy at 17. At the age of 20, I went back to high school, graduating two years later. Since I qualified for the G.I. Bill, I decided to attend business college in Washington, D.C. After two years, the G.I. Bill ran out, and I got a job at the Copyright Office of the Library of Congress. I was also going to school at night. Seven years later, I finally got a bachelor's degree from Strayer College, but I hated my work at the Library of Congress.

Out of boredom, I started doing landscape photography and displayed my pictures at the Library of Congress annual art exhibit. That led to photography school at night and an opportunity to do weddings on weekends. When I applied for the wedding job, the woman told me that I had to get a different camera. So I sold my stamp collection and bought a used Hasselblad. Later I helped Monte Zucker with some weddings, but even then I wanted to get my own look, opening a home studio.

My wife didn't like me having the studio at home, so in 1983 I rented a second-floor place in a little strip mall in Springfield, Virginia. Working from 6:30 A.M. until 3:30 P.M. for the government, I did sittings at the studio at night. Then my life at home started falling apart because I was never there, so I said, "Three more years with the government, and I'll quit." By the third year, I was making twice as much in my part-time photography as I was in my full-time government job. So in 1985 I went full time at the age of 34.

My print-competition entries started doing better and better and twice won for me Maryland Photographer of the Year. In three years I had enough merits to get my Master of Photography degree. I was successful because my work was different, and success gave me confidence. I quit doing weddings about three years ago and stopped working weekends and nights, but I would if I had to.

Even though they earn more than 100,000 dollars a year, clients who visit us aren't rich by the standards of this area. My sittings average about 4,200 dollars, yielding sales in excess of half a million dollars a year, which puts my studio in the top 1 or 2 percent in the country.

Three people work at our studio, including myself. Michelle, my full-time studio manager, handles most of the work at the office, confirms appointments, gets the mailouts ready, answers the telephone, keeps the studio straight, checks the orders after my sales presentation, handles the auctions and does just about everything else you can think of. My wife, Patty, does a tremendous amount of work, but not in the studio. She opens all the orders, and then frames and wraps them. In the last three months of the year, we hire a part-timer to set up the studio, in addition to helping clients with makeup and clothing.

My goal is for everybody to buy at least one framed wall portrait. That is how I get my average. Nothing is seen on paper until the portrait is finished. I don't want anything leaving here that isn't up to my standards, and paper proofs aren't what the finished product looks like.

I've always used slides for projection proofing. In a typical session, I'll make 70 to 100 exposures, which are then edited down to the best ones for projection. Two slide machines project onto a 30 x 30 board, so the clients can compare different expressions.

I try not to schedule more than two sittings a day, preferring to do photography in the mornings and selling in the afternoons. My studio is located on a 22-acre historical property, right outside McLean. I lease one of the houses on the property, so all I have to do is walk out the door to find ponds, fences, and old buildings. Sittings break down into 75 percent in the camera room, 20 percent outdoors, and 5 percent in the client's home or garden.

Total advertising amounts to about 8 percent of sales, including the mall displays, newspaper advertisements, and mailouts. Since I am kind of hidden away, I lease display space in three malls, but that creates a big overhead.

To survive in the future, I think you have to distinguish yourself, to do something different. Now every mall has glamour studios and high-volume chain operations, creating a public perception of portrait photography as being of low quality. Independent photographers will have to come up with a look that evokes emotion from the viewer. We must learn all we can from professional associations and compete in print judging at every opportunity.

Practical experience and working with the very best photographer you can find provide the best preparation for a portrait career. Try to be as good, if not better than, the person you're learning from. This will increase your discipline because you'll have to learn more detail, and your confidence about client satisfaction for what you're charging. You really have to increase confidence because you're selling something whose value is based on what you feel and the client agrees to.

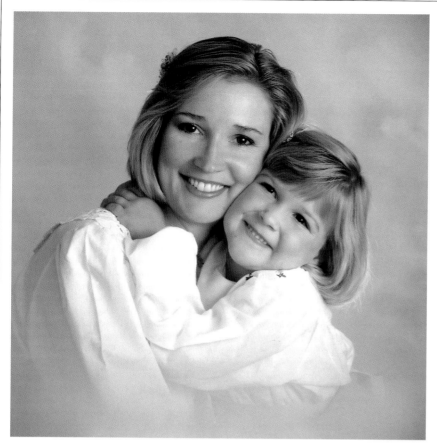

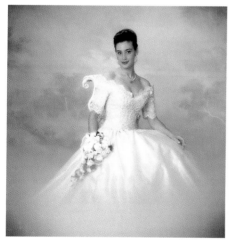

WILLIAM S. MCINTOSH

VIRGINIA BEACH, VIRGINIA

During the past 46 years of producing portraiture, William S. McIntosh has risen to the top of his art, establishing himself not only as a skilled artisan, but also as a gifted teacher and public speaker. He has lectured throughout the United States, as well as Europe, the Pacific Rim countries, Canada, and Mexico.

McIntosh was awarded fellowships by the American Society of Photographers (ASP), the British Institute of Professional Photography (BIPP), and the Royal Photographic Society. His portraits of the Joint Chiefs of Staff have traveled all over America for the Navy League; his work can be viewed at the Photography Hall of Fame, the Jones Institute for Reproductive Medicine, the Inwood National Bank, the Presbyterian Health Care Center, the Baptist University in Dallas, Old Dominion University Library, and the Pentagon. Kodak selected McIntosh for a program on The Learning Channel called "Techniques of the Masters," and Fuji Photo Film USA featured his images in a national advertising campaign on portrait photography. His work has taken him around the world, completing assignments for British Airways and the Egyptian Ministry of Tourism.

The business of portrait photography and the art of portrait photography are two different things. To most people, the business of portrait photography is going to a studio with a painted canvas or white background. The photographer may use balloons, stuffed animals, white baby carriages, etc., for children, and nice furniture, a bookcase, and other props for adults.

Portraits of this style are made in a relatively short time, usually at a modest price. They've been with us since photography began, and they'll always be with us. Sometimes they are very fine and can be considered art. Most of the time, however, they are formula photographs made to serve as a record for the individual or family.

If you want to study the art of photography, you need to study the great photographers and the great portrait painters of the past. I have well over 500 books on portrait photography and painting as an art, and that is where I get my ideas. If you don't know where those artists before you have been, how can you know where you're going?

As one of the first six people to earn the American Society of Photographers (ASP) Fellowship in 1973, I had a huge exhibit in the lobby of Virginia's largest bank. My work was on the cutting edge, and until this day some clients say my work resembles a magazine cover. In fact, one of the complaints I get is that "it looks like a magazine cover, and why would I want to put a magazine cover on my wall?"

The truth is, the public has to be continuously educated to accept portrait photography that is made on location, tells a story, doesn't look like a posed picture against a studio background, and is a lot more expensive. Convincing people that you are an artist and not just a craftsperson requires self-assurance. Some are put off by my strong desire to control every aspect of my portrait sessions. If I didn't assert myself—in a diplomatic way, of course—I would still be taking head-and-shoulder pictures in a studio. Photography isn't something you can be humble about. When you ask captains of industry, military commanders, and business leaders to change their offices around or to reposition locomotives, planes, and ships for a better photograph, you can't be modest.

Instead of showing slides or proofs, I present the finished product with the artwork already done. (The artwork on one of my portraits usually costs 100 to 350 dollars.) About a month after the sitting, I show the clients one or two fully finished and framed 24 x 30s or a combination of wall sizes.

If I go to a home for a child's sitting, I'll photograph the family at no extra charge. When they come to see the portraits, I'll have either two 24 x 30s or maybe a 16 x 20 and a 20 x 24. Doing the sitting in the home helps me decide what size portrait and type of frame they need.

Working entirely alone, I won't do more than 150 sittings a year. It is just me and an answering service, although I have agents in Northern New Jersey and Dallas, Texas. I don't advertise, but I do something once a year for a mall and bank exhibit that will give me a full-page color spread in the Sunday newspaper. I find a theme, such as the United States Joint Chiefs of Staff (photographed for a Navy League exhibit) or an area's outstanding religious leaders. Over the years, I've acquired the credibility that will allow me to do this.

Charity bazaars provide good contacts for me, too. For a silent auction, the organization gets a free 8 x 10 for every 100 couples, which is worth 500 dollars (this comprises the 200-dollar sitting fee and a 300-dollar print). And when they order, I offer an upgrade to a 24 x 30 with a 500-dollar discount.

In the early 1980s, I did sittings of 30 of the finest photographers in the country. They were all cultured, well read on the history of photography, and self-taught. Very few of them had gone to college. The problem with photography colleges is that the main thing they teach you is to print and develop your work in black and white. You really have to dig to find a good one.

For people trying to get into portrait photography, I would suggest they get a job with Olan Mills or K-Mart for several months to get their feet wet. This will teach them basic posing, basic lighting, how to control people, and how to get the expression. The main task is to learn to control people. I've had honor graduates come to work for me, and although they are the best technicians, they couldn't control the people.

Before I sold my business in 1981, I had the largest photography business in Virginia and one of the largest in the country. I had two studios in shopping malls, plus the headquarters in downtown Norfolk, which occupied a studio and a whole corner of a city block. It was a two-story building with a complete color lab. There were 46 employees in all the studios during the busy season.

When I wound up, we were doing 20 high schools and altogether about 12,000 sittings of all types. The studios in the shopping malls occupied about 1,500 square feet, and you could afford it then. Ten years later, however, you couldn't make money in malls.

The Norfolk area has about 700,000 people, and I dominated the photography there for 20 years. But I got tired of it. The business by then had grown to the point where I would sit in an office all day long and run it. I wanted to express myself in photography, and I didn't want to spend the rest of my life trying to make more money. I already had most of the things I wanted that money could do, and money has never been that important to me. I wanted to make beautiful pictures and enjoy the art of photography.

Believing that the Norfolk area wasn't big enough to support the kind of photography I wanted to do, I moved to Dallas. However, my timing was wrong because I hit Dallas about the time of the oil bust, and the move wasn't profitable.

I started in business with only 500 dollars. I had a partner who had 1,000 dollars, and we went into business in an old mansion in downtown Norfolk. We started photographing seniors with photoflood bulbs and a white background. The girls wore a black sweater with a string of pearls; the boys wore a dark coat, a dark tie, and a white shirt. We had to furnish clothing to about a third of them because times were not good back in the 1950s. The building wasn't insulated, and the cold water presented a problem with developing and printing. The first two years were really rough, but then I began to photograph weddings and penny-a-pound portraits of babies at department stores. Weddings were done on 4 x 5 sheet film with a 12-dollar minimum, plus 5 dollars for the album.

When my partner and I opened the studio in 1950, our only employee was a receptionist. My partner left early in 1952, and two years later I added the first full-time darkroom employee. That was when we really started moving. The senior season only lasted from about Labor Day to Thanksgiving, so I had to find something else to do the rest of the year, resulting in the development of a large portrait-studio business for the general public. Eventually, I discovered how to market expensive portraits made on location and have been off and running ever since.

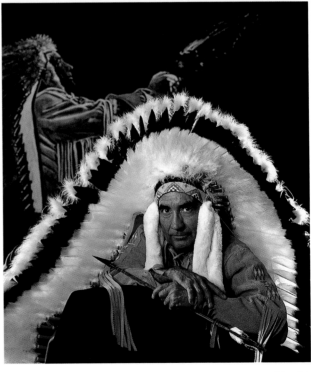

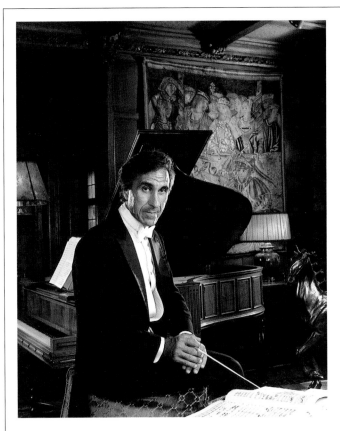

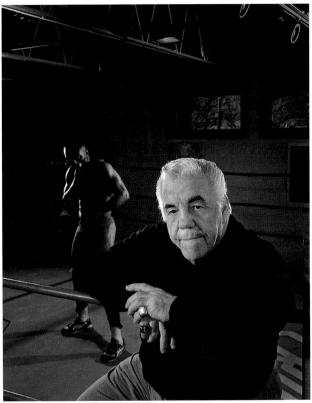

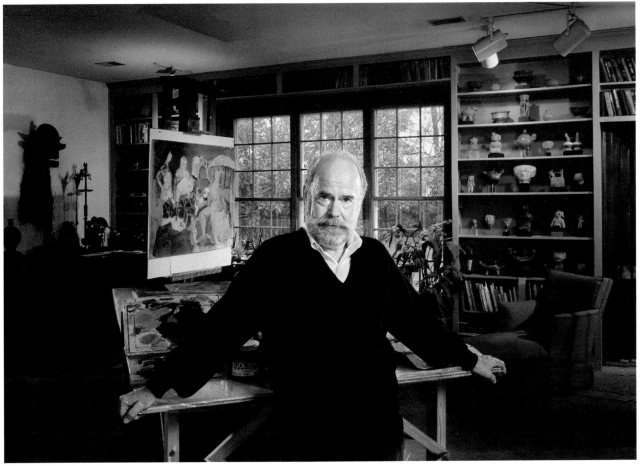

DAVID PETERS

SAN RAFAEL, CALIFORNIA

According to David Peters, who exhibits poetry alongside photography in a career filled with awards, "to elevate the ordinary to the spectacular requires a fascination and appreciation for the gift of life." He won the first-place award in the Western States Exhibition six times, the best-of-show award in the 1995 California Exhibition, and Photographer of the Year in the Greater Bay Area.

A member of Cameracraftsmen of America, Peters holds the Master Photographic Craftsmen degree from Professional Photographers of America (PPA) and the Fellowship degree from the American Society of Photographers (ASP). After speaking in Canada, New Zealand, and England, he did a 40-city tour in 1994 and a 33-city tour in 1993.

The very first pictures I ever took was of a girlfriend leaving for college. I dropped the film off at a pro lab, and that guy encouraged me upon seeing my snapshots. At the age of 17, I was accepted at the Brooks Institute, but after a year of study, I was told that I didn't have what it takes to be a photographer.

My father told me to do what I love to do, and I begged my way back into Brooks. It was there I met Jill, whose support and belief in me fueled my confidence. Opening my own studio with no business experience was a stupid thing to do, and I almost starved. With no apartment, I slept in the park, delivered newspapers in the morning, and worked at a movie theater at night. After we got married, I borrowed some money and bought a building in the bad part of town. We survived only by finding a florist to rent two-thirds of the space. That not only helped with payments, but got us weddings from people coming to the florist. That was 1971 and we moved to our current place in 1973, where things gradually got better as I learned how to sell.

For four years, I didn't make a profit until a very rude customer told me I was the worst salesperson he'd ever seen. So I devoted myself to learning sales. One course on small-business development from the Michael Thomas Corporation cost 11,000 dollars, and once I redesigned my studio according to those principles, we started having 10,000-dollar sales. But my faith in God definitely is the primary reason for my success.

Someone wanting to start today should focus not so much on the tools and gadgets of photography, but should place the biggest emphasis on how to reach people. In other words, the best way to start is to learn the art of creating a perception in peoples' minds. That is much more important.

Communication is what I would study. One thing that has made all the difference in the world to me is to be able to see the world through the clients' eyes. Once you can do that, it is the basis for all marketing, all sales, and all advertising. Then when you create that beautiful product, you won't be frustrated because your clients aren't able to understand what you're trying to say.

Years ago, I held what I called "Critique Night." Inviting about 400 clients, 50 responded, and I paid them with a 75-dollar gift certificate. Then I bounced 10 new ideas off them. The one that stood out was that a lot fewer people liked soft-focus portraits than I thought. That has changed the direction of the way I shoot. Now I assume that customers want sharp portraits,

unless they cherish the idea of soft focus as being romantic. A lot of time they're emotionally touched by portraits on the wall, not realizing they're responding to the feeling, not caring whether or not it is crisp in detail. I ask them if they like detail in their portraits. If they say they don't know, I ask what kind of books they read. If they say "history," I shoot it sharp. If they say "romance," I shoot it soft.

If I create the correct image, and if I support that image with the right people, beautifully written and produced brochures, and beautiful samples, I could market that to the right people, and they would assume everything else. What is important is that after three minutes, people know you are unique, and you can meet their needs. You're offering a very professional product that doesn't necessarily need to come from having a studio.

Lately with the downturn in the economy, we've found that a low-entry coupon is a good producer for us. There are some exclusive private schools around here, and I offer them discounted certificates as fund raisers. If they sell 20 of the 150-dollar coupons, they get to keep 30 dollars; if they sell 30 coupons, the amount increases to 75 dollars; if they sell 50 coupons, they keep 100 dollars; and if they sell 100 coupons, they keep the entire amount. So by selling 100 gift certificates, they raise 15,000 dollars, which appeals to them.

The nature of the coupon is that they get a sitting and a small print (5 x 7 or 8 x 10) at a price that is about half of what they would usually pay. It takes away their fear of making the initial contact with us because we aren't inexpensive. Our average sale is about 15 to 20 times the cost of the coupon.

Right now, we have four people on our staff. My wife, Jill, is the overseer and keeps the books. One person does reception work and runs the computer. Another handles production and keeps everything flowing. We do about 200 sittings a year, with an average cost of approximately 2,000 dollars.

It takes a very skilled person or a lot of time to train someone to do sales because the right word at the right time could mean the difference of 1,000 dollars. There is an art form to making clients pleased with their decision. But this becomes difficult if the client perceives it as a sales process.

My goal is to have two hearts rub up against each other, but sometimes in a sales consultation it just doesn't always happen. Two great facilitators are television and movie clips; they are powerful tools because they open up the communication process immediately.

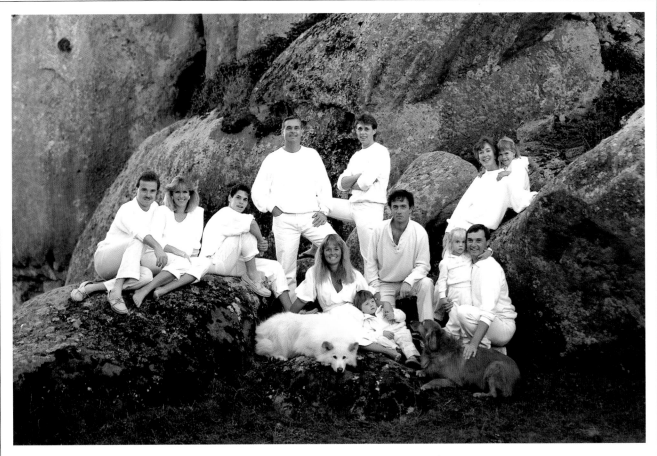

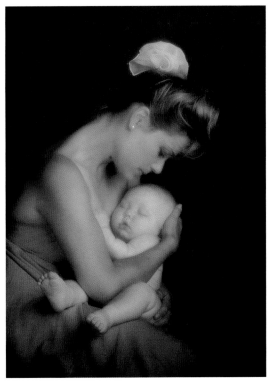

SARAH RIZZO AND KENT SMITH

PICKERINGTON, OHIO

Kent Smith and Sarah Rizzo have a balanced business in the Columbus, Ohio, area. Their work includes wedding, children, family, and senior portraiture, plus video services. Each of the eight social-function albums they've entered has earned Loan Collection status from Professional Photographers of America (PPA). Smith won Photographer of the Year in the six-state Mid-East Regional Exhibition three times, plus five Kodak Gallery Awards.

Rizzo earned her Certified Professional Photographer at the age of 21, her Master of Photography degree at 24, and her Photographic Craftsman degree at 25. She is a two-time recipient of the Bill Stockwell Award for best wedding album in the Mid-East Region.

KENT SMITH

After studying business and computer science in college, I was working in a technical capacity in AT&T's marketing department when I started with a home studio in Columbus, Ohio. After six years of part-time work, I went full time in 1987 but stayed in the home three years. I just had such a passion for photography that I didn't want to work for anybody else except myself. Many financial institutions turned me down, but finally someone gave me the opportunity to build a studio.

Today, Sarah and I run a 600,000-dollar business with one part-time and two full-time employees, without specials or gimmicks to bring clients to our door. We have only one form of promotion and advertising: clients telling their friends about us. That is it. No bells or whistles.

High-school seniors account for about 50 percent of our gross sales. We do about 600 seniors, 50 weddings, and 150 portrait sittings annually. We are open Tuesday through Saturday, plus two evenings each week.

If we can educate our clients about what fine portraiture can be, we'll have a thriving business for a long time. The words we live by is that we never want to devalue our product! If we were to run a promotion that was "two for one," "free," or "half off," we would be cheapening the product. And once it is cheapened, how can we ask more for it later?

We are in a tough business. When you think about it, most people consider themselves photographers, possibly mentioning their great vacation pictures as evidence. Brain surgeons certainly don't have this problem; not everyone's Uncle Charlie performs brain surgery on the weekends.

Owners of small portrait studios have some rough times ahead if they don't find a way to set themselves apart from the rest. By "rest," we mean the large chain operations that run special after special.) We have to find a way to disassociate ourselves from that market entirely. We never could compete at their level.

Educating the client is indeed the key to greater sales, and the general public definitely needs an education on what beautiful portraiture can be. We need to get them excited about our product and create a desire for it.

Let's face it: there aren't many absolute needs that drive clients to our door. It is desire. That desire is what we have to generate. Specials claiming 20 percent off don't create desire. Do you think Guess Jeans created desire by some special discount promotion? The advertisers created it with the image they portrayed.

One of the most exciting aspects of our business is elevating a client's perception. One mother wanting a family portrait. came to meet with us. She came simply to set up an appointment time because she knew just what she wanted: an 8 x 10 of herself, her husband, and two small children fairly close up, sitting in the studio in their Sunday best.

This was her perception of what portraiture could be because those large-volume operators have done their job educating the public. While she was there, I began to ask many questions regarding her family, her home, and the place where the portrait would be displayed. I also asked what the family enjoyed doing together. When I showed her some of our work, the transformation began. I was excited about the possibilities, and the excitement became contagious.

The end result of that session was a 30 x 40 canvas portrait of them dressed casually, walking away from the camera into an autumn field. The finished photograph fits perfectly in the space and blends beautifully with the color and formality of the room. A custom piece of art! This is something they'll never have to replace. It isn't just a record of their faces, but the way they felt as a family.

Another way we promote ourselves is how we display everything in the studio. We upscale by uncluttering. Our walls don't need to show every image we ever took. We've carefully designed each wall space to plant a particular seed, presenting each product as we would have our clients display it in their homes.

Fine merchandisers can teach us a lot. When you walk into a well-merchandised store, you know exactly what they're selling. For example, we sell two types of images, large wall portraits on canvas for open rooms; these portraits are sized to be enjoyed from the middle of the room.

The second choice is gallery-style portraits that are smaller in scale for hallways where the viewing distance is short. We try to simplify concepts such as this for our clients. Confusion kills sale, and clutter leads to confusion. What are you really selling?

The vocabulary and proper attire of our staff promote our image. Some words are never used, and other words are encouraged in our staff meetings. Also, our enthusiasm is some of best promotion. Many clients express their appreciation for our care and concern. Just yesterday a mother thanked us for the guidance and ideas we gave her. She

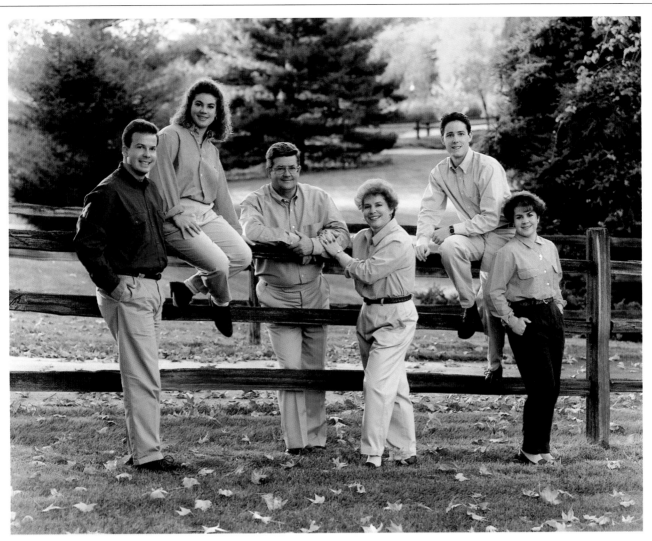

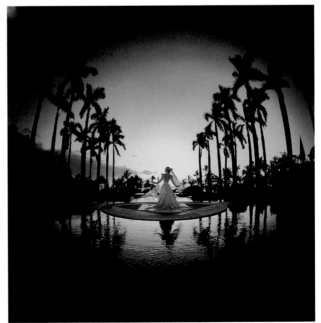

confessed she had previously made an appointment at another studio when her friend recommended us highly. She said the difference between studios was unmistakable from the first telephone call. We got her thinking about aspects that had never occurred to her. And the day before the session, we called to see if she had any last-minute questions or needs. When the family arrived, we called everyone by name and made them feel comfortable. She said she felt we really cared about her and her family.

There is one really fabulous thing about all of the above promotions we use in our studio. They are absolutely free! Our passion is our craft and customer satisfaction, with not much concern for the bottom line. The customer is always right. We treat clients that way. Our motto is "Good enough isn't good enough."

We have a staff meeting every week, and each time a different member is in charge. So we get a lot of different problems solved, things like clients being late. Because that used to be a problem, we came up with the idea of a five-for-five special. If customers arrive five minutes early, dressed and ready to go, they get 5 dollars off their sitting. It is unbelievable how great this offer works.

My name was on the studio before I met Sarah when I worked solo. I was mainly recognized for my wedding portraits and then seniors. Sarah and I love to work together because the total is equal to more than the sum of each of us. We enjoy working family groups together, and it doesn't matter who pushes the button or who the maker of that image is. We really enjoy going out and putting our heads together to create an exciting session for the client.

SARAH RIZZO

I got involved with professional photography while in high school at Marion, Ohio. I went to the Ohio Institute of Photography for six months, working for a photographer before and after that. Graduating from high school in 1984, I entered my first competition in 1987.

Children are really my forte. Since I don't have an assistant, I love to incorporate the parents into the session. I meet with them prior to the sitting and talk about how we're going to work as a team. I educate the parents, so they'll be the best assistants I could ever have. I approach it in such a positive way they love to help.

"Who knows your child better than you?" I ask them. I talk about do's and don'ts, such as "We never ask them to smile. We don't ever tell the children they're having their photograph taken.

We try to take their mind off it." I guide the parents and stay pretty much behind the camera.

With children, you have to make it happen quick. I really like to work with one outfit. I try to explain to the parent that the session suffers when you try to get a child through a clothing change. With one outfit, I can be more in tune to the child, getting more moods and expressions.

There are a few children who scream and cry because they've had a negative experience with a photographer in the past. I don't want to be that photographer.

It seems like every day Kent and I marvel at our teamwork. We truly balance each other's strengths and weaknesses. We have opposite interests within the field of photography. Kent is intrigued by the latest technical advancements and, therefore, always keeps us up to date. I'm drawn to the artistic elements of the profession, and I design new looks in photography on a regular basis.

If we were to make a recommendation to someone looking to form a partnership in their business, it would be to look for an individual somewhat the opposite of yourself. When two people have different viewpoints, they tend to have an excellent balance, broadening your business base.

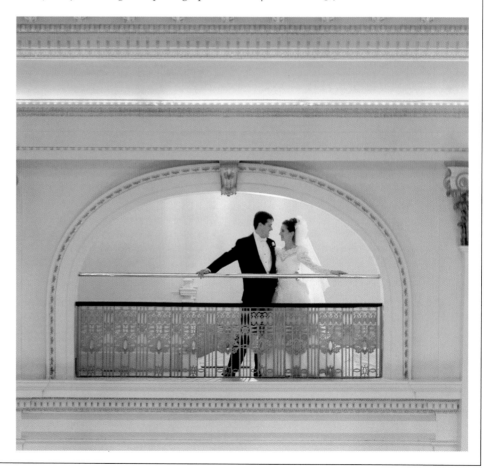

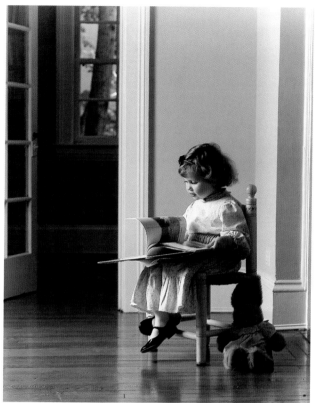

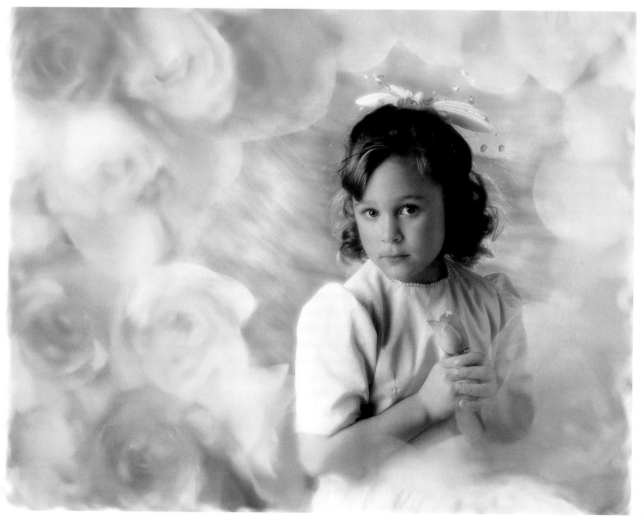

DUANE SAURO
SYRACUSE, NEW YORK

Often found chasing the sun on his Harley-Davidson motorcycle, Duane Sauro is better known for his ability to convey aesthetic and technical versatility in portraits. Although he was too young to drive a car, he photographed weddings at the age of 15 for his father, master photographer Daniel Sauro.

After earning his Master of Photography degree, Duane became the youngest recipient ever to receive the American Society of Photographers (ASP) Fellowship in 1983 with more than 25 prints accepted for the Loan Collection. Several of his prints have been exhibited at the Photography Hall of Fame and at Epcot Center in Walt Disney World.

Duane taught three times in Great Britain, where the Guild of British Portrait Photography has made him an honorary member. He spoke at five national conventions for Professional Photographers of America (PPA), as well as at many state and regional conventions.

I am a second-generation studio owner, following my dad who began the business in the mid-1940s. The nature of the business at that time was more high-quality wedding and portrait in the traditional middle-income market, fairly ethnic in its orientation. Dad believed in the Professional Photographers of America (PPA) program, and he was tuned into the quality needed to accomplish the Master of Photography degree, which he'd earned a long time ago.

When I came into the studio, there was a gradual change, mostly in the nature of the clients. They weren't necessarily more affluent, but they had a much more contemporary view. At this point, however, I would say our clients are much more on the affluent side.

In portraiture, it was a matter of developing new clientele based on what we were looking to accomplish. In weddings, we just had a gradual alteration because dad's wedding attitude was more contemporary and progressive than his portrait viewpoint. My dad ran the studio with two part-time employees, and I've expanded it slightly; we now have four full-time employees and one part-time employee. The expansion was due to an enlargement of the product line.

I found the stylized portrait I was doing needed to be changed in the printing process—whether via diffusion or printing off-color—so we opened our own lab. The need was due more to the nature of the work rather than the increase in volume. The printing end was an entirely new department, and there were a lot of growing pains because we had to discover the most cost-effective way of doing printing. Typically, doing your own lab work isn't the most cost-effective way, although it is more quality-effective.

The product line that we're starting to expand is painting photographs with oil. It is an area of our business that does a lot to promote the photographic end. When people come into the studio, they see the diversity that is available to them. That increases our credibility, not just for that extreme task but also across the board. For example, high-school seniors know they can get their portraits somewhere else, but they come here because they see the diversity they can get.

Once we had contracts with high schools to do an entire senior class, but we dropped them in 1994 because it is so labor intense, and I needed to invest my time elsewhere. Rather than expand, I chose to keep my business on the controllable level. If I'm not spending my time as a manager, I have more time to create as a photographer. We still photograph seniors, but not on a contract basis.

Our primary advertising is word of mouth because it means more to the public and carries greater strength with them. We do bridal shows for our wedding-product line and direct mail for our portrait area. Of course, our displays help both portraits and weddings.

I'm routinely promoting through credentials and print accomplishments, as well as publicizing my speaking appearances here or abroad. I do anything that will promote the studio and its credentials. It is of no value to have a Master's degree unless you remind the public that you have it. Publicity is more effective, I believe, in suburban rather than big-city newspapers because they have more of a community slant to them. Also, it is more cost-effective, and we get a better response.

My advice to someone getting started in photography is to get involved with another studio. That is a very important first step. In addition, some type of formal education is needed, whether it is a four-year program or simply some courses that help with the technical area.

Once you're established as an assistant with an existing studio, you can learn a wealth of information by being in the presence of an experienced photographer and being able to ask questions. When you're actually employed at a studio, you can start getting involved in programs like PPA, reaping the benefits of the ongoing education. Don't ignore the business end of it because that requires as much education as the technical and artistic areas. Don't think that because you enjoy photography, it will automatically make money.

I feel there will always be a future for still photography. When I purchased my business, I asked myself that question. But I think that the way it is produced will change. Even with more computer-generated images, we still must have the artist who gets "that look" from a client. We still have to work on a one-on-one basis to get that.

People just starting out who don't have artistic expertise or their own styles will be subjected to more of a price war, competing with Sears and K-Mart. However, there is always a segment of society willing to pay for a product that is expertly done, and there will always be photographers who will give these individuals expert services.

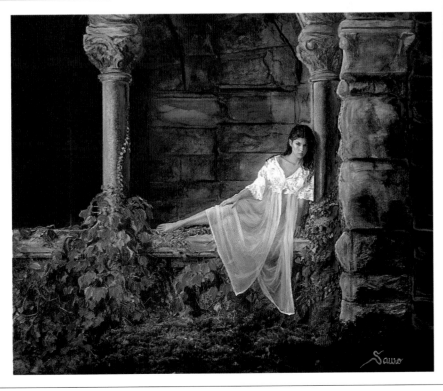

BURGHARD SCHMACHTENBERG

SOLINGEN, GERMANY

Master Class Photographer Burghard Schmachtenberg is known not only in the Cologne area of Germany, but throughout the world for his talent, artistry, and business skills. He has spoken to photographic groups in Singapore, Hong Kong, Taiwan, the Philippines, Malaysia, Indonesia, Korea, Thailand, Arabia, Australia, New Zealand, Japan, Mexico, Argentina, China, Holland, Belgium, Luxembourg, Great Britain, France, Spain, Switzerland, Austria, Norway, Sweden, Finland, Denmark, and Ireland.

Born in 1947, Schmachtenberg has won numerous print honors, including Kodak competitions featuring portraits of men, children, and families. His winning photograph in the great Arbeitskreis Deutscher Portrait Photographen (APP) competition was exhibited at the Photokina Gallery. In addition to APP, he also is a member of the British Institute of Professional Photography (BIPP), Professional Photographers of America (PPA), and Colour Art (European Professional Portrait Photographers).

Until now, we've had a "latent" underdeveloped market. If every living room has a television, a videocassette player, a compact-disc player, and a stereo system, it should also have a professional portrait. This means that the photographer must continually have new ideas, better quality, and better sales methods.

Instead of competing in terms of price, photographers should compete for ideas. At the beginning of my career, my price system was based on high volume, like other photographers' in the area. As my quality increased, surpassing other studios, I was able to raise prices and reduce sales volume.

In Germany today we have three different classes of studios. The Studio A class offers cheap prices, less service, and cheap quality. The Studio B class is aimed at the middle class and provides middle prices, middle quality, and middle service. The Studio C class features high-class studios, with the best images, best studio decor, best quality, and reasonable prices.

In the future, I predict that we'll have only Studio A and Studio C classes. The appearance of a good photography studio is vital to its success. It should be generous, functional, and cozy; decor will make your customers feel comfortable. Colleagues from other towns should rate your studio, so you can overcome your own business blindness. You can pick up new ideas and omit possible errors.

An excellent window display attracts 67 percent of our customers, which should be changed 12 times a year. Ask your clients for permission to show their portraits in the window. If their answer is "yes," they should ask you such questions as how big, can I buy it afterwards, and how much will the frame cost. If they don't ask those questions, I don't put their picture in the window.

The customers' first impression while entering your studio is psychologically important. You should give them the feeling of being among friends who don't intend to deceive them. I believe in the German saying, "The customer is king." Employees must be trained to make the customers feel welcome and exhibit excellent knowledge of the subject. Staff members must be able to sell our products with assurance and firm conviction. Our customers always should leave the studio with the feeling that they've received the best possible product at a reasonable price, so they'll enjoy coming back and recommend you to your friends.

This high objective can be reached by careful selection of employees, their regular training, and attractive team-bound system. Employees are always expected to be polite, good-tempered, and amiable, concentrating on the subject and the customer at the same time.

Customers will judge photographers not only by their knowledge of the subject but also by their appearance. Their warm personality and capacity to share the feelings of others put their customers at ease.

Principles for success include fair dealing, honesty, generosity, and flexibility. Photographers never should be intrusive or presumptuous, nor should they try to deceive or cheat any customer! In summary, the manager of a photography studio should be: a first-class photographer, full of new ideas; a good buyer and seller; a psychologist; a public-relations specialist; a stimulating conversationalist; and a fascinating entertainer, especially with children.

My career began in 1965 with "Lehre," which in the strict German system means that you have to learn from a master-class photographer. Once a week for the first three years, you have to attend a special photography school run by the government, followed by an examination. Then you can have the title "professional photographer," but you aren't permitted to open your own studio. Still working as an apprentice for at least five more years, you also have to attend evening school for two years to be trained for the master-class examination. After passing that hurdle, you're allowed to open your own business.

I started my own studio in 1972, buying my father's small camera shop by paying him monthly. Also, I rented a small shop beside the camera shop and opened a portrait studio. Most German portrait studios include a camera shop selling to amateurs, who also represent potential clients for the studio. In 1990, I opened a new business that combines fashion and portraiture. We sell and rent bridal costumes and menswear, plus all that is needed for a wedding: rental cars, wedding-invitation printing, children's clothing, etc.

The more fashion clients we have, the more clients we get in the studio. With this combination, we've tripled our studio wedding sales. In the beginning we had three people on our staff, but now it totals 15 with specialists in photography, bridal gowns, and menswear.

We must do about DM 150.000 in sales for each employee in order to meet overhead expenses. Being a good photographer isn't enough to be successful in business because you also have to be a good at sales, window decor, psychology, body language, bank finances, and even bathroom cleaning.

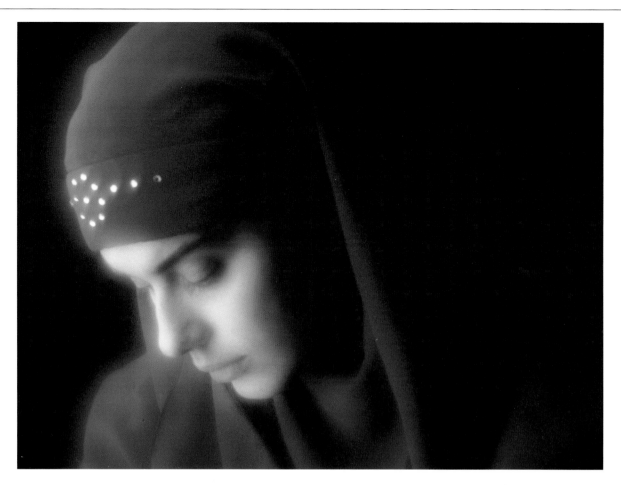

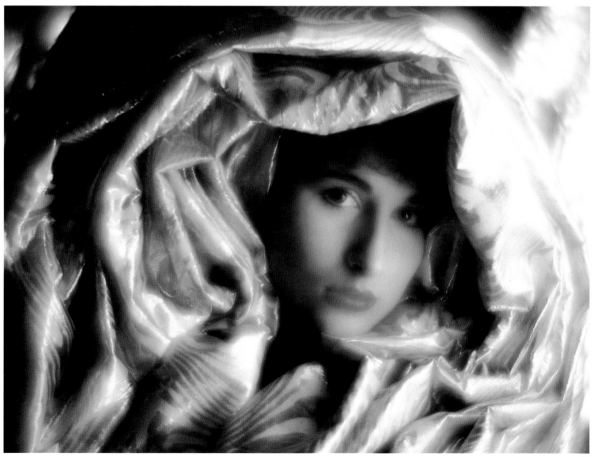

In order to succeed, you must also develop your own style. Don't copy other photographers. To open a new studio, you need a minimum investment of DM 60.000 for studio equipment, DM 40.000 for decor, DM 20.000 for first-year advertising, DM 50.000 for inventory, and DM 20.000 for "bad days." The total is DM 190.000.

It is common knowledge that most potential customers are first interested in a good portrait. Only later do they look at the price. When offering the finished portrait, you should not forget to show a suitable frame and other useful or desirable accessories.

Photography exhibits can be an effective means of advertising. You can arrange them in public facilities, such as town halls, banks, galleries, cafes, restaurants, hotels, and even hospital waiting rooms. Speaking at meetings can help your image considerably.

Once during a slump in business, I announced in the newspapers a search for "Miss Zopfchen." We offered to take portraits, free of charge, for a big portrait exhibit. "Miss Zopfchen" was to be chosen by the visitors and rewarded with a prize by our firm. It was great fun for the little girls and for their parents who later bought their pictures at greatly reduced prices. Most important, it was a great success for me and my working team. These contests are particularly effective in improving your image, but the best publicity is done by satisfied customers who promote your business by talking about it to other people.

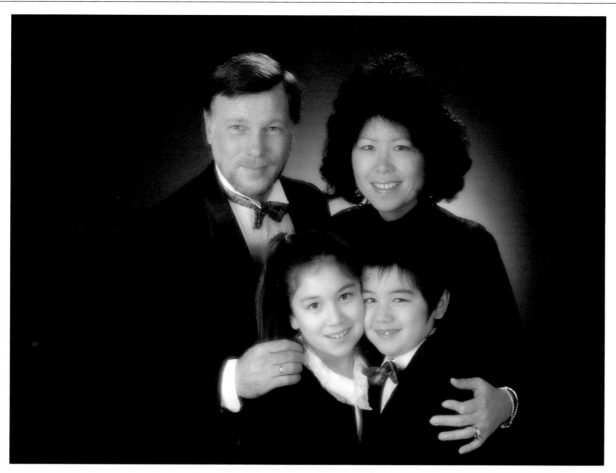

PAUL SHIPWORTH

DALLAS, TEXAS

As president of Gittings of Texas, the legendary portraiture corporation, Paul Skipworth directs studios in Dallas, Fort Worth, and Houston, plus operations in 12 other cities throughout the South. In 1995, he photographed more than 150 presidents, kings, and prime ministers for the fiftieth anniversary celebration of the United Nations, winning the year's most prestigious assignment. A Fellow of the American Society of Photographers (ASP), Skipworth also holds the Master of Photography and Photographic Craftsman degrees from Professional Photographers of America (PPA).

In 1985, Skipworth was named the official photographer for President Ronald Reagan's inauguration, with a team of more than 100 photographers covering the swearing-in ceremony, the simultaneous balls, and the surrounding activities. In one night, these professionals photographed 4,000 couples.

Continually in demand as a speaker, Skipworth appeared at the PPA National Convention and more than 20 state conventions; he has lectured in Puerto Rico, Mexico, and Canada as well. He has also taught at the Winona International School of Professional Photography many times, and at schools in California, New England, Georgia, and Iowa.

When I first went into business in 1969, my wife and I agreed that we wouldn't take any money from the studio, living off her teacher's salary. I paid all the bills but didn't draw a salary or bonus. Our first-year sales were 48,000 dollars; the second year, 96,000 dollars. The third year we had 200,000 dollars in sales, and my accountant said we were going to have to spend some of that money because we had 60,000 dollars in cash in the bank. So I started paying myself 100 dollars a week!

Adequate capital is the key to surviving and making a business grow. I think that the biggest mistake young photographers make is going out and buying a bunch of things as soon as it looks like they're going to be successful. Then they hit a hard spell and don't have any reserves. And the hard times will come!

After working for Bill Cowan in Shreveport, Louisiana, for six years and then doing my Army tour, I decided to go into business for myself. So I went to Houston and visited with Paul Gittings, Jr., and Fred Winchell at the famous Gittings Studios. Fred told me that if I were going to be successful in an upscale portrait market, I had to be concerned about five things. First, my photography had to be first class. Second, I should offer a variety of poses for people to choose from, not the same thing over and over. People like to make choices. Third, studio decor must make people feel comfortable and create a proper environment for sales presentations.

Also, I needed to determine pricing, so that products relate to each other. For example, a 16 x 20 in one finish would be the same price as an 11 x 14 in a higher finish or a 20 x 24 in a lower finish. Thus, people could buy a better finish and get a smaller print, or buy a larger print and get a less expensive finish for the same amount of money. Finally, I had to find people who have the same concern for clients that I do. I was supposed to hire people who would go out of their way to serve customers, even if it means going with them to buy clothes for the session!

If you're getting into this business, you need more than a technical knowledge of photography and the use of the equipment. Portrait photography is more of a people game, so I think a good, solid, liberal-arts education is vital. You need to learn something about history, politics, humanity, and the arts. Whoever you're dealing with, you have some idea of how to relate to that person. The quicker photographers can get clients to be at ease with themselves, the sooner they'll be successful.

The ability to communicate with people makes it easy for them to be successful. The image you wind up with on paper is really about how you relate to that person.

I have a rule of thumb that every employee should contribute 110,000 dollars a year in gross sales. So if a studio did 350,000 dollars in sales, it would have three employees. And with three people staffing a studio, one of them serves as the administrator, keeping up with appointments and everything that goes on in the studio, making sure orders are sent to the lab and are delivered when they come back. The photographer does the sessions and some marketing. The salesperson who follows up gets to know the clients and finds out how the sitting went.

If you don't have a way to get your proofs back and your finished work picked up, then you have money sitting there that you can't use. A studio literally can go bankrupt if it has too many proofs out. When I bought Gittings in 1987, they were showing only paper proofs. But the average order went up considerably when we went to slides because it is hard for a client to imagine what a little proof looks like as a 16 x 20 or larger print. Selling really has more to do with the end relationship than what you're selling. If you believe in someone, you'll buy from that person.

A good salesperson can sell from paper proofs, but being able to show that image on the wall makes all the difference in the world. When we go into a home, we usually show a 30 x 40 image on the wall. But in the event that the customer doesn't have a suitable wall, we carry a case that has a 30 x 40 white board that we project on.

Our studios send film and negatives back to a central lab, which finishes the prints, including dry mounting and gold stamping with our logo. The order then goes back to the studio, where staff members put them in folders and then in boxes with gift tissue.

Frames represent about 15 percent of our sales because 60 to 70 percent of our clients buy frames from us. If they asked us, we even would go to their home and hang the portrait.

There are no great secrets, so long as you remember that the bottom line is to make money. To do that, you have to bring in more money than you spend. I'm still struggling to be successful in the photographic field. What success I've had thus far I would attribute to some great, great people who helped me early on, who taught me some basic business philosophy and how to do deal with people in the portrait business. That is what it is really all about.

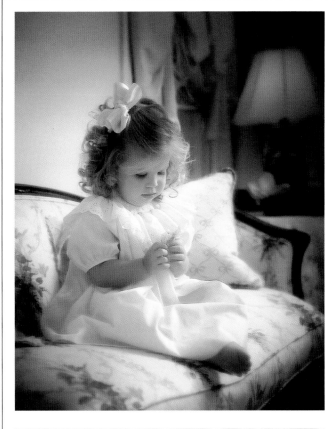

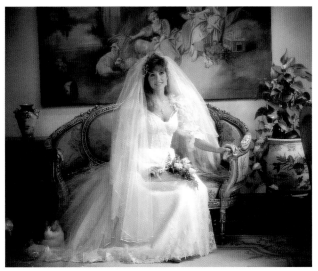

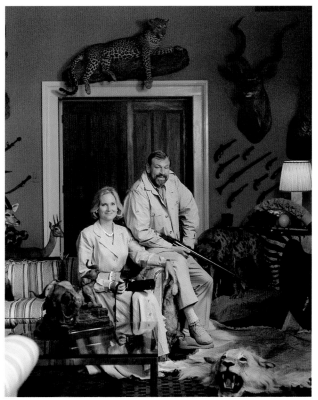

ALLAN P. SMITH

DETROIT, MICHIGAN, AND TOLEDO, OHIO

In May 1981, Al Smith opened his first studio in a renovated television-repair shop in Detroit. In 1985, he opened a second studio in Toledo, Ohio, which was followed by a third studio in Pontiac, Michigan, in 1987. That was the year his business did a million dollars in sales.

Shortly thereafter, Smith sold the business to his partner due to differing opinions about future plans. In 1991, he purchased a mansion in the historical Old West End of Toledo; AM Renaissance Photography, his dream studio, opened in September 1992. Two years later, he opened a franchised Renaissance Photography Studio in Detroit.

Reared in Mississippi, Smith attended Labor Law School at Wayne State University, Wayne County Community College, and Oakland University, and took several continuing-education courses in photography and a correspondence course from the New York Institute of Photography.

In 1987, we grossed about 1 million dollars in sales, and that is when we started having problems. My partner and I began growing apart; each of us had different ideas, so we split. I took the Toledo studio while he kept Detroit and Pontiac, Michigan. A few years later, I opened another studio in Detroit because I realized there wasn't a minority studio on the east side of the city. Now I have about six employees in the Toledo studio and three in Detroit, although I get up to about 15 combined during the busy season.

Toledo actually started as a test market to see how strong we could be in another area. After business got so good in Toledo, I bought an old college, Mary Manse, which I believe was one of the first colleges for women in the United States. It has 73 rooms, offering all sorts of different setups. One room is set up as a locker room, and several of the rooms have natural fireplaces. It is a photographer's dream!

Organization and money management are the keys to running a studio. When you start growing and money starts coming in, you need to operate your business just like you're starving to death. Otherwise, hard times will hit, and you'll be in trouble.

Our business is about 80 percent high-school seniors; the rest, families and some weddings. As my senior clientele grows, I'm getting more requests for family portraits. I realized that if you do a good job, the average sale on a family portrait will bring more money than a high-school senior because you spend less time with the family group. Now I get into an elaborate projection presentations, and we see the average going up. We spend about 10 percent of sales on advertising, using radio and some television. But the bulk is direct mail.

When I grew up in the South, my father taught me to give not 100 percent but 150 percent to anything I set out to do. Then my wife got behind me and helped me get started. It wasn't easy, but you have to be willing to really work hard. I want to have something to leave my six-year-old daughter.

Actually, I got started when I was about six. My father gave a Brownie box-type camera to my sister for Christmas in about 1956. It didn't appeal to her, so I picked it up. At that time you had to have the film developed at the drugstore, so I decided to try my hand at it. I put it on the stove in a pan of boiling water.

Growing up in the South, my parents weren't able to buy the equipment I needed, so after high school I moved to Detroit. Working for General Motors, I attended Wayne State University at night, majoring in industrial relations. At that time, I thought I wanted to go into labor relations. I thought I had a secure job, but I found out that wasn't true. The 1974 oil embargo came along, and General Motors laid off a lot of people. I decided that if someone was going to be in charge of my future, I wanted it to be me.

When I told my wife about my feelings, she asked, "When you were a child, what did you want to be when you grew up?" I told her what I really wanted to be was a photographer. She bought me a camera and enrolled me in the photography program at Wayne County Community College.

From there, I studied under George Lungberga, helping him at the studio. On Saturdays, he would take his assistants out on weddings to be his lighting people. While he was photographing, he would explain to us what he was doing. Then when we got back to the studio to unload and get the film ready for the lab, we could ask any questions.

From there, I took a correspondence course at the New York Institute of Photography. Then I found out about the Winona International School of Professional Photography and took several courses there. I went out to Santa Barbara to study under Paul Skipworth at the West Coast School, and then I went to Hawaii for a course with Donald Jack. After a week-long course with Marty Rickard, we became really close friends. I've taken all types of classes and seminars. I'm still learning.

Our first studio was in Michigan and the second one in Ohio. I had relatives who would come to Detroit to have their pictures taken and then show them around their school in Toledo. They started calling me, asking if I would come down to rent a hotel room and photograph them for their senior pictures. I told them I would come and survey the area. Seeing that there wasn't a studio doing the type of work I was doing, we opened up a studio there. My partner and I also talked about opening up a studio in Atlanta, but that was a long way off, and we didn't do it.

To someone who wants to start a career in photography, I recommend studying under a good mentor, someone who really cares about the profession and wants to keep it going. I would suggest that you attend every seminar and school you can, but the key is finding a good mentor. For your formal education, I advise taking a lot of business classes and then find a mentor. Portrait photography is heading into electronic imaging, but there always will be a need for the custom-enlargement family portrait.

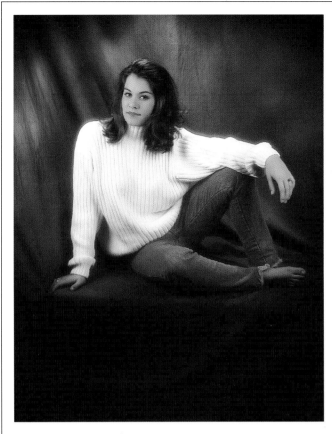

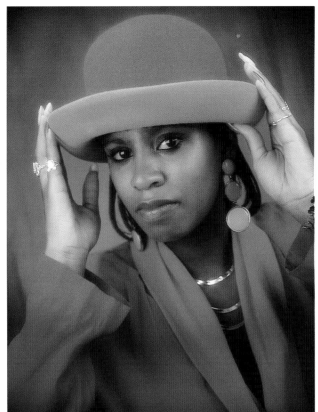

DAVID LEON SMITH, JR.

STONE MOUNTAIN, GEORGIA

David Leon Smith, Jr., believes that people don't create; they only rearrange and rework what God already has created. He also maintains that true success comes from having the desire to serve God and believing that nothing is possible without His Light.

Smith is a Fellow of both the British Institute of Professional Photography (BIPP) and the American Society of Photographers (ASP). In addition, he holds the combined degrees of Master of Photography and Photographic Craftsman from Professional Photographers of America (PPA). He is the past president of the Georgia Professional Photographers Association, and from 1993-1995 he served as the president of the 13-state Southeastern Professional Photographers Association.

Most of the top-of-the-line portrait professionals in the Atlanta area work out of home studios, but that restricts growth in my opinion. I don't discount the importance of a home studio because that is where we first began; we just outgrew our home. If you want to stay small, that is fine. But if you want your business to grow, you're going to have to move up to a storefront or an equivalent location.

In 1994, we added a second studio in Loganville because many of our clients were driving 40 to 50 miles to our Stone Mountain location. Gittings is the only Atlanta area studio that is priced higher than we are, and I would consider our prices high-medium.

Our staff currently totals six. My wife, Linda, handles most of the sales and the payroll. Judy Richardson makes all the decisions when Linda and I are out of the office, pays the bills, and makes the deposits. Tammy Donifrio, our newest employee, takes care of customer files, follows up on delinquent accounts, and helps with sales. Jason Smith, Lynn Brown, and I photograph the weddings and portrait sittings.

When we aren't doing photography, we help out with lab work and anything else that needs to be done. Our sittings increased to about 1,500 in 1994 because Jason and Lynn could do sittings on the days I was off, and that was my goal in hiring them. On average, we shoot about 40 or 50 weddings a year.

A newsletter containing information about our studio and seasonal specials is mailed quarterly to past clients. It has been a tremendous way for us to advertise because it is a great way to get into our customers' homes. In addition to our 2,000-name mailing list, we also put the newsletters in different shops and malls. Publishing a newsletter is easy for me because I got my start as a graphics designer working for a printing firm.

Newspaper advertising is used for seasonal promotions and specials, but I don't feel the Yellow Pages have yielded as much value for the money spent as the other media. Our displays in restaurants have been very rewarding. One of our most powerful uses of advertising is our previews. We get hundreds of dollars of return in sales from clients showing their previews to friends and relatives. This brings new customers to our studio. I am in the process of conducting a customer survey to ask clients whether they prefer previews or electronic imaging.

Our newsletter helps with client management. I don't think our clients are ever a problem; the difficulty occurs in the management of the client. Occasionally a client comes along who you're just going to have problems with. A lot of the time it comes back to the preview system when the customer has kept them out too long. You have to stay on top of that and follow through constantly.

The other problem is that some of our clients are trying to have our work copied. We took a step to advise them about copyrighting in our newsletter because I don't think people understand the concept of copyrighting.

My father was a photographer, so I was always around cameras. When our children were little, I bought a 35mm camera and began photographing them. Some "serious-amateur" friends of mine encouraged me, and the next thing knew I was being introduced into the Georgia Professional Photographers Association. By this time, I had sold a few prints, and some of the photographers said my work looked very promising. They encouraged me to pursue more of the art end of it.

So I attended some of the Georgia meetings and joined the association. Some of the talented photographers I met there really fired me up, and I give them a lot of credit for my success. But all of my talent comes from God, and I try to be a channel for His creativity.

Linda and I opened our first studio at home in 1970, then moved into a storefront a year later, just the two of us, with no employees. We added employees as we grew, and at one time had six full-timers and one part-timer.

If I were seeking an education to prepare me for a portrait career, I would check first to see what local schools had to offer in the way of business, some courses that would give me the knowledge of what it takes to get up and running. Given a choice, a photography school would be great, but most liberal-arts schools have photography courses. Wherever I went, I would combine art with business. If I could go back in time and study all over again, marketing and advertising would be high on my priority list.

Second, I would be cautious about borrowing too much money that I couldn't pay back. I know that doesn't sound like an education, but that is very important in forming a business. Third, I would look at professional organizations because there is a lot of information there. When clients try to decide about which photographer to choose, they look at your credentials.

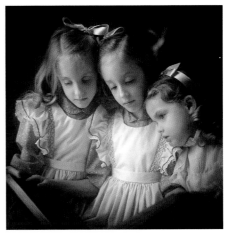

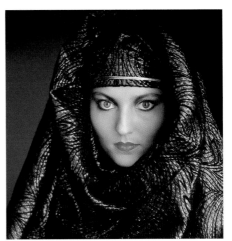

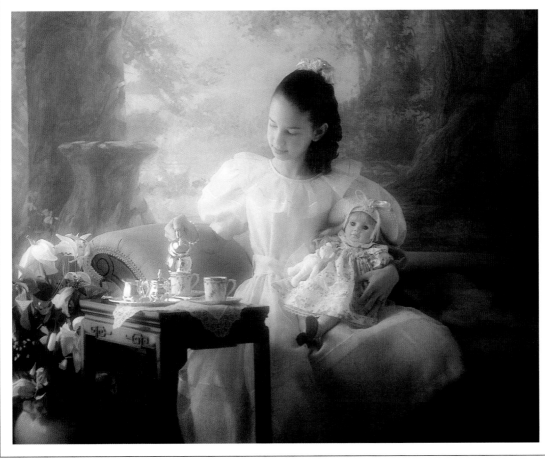

MERRETT T. SMITH
LOS ANGELES, CALIFORNIA

Known as the "photographer of the stars," Merrett T. Smith is one of only 40 members of the elite Camera-craftsmen of America. He earned the Master of Photography and Photographic Craftsmen degrees from Professional Photographers of America (PPA). Although Smith's gallery looks like a "who's who" of show business and politics, he is quick to point out that more than 70 percent of his time is spent with noncelebrities. He has lectured in China and Japan, as well as at the Winona International School of Professional Photography and the West Coast School.

Luminaries in Smith's gallery include Presidents Richard Nixon, Gerald Ford, Ronald Reagan, and George Bush; First Ladies Nancy Reagan and Barbara Bush; film director Steven Spielberg; photographer Yousuf Karsh; talk-show host Barbara Walters; performers Ann-Margret, Johnny Carson, Jaclyn Smith, Bob Hope, Jack Lemmon, Dick Van Dyke, Olivia Newton-John, Bob Newhart, Tom Jones, Tim Conway, The Osmonds, Andy Williams, and Dionne Warwick; and all of the recent presidents of the Mormon Church.

Celebrity portraits in your window attract business because everybody figures if you are good enough for the stars, you are good enough to shoot their portrait, too. As a rule, I am quite a happy person, and that makes it easier to work with celebrities. I try to find common ground with them, to talk about something I'm familiar with so I don't have to stop and think a lot. Some people you can joke with, and some you can't.

Women like quite a bit of time in a portrait session, and, of course, I allow them that. Men, however, usually are in a hurry, and I try not to hold them up. I always have the camera room and lights set up when they arrive. I know what they want, and I don't have to experiment, so one hour is all it takes. For example, I photographed all of President Ronald Reagan's cabinet members for years, and one thing that helped us was that we were completely set up when they got there. I always made Polaroid tests, so the actual sitting to do about 40 exposures took only 15 minutes.

My session with President Reagan in the White House was one of the most difficult of my career. I had a 1 P.M. appointment with Reagan but was running a bit behind. I'd just finished photographing Elizabeth Dole, the Secretary of Transportation, in her office. She arranged for all my equipment to be taken to the White House because of the heavy rainfall.

The dogs were unable to sniff through all the equipment, and it had to be checked by hand. We were held at the gate in the downpour with no cover, so when I entered the Oval Office I was dripping wet from head to toe. I hurried to set up and heard the President's voice down the hall as I shot off one Polaroid. He came in, took one look at me and my assistant, and decided to give us more time. Nancy Reagan came in toward the end of the session, so I photographed them together, producing one of the best portraits I've done of them.

Photographer Yousuf Karsh visited Los Angeles in 1972 and said he wanted to come over to "check out" my Gowlan camera and Norman lighting system. After he saw what he came to see, I asked if I could photograph him. He graciously said, "I'd be honored." The result was a portrait that he loved. Then he turned my camera on me, so now he has a "Merrett" on his wall, and I have a "Karsh."

For years, my studio was in the Century City area of Los Angeles, but the lease gradually rose from 400 dollars to 7,500 dollars a month. All of my profit was going for rent, so I moved out. Now that I'm working out of my home, I have a lean staff, with just my wife, a full-time receptionist, and a couple of assistants to help on location. Because I don't have a lot of room here, we encourage out-of-studio work by cutting our location session fee by two-thirds.

When we first located at Century City, we filled our windows with portraits of stars; It looked like we were doing lots of celebrities, but we did lots of promotions to pay the rent. We went to all the offices around Century City and put flyers under the door, advertising Secretaries' Week, Valentine's Day, and Christmas. Although I didn't like it, we gave out gift certificates and handled the Family Record Plan.

These promotions remind me of our early days at Salt Lake City. When I was about 12 years old, I saw film developed and prints made at a Boy Scout meeting. I got really excited and decided that was what I wanted to do. The next summer I worked and got enough money to buy a developing set and camera. I put quilts up on the window and started my own darkroom. In high school, I was the yearbook photography editor, and from there I went into the Navy, where I served as amphibious-forces photographer in World War II. I got three years of good training there, but my chief interest was portrait photography.

Coming out of the Navy, I decided that I was going to get into photography some way, so I bought the studio of a man in Utah. For several years, I operated the studio while studying business in night school. From there, I went into construction work with my brother and then ran a photography-supply firm.

Next, I went into a partnership with another photographer for a couple of years before deciding I wanted to get out on my own. In 1953, I bought an established studio with two camera rooms and two photographers, doing about 15 sittings a day, but I wanted to do better-quality work. So I started doing adults and family groups in one of the camera rooms. At the same time, I kept my eyes open for any kind of promotions, like beauty contests. After a few years, I started putting their portraits on display in the Hotel Utah. They were all handcolored oils done by my wife, Gail, in sizes from 20 x 24 to 30 x 40. After about 10 years, our dollar volume went up 80 or 90 percent. Then I came up with the idea of putting large portraits of celebrities in Salt Lake's Theater-in-the-Round, which brought in top-name stars. It was one of the greatest promotions we ever did. Everybody saw it!

By this time, we had about 12 employees: always three full-time sales specialists, darkroom technicians, and order-assembly people. My wife took care of a lot of the oil artistry, and I did a lot of the retouching myself. Kodak put on programs that I would always attend, trying to learn as much as I could. At the same time, I was going to school and studying business.

After we did the Theater-in-the-Round, Wayne Newton became our biggest customer, asking us to take portraits of his horse and copy lots of family pictures. We did Rhonda Fleming's wedding, and the stars encouraged me to come to Los Angeles. With our seven children, Gail and I packed up all our belongings in the family car and a U-Haul trailer and headed for California. I took out a small-business loan and opened up in Century City. For a while, I kept the studio in Utah, but the travel got to be too much, so I sold it. Once we were established in Los Angeles, I photographed some big stars, as well as Richard Nixon and Ronald Reagan. Through those portrait sessions, we got involved with the Republican Party, and our celebrity business gradually grew.

If I were starting out today in a small city, I would use the newspaper to promote myself and advertise monthly specials. For instance, May would be children's month or something like that. If you promote yourself and bring in people, you have to give the customers first-class treatment because you want them to come back.

Your sales staff has to have "sweet persistence," not hard-pressure sales. Another thing is to keep a good-looking studio, and have your work look better than anybody else's. I would go with the Kodak Prism system and start with something like the Family Record Plan or selling a five-year album of portraits.

Looking back, I think I would have had a hard time if I hadn't taken those business classes. When I learned a business or sales technique, I could go back to the studio and try it out. One important thing is to realize your weakness, and mine was keeping books. You need an accountant to tell you right where you are. I kept a day-to-day chart, so I could review promotions and averages.

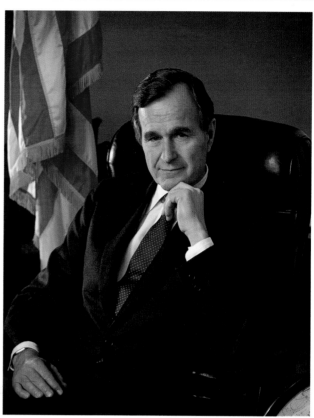

JOSEPHUS T. SPRANGERS

ULVENHOUT, THE NETHERLANDS

A Fellow of the British Institute of Professional Photography (BIPP), Josephus T. Sprangers is also a qualified member of the Dutch Institute of Professional Photography. He conducts master classes and lectures regularly in The Netherlands, Belgium, Germany, England, Scotland, and Norway. In 1994, he was a joint winner with Tracy Turner of the Peter Grugeon Award, presented by BIPP.

Sprangers was the bride's-album-competition winner in 1992 at the Buxton Convention and in 1993 at the Bournemouth Conference, both in England. He also won two silver and three bronze awards in 1993, followed by one gold and four bronze awards in 1994.

In the Netherlands, Sprangers swept first prize and the Golden Camera at Kodak's first Camera d'Or competition in 1983, 1989, and 1991. He also won the International H. E. Prize for illustrating photographers in 1983 and the Color Art Photo prize in 1986.

Most of the problems and needs of my clients revolve around the question "Will the photograph fit well in my home or office?" My answer, with the help of pictures of their interior and a brief description, is that we'll compose a photograph that will enhance their decor. I try to inspire, not indoctrinate, my clients by showing them some of my portraits, and they stimulate me by describing their tastes and feelings.

Then we discuss their fears about posing before the camera, and why they have them. Is it because they had negative experiences with earlier sittings, or is it something with their appearance? Once I uncover their fears, I tell them how some actors and singers have turned similar negative fears into positive qualities. Identifying with my clients' concerns, I tell them about my own fears and how I've coped with them: my fear of talking into a microphone, of conducting a lecture, etc. It always works!

To succeed over the long haul, you have to do every job not as the last of a number of jobs, but as the first one. You have to fight a number of failures before finding success. I totally endorse the expression of Kenneth Olav Linge, a Norwegian photographer: "Success is not in never falling but in rising every time you fall."

Specialization is the way to build a profitable portrait-and-wedding business. While others position themselves with price manipulations, you can ask high prices for your photography by striving for top quality. There always will be a market for high-priced and high-quality craftsmanship. That is why I advised my children to come into this profession.

Invest carefully in studio equipment in order to keep your debts as low as possible. Your work will be more enjoyable, and your profession will prove to be one that you'll recommend to your children, too. I recommend a proprietorship as the best form of ownership for a small business.

Our staff has three members in addition to me. My wife coordinates the staff and handles administration, public relations, and reception work. One assistant does handcoloring and retouching, mounts wedding albums, and helps with photography. Another staff member models for my seminars and lectures, assists with exhibits, and handles framing and mounting. A junior assistant does all-around work as needed in the business. The only outside expert I use is an accountant.

Born in 1947, I became interested in photography by looking at the "magic world" through the viewfinder of a "Senior Scouts" camera when I was a Boy Scout. It is still a "magic world" for me. About 1965 or 1966, I wanted to be a professional musician and joined a beat group with three or four performances each week. However, my parents wanted me to follow in my father's footsteps as the director of a dairy factory.

My studies weren't going well because I was more interested in music and photography than business management. My parents finally gave me a choice. If I could find work in photography—not music—within a week, I would be permitted to give up my studies. Fortunately, I got a job as a printer in a photographic lab.

Then came 1½ years of compulsory Army service, which was quite a change in my lifestyle, with no music and no photography. I asked for a job in the photographic department, and they said, "That's possible." Instead, I became a tank driver! I had to defend my country… against whom? After Army service, I worked for a few months in a bakery because I couldn't find work as a photographer although I wrote dozens of letters. In 1969, I succeeded in landing a job with several social photographers and retail shops. These different jobs didn't satisfy me, so I opened my own business after getting my certificate at the Dutch School of Photography, which qualified me for a license to start. I began business with a retail shop and portrait studio.

With hard work, my sales increased. I had no debts, even though I had to drive 80 miles every day to my business. If you don't have debts, you don't have to deal with stress, and you can relax. At the start, 70 percent of my sales came from the camera store and 30 percent from the studio. Over the years, it changed to be almost 100 percent photography.

Emphasizing high quality and highly skilled craftsmanship, I began making progress. This paid off in 1983 with first prize and the Golden Camera in the Kodak Camera d'Or competition for social photographers. In 1987, I started a gallery to present my work in a better way. About this time, I also participated in trade exhibits for the consumer and used the newspaper to publicize the prizes I'd won.

Currently, we position ourselves in the market as a low-volume, high-quality, high-priced studio. Our goal is for each portrait to reflect the personality of our subjects, so that the viewer is emotionally moved. I try to find the characteristics of each person: introvert, extrovert, charismatic, etc.

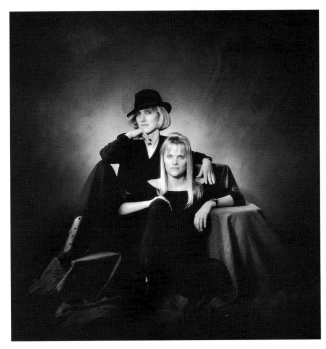

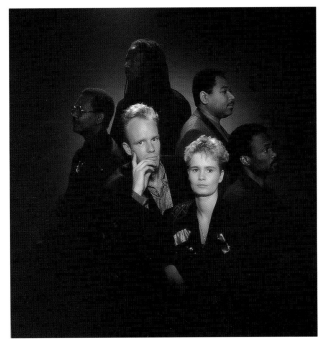

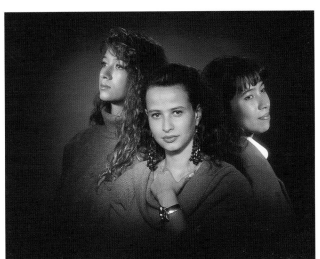

JAY STOCK

MARTINS FERRY, OHIO

One of the few living members of the Photography Hall of Fame, Jay Stock is recognized worldwide as a premier photographic artist. He was the first photographer to exhibit his work at the United States Capitol, showing more than 125 limited-edition prints that included studies of African, European, and Native American peoples.

In 1982, the American Society of Photographers (ASP) created its International Award to honor a person who or corporation that has made the greatest contribution to the field of photography on the international, historical, and professional levels. The first recipient was Stock, honored for his lifelong body of work.

Stock has traveled to five continents to create photographic studies of such diverse peoples as the Amish, the coal miners of South Wales, the mountain people of Georgia, and the Eskimos. His skill, dedication, and artistry have been a primary force in elevating portraiture to an art form. He has lectured and taught at a host of schools and galleries including Syracuse University, the Rochester Institute of Technology, and Chalon sur Soane of France. He is a prolific author, with articles and photographs published in leading magazines and books.

Stock is a Fellow of ASP, the British Institute of Professional Photography (BIPP), and the Royal Society of Arts. Professional Photographers of America (PPA) awarded him the Master of Photography and Photographic Craftsmen degrees, and he was named Ohio Photographer of the Year five times.

With a 400-dollar veterans bonus from the state of Ohio, I began my photographic career with a 4 x 5 Speed Graphic, some film holders, an enlarger easel, a developing tank, and some photoflood lights. It wasn't enough money to purchase the items essential to begin business, but a positive attitude, along with my long-term goals, enabled me to eliminate the stress and focus on my objective.

As I began my business, I worked out of my home and did all my sittings on location. My first darkroom was our kitchen. After my wife had washed and put away the supper dishes, I put the enlarger on the kitchen table, added all the chemical trays necessary to make the prints and washed them in the kitchen sink. The same sink was used to develop film and wash trays. It was a long and tedious job, but film processed in that sink 45 years ago is still in great shape and can produce beautiful prints today.

All this was done on the side as I maintained a full-time job on the railroad as a steam-locomotive fireman. When work slowed down on the railroad and I was furloughed, I returned to the coal mines to support my family. At this point in time, my photography continued to grow but not to the point of solely supporting my family. After three years of working out of my home, I rented a second-floor studio for the next 10 years. I continued to work in the mines and the railroad for my entire 10 years at this location.

With my first studio, I joined all the local and state organizations through which I received wonderful help via lectures on all aspects of photography. This was my first exposure to entering prints in competition, and I publicized my awards with the local newspaper. Since we had a second-floor location, I used windows of other business fronts to hang my award-winning pictures. Before too long, I had displays in furniture-store windows, drugstore windows, and wherever I found a storefront for rent.

This was a great way to grow through exposure in neighboring towns, especially with seasonal displays, including my Easter series of ministers from all local towns and high-school seniors who came to my studio for their work. We also displayed portraits of pets in veterinary offices, plus wedding portraits and wedding albums in all of the local florists, department stores that sold bridal gowns, and stores that rented formal menswear. Regardless of the location, I hired window decorators from large department stores to create professional-looking displays to enhance my public relations and advertising.

Another idea that proved successful was an exhibit in a large park during the Fourth of July weekend, a time when several thousand people visited the park. The photographs, all 16 x 20 or larger, were the actual prints sold to our customers. They were happy to bring their framed portraits back for the exhibit and were interviewed in a live radio broadcast from the exhibit site.

After 10 years in our second-floor studio, we purchased a plot of land in the residential section of a neighboring small town with a population of about 8,000, and built a combination home and studio. I continued to work for the railroad and coal mine for the first two years in our new home studio.

Then after 14 years in photography, I finally went full time. It was a scary move because I'd borrowed all the money I possibly could to build the home studio. While I did all the darkroom, retouching, oil tinting, and sittings, my wife did the reception work. We were able to pay off our complete loan of 25,000 dollars in three years, and we were on our way!

Through the creation of new concepts, I began to win trophies and blue ribbons in all categories, not only in our local and state organizations, but also in those of surrounding states. I was invited to write articles and appear at local, state, national, and international organizations as a speaker and print juror, a capacity I still serve in today. For many years, I've been a teacher at professional schools run by accredited state organizations.

Jay's Studio and Jay Stock's Gallery are family-owned businesses with a minimal staff composed of individuals well versed in a variety of functions that are essential to efficiency. These functions include print finishing, dry mounting, canvassing, framing, bookkeeping, corresponding, selling, and reception work.

It has been my experience that by identifying your clients' needs, you eliminate future client problems. Identifying these needs is quite simple: you simply discuss prior to each sitting exactly what the client wishes to have done. Then you can envision the portrait while creatively interpreting your clients' wishes.

Photography is still in its infancy in my opinion, and I see a resurgence in black and white. Many wonderful types of film and paper are being introduced both in black and white and color. The capabilities of digital imaging are unpredictable; however, I don't foresee the elimination of high-quality film and paper, nor of great artists, who will always have a place in our society.

JOSEPH K. S. TAN

SINGAPORE

Joseph Tan Kwang Siang, who is better known as Joseph K. S. Tan, was born in Pontian, a small village in Johor, Malaysia. While working for the Shell Oil Company, he bought his first camera at the age of 35, and a new career was born. After graduating from the Photographic Society of Singapore's ninth photography course, he won the eighteenth Singapore International Salon Competition Award in 1967. A year later, he became a member of both the Photographic Society of America and the Royal Photographic Society of Great Britain.

The Federation Internationale de L'Art Photographique in Berne, Switzerland, awarded Tan its Distinction Diploma Award for Excellence Services in 1971, followed by the licentiateship of the British Institute of Professional Photography (BIPP) in 1987. He is the first professional photographer in the Far East to become an Associate of the London-based Master Photographers Association and an associate of the Photographic Society of New York. Agfa Color presented him with the "Portrait Photographer Award of Excellence" in 1991.

Since 1988, Tan has been on the panel of judges for Kodak's Bride of the Year contest; he also served as a judge for the seventh Bombay Creative Photography Association in India. In December 1994, he was admitted to the associateship of the India International Photographic Council.

At the age of 42, I left a secure job as the head of oil accounts with Shell Singapore to begin a new career as a professional photographer. I gave up the security of a job with a large corporation for a new love. I took my 50,000-dollar, early-retirement package from Shell to risk it all on a new profession.

Starting in 1970 with a studio and photographic shop, I gained experience by accepting various assignments. During my first four years, I should have concentrated solely on wedding and commercial photography instead of dealing with photographic equipment and accessories, which led me nowhere.

With lots of patience and perseverance, I survived those early years because of total dedication to my work. Aided by encouragement and moral support from my family, I left Singapore for Europe in 1977 to spend the next seven years in a quest to widen my knowledge of photography.

Lack of training in my career path also hindered my early career, and I now consider the minimum education for someone starting today to be a Cambridge Certificate at the "ordinary" level, with proper coaching from an experienced photographer. For a start, a recognized licentiateship degree in photography would be an advantage. I hold both a Cambridge Certificate and a licentiateship from the British Institute of Professional Photography (BIPP), awarded in 1987.

In 1985, I was appointed manager and chief photographer with the fashionable Robinson's Department Store Portrait Studio, where by chance the Second Queen of Brunei, Her Royal Highness Peng. Isteri Hajjah Mariam, saw my photographs. Not long after, I received a request to visit the royal palace in Brunei to photograph the Second Queen and Sultan of Brunei.

This was only the beginning. Later came 5 other royal sisters and eventually 22 princes and princesses! This marathon session required 4½ hours, involving some busy nannies coping with three to four changes of clothes for each child. I was so busy that I had no time to think of even taking a glass of water! They just kept on coming, each in a different set of clothes.

In 1990, I became a partner in the Portrait Canvas Bond Studio in Bangkok, Thailand, where I was asked to submit 20 copies of my biographical data to the palace for consideration to do the King's official sixty-third birthday portrait. The screening continued for 10 months, after which came the final hurdle of approval by the King's private secretary.

With some nervous apprehension, I showed up at the royal palace and donned the customary white suit for my first sitting with the King of Thailand. I was quite surprised to find myself in the presence of a pleasant man with considerable knowledge of photography. With this interest in common, our conversation and photography session lasted an hour and a half. When the King moved to the throne to be photographed, we were firm friends. Ever since, the King greets me with a handshake and friendly smiles.

This royal contact led to a commission to photograph the three most important monks in Thailand, including the King's monk, the Supreme Patriarch. In two outdoor sessions, I captured their profiles for the coins, amulets, and temple portraits so highly valued by Thai Buddhists. Eventually, 50 Thai generals and their families also became part of my portfolio.

Royals are among my favorite clients because they appear so relaxed in front of the lens and, needless to say, pay handsomely for a job well done. I don't mind being whisked off at short notice in the first-class section of a jetliner, and I have no objection to being installed in palatial quarters in order to complete an assignment.

Photographing royalty involves a special precision. I have to be well organized and yet relaxed. There is no time to be nervous even though I am aware that I have only one chance to get it right! So because I can't afford to make a mistake, I keep my equipment and technique very simple.

Once the venue in the palace is chosen, my assistant loads the RB-67 with Kodak VPS and sets the shutter at 1/60 sec. Using a single light source and one back light, the set-up time is minimal. I'm usually told how long I have for the shoot, and it often isn't much more than 15 minutes, so I aim to take only one good roll.

What qualifies a photographer for such important assignments? It is unimaginable that royalty would employ someone with a "light" portfolio or someone whose specialty is doing rock groups for record albums. It is realistic to presume they want a competent and calm person, someone who is reliable, dignified, and pleasant. Conversing in English, you must follow some formalities, such as never turning your back on royalty and remembering to use the correct title when speaking to them. I always announce "Ready" before making an exposure, followed by "Thank you, your Majesty."

In 1992, I moved back to Singapore to establish Joseph K. S. Tan Master Photography in the Excelsior Hotel

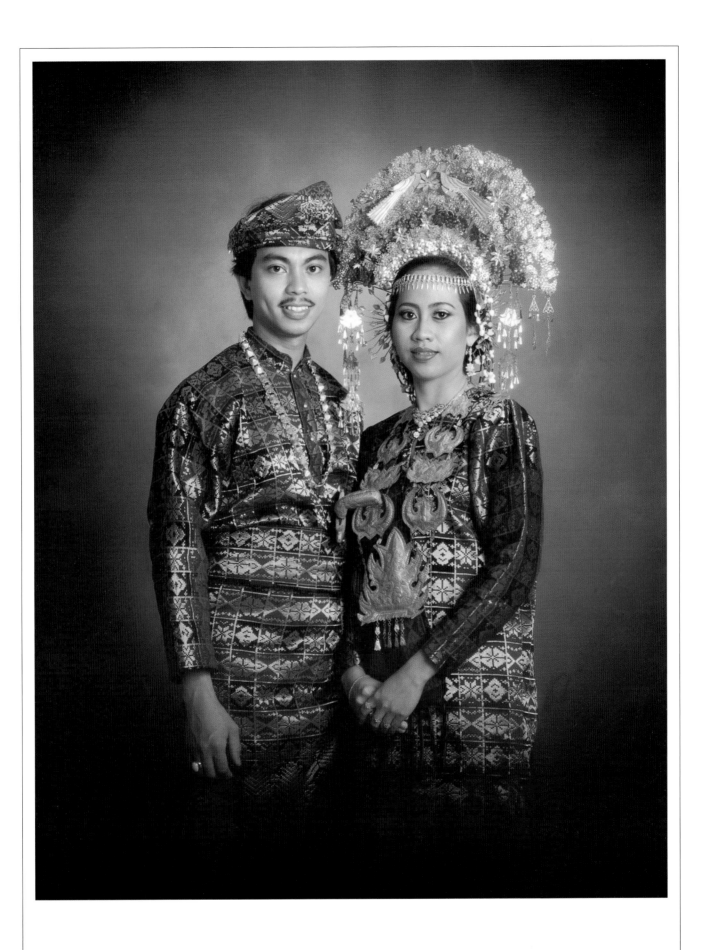

Shopping Centre, where I conduct beginning and advanced classes in addition to portrait sittings. At this stage of my life, I want to continue to pass on the knowledge I've gained, to give something back to those who want to make good portraits.

For those wishing to open a portrait business, I suggest seeking the expertise of an interior decorator, a lawyer, and a banker. For a three-person studio, I estimate 120,000 dollars in sales is needed to be profitable. A medium-volume sole proprietorship is preferred because I'm given a free hand in making major business decisions, and I am responsible for my own actions.

Joseph K. S. Tan Master Photography is a high-priced studio with the emphasis on high-quality prints processed in the United Kingdom. I emphasize the best service possible to my clients, personally inspecting all prints, thereby ensuring a high standard of quality. All bookings for studio assignments on portraiture and weddings are personally handled by me, while my assistants handle outdoor assignments, such as weddings and functions, in addition to industrial photography.

Time management is aided by punctuality, carefully recording all bookings, providing appointment cards, and restricting all sittings to a reasonable time. If you have problems with a client, be a good listener, and don't argue back. Assure them in solving their problems.

If you're starting a new business, look for a good location so as not to inconvenience customers. To cater to the high- and middle-income market, the studio should be located within the vicinity of a well-known department store.

The future of photography is still good. With the rapid advance of technology, it will be much easier to achieve excellent results. However, the knowledge of good photography is still vital.

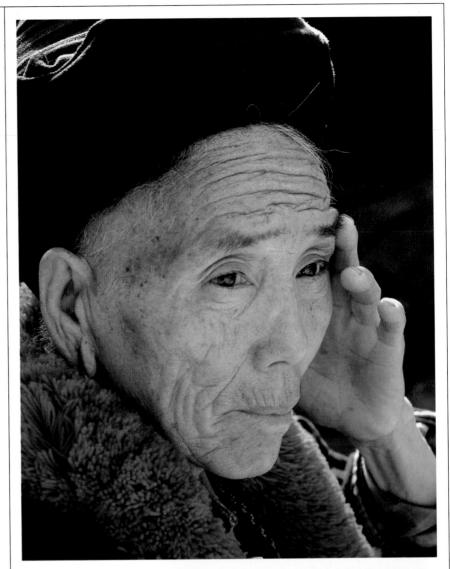

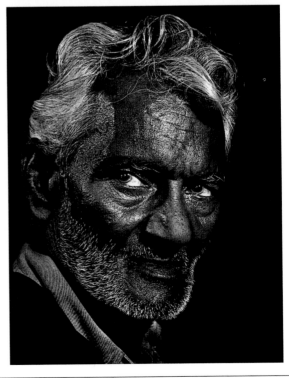

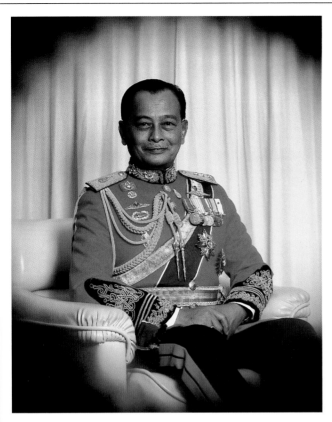

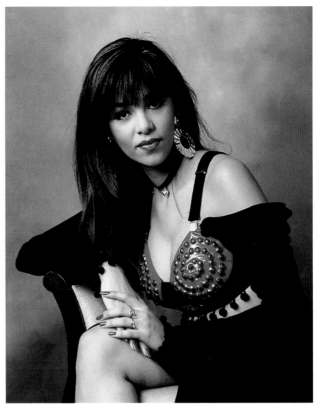

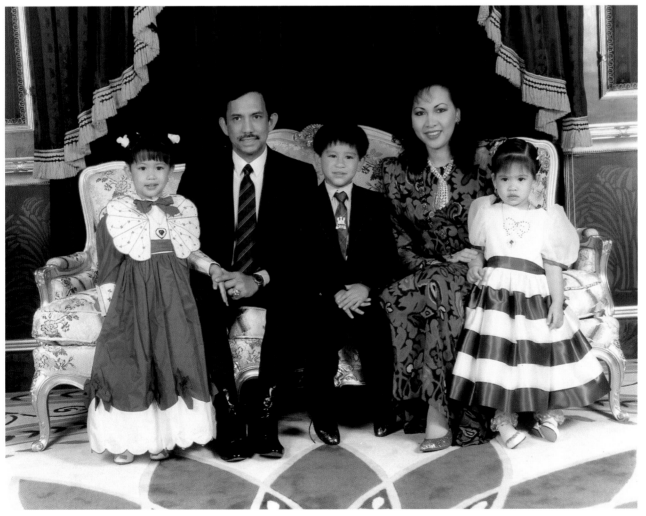

MICHAEL TAYLOR
PASADENA, CALIFORNIA

Kodak selected a Michael Taylor portrait for the cover of its 1994 book, The Portrait, *and features another of his portraits on every box of Pro 400 film distributed around the world. In three years, Kodak printed a Taylor portrait in its film advertising campaigns four times.*

The second youngest person to receive the American Society of Photographers (ASP) Fellowship, Taylor took only four years to earn his Master and Craftsman degrees from Professional Photographers of America (PPA). A member of XXV, he has won Photographer of the Year honors eight times from various associations, in addition to winning the Kodak Gallery Award.

Taylor was an exhibitor at the Photography Hall of Fame three times and at the World Biennial Photographic Exhibition; there, he was one of only five American photographers. He has presented programs across the continental United States, Hawaii, and Japan.

Since it only takes me about 10 minutes to set up, I can easily do four location sittings a day, or about 300 a year. The most I've ever done is eight in one day, but that is unusual.

To keep it simple, I usually use only two lights, a main and a fill, aided by a slow shutter to pick up ambient light. In the winter when it gets dark earlier outside, I carry a third light to do a little accenting. The main light is a Photogenic PowerLight, with a bare bulb, aimed into a Westcott Halo, which gives a beautiful roundness to the face. A typical sitting usually takes about an hour and a half, using six different backgrounds, so to speak, not just one place. I can get good variety in that time, making about 20 to 40 exposures. I use a mixture of strobe, window light, and natural outdoor light in order to change locations quickly. I am very efficient in the home when it comes to setting up.

Our studio is well located in Pasadena, so that I am probably 10 minutes from most of my sittings. Our staff is minimal, just two of us and a part-time employee. My staff members answer the telephone, schedule appointments, assemble orders, and assist our customers.

Although most of my sittings are done in the home, 99 percent of sales consultations transpire in the studio. I'm not a polished salesperson, but I start by projecting a 30 x 40 portrait and go down from there. When we switched over to projecting slides, our sales went up 40 percent. It is incredible, letting you finally take control of the sales situation. My great advantage is that I have clients who believe in me and trust me.

We've had some good people work for us, and they are capable of conducting a sales appointment. However, I've already developed a relationship with the clients because I've been to their house, and I know what they need. I don't have a typical sales personality, but I am very honest and enjoy what I do. I know it comes across.

Different finishes that we provide help us upgrade sales. The bottom of the line is a machine print with no special work or cropping on it. Then we have one I call a Florentine Portrait that has retouching done on it, pebble texture, and luster spray, and is placed in a black box with our studio logo in the corner. Then we have the top-of-the-line portrait, which is beautifully finished on canvas.

To advertise, I'm heavily involved with women's groups, fund-raising groups, philanthropic associations, and social organizations in Pasadena. We also do fund-raisers, silent auctions, and showcase homes. In addition, we do some direct mail, newsletters, co-promotions with other businesses and photography for local magazines to keep us visible in the community.

If someone is getting started in a new city, I would advise going to one of the prominent social groups, like the Junior League, and ask what you could do to help the members. For someone getting started in photography, I would say go to work for somebody else and learn how to deal with people.

Photography school gives you the foundation to build on, but in my opinion you would learn only 10 percent of what you could learn out there in the real world. If you go to college, I would recommend a liberal-arts degree because that would make you more conversant with people. In essence, I would hope that you have a passion for people and their interests. Your ability to develop a relationship and capture that rapport on film will make you stand apart from the other photographers in your community.

I've always enjoyed the arts. From kindergarten through high school, I was involved in painting and music. By practice and determination, I became pretty adept at playing my Selmer Mark VI alto saxophone. By my junior year in high school, I realized I had no innate musical talent. While I played well because of practice, I had no naturalness, no uniqueness in my play, and music didn't come from my heart. It came from a sheet of paper. I wasn't disappointed. I just knew I wasn't gifted in this area. Music lovers everywhere rejoiced when I retired.

During my last semester in high school, I took a photography class. The first print I developed was in a tray that was situated next to a specimen jar that looked like last Friday's main course in the cafeteria. (The photography classroom was located in the biology laboratory.) To this day, I still can feel that wonderful mixture of adrenaline and pleasure as I looked at this first print.

I'd always wanted to find something that I could do well. I found that in photography. I also found early on that, more than anything else, I enjoyed doing portraits and being involved with people.

After high school in Sacramento, I got a liberal-arts education from Westmont, a small Christian college in Santa Barbara. I got a lot of experience being the newspaper editor and the yearbook editor and doing public-relations photography for the college. I graduated in 1978 with a degree in religious studies.

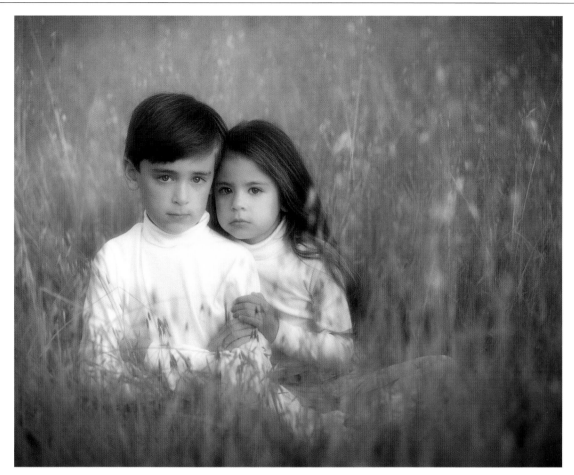

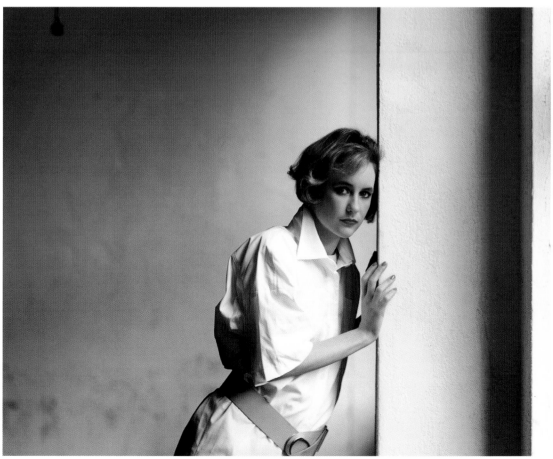

Then came 2½ years at the Brooks Institute in Santa Barbara, studying photography. When I was at Brooks, I found out that I really wanted to deal with people. While there, I joined Professional Photographers of America (PPA) as well as the Professional Photographers of California, attending a lot of meetings.

That was really helpful because it gave me a lot of contacts in the professional community. The whole time I was going to school, I attended PPA meetings in Los Angeles, giving me a pretty good balance. After graduating from Brooks, I had four or five offers. I finally joined Paul Skipworth because I liked his kind of classical location portraiture. He has studios in several cities, and I was assigned to Memphis, Tennessee, where I stayed for 4½ years. Skipworth provides a great environment to grow in and establish yourself. He gives you a foundation of classic portraiture that you build upon, and he doesn't force his photographers to do it exactly like he does.

Skipworth's photographers had to produce portraits that were saleable, but he wasn't opposed to letting them develop their own style. That was a fantastic environment. I got my Master of Photography degree while working in Memphis, and three days later left for Orange County, California, where I worked in a senior operation for three years. That was a terrible, yet wonderful business, photographing about 13,000 seniors a year and lots of proms. It was all head and shoulders with no variety. We had five to seven photographers, and what I did was to try to manage them.

After working for other people in Los Angeles for a year, I opened my own studio in Glendale, California, where I worked out of my house. It was a one-person operation. After a year, I moved into a small storefront, and then two years later found a larger place. When I started doing about 150 sittings a year, I hired my first employee. Now I am in a lovely location in one of the most beautiful and interesting cities in the world, Pasadena.

To me, portraiture in its finest and purest form is the location portrait. The marriage of subject and environment gives the most depth and tells the fullest story of our subject. By placing subjects in their work, home, or play environment, we're telling viewers something more about the customers. The location adds uniqueness, beauty, secondary points of interest, and character to the portrait. The studio portrait rarely can do that consistently.

It is those precious seconds when I look through the viewfinder that my creativity is at its height. Most people think that creativity means having a unique composition or lighting. To me, creativity is most important in solving a problem in a sitting. It is here where your abilities, your visual knowledge, and your desire to grow can come together because of the foundation you've laid. A new idea may arise from a portrait you saw last year, a seminar you attended three years ago, or an article you read last week. The source of your ideas isn't important, but the outcome of your ideas is. The creation and application of ideas is both satisfying and motivating. When I can bring all the elements of a fine portrait together in one unifying moment, I breathe a sigh of satisfaction...until the next sitting.

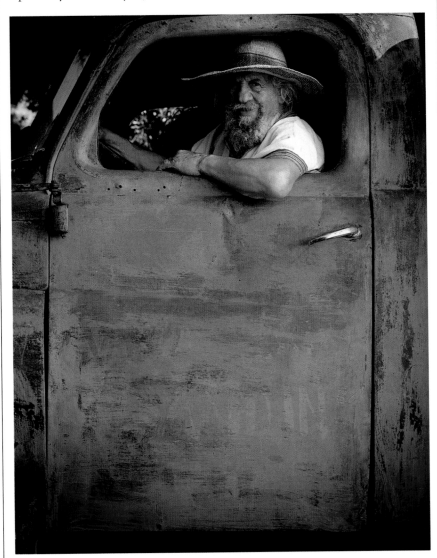

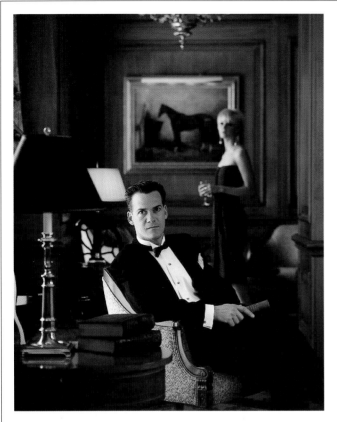
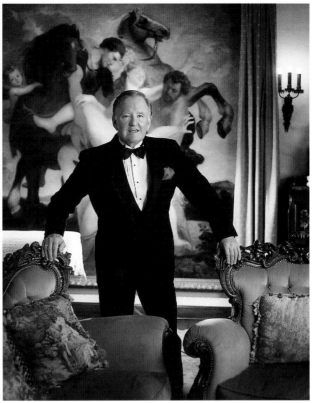

DARREN TILNAK
ABBOTSFORD, AUSTRALIA

A member of the Portrait Maker Institute of Professional Photography (PIPP), Darren Tilnak has acquired every accolade available, earning respect from his peers and international judges alike. He was the only photographer to win the Nulook competition three years in a row. A recognized master photographer with PIPP, he also has been named Australia's Photographer of the Year.

In 1991, Tilnak broke away from regimental, traditional portrait photography to make a name for himself with his designer portraiture, which exudes a timeless, emotional style. Even though he uses color as a medium, he shoots predominantly black and white. Tilnak drives a 1950s classic convertible and works out of a Victorian blue-stone studio, classified with the National Trust—part of the high-profile image that contributes to the success of his business.

It is very important to me to have direction taking a photograph, so we spend about an hour with the clients over coffee or wine deciding what they want to say in the portrait. I need to know what to say with the photography before I can actually say it. The art side is learning what to say, and the science side is learning how to say it. There is no point in knowing how to say it if you have nothing to say. What is the point in creating a technically perfect picture if the image is boring and doesn't say anything?

In 1990, I took a risk and started to produce imagery that was very unlike the rest of the industry. The rest of the industry at that time was producing a lot of color, doing a lot of studio work, a lot of half-length shots—pretty straight up and down, but nice quality. I decided to produce more of an art-type portrait where it is definitely environmental, where it tells a story behind the person.

This is shot pictorially where the person is only part of the whole picture. My work is 95 percent black and white. I get a real buzz when someone buys a 30-inch portrait that sells for 1,040 dollars, and you don't even see the subject's face. Clients are buying for the art aspect to hang on the wall.

The beautiful thing about my business is that it is really split in two. We've got the fine-portrait side of the business, which I run; the Bonnie Leder Photographic House is my school business. We photograph a couple of thousand students a year from the three universities in the Melbourne area. I do about only 150 fine-art portraits a year, three a week, averaging 4,500 dollars each. Our wedding coverage is a mixture of formal and candid. Some of the work is directed, but a lot of it is just shot while it is happening. We call it just pure candid.

Of the 150 fine-art sittings, most are couples, both young and old. A lot of the time, we've done their weddings, and at this point they've decided they want a portrait they can hang on the wall. Our clients' average income is between 35,000 and 50,000 dollars.

We have five full-time employees plus myself, and in busy periods about five casual employees. One person specializes in marketing and sales, and another focuses on production. Another woman acts as my personal organizer, as well as a customer-service manager and office manager. Her duties are pretty unique.

Proofs are shown in slide form with music, evoking emotion during the showing. All portrait proofs are shown at the studio, but we produce paper proofs for wedding work. After the album has been produced and paid for, customers can take the proofs home. Copyright infringement is a serious problem in Australia. That is one of the reasons that paper proofs aren't produced to give to the client.

While I was in high school, it was obvious to my teachers and family that I had a flair for photography. When I left school, I started working in interior design, and part of my job was doing photography. I put together a folio and started to subcontract to several photographers in Melbourne, as well as doing my own work.

When the opportunity came to become a part of the Bonnie Leder Photographic House, which has been open for 52 years, I took it up. I came here in 1982 as a manager. Six years later, I took it over. The studio was doing about 25 weddings a year—good honest weddings. The fine-portrait area was very promotional, but the sales weren't very high. Part of my job was to restructure areas that I thought would help the company, so I focused on the fine-portrait area and picked up weddings as well.

After managing the studio for six years and working closely with my colleagues, it was very difficult to become their employer. Another pain was delegating and learning to let go, trusting the staff to do what needed to be done at the time. Increasing prices also was a perplexing thing. I felt I wasn't being paid well enough for the quality I was creating. The company had been going for a long time with good photography but average prices, and I wasn't sure whether the public would pay my price. As it turned out, it was never a problem. I raised prices gradually, about 7 percent twice a year, which amounted to 14 percent a year.

If clients have a money problem, we have a lay-by system, which is a 16-week plan. It has worked very well in terms of the sale, and you don't lose the average. Of course, we also accept all major credit cards.

Studio hours are 9:30 A.M. to 5:30 P.M. Monday through Friday, and by appointment until 10 P.M. on Wednesday and Thursday. On Saturday, we are open from 9 A.M. until noon and by appointment only after that. Sundays are by appointment only. So we are available seven days a week.

First and foremost, I chose not to do a degree. I studied short and very intense courses not only on photography, but also subjects that would help my portrait work. I mixed photography with the study of psychology, human behavior, people skills, visualization, and dance. Once you find out what the people are about, then you

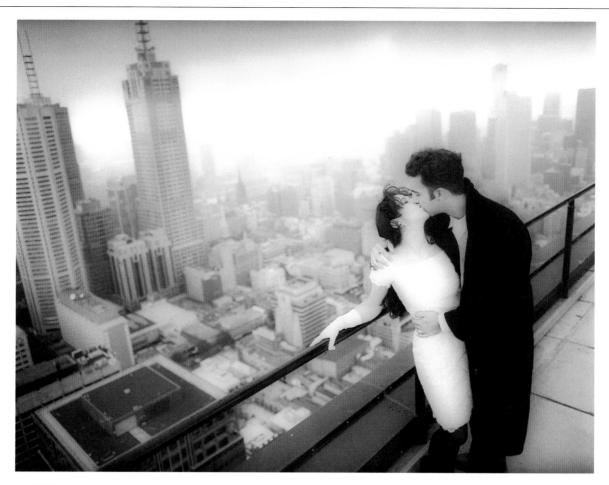

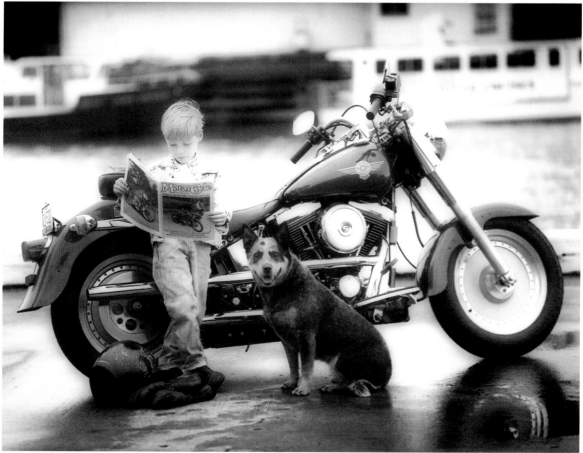

have something to say. I think the problem with photography schools is that they want to focus on science.

I've always been a big one for personal development. During the six years I was managing the company, from 6 A.M. to 8 A.M. every morning I studied such things as business, management, and psychology. If I had it to do over, I wouldn't do a photography degree because I feel that in the portrait arena, it is overkill.

For newcomers to the field, I suggest a 12-month course on the fine-arts side, coupled with something to do with human behavior and people skills. And you have to understand business as well. There are too many hungry artists out there. In the portrait arena, 50 percent of your skill has to be photography and the other 50 percent dealing with people and making them feel comfortable.

In 1994, I lectured in the Northern States of Australia. The audience members did visualization to music, bringing all their senses into it. A lot of photographers lack visualization skills. If you can't see an image, how can you put it on film?

It isn't surprising that some portrait photographers lose enthusiasm because they don't ever vary the way they work. They use the same location, the same lighting, the same poses, and the same film. There is no challenge in "sausage-machine" portraiture, and it shows in the pictures. Photography has a wonderful ability to create fantasy, yet for portraiture, it is often simply as a recording medium.

People come to me because they want art. My clients don't want the run-of-the-mill studio portrait; they want pictures that are totally unlike anything their friends have on their walls.

Every time I press the shutter, I ask myself "What am I trying to say in this photograph?" If it is drama that I'm trying to convey between two people, then it is drama I must produce. Immediately you become the director not the photographer, and you must induce emotion between them. This isn't easy. I often act out the part that one of them must play, over and over, until they want to do it themselves. If someone viewing the image gets involved and works out what I'm trying to say, I've achieved my goal.

What I want to do with my pictures is to tell a story and to create emotion. Everything else is secondary to the creation of real feelings. Portraiture is an emotional medium. It is so much more than simply picturing people's physical appearances. It is about conveying the extra dimension that is their personality of character.

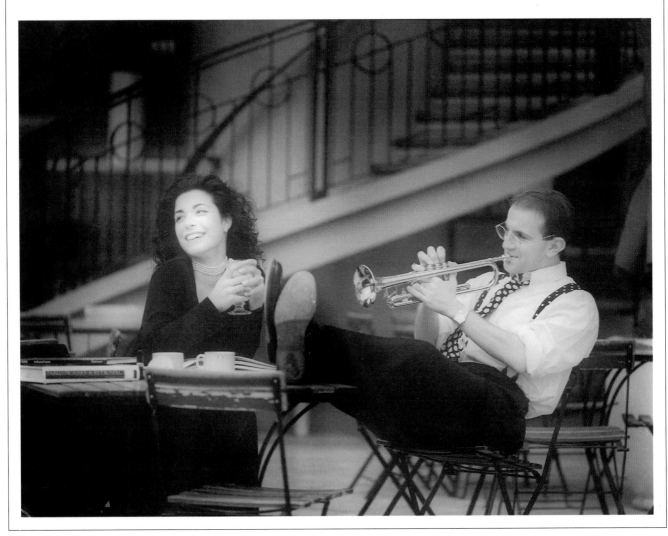

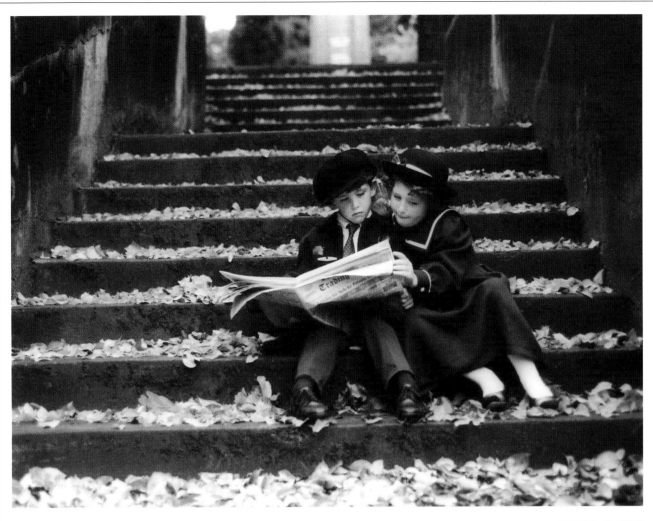

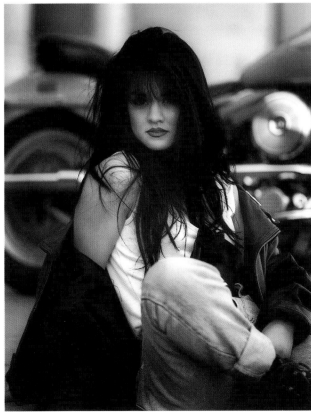

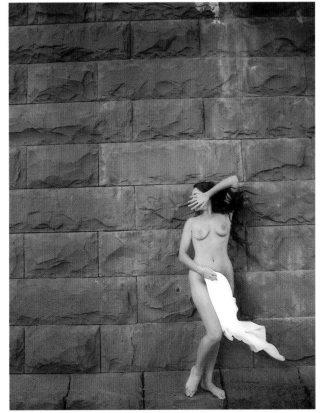

RONALD AND TRACY TURNER

CARDIFF, WALES

Both Ronald Turner and his daughter, Tracy, are fellows of the British Institute of Professional Photography (BIPP). Winner of more awards than any other British portrait photographer, Ronald is a founder of the highly regarded Guild of British Portrait Photographers, a group restricted to 20 of the country's leading portraitists.

Ronald was the first European to win the Grand Award of Wedding Photographers International; he also won four of the organization's first-place awards. A Kodak Portrait Photographer of the Year, Ronald has received 11 Kodak Gold Awards, as well as the Kodak "Shooting for Gold" portrait and wedding trophies.

In BIPP, Ronald was the first ever British Euro Gold Medalist. He was twice named National Portrait Photographer of the Year and three times the National Wedding Photographer of the Year. Ronald has had work selected for the International Photography Hall of Fame and Museum.

Born in 1965, Tracy became the youngest portrait fellow of BIPP in 1994, tying with Dutch photographer Josephus T. Sprangers for the Peter Grugeon Jubilee Award for the best fellowship submission. She won both joint first and second place in the annual competition of the Guild of British Portrait Photographers.

Also in 1994, Tracy amazed the photographic profession by winning in one judging an incredible six Kodak Gold Awards, doubling the record her father had set five years earlier.

Invest the pennies in your pocket in your mind, and your mind will put pennies in your pocket. That aphorism has guided my career since my wife, Barbara, and I started our business from home in 1970. We had no money, but a lot of enthusiasm.

The first few years were tough, and with a growing family to look after, money was very tight. It wasn't impossible to cope, however, and sales grew and grew as our reputation spread. Soon it became obvious that the hiring of a receptionist would be the only way I could increase volume and profit, freeing me to take more sittings. We are now a family business, with no employees outside the family. Daughter Tracy and eldest son Martin are qualified photographers, actively engaged in both weddings and portrait sittings. Tracy deals with most of the sales, including the transproof viewing sessions. Martin handles the orders, mounting, and framing. To a certain extent there is an overlap, so each can do the other's work. Barbara does the bookkeeping, banking, and odd jobs that always need to be done.

It is vital to listen to clients' needs and to research what they really want. Sometimes they may not realize exactly what they want, but by suggestion and discussion we can draw it out. Most clients have money to spend on fine photography if they feel we've captured a "once-in-a-lifetime" experience.

Most clients appreciate our professionalism and the way we work so well as a team. Most of them like the personal and friendly service a family business provides. Having male and female photographers at the studio also is an advantage.

Give the client the benefit of the doubt. Try to put yourself in the customer's shoes. Learn from your mistakes so that you eliminate problems before they arise. We see all clients by appointment and prepare well to save time later.

Our goal is to ensure that our product and service continue to be the best in our area. By so doing, the foundation of our business was established, giving us excellent client loyalty with short-, medium-, and long-term benefits in repeat business and referrals.

We specialize in people photography, which in reality means mostly portraiture and wedding photography. We also do some advertising photography usually where there is a strong emphasis on the "people" content. Our specialty is location portraiture.

All of our color processing, printing, and retouching is handled by an outside lab. Little if any control is lost, as we've built an excellent rapport with the owner and staff. By using a lab, we have more time free both to concentrate on our photography and to look after our clients.

We're often told that our studio looks inviting, and we're spending several thousand pounds on the building to make it even more so. Our windows are changed every month by a professional window dresser.

These days it would be more difficult to take the bold step to become a professional photographer than when I started. Ideally, a good camera, some lights, and enough capital to cover the making of a portfolio, sample portraits, and initial marketing should be the minimum requirement. However, it is surprising how much enthusiasm and persistence can make up for a lack of material resources. With the right attitude, everybody should be able to succeed if they put their mind to it.

A problem for anyone coming into the profession is guidance on photography technique, style, and business/marketing techniques. Seminars are an excellent way of learning these skills.

Gradually, we can find our own style and learn to tune in to our own creativity by learning from the best in our profession, both past and present. Learn from those you look up to, but take care never to copy other photographers' styles; instead, use their ideas as a springboard to finding your own style. Learn from other art forms, such as painting, sculpture, films, and the best advertising photography.

Believe in yourself. Set goals so that you keep moving yourself forward. Keep your business small and manageable, so that your overhead expenses don't drive you to work too hard and lose your enthusiasm for your work and love of photography.

Don't take shortcuts. Few successful businesses have gotten where they are without research and development, so devote some time to experiment—you'll be surprised at the leaps forward you can make. Much of our success is due to experimentation and our research into impressionist painting. Having visited the studios of Renoir, Monet, and Cézanne, and many of the places they painted, has inspired and helped us attain a more painterly look in our photography.

For the future, I hope our profession can learn to produce such mind-blowing images that the public will be educated to accept them as photographic art and will be willing to pay the price such work deserves.

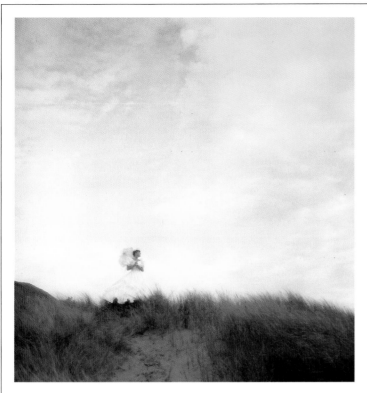

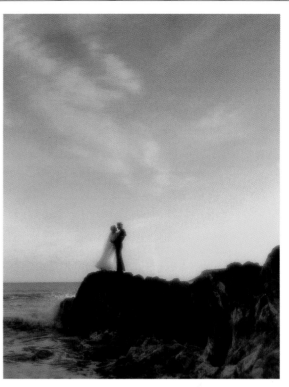

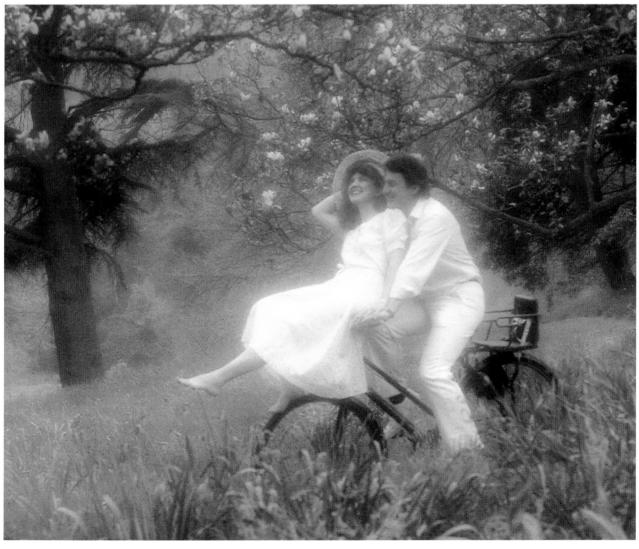

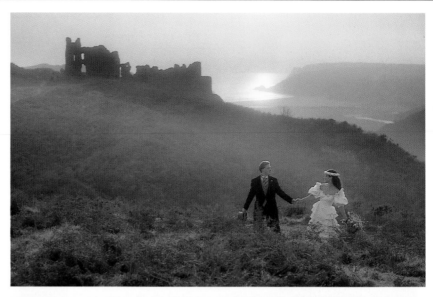

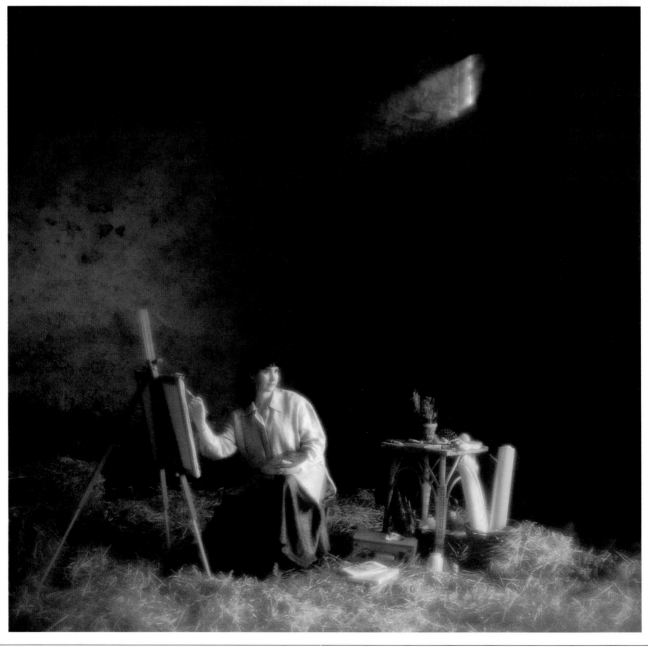

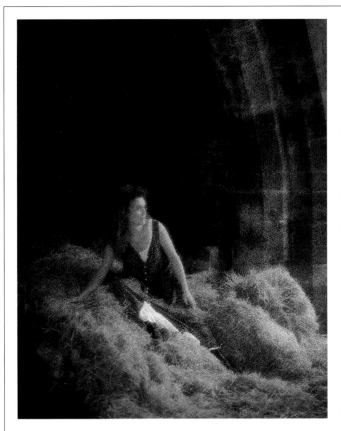

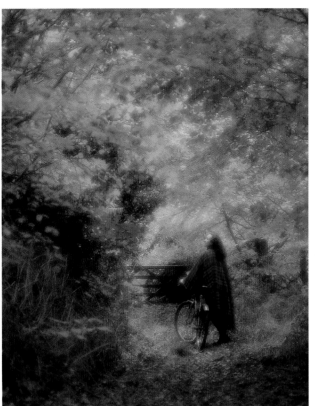

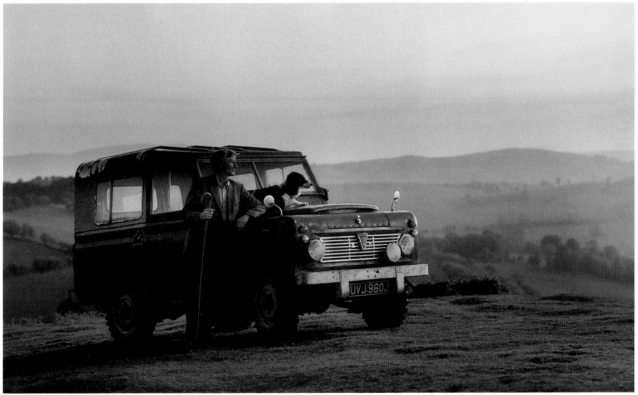

JOYCE WILSON
INDIANAPOLIS, INDIANA

Joyce Wilson began her photographic career in 1961 taking pictures of children sitting on Santa's knee. The holiday job in a Santa Claus house evolved into a full-fledged career in which Wilson covered assignments from London to Los Angeles. Considered one of today's premier portrait photographers, she is a frequent lecturer and judge for photographic conferences throughout the world. For the past 25 years, she has taught classes at the Winona International School of Professional Photography and the West Coast School, among others. She has also led workshops and seminars in the United States, Canada, England, Australia, and New Zealand.

Wilson holds the Master of Photography and Craftsman degrees from Professional Photographers of America (PPA). She was awarded the American Society of Photographers (ASP) Fellowship degree, as well as an honorary Master of Science in Photography from the Brooks Institute in Santa Barbara, California. She now serves as a director of the International Photography Hall of Fame, where her work is part of the permanent collection.

Honored numerous times for photographic excellence, her work is in demand by the photographic world for illustrations, exhibitions, and advertising campaigns. Fuji film features her in its advertisements, and a book of her images has been published as part of the Famous Photographers Portfolio series.

My religious training as a child taught me that nothing was ever too difficult if we believed that we were put on earth to glorify our Maker. Regardless of what you call this Spirit, it is the creative force that is a part of all of us, and somehow this creative process is an integral part of the motivation for my career in photography.

Regardless of the circumstances, I put my best effort forward because it is so important for me to be able to please my client and do my best. That is the secret: I never allow my mental or physical condition to override my performance on a day-to-day basis. I know that once I start working, something magical will happen.

I recently read a book entitled *The Artist's Way* by Julia Cameron. It was written to teach through spirituality—a way of freeing people to discover their creative selves. I realized while reading this book that I was very fortunate to have been given this legacy from my parents during childhood. When you live life to the fullest and enjoy people and all the beauty you're surrounded by, you learn not to worry about the things you cannot control. It is unfortunate that many people have to learn this process as adults to allow creativity to flourish.

Santa Claus pictures launched my career in 1961 when I needed extra income for the holidays and agreed to help a friend. I donned a pixie outfit and learned to use some rather simple 35mm equipment. The film and money from the Santa House had to be delivered each night to my photographer friend, and eventually I became outspoken about the garish oil portraits he was delivering to customers. I told him the portraits were ugly, and that black-and-white photographs were certainly nicer. He challenged me and told me the best color artist in the city was doing his work; he also asked me if I thought I could do better.

I put my art training to use and set out to prove my point. Within the next six months, I found instruction in photographic oil painting and began freelance painting for photographers. One of the photographers gave me a stack of *The Professional Photographer* magazines from the 1950s and told me to read the painting articles. I opened the first magazine to the Loan Collection prints from the National Exhibit and became obsessed with the desire to become a photographer.

The photographer who had given me the magazines sold me a Rolliecord for 65 dollars, lent me a book on photographing children, and told me to start taking baby pictures. From this humble beginning, I was hooked. I discovered this magical "thing"—this camera—and I began photographing my children and the children of all my friends. Thus, a portrait photographer was born.

Looking back now, I realize that these early images were pretty good because there was a wonderful sense of freedom and emotion to the way I photographed children. But technically, I didn't know what I was doing. I encouraged my husband to join me in this new venture, and we attended night-school photography classes at a local high school.

A few years later we joined the Indiana Professional Photographers Association and in 1965 attended a class with Adolf "Papa" Fassbender. This class was a turning point. I still have the faded and scribbled notes, and I realize that much of my philosophy and approach to the art of photography stems from this early training from a man who was a master technician and pictorialist of the early European style.

Within the next two or three years, I attended a business seminar in Chicago, an advanced oil-painting course, and as early as 1967, an environmental-portrait workshop. My husband was studying photography with me during this time, while holding down another job so we could pay the bills and feed our three children. In 1965, he had a serious heart attack and another one in 1970. He didn't survive the second attack. I found myself with no life insurance, three children under high-school age, and a small portrait/wedding business that was growing steadily but that had grossed only 35,000 dollars in 1969.

The business was always primarily a portrait studio, and I rarely covered more than 10 weddings during a year. As early as 1965, I began teaching oil-coloring classes to supplement the studio income. In 1971, with the help of the color lab I was working with, I began to promote to high-school seniors on a noncontract basis. My husband and I were never successful in getting the local school contracts, and in retrospect, it was fortunate. The promotion to do seniors as regular studio sessions became very successful over the next few years, and the cash flow from this steady work provided a good balance.

In 1969, we joined Professional Photographers of America (PPA) and started entering photographic-print competitions. By 1973, I had earned the Master's degree, and in 1974, I earned my Craftsman degree. Then in 1976, my thesis and portfolio of prints

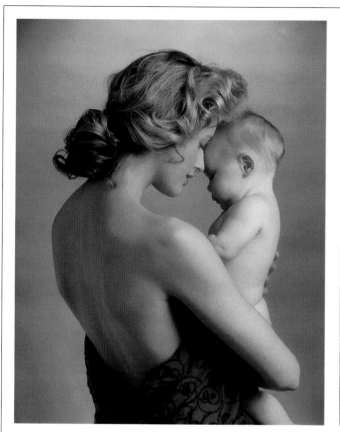

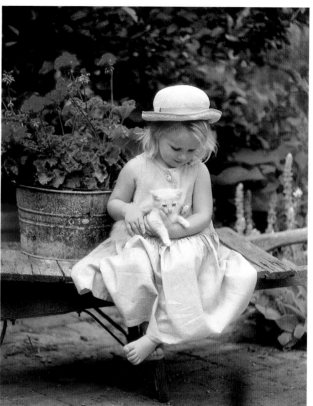

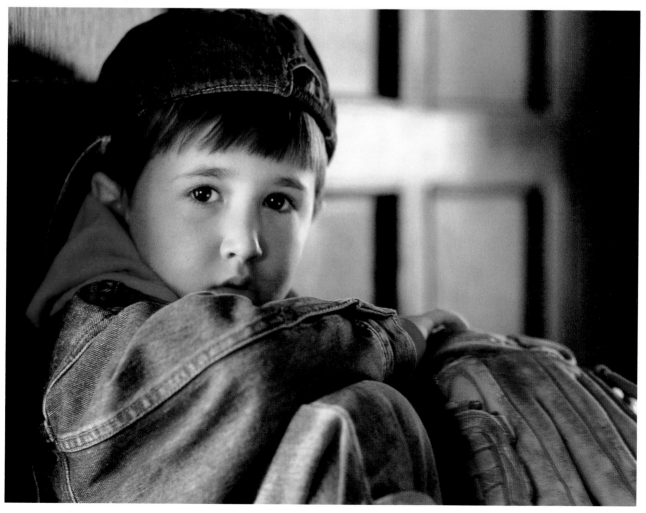

were accepted, and I was awarded the coveted American Society of Photographers (ASP) Fellowship.

About this time, I began teaching at the Winona International School of Professional Photography and was also invited to teach at West Coast School, plus several other continuing-education courses around the country. These classes are one-week courses designed for photographers to develop and fine-tune skills in many different fields of photography. It has been 25 years since I started teaching photography courses. I still enjoy sharing my experiences and helping photographers realize their potential, and I'm always inspired and learn from the students.

When I decided to become a photographer 34 years ago, educational materials, seminars, and workshops were scarce, and with three small children, I couldn't afford the luxury of a full-time school commitment. I wish there had been an opportunity for me to gain technical training because that was the most difficult and frustrating period to struggle through.

Art classes and various creative projects throughout my early school years helped me develop a natural instinct for composition and design, and I could express myself through the photographic medium even at the outset of my career. However, lighting intricacies, film latitudes, exposure, and all the technical aspects of the photographic craft were slow in coming as I played the game called "learn and earn."

I believe that it is very important to get good technical training whether it is through attending school, going to seminars, or apprenticing. The quicker you learn the technical skills, the easier it becomes to express yourself with the camera. You only become a creative photographer when the tools of the trade are secondary, and you are free to concentrate on the subject and the statement you wish to make. You could stumble around in the dark for five years making mistakes that you can cure during a five-day workshop.

If the financial resources are available, it would be wonderful to attend the Brooks Institute, the Rochester Institute of Technology (RIT), the Art Center, or a college offering photography courses before you have family commitments. The photography schools offer a more complete education in all aspects of photography and preparation to enter the commercial market than other schools do. Most college curriculums are developed as a fine-art approach, which is wonderful but not necessarily easy to market and earn a living with.

Realistically, an apprenticeship with an established professional is the ideal learning tool, but that doesn't happen easily as these positions are at a premium. If you go into the market as a freelance assistant and work with a lot of different photographers shooting advertising and commercial assignments, you can learn a great deal while earning an income. In a small portrait/wedding studio, apprenticeships are rare because it can't support another person who isn't bringing in paid work.

It is great to be a second- or third-generation photographer in an established business, but that doesn't happen often either. The young people brought up in this industry sees what goes on behind the scenes—the long hours, deadlines, and how this business has a hold on your life—and these kids decide they want a more regular existence and a steady paycheck.

It is probably more difficult to begin a career in photography today than it was 35 years ago. However, I believe anyone who is dedicated and wants to be a photographer can make it happen, regardless of the timing, the circumstances, and the business climate. Only the brave at heart, risk-takers, free souls, and those willing to sacrifice may apply! You must be willing to sacrifice for the sake of your art, and put in the time to get name recognition and establish yourself.

I believe that young photographers need to understand that if they start out with cheap pricing and give their work away, they're perceived as cheap, and it is hard to shake that reputation. This mentality will undermine what they're ultimately trying to accomplish. It is better to market their work at a fair price and struggle for a couple of years until they build a clientele. Don't be afraid to ask what your work and time are worth.

My life story and the evolution of my photographic career are always an inspiration to others. My career has gone the whole spectrum—starting with Santa pictures and coupons for children's portraiture in the 1960s to the carriage-trade business, advertising campaigns for Fuji film, and fine-art gallery exhibitions that I'm involved in today.

From the very beginning, I was drawn to the aesthetics or the art of photography. Photography has always been an emotional experience, not intellectual or scientific. I'm continually stressing the importance of not being swept along in the tide of conformity and mediocrity.

I'm not certain that what I do technically and photographically is any-thing special. What is special is my ability to relate to my subject—to create an atmosphere whereby there is an integration of souls. I believe there is a unique beauty in every subject that comes before my camera, and that attitude shows in the finished product.

The studio thrived for 25 years with a diversified schedule photographing children, families, executives, high-school seniors, and few special weddings. Then one day, I realized that I was in a comfort zone and the magic was gone. I made a drastic decision at that time to specialize, by virtue of pricing and fees, limiting assignments for client work and lectures. I'm also represented by a great stock agency and very involved in photographing children and lifestyle images for stock. The income from stock sales has given me additional freedom to pursue my dreams at this stage of a long, wondrous career. The extra time has enabled me to return to my first love of fine art.

The past few years have been creative and productive with time devoted to personal projects. The central theme of my personal work is a celebration of the female: her spirituality and oneness with the universe. I've returned to black and white, which I love. Much of this personal work is produced with alternative and nonsilver processes, such as old world Bromoil and Carbo printing techniques, Van Dyke and Kwik Print, and platinum and Polaroid image transfer.

The studio in Indianapolis still services a select clientele that covers a broad base from London to California. My sister works with me full time and manages the studio when I am out on assignments or teaching. She is also an excellent retoucher and artist and does most of the production work excluding film processing and printing. I hire a freelance assistant on a day rate to work on assignments for location sessions, and to assist each Friday when we have scheduled stock sessions.

Photography is my passion and my art, and I plan to be shooting assignments well into my eighties, God willing. A friend, many years ago, told me to follow my own star. I've always been true to my intuition, and at this stage of my career it is gratifying to find my star shining bright and the vision becoming clearer. Master photographer Yousuf Karsh has stated that his favorite photograph will be the one that he takes tomorrow, and I believe that my best work is yet to come—the best of visual images and a legacy of hope and inspiration to photographers searching for truth.

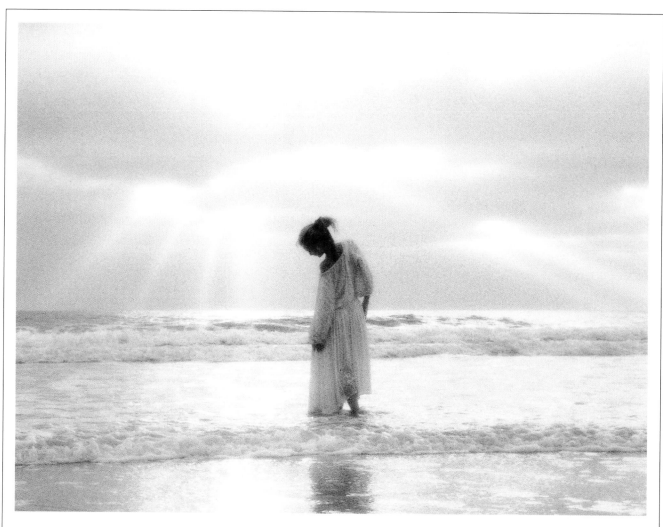

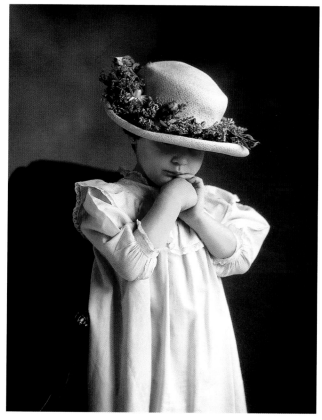

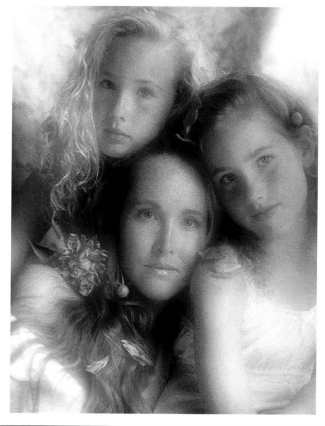

RESOURCES

BUSINESSES AND MANUFACTURERS

Camera World
1809 Commonwealth Avenue
Charlotte, NC 28299
800-868-3686,
704-375-8453
*Sailwind darkening vignetters:
Leon Pro II, Leon LVK*

Current, Inc.
The Current Building
Colorado Springs, CO 80941
800-525-7170
Greeting cards for children

Direct Marketing magazine
224 Seventh Street
Garden City, NY 11530
516-746-6700
Mailing lists

Eastman Kodak Company
343 State Street
Rochester, NY 14650
800-233-1650
*Printed advertising materials:
color postcards*

EFS
2525 Horizon Lake Drive
Memphis, TN 38133
800-238-7675
fax 901-371-8093
Charge cards

Gross-Medick-Barrows
P. O. Box 12727
El Paso, TX 79913
800-558-0114
Photograph folders and boxes

Harrison and Harrison
677 North Plano Street
Porterville, CA 93257
209-782-0121
*Black-dot diffusers, low-
contrast filters, color viewing
screens*

Bruce and Sue Hudson
16627 Benson Road South
Renton, WA 98055
800-952-6609
Pre-portrait videos

Hugo Dunhill Corporation
630 Third Avenue
New York, NY 10017
212-682-8030
fax 212-983-1676
Mailing lists

Larson Enterprises
365 South Mountainway Drive
Orem, UT 84058
801-225-8088
*Reflectasol, Starfish, and
Soff-Strip*

Lindahl Specialties, Inc.
P. O. Box 1365
Elkhart, IN 46515
219-296-7823
fax 219-296-7636
Lens shades, filters

Marathon Press
P. O. Box 407
1500 Square Turn Boulevard
Norfolk, NE 68701
800-228-0629
*Printed advertising materials:
color postcards*

McGrew Color Graphics
P. O. Box 19716
Kansas City, MO 64141
800-877-7700
*Printed advertising materials:
color postcards*

Miller's Professional Imaging
P. O. Box 777
Pittsburg, KS 66762
316-231-8050
fax 316-231-6783
Film and digital processing

NPC Photo Division
1238 Chestnut Street
Newton Upper Falls, MA 02164
617-969-4522
fax 617-969-4523
 *Polaroid filmbacks for 120
 cameras*

Photogenic Machine Company
525 McClurg Road
Youngstown, OH 44512
216-758-6658
 *Electronic flash equipment:
 Eclipse umbrellas, Flashmaster,
 Master photo rails, PowerLight,
 Skylighter*

Photographers Warehouse
P. O. Box 3365
Boardman, OH 44513
800-521-4311
fax 216-758-3667
 *Electronic flash equipment:
 Medalite, mini-slaves, accent
 lights*

Quantum Instruments, Inc.
1075 Stewart Avenue
Garden City, NY 11530
516-222-0611
fax 516-222-0569
 *Qflash, Master Slave, Radio
 Slave 4i, Turbo battery*

Regal Photo Products
2769 South 34th Street
Milwaukee, WI 53215
800-695-2055,
414-645-2050
fax 414-645-9515
 *Regalite Six-Footer camera
 stand*

Studio Systems Software
890 Town Clock Plaza
Dubuque, IA 52001
800-397-2276,
319-556-6115
 *CARM studio-management
 software*

Charles R. Swindoll
Insight for Living
P. O. Box 69000
Anaheim, CA 92817
714-575-5000
fax 714-575-5495
 Motivational materials

Tallyn's Photo Supply
1609 West Detweiller Drive
Peoria, IL 61615
800-433-8685
 Tallyn Softfusers

T. J. Edwards Company
146 North River Road
Auburn, ME 04210
207-786-4238
fax 207-786-2810
 *Wyman hot-foil-stamping
 machines*

Veach
Route 11, Box 11409
Kennewick, WA 99337
800-523-9944,
509-586-3659
 Hot-foil-stamping machines

Wicker by Design
2705 Newquay Street
Durham, NC 27705
919-383-6212
 Wicker products

ORGANIZATIONS

American Society of Photographers
P. O. Box 3191
Spartanburg, SC 29304-3191
803-582-3115

Professional Photographers
of America
57 Forsyth Street NW
Suite 1600
Atlanta, GA 30303
800-786-6277,
404-522-8600
fax 404-614-6400

PUBLICATIONS

Dr. Stephen R. Covey
*The 7 Habits of Highly
Effective People*
Covey Leadership Center
P. O. Box 19008
Provo, UT 84605
800-553-8889
(Audiotape also available)

Dartnell Corporation
*How to Design a Personnel
Policy Manual*
4660 Ravenswood Avenue
Chicago, IL 60640
800-621-5463,
312-561-4000
fax 312-561-3801

Economics Press
Office Topics
12 Daniel Road
Fairfield, NJ 07004
800-526-2554

Frank Kristian
The Power of Composition
Self-published. 905-846-3452
ISBN 0-9691924-0-1

Jay Levinson
Guerilla Marketing
Houghton Mifflin Co.
222 Berkeley Street,
Boston, MA 02116
617-351-5000,
800-225-3362

Ernst Wildi
The Hasselblad Manual
Focal Press
Butterworth Publishers
80 Montvale Avenue
Stoneham, MA 02180
617-438-8464

Daniel Yergin
The Prize
Touchstone Books
Simon & Schuster
1230 Avenue of the Americas
New York, NY 10020
212-698-7000,
800-223-2336

INDEX